The Face of Mercy

A PHOTOGRAPHIC HISTORY OF MEDICINE AT WAR

THE PUBLICATION OF THIS BOOK
HAS BEEN UNDERWRITTEN BY THE

PROFESSIONAL IMAGING BUSINESS UNIT OF
EASTMAN KODAK COMPANY

THROUGH ITS CONTINUING SUPPORT OF
PHOTOGRAPHY IN JOURNALISM

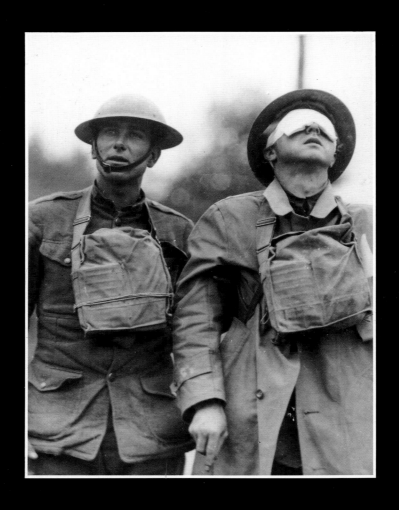

DEDICATED TO
THE MEN AND WOMEN
AROUND THE WORLD
WHO STRUGGLE DAILY
IN THE CAUSE
OF PEACE

The camera which isolates a moment of agony isolates no more violently than the experience of that moment isolates itself. The word trigger, applied to rifle and camera, reflects a correspondence which does not stop at the purely mechanical. The image seized by the camera is doubly violent and both violences reinforce the same contrast: the contrast between the photographed moment and all others.

As we emerge from the photographed moment back into our lives, we do not realise this; we assume that the discontinuity is our responsibility. The truth is that any response to that photographed moment is bound to be felt as inadequate. Those who are there in the situation being photographed, those who hold the hand of the dying or staunch a wound, are not seeing the moment as we have and their responses are of an altogether different order.

—John Berger, *About Looking*

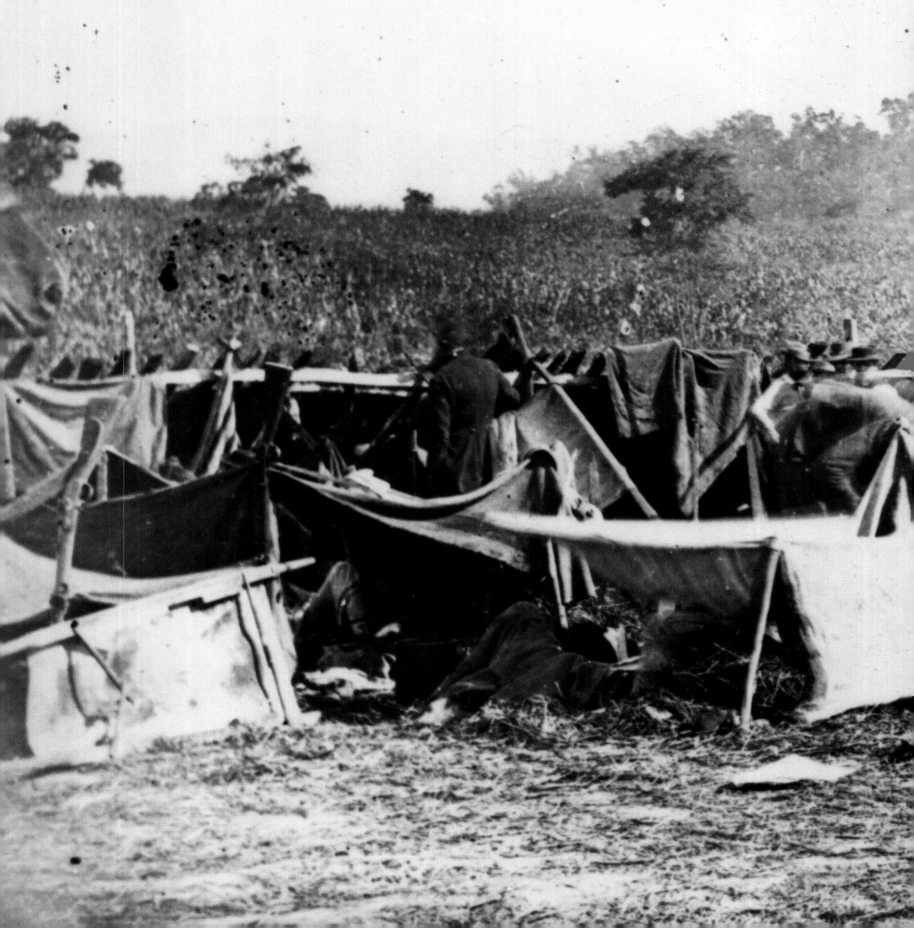

Regimental surgeon Anson Hurd, M.D., watches over wounded
Confederate soldiers who are shielded from the sun by tents made
of blankets, with muskets for tent poles.
Photographer unknown
Sharpsburg, Maryland, 1862

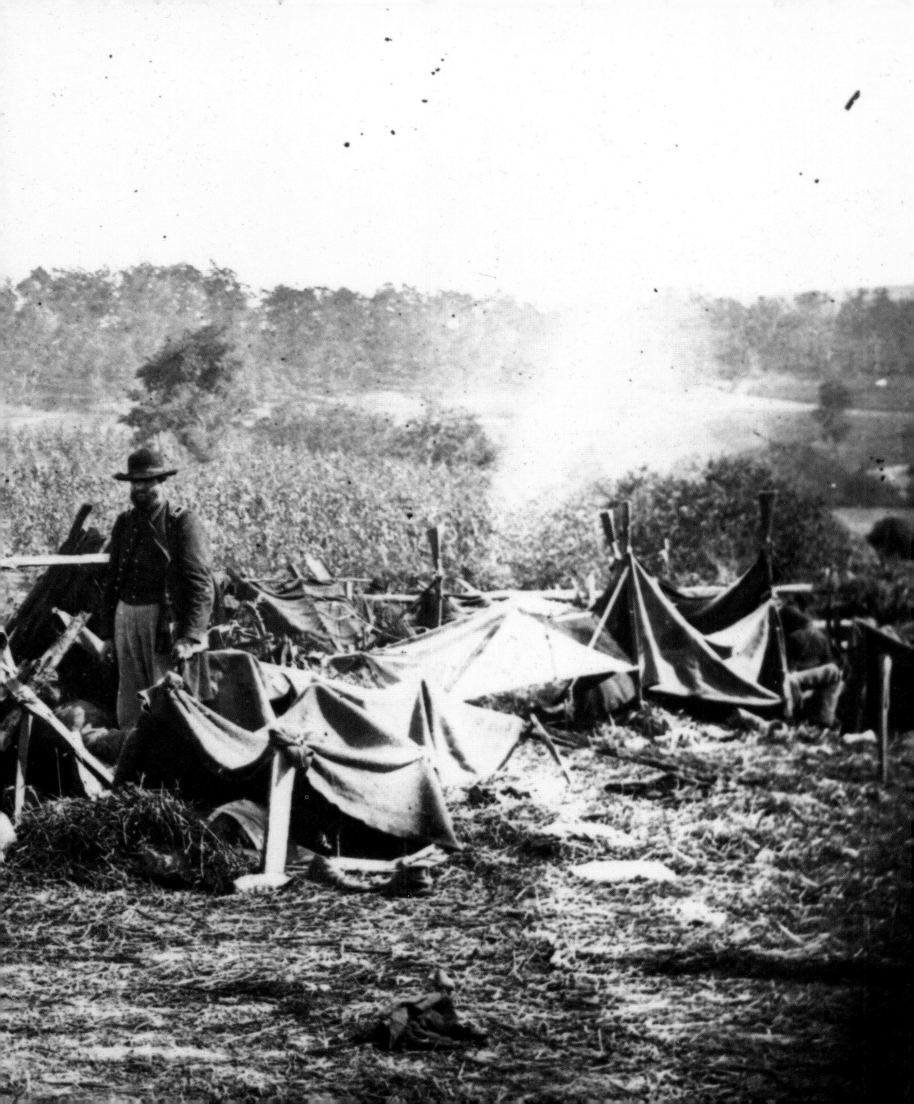

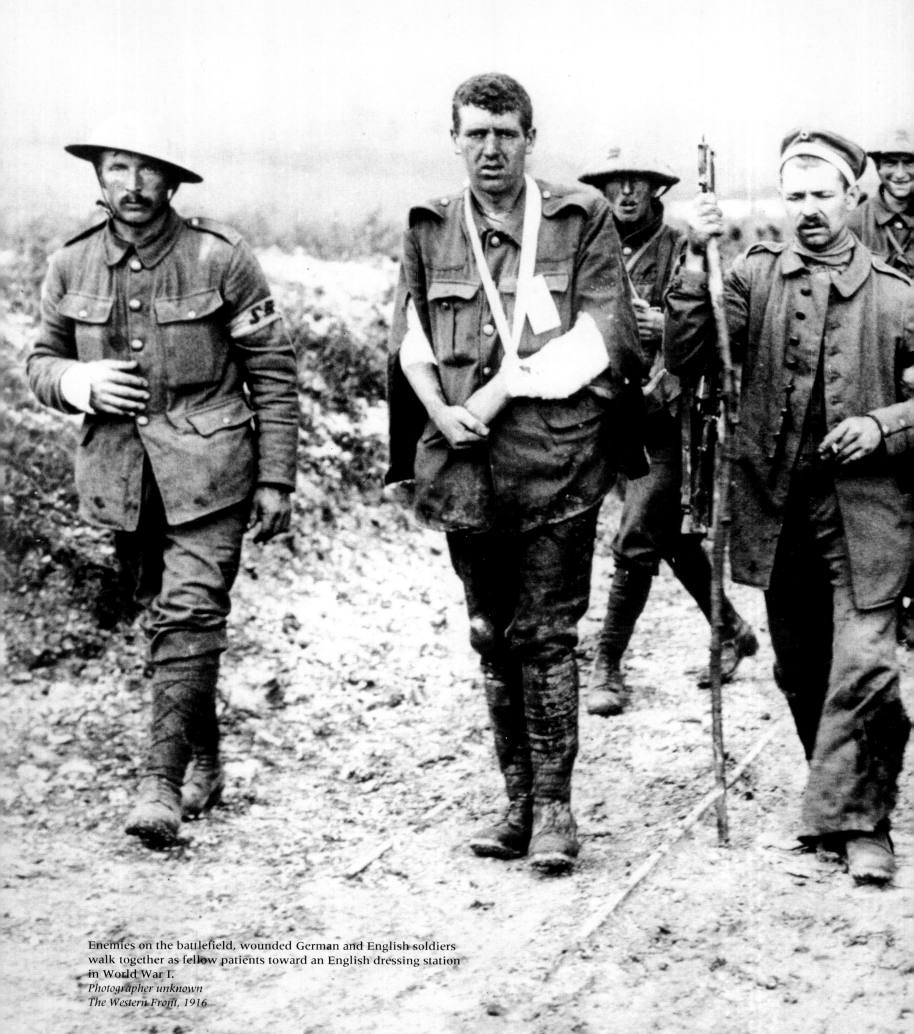

Enemies on the battlefield, wounded German and English soldiers
walk together as fellow patients toward an English dressing station
in World War I.
Photographer unknown
The Western Front, 1916

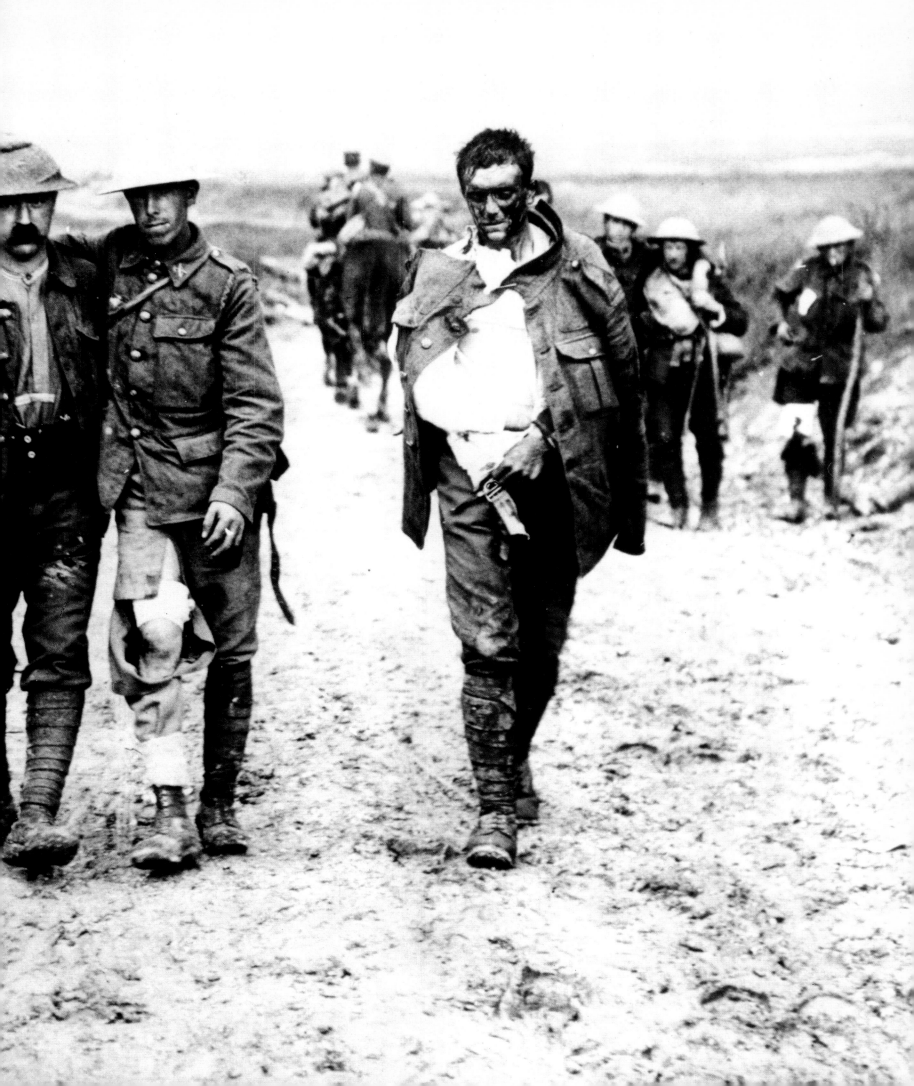

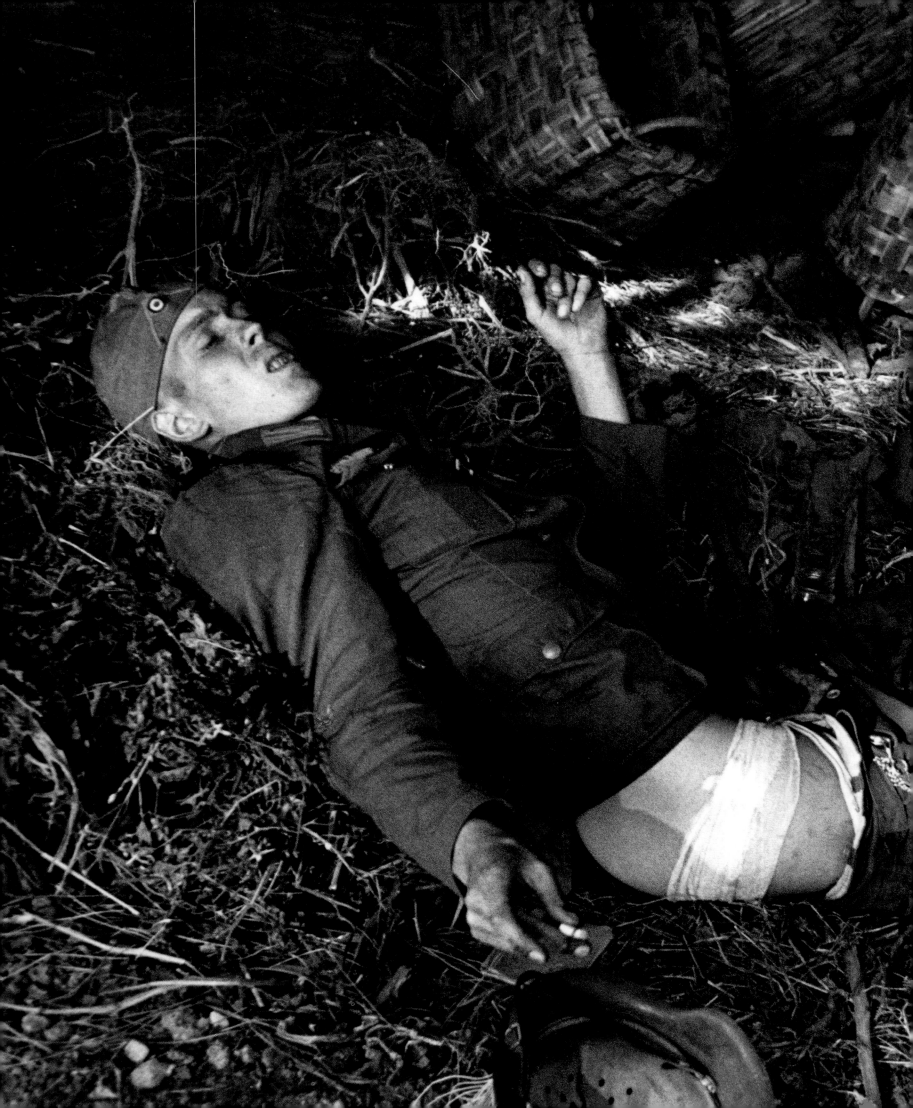

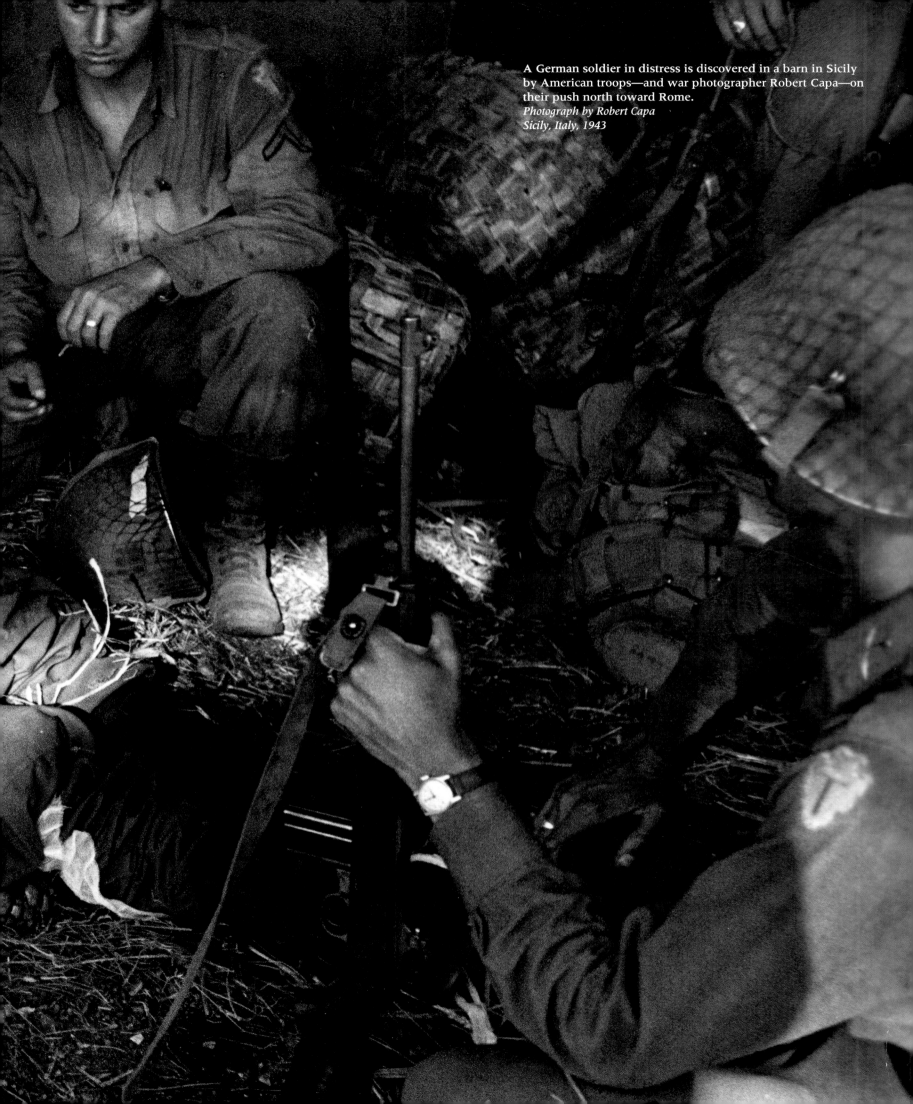

A German soldier in distress is discovered in a barn in Sicily by American troops—and war photographer Robert Capa—on their push north toward Rome.
Photograph by Robert Capa
Sicily, Italy, 1943

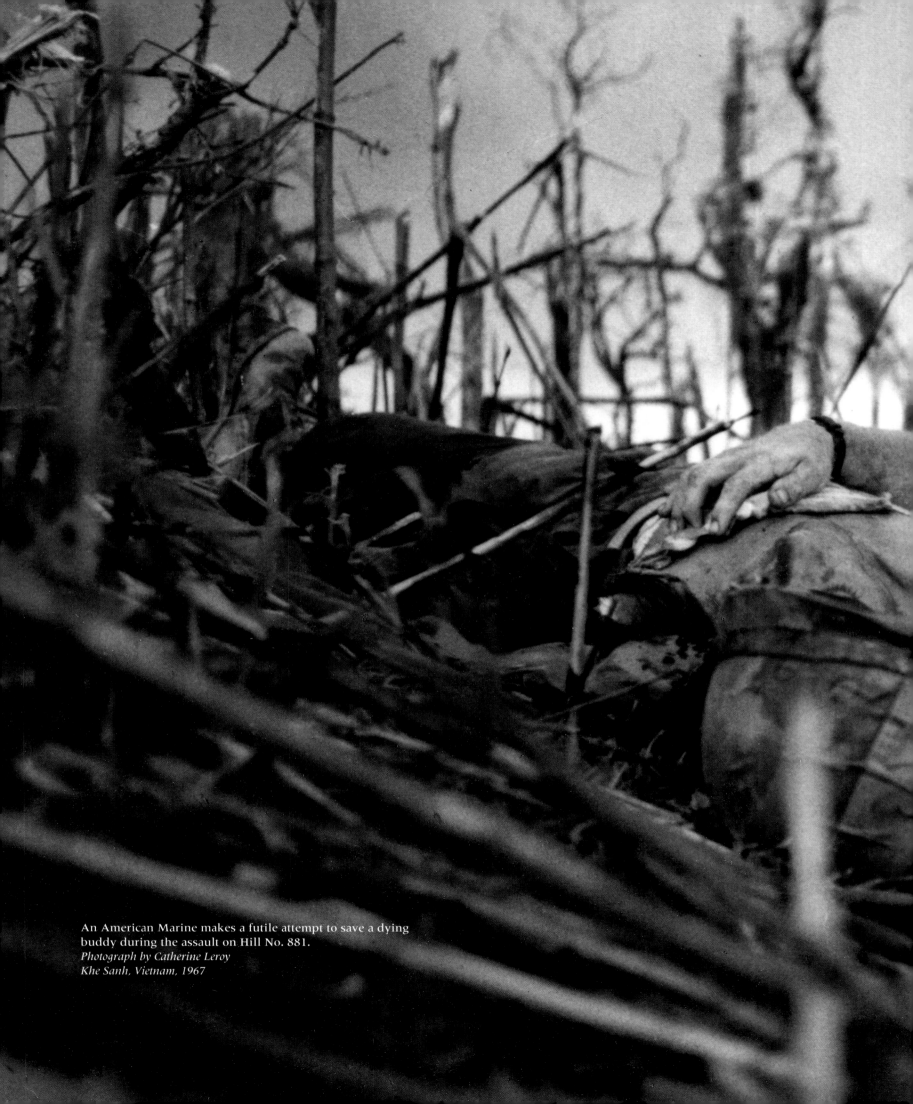

An American Marine makes a futile attempt to save a dying
buddy during the assault on Hill No. 881.
Photograph by Catherine Leroy
Khe Sanh, Vietnam, 1967

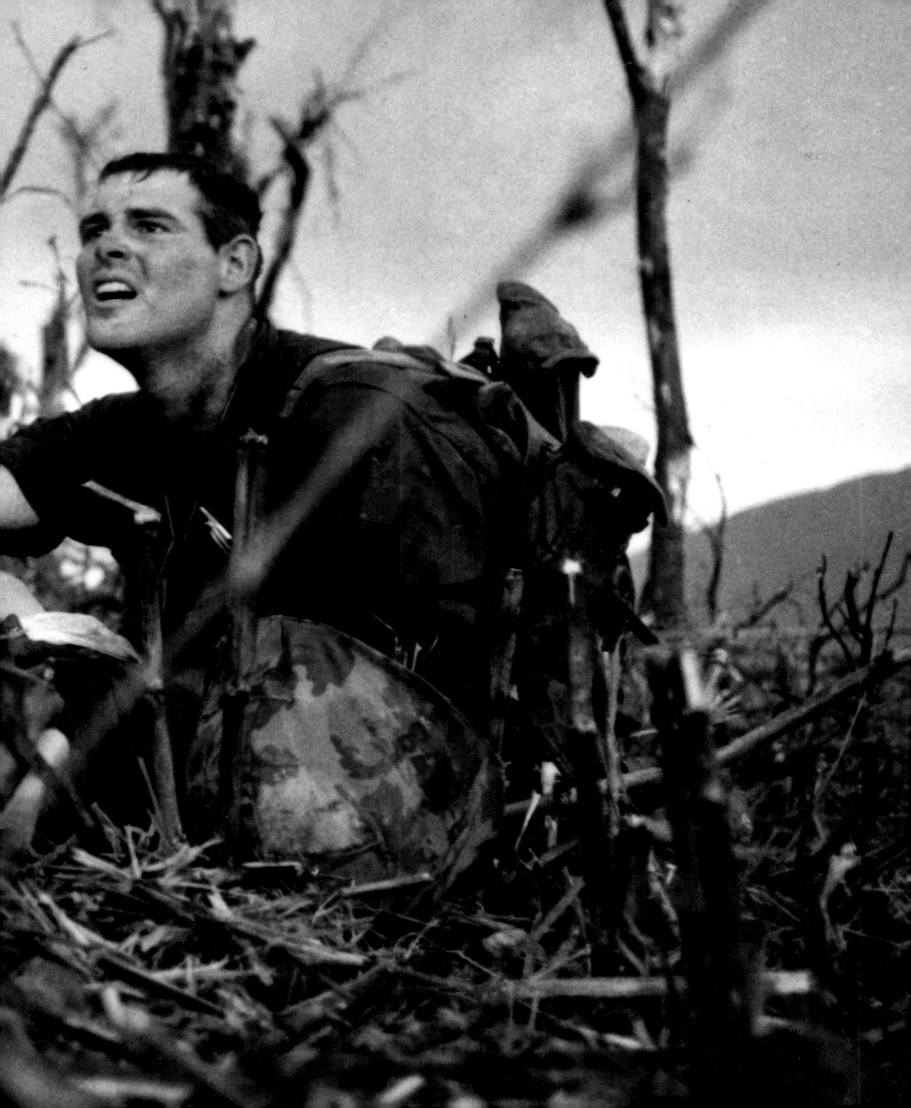

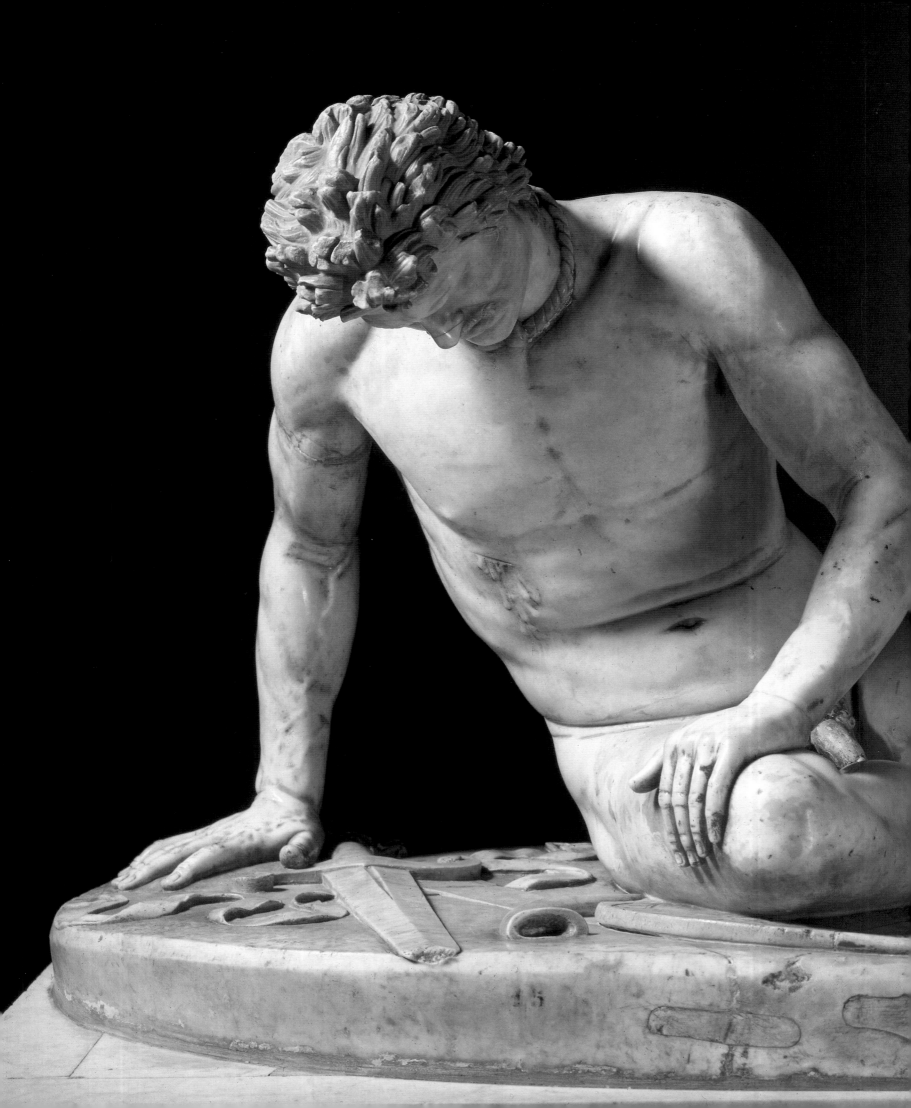

The Face of Mercy

A PHOTOGRAPHIC HISTORY OF MEDICINE AT WAR

Created and Produced by
MATTHEW NAYTHONS, M.D.

Prologue
WILLIAM STYRON

Narrative
SHERWIN B. NULAND, M.D.

Photographic Historian
STANLEY B. BURNS, M.D.

AN EPICENTER COMMUNICATIONS BOOK

 Random House

Created and Produced by
Matthew Naythons, M.D.

Art Director
Alex Castro

Photographic Historian
Stanley B. Burns, M.D.

Narrative
Sherwin Nuland, M.D.

Caption Writers
Stanley B. Burns, M.D.
Bernard Ohanian

Essayists
Gloria Emerson
Martha Gellhorn
Ward Just
Martha Saxton
William Styron
Judith Thurman

With special thanks to
Ray DeMoulin
Robert Loomis

Picture Editor
Anne Stovell

Picture Researchers
Dena Andre—*Washington, DC*
Ingrid Castro—*Paris*
Jay Colton—*New York*
Karina Djorak—*London*
Michal Donath—*Prague*
Arnold Drapkin—*Moscow*
Anne-Marie Ehrlich—*London*
Shirley L. Green—*Washington, DC*
Jennifer H. Greenfeld—*Washington, DC*
Isabelle Guisan—*Geneva*
Diane Hamilton—*Washington, DC*
Leny Heinen—*Bonn*
Suzanne Keating—*New York*
Bärbel Martens de Marina—*Madrid*
Tom Mattie—*New York*
Joan Menschenfreund—*New York*
Phyllis Montgomery—*Santa Fe, NM*
Phoebe Natanson—*Rome*
Chris Niedenthal—*Vienna*
Bridgett Noizeux—*Paris*
George Olson—*San Francisco*
Janusz Rosikon—*Warsaw*
Vivienne Silver—*Jerusalem*
Mária Sívó—*Budapest*
Assel Surina—*Moscow*

Photographic Printing
Bill Pierce

Editorial
Dawn Sheggeby
 Managing Editor
Rebecca Buffum Taylor
 Executive Editor
Kate Warne
 Assistant Editor

Text Editor
Rebecca Buffum Taylor

Editorial Consultants
Ray Cave
Harriet Heyman
Bernard Ohanian

Research
Bennett Hinkley
 Research Coordinator
Linda Jue
Susan LaCroix

Medical Advisory Board
Alfred Jay Bollet, M.D.
 Yale University
Maj. Gen. William Moore, Jr., M.D.
 Academy of Health Sciences

Marketing and Sales
Thomas McCarren
Jim Kelly
Jack Shattuck
 CPG

Accounting
Carla C. Levdar
Holly Herman
 Black Oak Services

Legal Counsel
Marc Bailin
 Marshall, Morris, Bomser,
 Fry & Bailin

Literary Agent
Deborah Schneider
 Schneider Gelfman
 Literary Agents, Inc.

Publishing Consultants
David Cohen
Dan O'Shea

Office Administration
Erika Gulick Smith

ISBN 0-679-42744-9

Printed in Italy
9 8 7 6 5 4 3 2 1
First Edition

MAR 23 1994

Page ii: An American soldier, blinded by poison gas, is led to safety by a comrade.
 Photographer unknown; Europe, 1918
Previous page: "The Dying Gaul" captures the typically solitary death of a Roman soldier wounded in battle.
 Artist unknown; Roman Empire, ca. first century B.C.

Contents

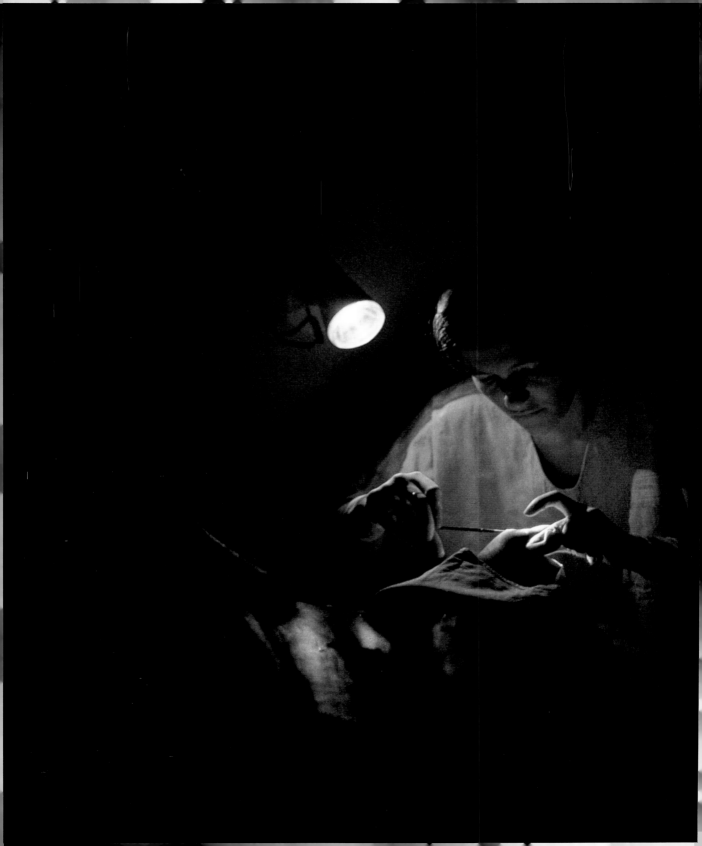

Prologue

William Styron

I n his illuminating chronicle of the Stone Age people of Western New Guinea, *Under the Mountain Wall,* Peter Matthiessen portrays a primitive culture with a most uplifting view of warfare. On the one hand, nothing better demonstrates the innate proclivity of human beings to wish to destroy each other than the incessantly bellicose activity of these people who, any anthropologist might observe, have plainly been at each others' throats for millennia, quite unaware that they have been behaving like the ancient Spartans or modern-day Germans and Americans. Yet there is a significant difference between their attitudes toward armed conflict and our own. Matthiessen comments on how the tribal wars seem to lack true aggressive venom. Whether this is due to an absence of politics and politicians, as we nonaboriginals understand such terms, or to a mysterious leaching-out over the centuries of the murderous spirit that makes our "civilized" armies function, the fact remains that the relatively cheerful wars waged by these people make us appear to be the real savages.

Although the New Guinea battles involve a certain amount of mayhem, usually inflicted by spears, the engagements themselves have the quality of spectator sport, almost entrepreneurial. Egged on by crowds of women on the sidelines, the warriors display a posturing machismo that suggests that glands, rather than politics or territoriality, may be warfare's universal prime mover. Wounds do occur but they are readily dressed by sphagnum moss, which is an ancient and worldwide remedy. When a more critical wound is suffered—that is to say, a single injury that is plainly lethal—the battle is quickly abandoned and both sides go home, one to celebrate the victory and the other to mourn the loss of the solitary victim. There is something touching and noble about a philosophy that regards war as a matter of moderation, and perhaps intuitively accepts collective aggression as an immutable part of the human conundrum yet converts that aggression not into wounding and death but into a form of play.

Had the rest of mankind pursued our primitive brethren's view of war as gamesmanship, there would be no need for a book like *The Face of Mercy,* this relentlessly disturbing yet somehow cathartic survey of the wretchedness caused by war, and the means by which men have attempted to treat injury and alleviate pain. Nor, one might add, would such

A doctor and nurse—French volunteers with Médecins Sans Frontières—tend to a civilian wounded by a land mine, working by flashlight to save fuel for "emergencies."
Photograph by Suzanne Keating
Sri Lanka, 1992

1

a book be needed if war were truly the benign delusion it has always remained in the minds of most of humanity, a vast hedonistic carnival in which money, power, sex, and glamour play the central roles. In virtually all wars, but in particular modern ones, only a tiny percentage of the military participants is exposed to danger, much less the focused terror and agony of real fighting. Countless men have a genuine longing for the thrills of combat, but if the reality were better known, and the ghastliness of the battlefield made to be the lot of all those who rushed to sign up, it is likely that wars would soon become extinct.

Consider the sex and the glamour. Even in a "good" war, like World War II, they often took precedence over loyalty, patriotism, and the desire to help destroy fascism, as factors motivating young men to sacrifice their lives. In the summer of 1945, nearly all of us nineteen- and twenty-year-old Marine second lieutenants, heading out from graduation at Quantico to the Pacific, were possessed by a single demented fantasy: the cocktail lounge at the Top of the Mark in San Francisco, sunset, two dry martinis, the turned-down bed waiting below, warm perfume, the blonde blossom of our dreams nestled close to our newly acquired golden bars. We had trained and toiled many months for this Faustian deal: two brief weeks at liberty in our swank gabardine uniforms with our adoringly compliant girls, and, as we sauntered down the streets, all the citizenry agape in admiration.

What is amazing is that during the period of our training, and of our fantasies, hundreds of our fellow Marine platoon leaders had died or been maimed in the terrible carnage at Iwo Jima and Okinawa (on Okinawa it was reported that a new second lieutenant's average time in combat, before death or wounding, was only a few hours), yet our awareness of this caused no serious qualm. Our desire for those golden bars, and the fragile delights they procured, extinguished the greater part of our fear. It was only when, far away from the girls, we were poised for the invasion of Japan (an Armageddon rendered needless, of course, by the atomic bomb) that many Marines began to indulge the dreadful suspicion that those recent bloodbaths might be harbingers of the greatest slaughterhouse of all.

While superficial though gorgeous entrancements often lure men into war, at the heart of war is suffering. This is a truth often lost, and one that *The Face of Mercy* generously illumines. So unspeakable is the anguish of war at its worst—much of it revealed in the text and pictures of this fascinating book—that at moments one is stunned with disbelief at our species' capacity for self-inflicted torment. But in placid acceptance of our folly, *The Face of Mercy* goes straight to the core of the ageless drama, confronting the damage and destruction wrought upon men during battle and showing the way in which constantly evolving medical strategies, dating from antiquity, have played an integral part in the history of war itself. Although it has become something of a commonplace that wars produce positive developments in medicine, it remains an engrossing subject and one that is chronicled here in brilliant detail.

There is a certain pathos, for example, in the fact that during the Civil War anesthesia first came into its own, permitting painless amputations, while surgical hygiene was still so primitive that many of those amputees, operated on by filthy hands wielding

filthy instruments, died rapidly of infection. Suppose these procedures had taken place only a decade or so later, after the Franco-Prussian War. By that time, Joseph Lister's germ theory was becoming generally accepted, and most deaths of this origin would likely have been avoided.

Such ironies abound in this book. Medicine becomes a paradigm for the fragile tie that human beings have bound between their creative spirit and their instinct for self-destruction. If the breakthroughs of peacetime produce lifesaving techniques for an upcoming war, so does military necessity create scientific advances that become lodged permanently in medical canon. During wartime, especially, there is often the conjunction of a medical crisis and a person of vision. In the sixteenth century Ambroise Paré, appalled by the barbarous method used to heal battle wounds, forever changes the process by trying what might simply be called a little tenderness. Two hundred years later the concept of human nutrition is permanently altered when a British naval surgeon, James Lind, treats shipboard scurvy with citrus fruit, effectively demonstrating a cure for vitamin deficiency.

The exigencies of a fearful epidemic among army troops in Cuba during the Spanish-American War causes Walter Reed to implicate the mosquito as the carrier of yellow fever, which becomes readily controllable thereafter. As technology develops, the pace of medical innovation accelerates in war after war. The brute nature of war itself, turning more calamitous as weaponry gains range and power, forces every warring race to discover increasingly effective modes of healing. New x-ray techniques, blood transfusions, the treatment of wound infections and burns, the dominion over disease (always war's lethal companion), better orthopedic procedures—these and countless other refinements have been generated by war to improve our problematic days of peace.

In the barely controlled chaos of war, is there any place for conventional rules of morality? This is a problem that has never been fathomed; our anguish over agents of destruction such as poison gas, saturation bombing, napalm, and nuclear weapons is evidence of the ongoing conflict. Two episodes described in *The Face of Mercy*, both involving ammunition, provide a scathing commentary on our ability to resolve the eternal confusion. In the 1890s, in Dum Dum, near Calcutta, British soldiers improved on the tissue-destroying capacity of their jacketed bullets by cutting off the tip of the bullet, thereby creating a famous small projectile that was deemed an enormous success because it virtually burst apart in the body. However, there were other schemes afoot. At almost the same time, in South Africa's Boer War, much of the firepower emanating from the newly developed small-caliber rifles caused relatively little damage as the bullets entered the flesh. It was an innovation hailed as "humane."

Amid war's mad incomprehensibility it is perhaps best that we regard medicine, and the face of mercy it presents, as the only saving grace.

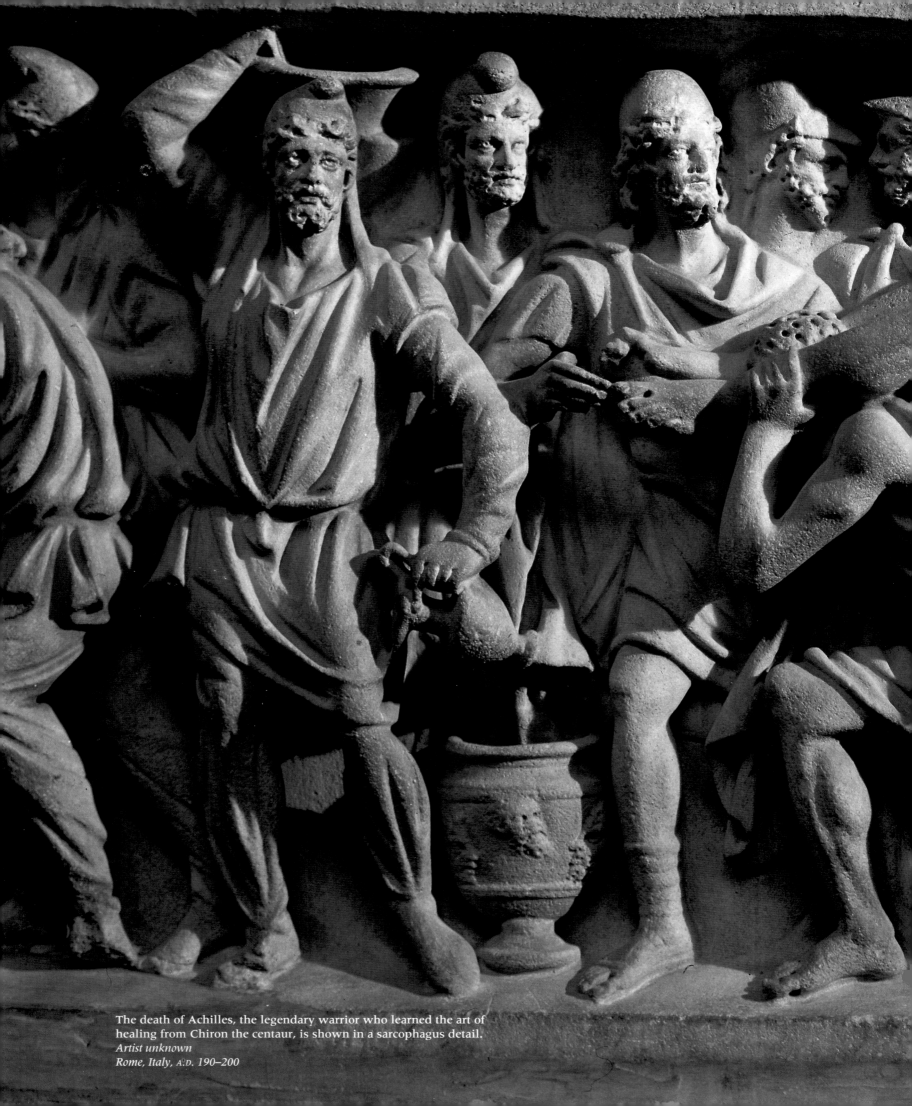

The death of Achilles, the legendary warrior who learned the art of healing from Chiron the centaur, is shown in a sarcophagus detail.
Artist unknown
Rome, Italy, A.D. 190–200

In Classical Times

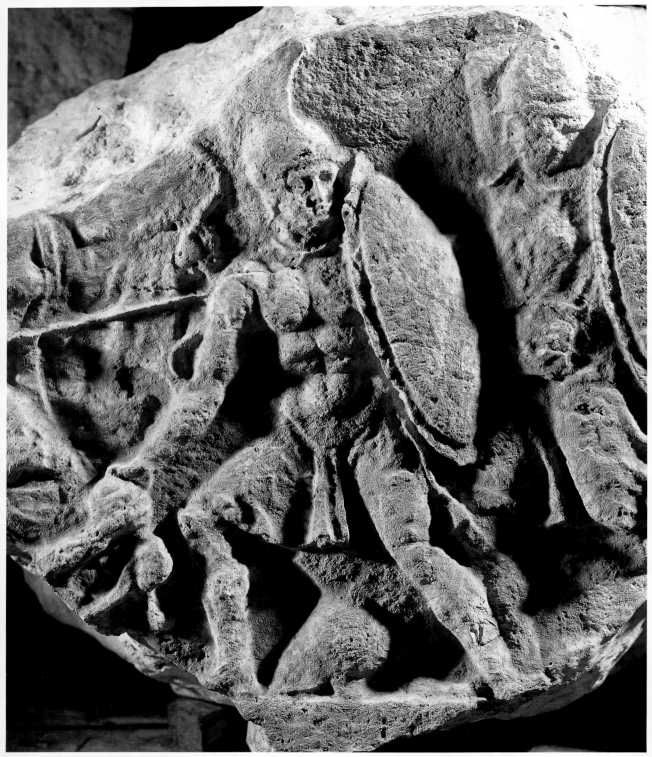

The Inglorious Healing Arts

He, to defer the fate of a sire sick unto death, chose rather to know the virtues of herbs and the practice of healing, and to ply, inglorious, the silent arts.

—*Virgil, from the* Aeneid, *Seige of Troy*

—poor boy! I never knew you,
Yet I think I could not refuse this moment to die for you, if that would save you.

—*Walt Whitman, from "The Wound-Dresser," * Leaves of Grass, *Civil War*

"'I won't let you die!' I shouted in his face. Even though I knew it was hopeless, I had to do something—for me if not for him. I had to try."

—*Craig Roberts, from* Combat Medic—Vietnam

Ancient military medicine was as primitive as the warfare of its time. Surgeons used tools much like the spears and swords used by the armies that fought at Troy in the thirteenth century B.C., whose exploits were recorded on this tomb of a Lycian prince. Hippocrates, in the fourth century B.C., brought the concepts of objective observation and deductive reasoning to the art of medicine. But it would take another few hundred years for the fate of the wounded soldier to improve with medical progress: the Romans, in approximately 200 B.C., introduced organized first aid in the field.
Artist unknown
Lycia, Turkey, 380 B.C.

T his is the face of mercy—and this is the face of medicine at war. Always outflanked by the technology of destruction and seemingly overwhelmed by the sheer magnitude of their humane obligation, those in the battle who have chosen to be healers have ever persevered in their calling. Each of them is, in a sense, anointed to be his brothers' keeper, though his brothers have been chosen to kill. In one or another form, whether in the Persian Gulf or on the plains of Troy, the stories of battlefield healing somehow take on the same quality—the quality of mercy unstrained. It is that same unstrained mercy of which Shakespeare wrote: "It droppeth as the gentle rain from heaven / Upon the place beneath: it is twice bless'd; / It blesseth him that gives and him that takes."

Era by era, century by century, and war by war, the healer has found himself ever less alone in his mission. Once a solitary figure on battlefields—once, in fact, not even a doctor but simply a compassionate comrade-in-arms—he who treats the wounds of his fellows was gradually joined by a host of adjutants that in itself has formed a kind of army, opposing the forces of death. At first field aids, and then nurses, wound dressers, ambulance drivers, medics, laboratory personnel, and finally helicopter pilots make up a few of the legions that have served in the doctor's army.

And now, in the twentieth century, the powerful echelons of modern medical science have joined the battle, a battle no longer fought only in the field. When doctors go off to war, they are but the front line of a massive campaign that reaches back into civilian life—big-city hospitals, university and federal laboratories, pharmaceutical research facilities, and even the design departments of engineering firms. The healing has never caught up with the killing, and perhaps it never will. But in the trying, enormous strides have been taken in the effort to understand the human body and its response to injury and disease. In this sense, the doctor has studied the tactics of his ancient enemy—warfare—and turned them to his own advantage, and to humankind's.

Nature herself is often to be found among the enemy, her forces lined up against those who would soothe the wounds of battle and fight the pestilence that always accompanies armed conflict. Her rats and her mosquitoes, her floods and her plagues, her famines and even the bacteria in her very earth have again and again overwhelmed armies and destroyed nations. Against all of this—against the destructiveness of battle and the savageries unleashed in wartime by nature—stands the figure of the doctor.

Even the battlefield itself has always been a great laboratory for physicians, an opportunity to observe and to treat, and an opportunity for bold innovation. Unhampered by the restraints that society and circumstance must impose on civilian medical practice, military physicians have had vast experience under conditions of desperation that almost never otherwise occur. Occasionally, those conditions have given rise to a form of what can only be called clinical courage, resulting sometimes in failure but not rarely in startling leaps forward that in peacetime might have taken decades to accomplish.

But for individual physicians, for those who have faced the stark realities of a battle's excruciating ordeal, war has been far more than just a laboratory of discovery. Its mass destruction on the one hand and its multitude of individual crises of suffering on the other have since antiquity called forth the humanity of healers to fulfill their ancient calling—the relief of suffering and the struggle against death. For soldiers who must kill for a cause they believe to be noble, war summons up relatively equal portions of those qualities that are the best of all that is within them and those qualities that are the worst. For doctors at war, whose mission is only to heal, the wellsprings that surface seem almost always to arise from the innate goodness and altruism that motivate humankind at its finest moments.

In his essay "Medicine, Warfare and History," the medical historian John Fulton wrote, almost forty years ago: "It is not commonly realized that many of the most significant advances in medical science have been made by medical officers in the armed services or by civilian physicians working under the stimulus of wartime exigency." Professor Fulton was not writing about advances that depended upon armed conflict alone; he was referring to the acceleration of progress that inevitably results from a concentrated effort that occurs concomitant with vast amounts of sickness and injury and vast numbers of personnel to combat them. The very acuteness of war speeds the recognition of medical needs and focuses medical effort, thereby hastening medical progress, as well.

Whatever havoc a war may wreak on society, it always speeds up the process of change. Humankind revises its image of itself and visualizes new horizons unthinkable

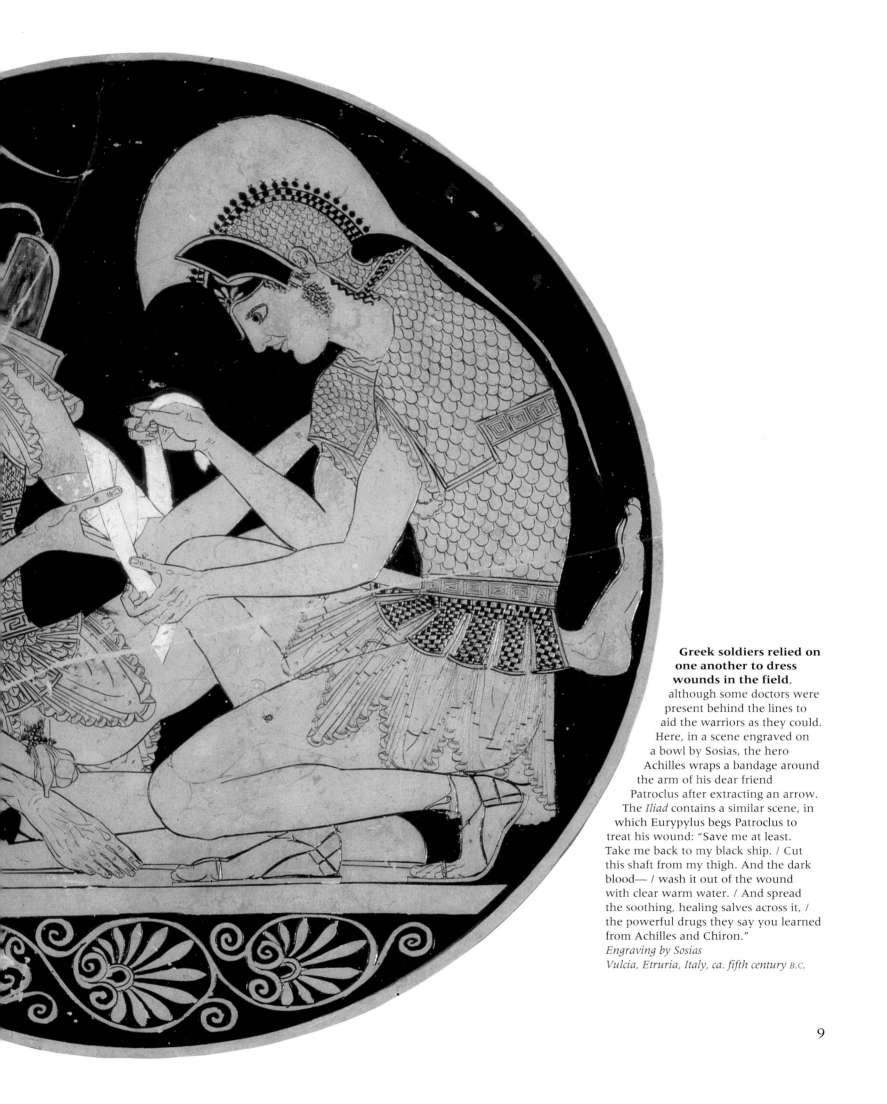

Greek soldiers relied on one another to dress wounds in the field, although some doctors were present behind the lines to aid the warriors as they could. Here, in a scene engraved on a bowl by Sosias, the hero Achilles wraps a bandage around the arm of his dear friend Patroclus after extracting an arrow. The *Iliad* contains a similar scene, in which Eurypylus begs Patroclus to treat his wound: "Save me at least. Take me back to my black ship. / Cut this shaft from my thigh. And the dark blood— / wash it out of the wound with clear warm water. / And spread the soothing, healing salves across it, / the powerful drugs they say you learned from Achilles and Chiron."
Engraving by Sosias
Vulcia, Etruria, Italy, ca. fifth century B.C.

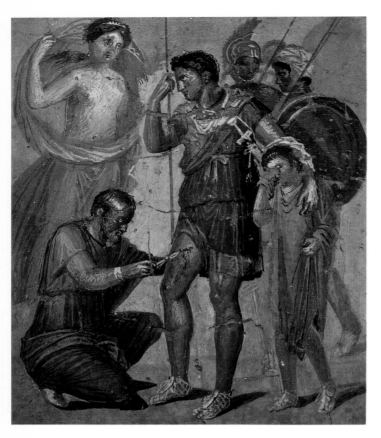

prior to the conflict, except to the most farseeing of visionaries. The collective mind is receptive to ideas that could not have been entertained had not Mars thundered his portentous message that things are no longer the same as they were, and neither are people. Herein lies the real meaning of John Fulton's statement. War hastens the progress of medicine because society and culture have expanded their view of life, and become ready for concepts previously unknown.

The relationship between medicine and war encompasses the outward manifestations of two of humanity's most basic, conflicting instincts—aggression and self-preservation, the need to destroy and the need to heal. The body's very tissues reflect this struggle in their constant process of breakdown and repair. Unfortunately, the ability and impulse to cure have never kept up with the ability and impulse to kill.

In the conflict between the Trojans and Greeks of some three millennia ago, the proportion of injuries to deaths was close to one-to-one. Unless a wound were minor, the ordinary soldier would likely die of it. And until the twentieth century, the true cost of war was a great deal higher. When infectious and nutritional diseases are also considered, the startling evidence emerges that, for most premodern wars, a general could expect to lose far more men to sickness than to slaughter. Think only of the fact that for every one of the Union soldiers who lost his life to a battlefield injury in the American Civil War, two others died of the pestilential and dietary consequences of military life. It was with good reason that Benjamin Rush, the most prominent American physician of the colonial period, wrote of the Revolutionary War: "Fatal experience has taught the people of America the truth of a proposition long since established in Europe, that a greater proportion of men perish with sickness in all armies than fall by the sword." Not until the Franco-Prussian War of 1870–71 did more men-at-arms die of their wounds than of the various forms of pestilence and inanition that hover always over great hordes of people concentrated in one area.

The dangers of encampment have been documented since the beginnings of Western culture. Of all the contributions of the Mosaic law of the Israelite nation, the attention paid to the sanitary habits of a newly organized people are of paramount interest to historians of medicine. The preventive medicine of Leviticus and Deuteronomy set standards unknown to the peoples of the time. Most striking to the student of war is the short section on the policing of a military camp found in Deuteronomy (XXIII, 9–14), where

Even when doctors were available to treat Greek soldiers, their skills were so rudimentary that they often relied on divine intervention. In this fresco from Pompeii, based on a scene from Virgil's *Aeneid,* the hero—wounded in the battle for Troy—is treated by the physician Iapyx: "The aged leech, with robe rolled back, and girt in Paeonian fashion, with healing hand and Phoebus' potent herbs makes much ado—in vain; in vain with his hand pulls at the dart, and with gripping tongs tugs at the steel. No Fortune guides his path, in no wise does Apollo's counsel aid: and more and more the fierce alarm swells o'er the plains, and nigher draws disaster." In the poem, Aeneas is saved only through the intervention of the goddess Venus—his mother—who magically provides Iapyx with a stalk of the healing herb known as dittany.
Artist unknown
Pompeii, Italy, ca. first century B.C.

specific instructions are given on the disposition of excreta "when the host goeth forth among thine enemies." But until relatively recent times, basic sanitation was of little interest to military commanders, and they were to reap the grim harvest of their ignorance and neglect.

Whether to solve the problems of sanitation or of psychological stress, whether to treat wounds or water supply, whether the fight is against cholera or cannon, typhoid or trauma—the challenge to medicine at war is always the same: to undo the crippling consequences that man's folly perpetrates on individual men, and to outwit the forces of death. And like every strictly military aspect of a campaign, the response of physicians has been both strategic and tactical—the grand plans for triage, transport of the wounded, hospitalization of the sick, and organization of echelons of treatment facilities have been laid out, while on the battlefield itself individual physicians have seen individual stricken soldiers and struggled to find better ways to care for them.

Even in this, there is some hope, even in the struggle between Aesculapius, the Greek god of healing, and Mars, the Roman god of war. Medicine, like the very science upon which it is based, has no nationality and bears no ethnic grudges. It knows no boundaries

A Roman mosaic celebrates Alexander the Great's defeat of the Persians (*below*). One of the most skilled generals in history, the young Macedonian was also a keen judge of medical talent. After his surge into northern India in 326 B.C., he arranged for exotic medicinal herbs to be collected and brought to his old teacher, Aristotle, for further study, and recruited several Hindu physicians to teach Greek doctors new techniques. His imperial capital, Alexandria, founded five years earlier on the Nile, became the world center of medical research for centuries to come.
Artist unknown
Roman Empire, ca. first century A.D.

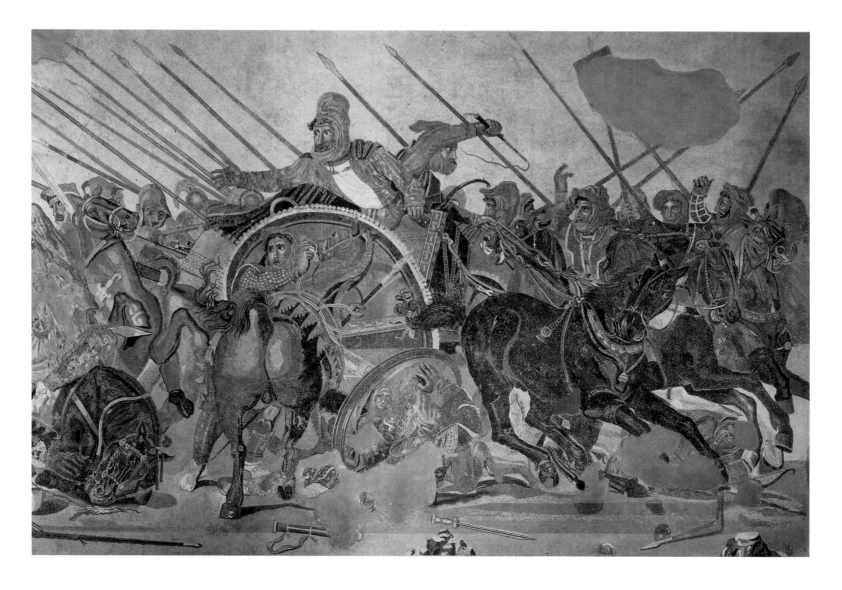

of geography, faith, or politics. Its only geography is the world, its only faith is good will, and its only politics is the universality of international cooperation. This, of course, describes medicine at its best. Doctors carry with them into war a standard worth marching behind, an ethic that stretches back to Hippocrates; it is the same, old, great, open secret of the real physician, whether in the military or not: "Where there is love of mankind, there is also love of the Art of medicine."

And so war is the ultimate medical challenge. The wound surgeon of the Roman Empire and the biotechnical military doctor in the Persian Gulf are linked across the millennia by the unifying theme of a physician's obligation to his patient—the obligation to relieve suffering. The by-product of caring has been progress, so that caring in itself

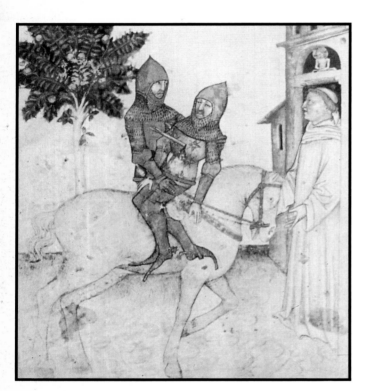

inevitably leads to more effective ways to treat disease and injury in peacetime just as in war.

The Greek word by which Hippocrates designated a healer was *Iatrós*, but in the ancient Ionian language from which Greek was derived, that word originally meant "extractor of arrows." From the very beginning, therefore, the concept of healing was related to the concept of care of those wounded in battle. Hippocrates knew that the field of battle was the proper training ground for those who would treat the diseases and injuries of their fellows. The Father of Medicine expressed it in an aphorism: "He who would become a surgeon, should join the army and follow it."

When the Crusaders set out from Europe to claim the Middle East for Christianity, they were often taken in and cared for by monks, as shown in this illustration from a fourteenth-century French manuscript, *The Romance of Lancelot*. Monasteries dedicated to the care of the sick date back to the sixth century A.D., when St. Benedict founded the Benedictine order and made healing its mission. Throughout the Middle Ages, however, from the fifth to the fifteenth century, the line between healing and fighting began to blur. The Knights of St. John Hospitalers, founded by a monk named Brother Gerard and responsible for building a two-thousand-bed hospital in the Holy Land, soon became a fighting order as well: they captured Rhodes from the Turks and held it for two centuries.
Artist unknown
France, fourteenth century

Early narratives of war abound with descriptions of weapons and injuries, but not of healing. Hygiene is not discussed, and only infrequently is mention made of the treatment of the wounded. Homer's mostly legendary *Iliad* provides the first description of war wounds and the provision that was made for their treatment. Although the great epic poet writes of only four days of fighting toward the close of what had been a ten-year war, he describes a total of 147 wounds of which 114 resulted in death. The great majority were inflicted by spears, with swords, arrows, and slung stones accounting for the rest. Accompanying the troops were men who were designated specifically as surgeons, but several of the chieftains were skilled in the art of wound treatment as well. Here Patroclus treats the arrow wound of Eurypylus.

Having laid hold of the shepherd of the people under his breast [he] *bore him to the tent, and his attendant, when he saw him, spread under him bulls' hides. There*

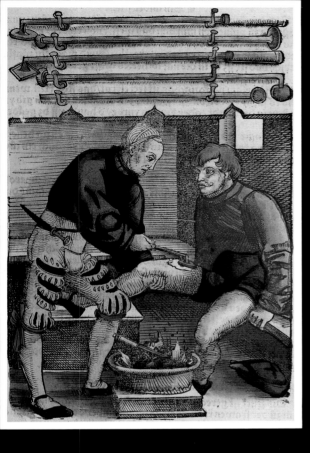

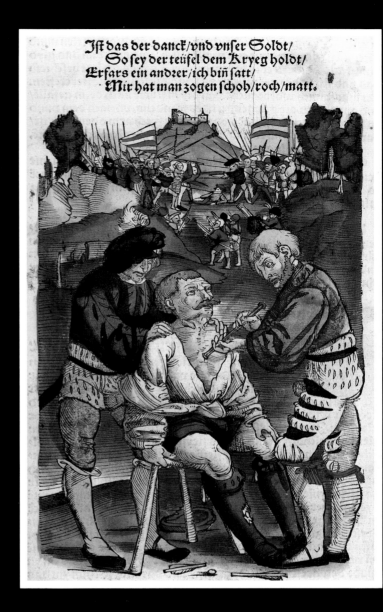

Ist das der danck/vnd vnser Soldt/
So sey der teüfel dem Kryeg holdt/
Erfars ein ander/ich bin satt/
Mir hat man zogen schoh/roch/matt.

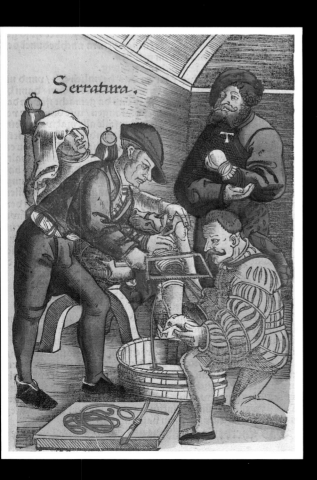

Serratura.

As the sixteenth century dawned, gunshot wounds were treated by the introduction of boiling oil or by cauterization with a hot iron *(above left)*, since surgeons thought that bullets were agents of poison and that heat would burn the poison out. But before any wound was treated, the bullet, arrow, or lance was extracted. A 1517 medical text recommended the use of a tubelike device to pull out arrowheads *(above)*; pincers and tongs were used to extract bullets. The surgeons' u[...] hands and instruments added [...] risk of infection, and the boilin[...] cauterization destroyed even m[...] sue than had the original bulle[...] many limbs had to be amputat[...] surgeon's use of an amputatio[...] this scene *(below left)* still repre[...] grim kind of progress: earlier a[...] tions were generally done with[...] *Woodcuts by Johannes Wechtlin* [...] *Germany, ca. 1517*

Patroclus, laying him at length, cut out with a knife the bitter sharp arrow from his thigh, and washed the black blood from it with warm water. Then he applied a bitter pain-assuaging root, rubbing it in his hands, which checked all his pangs; the wound, indeed, was dried up and the bleeding ceased.

Homer also describes an epidemic that attacked the Greek troops. Although some historians are convinced it was plague, the disease may very well have been the same contagious diarrhea that was so prevalent in the Mediterranean basin. Hippocrates would describe its devastating effects eight centuries after the battle of Troy. In 1915, it was still present, killing thousands of British troops at Gallipoli, just across the Hellespont from Troy.

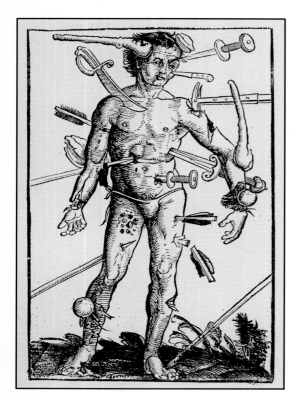

The wound care rendered by Patroclus was the standard for its time and for more than two millennia thereafter, until the invention of gunpowder introduced fearful new forms of murderous injury. What varied during those two thousand years was not so much the treatment of wounds as the treatment of the wounded themselves. Some of the ancient armies were scrupulous in the care of their injured, and some were quite barbaric. Xenophon, in his *Anabasis,* wrote in 386 B.C. that his own troops carried the wounded on their backs during the retreat home after the Persian defeat at Cunaxa, but this was hardly a general rule.

For another twenty-five hundred years, wounds would remain less decisive than the horsemen of pestilence and famine. There is no starker example of the debilitating effect of disease upon a military power than the story of the plague of Athens in 430 B.C., which confounded the military strategy of the Greek leader Pericles and led directly to the destruction of the Athenian Empire. When the Spartans attacked, the Athenians, knowing they could not defeat their enemy's stronger army, retreated behind the walls of their city, planning to destroy the Spartan power by a series of attacks carried out by their own vastly superior naval forces. Fearing the Spartan soldiers, farmers from all the surrounding countryside flocked into Athens, doubling its population and straining sanitation and municipal services. When an epidemic of uncertain nature broke out, it spread rapidly through the cramped populace. In time, the disease decimated the navy and destroyed the power of the Athenian fleets. There has been much historical speculation about the nature of the disease, with retrospective diagnoses that range from plague to toxic shock syndrome. Whatever it was, its ravages were severe enough to ensure a Spartan victory. The Golden Age of Greece ended not with a great battle, but with a great pestilence.

A "Wound Man" graphically details the injuries that might befall a soldier and shows—through the weapons' points of entry—the sites of the arteries to be used for ligation (tying off a vessel to stop bleeding). Evolved from ancient healing diagrams based on the zodiac, it was used to illustrate surgical textbooks for nearly three hundred years, beginning with its introduction in the fifteenth century. This particular carving, which appeared in Hans von Gersdorff's *Feldtbuch der Wundartzney* in 1517, became one of the most famous of the "Wound Man" carvings and diagrams used to train military surgeons.
Artist unknown
Germany, sixteenth century

Relatively sophisticated prosthetic limbs demonstrate that surgeons in the 1500s possessed an increasingly subtle understanding of joint articulation and the musculoskeletal system. Articulated steel devices began to replace the earlier, cruder, wooden prosthetics, and were more flexible. Amputation techniques changed, too: surgeons began to use ligature to arrest bleeding after surgery, rather than the more painful cauterization technique then in vogue.
*Drawings by Ambroise Paré
France, ca. 1575*

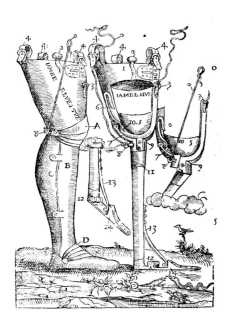

The glories of Greece were succeeded by the glories of Rome, but they were of quite a different kind. The one stressed esthetics, the other stressed organization; the one stressed the liberty of the individual, the other stressed the stability of organized government; the one stressed philosophic contemplation, the other stressed the pragmatism of action; the one stressed the study of nature, the other stressed the study of engineering; the one went to war to safeguard its peace, the other went to war for that reason, as well, but also to advance the needs of the empire. When that empire was fully developed, its armies could boast the beginnings of an organized system of medical care, the first that the world had ever known.

In the early days of the empire, however, the Romans considered medicine, and natural science in general, to be Greek and therefore suspect, until Julius Caesar gave physicians the right of citizenship. Up to that time, the treatment of disease was a domestic undertaking, characterized by home remedies and herbs. This was reflected in the military, where the Roman fighting man took his own bandages to war. In general, combatants cared for themselves and each other, just as they might have done at home. When a wound appeared to be mortal, the soldier made his way as best he could to a quiet place, to think his last thoughts as death approached. The nobility of such an end had great appeal to the Roman mind; it was perhaps for this reason that a marble copy of a well-known Greek statue commemorating a victory over the Gauls in Asia Minor was so popular in Rome. "The Dying Gaul" depicts a powerfully built warrior as he sinks into his final position of death, his life's spirit flowing out of an open wound under his right breast. It is clear that this brave man is dying alone, and unattended.

The Romans did not usually desert their wounded comrades who seemed able to survive. Often, they attempted to billet them in homes or with garrisoned troops. As the decades passed and the great days of the empire drew closer, medical care gradually became more well defined. There is some evidence, by 200 B.C., of a class of men designated as *medici vulnerarii,* or wound surgeons. These men were probably untrained in medical matters, and were simply being assigned to provide wound care as well as they could.

It was not until the reign of Julius Caesar (54–44 B.C.) that the Roman military medical system began to take shape. Caesar's motive in conferring Roman citizenship on all practitioners of medicine (the most able of whom, of course, were usually Greek) was very likely the improvement of the care of his army. Apparently, *medici* better educated than their predecessors were by then stationed with the troops and classed as noncombatants. The *medici* treated the common soldiers, but the senior officers brought personal physicians with them to war, a practice that would continue until the nineteenth century.

Trajan, emperor from A.D. 98 to 117, is described by the ancient historian Pliny the Younger as having visited the wounded in their tents and personally paying for the care of his soldiers. His victory in the Dacian campaign is commemorated by a column in Rome on which uniformed army surgeons are seen bandaging the wounded. The fact that they are wearing the same uniforms as the soldiers has been thought to mean that the *medici* of this period were still ordinary legionnaires who, unlike their predecessors, had been given some special training. A contemporary book credited to Trajan describes military hospitals.

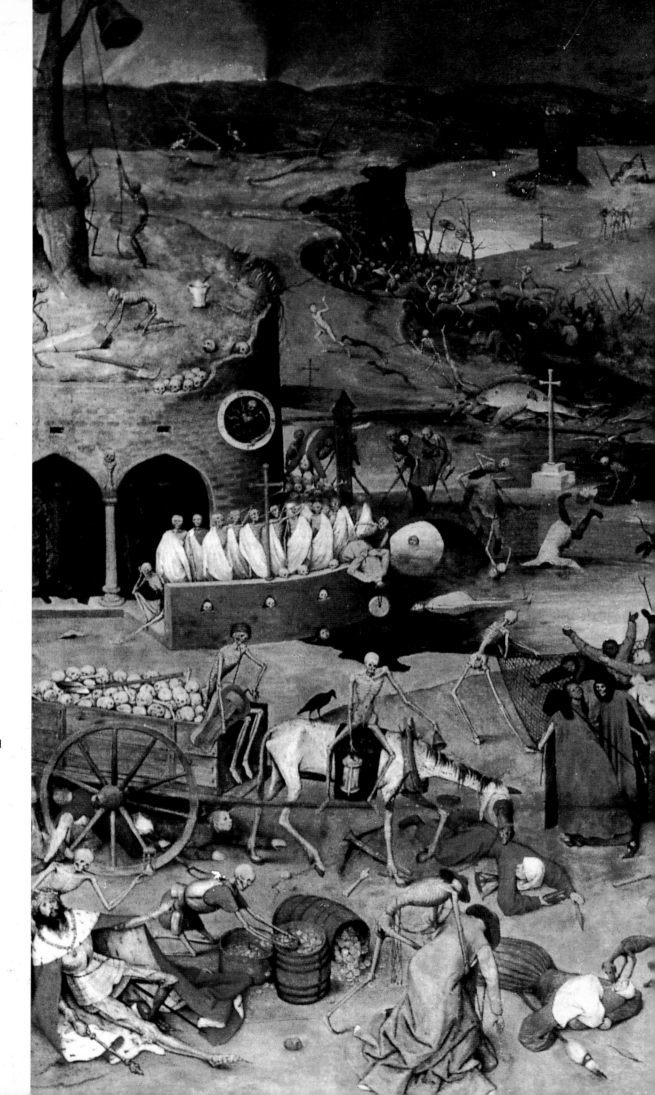

The bubonic plague epidemic of 1347 known as the Black Death killed a quarter of Europe's population in the space of three years. Two centuries later, Flemish painter Pieter Bruegel the Elder captured the terror that the plague still inspired across the Continent in his *Triumph of Death.* Warfare had played a key role in the rapid spread and fear of the plague, as traveling armies carried it across Europe. The first documented outbreak, in fact, may have been escalated by biological warfare: according to one account, a band of Tartars, fighting Italian merchants in the Crimea in the mid-fourteenth century, tossed the corpses of soldiers killed by the plague over the stone walls into the Italian encampment. When the Italians fled, they brought the plague home with them. Within three years, it became so virulent it actually put a temporary end to hostilities: England and France declared a six-year truce in the Hundred Years' War because they lacked the manpower to fight.
Painting by Pieter Bruegel the Elder Flanders, ca. 1556

16

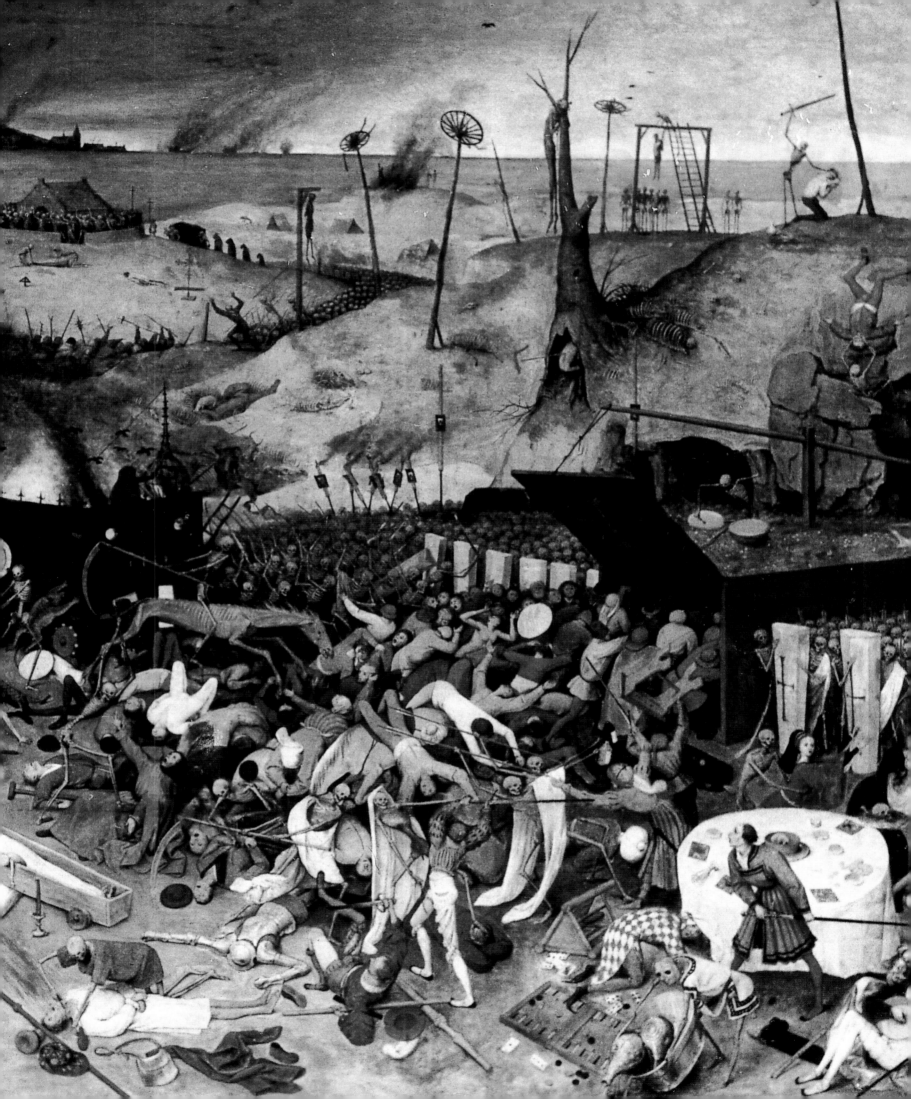

By this time, every legion and every warship probably had at least one of the *medici* attached to it—hardly adequate medical coverage since there were seven thousand men in each legion. The *medici legionis* held noncommissioned officer rank, and were subordinate to no one except the commander of their camp or ship. The guiding principle of Trajan's time foreshadowed the later statement of Aurelian, emperor from A.D. 270 to 275: *Milites a medicis gratis curentur,* or "Free medical care for the soldier."

Because Roman landowners had long recognized the need for separate quarters, called *valetudinaria,* for their sick slaves, it is not surprising that the Roman Empire of this period maintained what seem to have been well-equipped hospitals for their soldiers. These military versions of the *valetudinaria* were meant for the treatment not only of the wounded, but also for those who became sick with noncombat diseases. They were built even in the farthest reaches of the empire. In the few that have been unearthed, there is evidence of attention paid to such sanitary precautions as drainage and water supply. However rudimentary the system, it represented the first-known instance of formal care for the sick and wounded. Like so many of the accomplishments of Rome, this one bespeaks the attention of central authorities to some official arrangement for the needs of its citizens.

But with the fall of the empire, all of this disappeared from the West. In the Middle Ages, nobles continued to go to war with their own surgeons and physicians, but the troops were without medical care of any kind except what each man could provide for himself and his fellow. Unless a wound were superficial, the ordinary soldier would probably die. A wounded knight might be held for ransom, but the plain soldier slowed by an injury was likely to be hacked to death by the pursuing hordes of the enemy.

The highly organized army of the Byzantine Empire, however, arranged in a system of brigades and divisions from the middle of the sixth until at least the middle of the tenth century, did have what might be called a medical corps. *Scribones,* who functioned as corpsmen, were positioned two hundred feet in the rear of an action and had the duty of bringing out the wounded during the fighting. Army surgeons and physicians were attached to the various military groups as well. Moreover, Byzantium provided, as had Rome, asylum facilities for permanently disabled soldiers.

In the West, however, no such arrangements appear to have existed. There is no evidence, for example, of an organized method of caring for the sick and wounded of the Crusades. The heavy swords, lances, and battle-axes of the period created ghastly wounds, and the situation was often complicated by the heatstroke suffered by so many of the warriors who wore chain armor. Scurvy, typhus, and dysenteries of several sorts claimed countless lives, and neither sanitation nor discipline was improved by the hordes of camp followers who went along on each of these disordered adventures in Christian liberation. When the pious Godfrey of Bouillon, defender of the Holy Sepulchre and the first Christian ruler of Jerusalem, led his victorious army into the Holy Land at the end of the First Crusade in 1099, he brought with him no fewer than twenty thousand women.

The treatment of most battle injuries during the Middle Ages barely differed from the simple care given to a soldier of classical Greece or to the Dying Gaul who found a

Carrying sweet-smelling herbs and flowers in a beaklike cloth to ward off the stench of death, a medieval doctor sets off to treat plague victims (*far right*); other doctors hold sponges soaked in aromatic vinegar to their noses (*near right*). Although physicians in the 1300s didn't understand that the plague was transmitted to humans by fleas from infected rats—and then, if it attacked a person's lungs, directly from human to human—they did have a notion that it was somehow contagious. Public health measures instituted by the Venetian government detained ships suspected of carrying the infection for forty days, or *quaranta giorni*—the origin of the word "quarantine." But for the most part, the mysterious Black Death seemed to the world ubiquitous, unforgiving, and unstoppable.
Artists unknown
Near right: Germany, sixteenth century
Far right: Europe, fourteenth century

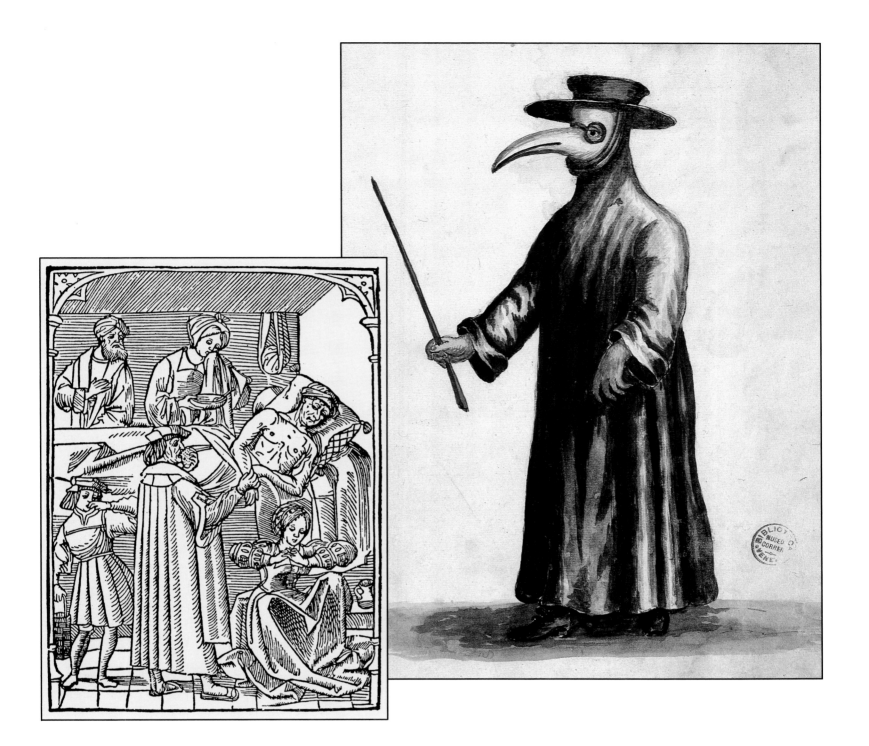

secluded spot where he might bleed out his life. The ordinary soldier rarely received any treatment at all; and even the noble knight, for all his access to a physician's therapeutic attempts, did not often fare much better. From a group of medieval epics, the medical historian Colonel Fielding Garrison created a composite picture of the gravely wounded knight.

> We see the wounded knight laid upon the ground, his wounds examined, washed and bandaged, often with a wimple from a woman's forehead; the various practices of giving a stimulating wound-drink to relieve faintness, of pouring oil or wine into wounds, of stanching hemorrhage or relieving pain by sundry herbs, of wound-sucking to prevent internal hemorrhage, the mumbling of charms over wounds; the many

balsams, salves and plasters used in wound-dressing; the feeling of the pulse in the cephalic, median and hepatic veins to ascertain the patient's chances of recovery; the danger of suffocation or heat-stroke from the heavy visored helmet and coat of mail; the eventual transportation of the patient by hand, on shields or litters, on horseback or on litters attached to horses; the sumptuous chambers and couches reserved for the high-born, and the calling in of physicians, usually from the famous schools of Salerno or Montpellier, in grave cases. The ministrations of womankind are always depicted with great charm, and prelude the organization of sick nursing in the later mediaeval period.

In spite of everything, the knight will probably die.

The calling in of physicians was often an act of futility in the Middle Ages. Little had changed in wound treatment for more than a thousand years. Pain was relieved by opiates derived from the poppy, the mandrake, and similar botanicals, as it had been since antiquity. Although some surgeons appreciated better than others the need for cleanliness, the basis of infection and gangrene would not be elucidated until relatively modern times. Surgeons treated bleeding arteries and veins with finger pressure or by grasping them with hooks so that they might be twisted into submission. If these methods did not succeed, they might attempt to tie the vessels with stout thread, which usually became infected enough to fall away in a sea of foul pus less than a week later, often resulting in fatal hemorrhage. If all else failed, a red-hot iron was applied to the bleeding tissue, frequently destroying the very flesh the surgeon was trying to heal.

The gradual introduction of new weapons increased the complexity of battlefield wounds, and made them more difficult to treat. The Greeks had developed various forms of catapults for siege warfare, among which the gigantic engine called the ballista was one of the most powerful. In the Middle Ages, the principle of the ballista was scaled down to create the handheld crossbow, perhaps the most dangerous weapon of that period. So fearful were its effects that Pope Innocent II forbade its use and denounced it in 1139 as "hateful to God and unfit for Christians." Not only was his injunction forgotten, but two centuries later the weapon was crafted of steel to render it even more powerful.

A different and quite novel agency of death was used for the first time in the Battle of Crécy in 1346. The explosive force of gunpowder would have a profound effect not only on the art of warfare,

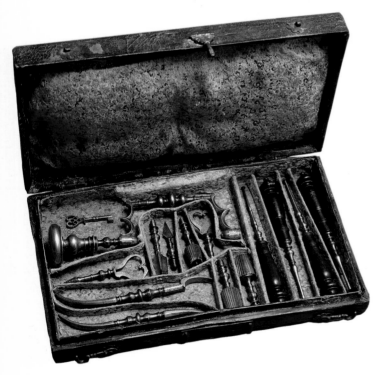

Ambroise Paré's accidental discovery that boiling oil was useless torture and bad medicine convinced him that medical science could best be advanced through experimentation and experience. After becoming a military surgeon at the age of twenty-six in 1536, Paré traveled throughout Europe with French noblemen, treating their battle wounds. He was so highly regarded by the French officers that he was smuggled into the beseiged city of Metz in 1552 to combat both high mortality and sagging morale by performing surgery on their wounded young soldiers (*right*). His surgical kit (*left*) contained various probes, eye bolts, and trepans, used to pierce the skull.
*Left: Musée de Laval
France, sixteenth century
Right: Painting by Théobald Chartran
France, sixteenth century*

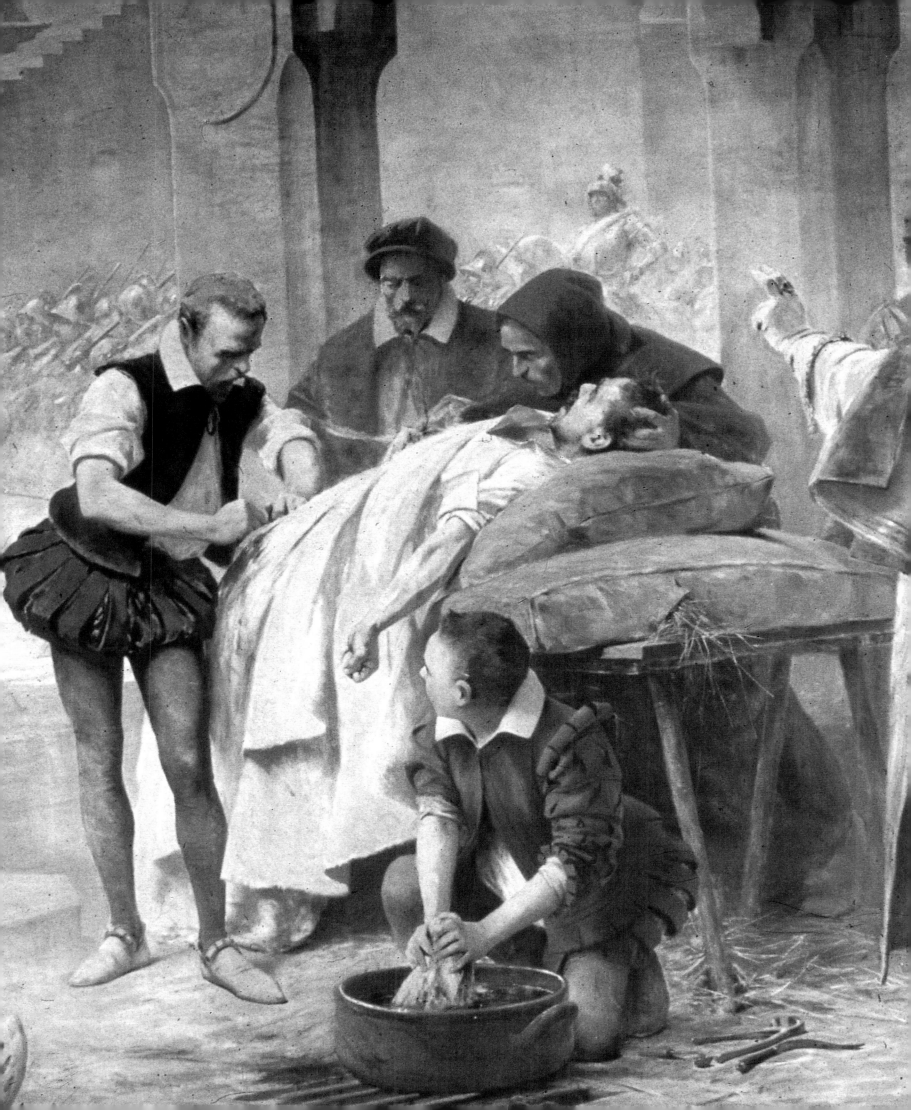

but on medicine and all of civilization, as well, as described by the medical historian Ralph Major.

> *The records of the city of Florence, Italy, in 1326 describe the manufacture of brass cannons and iron balls. Presently we read of hand guns loaded with powder and shot and fired from a touchhole at the top; then of short guns, or pistols, named from Pistoia in Italy, where they were invented. Gunpowder was beginning to exert its influence on civilization and to alter the art of war. Also it was beginning to affect the whole fabric of society, for a common foot soldier armed with a hand gun and a lighted fuse could, with all ease, blow the noblest knight in Christendom off his white charger.*

For the first time in the recorded history of war, a new kind of injury presented itself, and it confounded surgeons. Unlike arrows or blades, a bullet quite often did not pursue a straight course once it entered its victim's body, but veered off in one direction or another depending on its velocity and the density of the tissues it encountered. Stories were told, and still are, of the apparently incomprehensible will of these enigmatic little missiles that damage structures far afield from their expected travels. Surgical writings of the fifteenth century increasingly devoted their pages to the great new medical riddle of the time: what is the best way to treat a gunshot wound?

The finest surgical minds of the day came up with an answer, but it was wrong. Like so many other wrong theories throughout history, this one was based on misinterpreted observations. When a blade entered its victim, it usually cut cleanly; so in the rare cases when the victim of a thrusting blade wound did not die quickly, his wound usually healed in a straightforward manner. Bullets, on the other hand, often crush, contuse, and rip their way through tissue, carrying bits of clothing and skin deeply into the muscles and body cavities, predisposing their victim's wounds to putrefaction and pus. The appearance of these discharges made doctors think that bullet wounds must be poisoned, and that it was therefore necessary to purge the venom. The oldest of the German surgical textbooks, written by Hieronymus Brunschwig in 1497, states: "In case a man has been shot with a gun and the bullet is still in place, he is poisoned by the powder."

Some of the methods used to get rid of the "poison" made good sense, even viewed with the perspective of five hundred years. The surgical technique called debridement, for example, which is the cutting away of injured or destroyed tissue, allowed the surrounding healthy structures to heal more efficiently. Various forms of forceps, called by such evocative names as the "stork bill," the "twister," and the "unloader," were used to remove not only the bullet itself, but also offending bits of foreign matter. Other treatments, though thought to be logical, were in fact dangerous. Several kinds of oils and greases were poured into bullet holes—Brunschwig is said to have recommended the pouring in of bacon fat to encourage the formation of pus to loosen an impacted projectile and lubricate its exit.

But the dictum of wound poison led many surgeons of the time to adopt even more extreme measures. Pope Julius II, the great patron of Michelangelo and Raphael,

Scene from the Retreat from Russia by Théodore Géricault captures the agony of France's devastated army in the year 1812. Napoleon, like Hitler more than a century later, was defeated as much by the Russian winter as by its army. Military doctors were helpless to treat their troops' exposure and starvation. The French, however, could take some small comfort in the knowledge that their medical care was among the best in the world, and that their wounded were in good hands: under Napoleon, only doctors and surgeons trained in special state-run schools were allowed to practice medicine. The most famous doctor of the era was Napoleon's brilliant chief surgeon, Dominique-Jean Larrey, who performed over two hundred amputations in a twenty-four-hour period during the Russian campaign. Despite the efforts of Larrey and his staff, the Grand Army suffered 300,000 casualties; only 10,000 men returned home able-bodied.
Painting by Théodore Géricault France, 1814

had as his private physician a surgeon named Giovanni di Vigo, who had acquired a great deal of experience in military medicine during the numerous wars between Italian cities. In January of 1514, di Vigo published a book on his experiences with the sick and wounded. Through twenty-one editions and translated into six European languages, that book became the standard work on surgery during the sixteenth century. Di Vigo devoted much of his text to two topics that preoccupied surgeons who published during that period. The first was the treatment of gunshot wounds, against whose "poison" di Vigo recommended purification by boiling oil or the red-hot cautery iron. The second was a new and terrifying epidemic being spread throughout Europe by migratory soldiers.

Frenchmen preferred to call the epidemic the Neapolitan disease, but syphilis, as it later came to be known, was most often referred to as *morbus gallicus*, the French disease. Until very recently, there was no strong evidence of its existence in Europe prior to the last decade of the fifteenth century, and so the legend arose that it was brought home from the Western Hemisphere by the crews of Christopher Columbus's ships. Very likely though, it was already present in a mild form in Europe until that time, and suddenly underwent a dramatic increase in virulence. Syphilis first became a major problem when Charles VIII of France invaded Italy in 1494 in an attempt to take over the kingdom of Naples. Although the troops had brought with them their own swarms of prostitutes, they were soon joined by equally enthusiastic prostitutes from the city itself. When the army disbanded, the soldiers and their women scattered throughout the continent, spreading venereal infection wherever they went. Not since the Black Death of the mid-fourteenth century had Europe been afflicted with such a pestilence.

It was a period of remarkable laxity in moral standards, both public and private. Popes came from families with names like Borgia and di Medici. Bishops lived like sybarites, and even priests had mistresses. Pope Sixtus IV may have built a foundling hospital and several churches, but he was also said to be the proprietor of a prosperous whorehouse in Rome.

War, abetted by a general lasciviousness that pervaded every class of society, now unleashed on mankind this new plague that ranks with the worst infectious diseases ever known. First mercury (introduced by di Vigo), then Salvarsan (the "magic bullet" developed by Paul Ehrlich in 1910), and then penicillin have been used to treat it, with ever increasing effectiveness—but syphilis is with us yet, and, like war itself, may never disappear.

Di Vigo's authority was preeminent. When he dictated that boiling oil be poured into gunshot wounds, a generation and more of surgeons did exactly that. Among the most convinced of his readers was a young Frenchman named Ambroise Paré. With a certainty he had acquired from reading authorities such as di Vigo and Brunschwig, this informally educated twenty-six-year-old barber-surgeon went off to his first military encounter, the campaign of Turin, in 1536. Like all army doctors of the time, he was not in battle to treat the troops but to minister to the needs of the high-ranking officer who had hired him, the Marshal de Montejan, a colonel-general in the army of King Francis I.

Paré had learned to prepare the "oil of elders, scalding hot," which he poured into missile wounds or onto the bandages with which he bound up the injuries of those men horribly burned or disfigured by exploding gunpowder, an innovation he

described as "this most miserable and pernicious kind of invention . . . this hellish engine, tempered by the malice and guidance of man." Though he recognized the barbarity of the cure, and his innately gentle nature rebelled at its use, he had learned early in his military career that measures appearing abhorrent to ordinary men often become, amid the chaotic urgencies of battle, the only merciful path to the ultimate relief of suffering. This lesson had been brought vividly home to him in one of his earliest experiences of the horrors that follow upon battle, recalled in a sixteenth-century translation of his memoirs.

> *I entered into a stable thinking to lodge my owne, and my mans horse, where I found foure dead soldiers, and three which were leaning against the wall, their faces wholly disfigured, and neither saw nor heard, nor spoake; and their cloathes did yet flame with the gunpowder which had burnt them. Beholding them with pitty, there happened to come an old souldier, who asked me if there were any possible meanes to cure them, I told him no: he presently approached to them, and cut their throats gently and without anger. Seeing this great cruelty, I told him he was a wicked man, he answered me that he prayed to God, that whensoever he should be in such a case, that he might finde some one that would doe as much to him, to the end he might not miserably languish.*

Not only was the theory of wound poisoning erroneous, but the severe trauma of hot oil served to destroy even more tissue than had the bullet or burn itself, and to create complications that were sometimes worse than the original wound. As a result of his very first experience with the destruction caused by guns and powder at the siege of Turin, Paré abandoned forever the cruelties of the therapeutic aggression he had been taught. Necessity mothered his unplanned experiment—he was forced into it because he ran out of boiling-hot oil.

> *Now at that time I was a fresh water souldier, I had not yet seene wounds made by gunshot at the first dressing. It is true, I had read in [Giovanni] de Vigo, in the first booke of wounds in generall, the eighth chapter, that wounds made by weapons of fire did participate of Venenosity, by reason of the pouder, and for their cure commands to cauterize them with oyle of Elders scalding hot, in which should be mingled a little Treackle; and not to faile, before I would apply of the sayd oyle, knowing that such a thing might bring to the Patient great paine, I was willing to know first, before I applyed it, how the other Chirurgions did for the first dressing, which was to apply the sayd oyle the hottest that was possible into the wounds, with tents and setons; insomuch that I tooke courage to doe as they did. At last I wanted oyle, and was constrained in steed thereof, to apply a digestive of yolkes of egges, oyle of Roses, and Turpentine. In the night I could not sleepe in quiet, fearing some default in not cauterizing, that I should finde those to whom I had not used the burning oyle dead impoysoned; which made me rise very early to visit them, where beyond my expectation I found those to whom I had applyed my digestive medicine, to feele little paine, and their wounds without inflammation or tumour, having rested reasonable well in the night: the others to whom*

*was used the sayd burning oyle, I found them feverish, with great paine and tumour
about the edges of their wounds. And then I resolved with my selfe never so cruelly, to
burne poore men wounded with gunshot.*

Willingly or not, Paré had carried out a successful clinical experiment. He had
made the right observations and drawn the right conclusions, and neither he nor mili-
tary surgery would ever again be the same. The story of Paré's great test of hot oil has
become a medical legend, because it established for posterity the most basic rule of all wound
surgery—the principle of gentleness.

There is a humility in the writing of Ambroise Paré that infuses not only his
advice to those who read his books, but also his treatment of the wounded. Again and
again, the reader encounters a phrase that is the epitome of his philosophy of the art of
medicine: "I dressed him and God healed him." Paré reintroduced the use of the ligature
to tie off bleeding vessels, and thus saved many thousands of soldiers the shrieking
agony of red-hot iron pressed into an open wound.

Because Paré wrote voluminously and well, his philosophy of gentleness was dis-
seminated throughout the continent. And well that it was. For more than a century
after the siege of Turin, Europe would be a battleground of roaming armies in one cam-
paign after another. The Italian Wars lasted until 1559, the Wars of Religion from 1562
to 1598, the Thirty Years' War from 1618 to 1648, and the wars of Louis XIV from
1672 to 1697.

Everywhere they went, soldiers continued to carry with them pestilence, starvation,
and violence. The French invented the flintlock in 1615 and applied it to muskets in
1635. Not content with the harm thus done, they added the bayonet in 1640. Toward the
end of the seventeenth century, the hand grenade came into use. What Paré had said of
guns and mortars was becoming ever more true: "As though it were not sufficient to have
arms, iron, and fire for man's destruction, in order to make the stroke more speedy we have
furnished them, as it were, with wings, so as to fly more hastily to our own perdition."

By this time, the weapons of death had become more effective, but the thera-
peutic arsenal of the doctor was not showing much improvement. There were still no for-
mal medical arrangements for the ordinary soldier, and the threat of pestilence was
ever increasing as larger and more numerous cohorts of armed men and their camp
followers traveled far and wide across the European continent. The problem of camp fol-
lowers, in fact, had become so severe that at the conclusion of the Thirty Years' War in
1648, there were 40,000 soldiers in the Imperial and Bavarian armies—and 140,000 pros-
titutes and other hangers-on.

As the number of poorly trained barber-surgeons increased, so did the alacrity
with which they rushed into operating in cases of doubtful necessity. Colonel Garrison
refers to the seventeenth century as "the great period of amputating," when "wholesale
lopping off of limbs ofttimes resulted in the speedy death of the patient from shock
and hemorrhage and filled the streets of the cities with mendicant cripples, whose
grotesque yet wretched status has been forcibly commemorated in art by Bosch,
Brueghel [*sic*] and Callot. The principal indications for amputation were cold, dry and moist

Spanish artist Francisco Goya captioned this etching, from his *Disasters of War* series, "Treat them, and then take care of the others." Goya was sixty-five when he began the series, which took him more than a decade to complete, and was inspired by Napoleon's five-year occupation of Spain, beginning in 1808. Reflecting on Goya's vision in another dark time, 1943, Aldous Huxley wrote: "War always weakens and often completely shatters the crust of customary decency which constitutes a civilization. It is a thin crust at the best of times, and beneath it lies—what? Look through Goya's *Desastres* and find out." *Etching by Francisco Goya Spain, 1810*

gangrene, but unfortunately the apprentices resorted to any excuse for practising on their patients to bolster up their own conceit."

Thus far, the only significant contributions that war had made to the art of healing lay in the treatment of wounds. But even here, the general level of training of most surgeons and physicians was so low that many of them ignored or were unaware of the principles of debridement and gentleness that had been established. Nevertheless, their very presence near the battlefield made a difference to the soldiers. Surgeons, though they may not have been able to save many lives, raised the morale of the wounded and provided care of the kind that in a later period would be provided by military nurses.

The seventeenth century was the era in which the basic foundation stones of the scientific method—inductive reasoning and planned experimentation—finally emerged. With the beginnings of inductive reasoning and then the advent of the Enlightenment in the eighteenth century, it became possible to glimpse the first glimmerings of true medical discovery and a future in which those discoveries made in wartime might ease the burdens of civilian populations in periods of peace.

If ever a medical milestone reflected the advancing spirit of its age, it was James Lind's brilliant elucidation of the cause and prevention of scurvy. The rational analysis, the objectivity, and the freedom from conjecture that characterized the new thinking of the Enlightenment intellectuals are all seen in his discovery and the process by which he made it.

After an apprenticeship in Edinburgh, the twenty-three-year-old Lind was employed by the Royal Navy in 1739 as a surgeon's mate, a civilian job of low rank. Eight

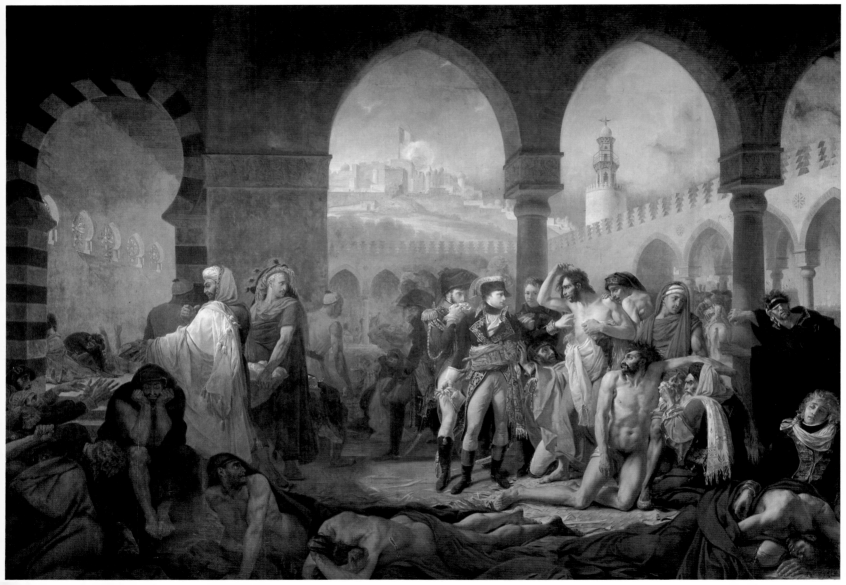

years later, as ship's surgeon on the HMS *Salisbury* cruising the English Channel, he conducted the first recorded controlled experiment on human subjects, for which some credit him with being the founder of clinical research.

There is evidence of the existence of scurvy dating as far back as the classical period. Various commentators of the Middle Ages and Renaissance describe clinical findings that could only be consistent with the ravages of vitamin C deficiency. The great voyages of discovery and the increasing military role of navies in the sixteenth century made scurvy a devastating problem. Outcomes of battles, and sometimes of wars, too often depended on the number of cases of this debilitating and lethal disease among the sailors. As Lind himself wrote: "Armies have been supposed to lose more of their men by sickness, than by the sword. But this observation has been much more verified in our fleets and squadrons; where the scurvy alone, during the last war [War of the Austrian Succession] proved a more destructive enemy, and cut off more valuable lives, than the united efforts of the French and Spanish arms."

Having seen thousands of cases of scurvy, Lind's logical mind was able to rule out the speculative causes that were being put forward. His experience led him to believe, as other observers had in the previous two hundred years, that the disease had several causes, but could be avoided and even cured by ingesting citrus fruits. None of his predecessors had thought to test the idea in any systematic way, and Lind now proposed it as a hypothesis based on the observations he had made of sick sailors, the failed explanations of other physicians, and his own attempts at various forms of treatment. He had thus completed the first two steps of the process of inductive reasoning—observations and the hypothesis meant to explain them. The next step was to design an experiment, which he carried out in May of 1747, by dividing twelve scurvy patients into six groups of two sailors each; one of the groups was fed two oranges and one lemon a day, while the rest were given different possible remedies. The citrus eaters became rapidly well, while the members of the other groups were not significantly improved during the fourteen days of the study. And so, Lind had shown how to cure a vitamin deficiency long before vitamins had ever been heard of. It would be difficult to imagine a more direct effect of military necessity on the progress of medical science.

Although Lind's thesis was proven correct often enough in naval practice in the succeeding years, it was not until 1795, the year after his death, that the British admiralty issued the order to give lemon juice routinely to sailors, with the result that scurvy disappeared from the Royal Navy.

Lind's experiment is not the only eighteenth-century military medical advance that proved to have considerable civilian significance. Dr. John Pringle, a believer in the principles of inductive reasoning who held a chair in ethical philosophy at the University of Edinburgh, was appointed physician general to the British Army in 1745. Seven years later, he published *Observations on the Diseases of the Army*, an extensive study of infectious disease, sanitation, and antiseptic methods, whose principles applied to groups of people living or working in confined areas such as camps, barracks, jails, hospitals, ships, and mines. The book laid down concepts of hygiene that became the basis for the preventive care and treatment of both military personnel and civilian populations living in close quarters.

After the Great Plague of London in 1665–66, the bubonic plague disappeared from Europe, though not from other parts of the world. In *Napoleon Visiting the Pest-House at Jaffa* by French painter Baron Antoine-Jean Gros, Napoleon's armies confronted the plague in his march through Syria in 1799 (*left*). Napoleon personally visited his men who were struck with the plague and touched their sores, in an attempt to rally his troops and prevent panic among them, but he was finally forced to retreat after losing one thousand of his eight-thousand-man force to the disease. An 1884 outbreak in Hong Kong gave two scientists working independently, Shiramiro Kitasato of Japan and Alexander Yersin of Switzerland, the opportunity to identify the plague's causative organism, *Pasteurella pestis.* Until the discovery of antibiotics in the early twentieth century provided a cure for the isolated cases that still crop up every year, containment—through rat control and quarantine of the infected human population—was the public health official's only effective weapon against the disease.
Painting by Baron Antoine-Jean Gros France, 1804

Largely due to ignorance and a poorly organized medical system, the patriot army fighting in the American Revolutionary War disregarded much of Pringle's sound advice on the care of fighting troops. In July of 1775, the Continental Congress did create what they called the Hospital for the Army, the official name for the armed forces medical department; but charges of corruption and inefficiency, many of them justified, all but nullified its efforts at a proper organization of sanitary and treatment methods.

Not all of the difficulties could be blamed on the medical department itself. To a great extent, its problems reflected the political and military amateurisms of the Continental leadership and the backward state of medicine in the colonies. Of some thirty-five hundred physicians in North America, fewer than two hundred had medical degrees. The Continental Congress had no understanding of the requirements of supplies, instruments, facilities, shelter, and manpower that were necessary for adequate care of the sick and wounded.

Magnifying the problems was the most lethal of the dangers to colonial troops: smallpox. Smallpox was a constant presence in the coastal towns and cities throughout the war. Time and again, major military decisions by both sides were made on the basis of its prevalence. British General William Howe, for example, had to evacuate Boston in March of 1776, because the prevalence of smallpox in the city posed a great danger to his troops, two thousand of whom were sick, many with smallpox. The safety of preventive methods was debated heatedly until 1777, when General Washington decided to inoculate the entire army in order to decrease the 16 percent mortality rate among his infected soldiers.

Until the mass inoculations, smallpox was a critical factor among the reasons why 90 percent of American deaths in the war were due to disease and only 10 percent resulted from battlefield injuries. So much was smallpox the decisive element in the 1775–76 Canadian campaign that the historian James Flexner has stated that, but for the disease, Canada would now be part of the United States. In the spring of 1776, an American army of two thousand men under Benedict Arnold and Richard Montgomery laid siege to Quebec. Even though it was the linchpin of British authority in Canada, the city was being defended by a much weaker force than their own. An outbreak of smallpox in May infected nine hundred of the Americans. The colonial commanders were forced to lift the siege and retreat to Crown Point on Lake Champlain, where many of the soldiers died. One senior officer wrote to Washington: "The raging of the smallpox deprives us of whole regiments in the course of a few days. Of the remaining regiments from fifty to sixty in each are taken down in a day, and we have nothing to give them but salt pork, flour and the poisonous waters of this lake."

The widescale inoculation of the troops demonstrated that the method was safe for civilian populations as well—better the 1 percent mortality from the inoculum than the 16 percent from the natural disease. When Edward Jenner introduced the much safer and more effective method of vaccination in 1798, America was receptive. At the outbreak of the War of 1812, the entire U.S. army was vaccinated, the first time such an undertaking was carried out on an American fighting force. In 1805, Napoleon's entire army had been vaccinated.

The American War of Independence was fought just before one of those dramatic jolts of historical fortune that turn the seeking face of Western civilization in a new

French soldiers are vaccinated against smallpox with injections of cowpox, using the best method available in the early nineteenth century: scraping pustules directly from the cow. Smallpox played a significant role in military history as the New World clashed with the Old—the disease, brought from Spain, wiped out millions of Aztecs in the sixteenth century, helping the Spanish to conquer Mexico; and outbreaks among Native Americans in Massachusetts in 1616 and 1633 defeated their attempts to resist pilgrim settlers. Infecting a healthy person with a mild case of smallpox as a prophylactic to provide immunity against the disease appears to have originated in China twenty-five hundred years ago, although the practice didn't reach Europe and America until the eighteenth century.
Painting by Alfred Touchemolin Paris, France, ca. 1900

direction. The jolt was the French Revolution—it loosed a series of forces that affected not only politics, but the entire content of European civilization. Fresh breezes blew away the stagnation of centuries, and the minds of philosophers, writers, artists, entrepreneurs, and the few scientists of the time were stimulated in a way unknown since the Renaissance. The art of medicine leaped forward onto changed pathways that were forged by scientific reasoning and supported by a university- and hospital-based system of medical training with credentialing and regulatory societies. *Liberté* applied as much to medical thought as it did to the rights of humankind.

In this receptive atmosphere, the old shackles of medicine's tradition-bound heritage were first loosened and finally thrown off completely. The principles of the physical examination were developed; the anatomic basis of disease came to be understood; great teachers of medicine and surgery in England, Scotland, and particularly in France began to attract students from all over Europe, Asia, and the United States. This led to a free exchange of ideas, a kind of medical *fraternité* that disseminated the new knowledge with a thoroughness unknown to past generations.

Egalité, as well, forever changed medical science. Prominence in medical leadership increasingly went to those who had proven their abilities, rather than passing only among the hands of the privileged class. In France, medical professorships were determined on the basis of an open competition, called a *concours,* among a small group of the most qualified candidates.

In that age of *égalité*, it was possible for the fatherless son of a peasant to rise to the position of professor of surgery at the new army medical school at Val-de-Grâce, and then

The Portuguese Sore, the French Disease, the Chinese Pleasure Disease—by any name syphilis began ravaging Europe shortly after its appearance late in the fifteenth century during French King Charles VIII's siege of Naples. Legends of the time claim that Naples' leaders sent the city's prettiest prostitutes out to spread the disease among Charles' troops, European mercenaries who later carried the disease home after the war. The famous Italian physician Giovanni di Vigo recognized at once that syphilis was a "contagious disease" and "derived above all by coitus." But it would be centuries before an effective treatment— penicillin—was discovered. Here, a Spanish soldier receives the steam treatment for the "Neapolitan Disease."
Artist unknown
France, sixteenth century

to become surgeon-in-chief of the Grand Army of Napoleon in 1812. Dominique-Jean Larrey was made a baron by Napoleon for many reasons, not the least of which was stated in the emperor's encomium to his revered companion-in-arms.

Larrey was the most honest man, and the best friend to the soldiers, I ever knew. Vigilant and indefatigable in his exertions for the wounded, Larrey was seen on the field of battle, after an action, accompanied by a train of young surgeons, endeavoring to discover if any signs of life remained in the bodies. In the most inclement weather and at all times of the night or day, Larrey was to be found among the wounded. He scarcely allowed a moment's repose to his assistants, and kept them eternally at their posts. He tormented the generals and disturbed them out of their beds at night whenever he wanted accomodations or assistance for the wounded or sick.

War itself was transformed by Napoleon. Gigantic armies, huge and astonishingly rapid troop movements, and the use of field artillery as a major tactical weapon characterized the surprises that his enemies faced in the early campaigns. The number of medical officers was large, but they were of unequal levels of training, since the new French system of medical education was just beginning to take shape.

With such large numbers of soldiers taking part in battles of great ferocity, casualty rates were high. Early in his experience, Larrey abandoned the old practice of not treating the wounded until after the fighting was safely over. Not only did delayed treatment cause more suffering and deaths, but the large numbers of walking injured that accumulated after a battle, as well as the clumsy and depressing hospital wagons transporting the more seriously wounded, might sometimes clog the roads for as long as two days. Larrey ordered that his medical officers were to make their way to each individual casualty as soon as possible, though the battle still raged and the hand-to-hand combat was swirling furiously around them. Few modern-day orthopedists are aware that their aphorism "splint 'em where they lie" found its first expression on the bloody fields of Napoleonic conquest.

Since Larrey introduced it, the concept of treatment at the earliest possible instant has been a pillar of all trauma care, whether civilian or military. He pointed out the dangers to which untreated, unbandaged wounds are exposed when injured soldiers are transported over bad roads and in extremes of weather. In such conditions, he wrote, "The greater part of the wounded perish on the way." This was no longer to be tolerated.

The baron's dictum extended even to major surgery. When amputation was necessary, he found that surgery immediately after wounding resulted in more rapid healing and far fewer cases of the dreaded tetanus than if it were delayed. The faster healing, in turn, lessened the probability of hospital fever or gangrene, complications with a nearly certain mortality. Larrey had yet another reason to insist on expeditious surgery: in spite of all vigorous efforts, the wounded sometimes had to be abandoned, at least temporarily, on the field of battle. How much better it is, argued Larrey, that amputations or similar urgent surgery be done while the fighting still raged, so as to leave those unfortunate men with cleanly dressed wounds, which can better withstand the further hardship of several days of inattention or even of capture by the enemy.

Larrey lived by his own dicta—he never asked his medical officers to attempt anything that he himself was not willing to do with enthusiasm and humanity. At the ferocious battle of Borodino, so vividly described by Tolstoy in *War and Peace,* he personally performed two hundred amputations in twenty-four hours. There was plenty of work for him to do that day beyond the feverish activity of operating—some twenty-eight thousand Frenchmen died of their wounds, as well as forty thousand Russians.

Many descriptions have been written of Larrey's heroism in the midst of the carnage taking place around him on the battlefield. He served under Napoleon in twenty-five campaigns, and was a direct participant in some four hundred skirmishes, and in every one of them he and his medical officers worked in the thick gunsmoke of the action. He would position himself and a small group of assistants in the heaviest of the fighting, so that wounded soldiers might be expeditiously brought to him. When necessary, he led his men through disordered crowds of struggling combatants to reach an injured man; to those who saw him, he appeared to have no fear of death.

If an operation were necessary, Larrey did it then and there, not rising from his patient until all wounds were properly cared for. He often worked under intense enemy fire, assistants falling on all sides, but he himself was somehow miraculously spared. So intent would he be on his work that, on a few occasions, he found himself swamped by the advance of the enemy. At the battle of Eylau, the Imperial Guard had to mount a frenzied cavalry charge to save him. Another episode took place at the battle of Waterloo, one that exemplified the regard in which even the enemy held the mythic chief surgeon of Napoleon. Scanning the field, the Duke of Wellington spied a French medical officer working so close to the English lines that his face was easily seen. When told it was the legendary Baron Larrey on whom he was gazing in admiration, Wellington raised his arm in salute and ordered his gunners to direct their fire elsewhere.

In battle, Larrey recognized no rank other than the degree of injury, and ordered others to do the same, "according to a rule which I established, dressing those first who were most grievously wounded, without regard to rank or distinction." His philosophy was perhaps the origin of today's ethical triage, and his writings are filled with his regard for the brave men he treated with such devotion: "I found it impossible to suppress my tears, even while I attempted to support the courage of the wounded. . . . In the midst of such heart-rending scenes, how could we attend to anything but the performance of our sad but humane task?" Larrey was motivated by more than the two-thousand-year-old obligation of the physician—his personal commitment to the soldiers who came under his care, even those of the enemy, was the ultimate inspiration for his work.

The results of Larrey's innovations and personal skill were remarkable. In his *Memoir on Amputations,* he describes a 10 percent survival figure reported to him before his new measures were instituted, while he himself could afterward report, "More than three-fourths have recovered after our amputations, some of whom even lost two limbs."

Much of the baron's success was due to another factor. He introduced the flying ambulances, or *ambulances volantes,* which had the speed and mobility of light artillery, enabling their drivers to maneuver rapidly through the debris of a battlefield. In Larrey's system, therefore, soldiers were cared for directly at the scene or rapidly trans-

ported to front-line hospitals in the charge of specially trained surgeons' assistants equipped to treat them on the way. The new ambulances were light carriages mounted on springs and equipped with supplies such as bandages and refreshments so that treatment could begin at once. There were two types of *ambulances volantes:* the smaller two-wheeled vehicles carried two patients and the personnel to treat them, while the four-wheeled ambulances held twice that number. Attention was even paid to their appearance, lest they depress the wounded by seeming too like the "dead-wagons." In Larrey's words: "These carriages united solidarity with lightness and elegance." Not until the Medevac helicopters of a century and a half later would an innovation in transport have such a striking effect on efficiency of care.

In the Napoleonic wars, as in all others up to that time, far more soldiers died of pestilence than of their injuries. All the usual diseases appeared in statistics, including the loss in the expedition into Egypt (1798–1800) of 1,689 men from bubonic plague. In this same campaign, the French encountered an eye disease that was entirely unknown to them and often resulted in blindness—trachoma, a contagion of the cornea. Larrey recognized that trachoma was infectious, and instituted prophylactic measures that soon brought it under control. Scurvy, too, was seen by Larrey in Egypt, but in these early years almost none of the continent's armies was yet aware of Lind's work treating sailors. With the wisdom that came of his long experience and his close involvement with the day-to-day lives of his men, Larrey nevertheless recognized that scurvy was due to some deficiency in the soldiers' diet, but he could not fathom exactly what it was.

Some deficiency in the soldiers' diet. But behind this deceptively simple statement are some of the most abstruse complexities of biomedical science, almost none of which were so much as guessed at by Dominique-Jean Larrey or anyone else at the time. Unknown were vitamins, enzymes, trace elements, hormones, cellular transport, or any of that host of other esoterica of digestive and metabolic physiology that the human body employs to nourish itself. The world would see the work of several more generations of military physicians before any of these factors were understood, and would witness another several wars before armies provided what are now known to be the basic nutritional needs of their soldiers.

The ambulance corps of the Fifty-Seventh New York Volunteers
removes the wounded after the Second Battle of Bull Run.
Photograph by Mathew Brady
Virginia, 1862

The Civil War Era

Before the Fog Was Lifted

I sat down by him, wiped the drops from his forehead, stirred the air about him with the slow wave of a fan, and waited to help him die. He stood in sore need of help— and I could do so little; for, as the doctor had foretold, the strong body rebelled against death, and fought every inch of the way. . . . to the end he held my hand close, so close that when he was asleep at last, I could not draw it away. Though my hand was strangely cold and stiff, and four white marks remained across its back, even when warmth and color had returned elsewhere, I could not but be glad that, through its touch the presence of human sympathy, perhaps, had lightened that hard hour.

—*Louisa May Alcott, from* Hospital Sketches, *Civil War*

Civil War medicine is often remembered by the vast numbers of non-sterile, brutally simple amputations performed on soldiers of all ages—some as young as thirteen. Morphine, one of only a handful of painkillers available to Civil War doctors, was first used as a topical analgesic; it was packed directly into wounds although it often stimulated infection. The first recorded use of a hypodermic needle was by a Confederate physician seeking to hasten morphine's comforting effects. Here, eighteen-year-old Robert Freyer of the New York Volunteers is ready for discharge after the amputation of three fingers.
Photograph by Reed Bontecou, M.D. Washington, D.C., 1865

Soldiers in the field throughout the nineteenth century continued to pay the price of medicine's ignorance, as malnutrition and various infections decimated armies during this time. In the two brief years of the Mexican War, from 1846 to 1848, almost 11,000 of the 100,000 troops died of disease, while only 1,549 lost their lives to battlefield injuries. The troops were so poorly supplied that a soldier often wore the same threadbare, ragged uniform for months. The government had no real knowledge of even the most basic principles of military sanitation. Whether neglectful or ignorant of Larrey's innovations, the entire U.S. Army would have neither a single ambulance during the conflict nor formal hospitals or even hospital tents for the wounded. Worse yet, at the war's end huge numbers of men with dysentery returned to the United States infected, spreading a fatal, foul plague of pus and blood-flecked diarrhea through their home communities.

This overwhelming loss to disease repeated itself when the British, the French, and the Russians committed major concentrations of troops to the campaign in the Crimea in 1854 and 1855. The carnage was incomprehensible. Of 407,000 troops, the British and French lost almost 17,000 to battle wounds and 77,000 to disease; of 324,000 troops, the Russians lost almost 35,000 to battle wounds and more than 37,000 to disease. The Russians sustained the highest percentage of battle losses, and the French

The port of Balaclava on the Black Sea was the scene of a key battle in the Crimean War (1853–56)—fought by British, French, Turkish, and Sardinian troops allied against Russia—and of a cholera outbreak in November of 1854. "If anybody should ever wish to erect a 'Model Balaclava' in England," wrote Fanny Duberly, who accompanied her soldier-husband to the Crimea, "I will tell him the ingredients necessary. Take a village of ruined hovels and houses in the extremest state of all imaginable dirt; allow the rain to pour into and outside them, until the whole place is a swamp of filth and ankle deep; catch about, on an average, 1,000 sick Turks with the plague, and cram them into the houses indiscriminately; kill about 100 a day, and bury them so as to be scarcely covered with earth, leaving them to rot at leisure. On to one part of the beach drive all the exhausted *bat* ponies, dying bullocks and worn-out camels, and leave them to die of starvation. They will generally do so in about three days. Collect together from the water of the harbour all the offal of the animals slaughtered for the use of about 100 ships, to say nothing of the inhabitants of the town—which together with an occasional floating human body, whole or in parts, and the driftwood of wrecks, pretty well covers the water— and stew them all together in a narrow harbour, and you will have imitation of the real essence of Balaclava."

The British photographer Roger Fenton, dispatched to the front by Queen Victoria in 1855, was assigned to provide propaganda pictures to counter reports in the British press about the troops' inhumane living conditions. Historians agree that Fenton did his job well: his photographs were misleading, and glorified the appalling conditions of the war.
Photograph by Roger Fenton
Balaclava, Crimea, ca. 1855

suffered the highest percentage of disease losses, in any war in history. Cholera was by far the most commanding captain of death in the Crimea. Scurvy was its sergeant major.

Of the three great powers, Britain was perhaps the least medically prepared for war. The appalling British losses and the dreadful conditions under which they took place were captured by a series of photographs and newspaper dispatches by London *Times* reporter William H. Russell, one of the first war photojournalists. The vivid images shocked Parliament and the public alike. The War Office immediately sent the thirty-four-year-old superintendent of the Institution for the Care of Sick Gentlewomen, Miss Florence Nightingale, to the Crimea. Supported by £30,000 donated by some of her personal friends and a sum raised by the London *Times*, she found herself, in spite of bitter opposition from some of the leaders of the military, with a great deal of independence. A genius of organization, Nightingale was a remarkable bedside nurse as well. For the compassion and tender counsel she gently dispensed to sick soldiers on her nightly hospital rounds in the Crimea, she became known to those adoring men as the Lady with the Lamp.

Because of Nightingale's efforts, the army medical system was reorganized, and the British fighting men went from being the most poorly served to the best. No army had ever had a nursing service before she came to the Crimea. Prior to her work, nursing had been associated only with camp followers, women of low morality, and nuns under the directives of the Catholic Church. Florence Nightingale elevated nursing to a profession of high stature, no longer restricted to loose ladies on one hand or the hospital orders of nuns on the other. In 1860, she founded the first professional nursing school at St. Thomas's Hospital in London, which later became the model for all institutions of its kind.

Florence Nightingale's work in the Crimea opened the door for women who sought to contribute to military healing in the wars that followed. Her courage and competence set off a series of reverberations that would influence medical care throughout the American Civil War, from 1861 to 1865. Dorothea Dix, already renowned as a reformer of mental hospitals, volunteered to recruit nursing help for the Union army; and, in April of 1861, she was appointed superintendent of female nurses. Some three to four thousand women worked in Union hospitals during the war. Of the few who were stationed in field hospitals, one of the most famous is Quaker widow Mother Bickerdyke, who tended to the needs of soldiers on the battlefield and served in 1863 as the only female nurse in a field hospital caring for two thousand patients near Chattanooga. Clara Barton, a clerk in the U.S. Patent Office who in 1861 had organized an agency to distribute supplies for wounded soldiers, was another veteran who served under conditions of direct combat. A year after founding the American National Red Cross in 1881 (which later became the American Red Cross), she convinced the U.S. Senate to ratify the eighteen-year-old Geneva Convention recommendation on the humane treatment of prisoners and casualties of war.

Louisa May Alcott and Walt Whitman also appear in the annals of Civil War nursing. There is no more vivid description of wounded Civil War soldiers and their nursing care than in "The Wound Dresser," from the collection *Leaves of Grass* by Whitman.

> *From the stump of the arm, the amputated hand,*
> *I undo the clotted lint, remove the slough, wash off the matter and blood,*

At work in the Crimean War, Florence Nightingale described herself modestly as "cook, housekeeper, scavenger . . . washerwoman, general dealer, store-keeper." In reality, this powerful and charismatic woman changed the practice of military medicine by professionalizing the nursing corps, focusing on sanitation and nutrition, and cutting through red tape to deliver, in the words of one historian, "less regulations and more service." Biographer Lytton Strachey described her thus: "To the wounded soldier on his couch of agony she might well appear in the guise of a gracious angel of mercy; but the military surgeons, and the orderlies, and her own nurses . . . could tell a different story. It was not by gentle sweetness and womanly self-abnegation that she had brought order out of chaos in the Scutari Hospitals, that, from her own resources, she had clothed the British Army, that she had spread her dominion over the serried and reluctant powers of the official world; it was by strict method, by stern discipline, by rigid attention to detail, by ceaseless labour, by the fixed determination of an indomitable will." *Lithograph by Day & Son Scutari, Crimea, 1856*

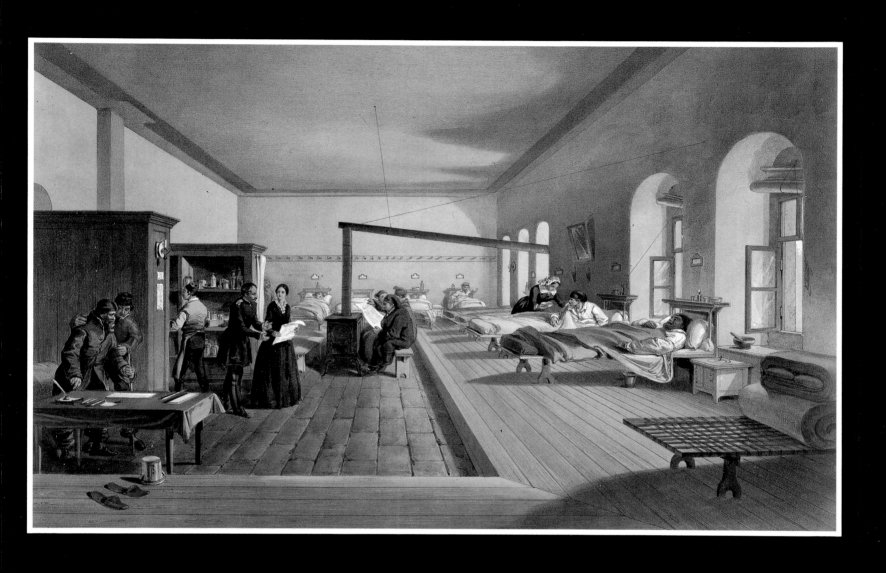

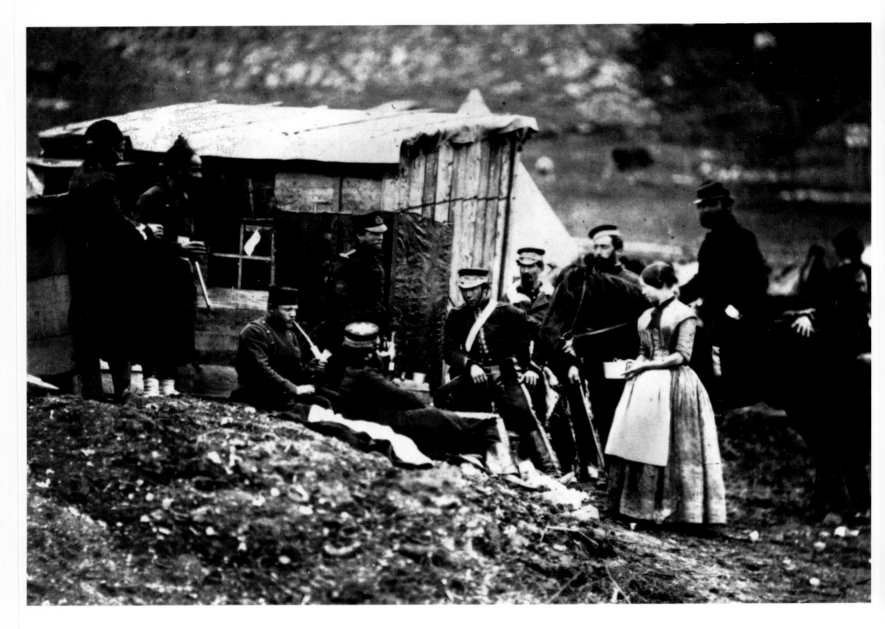

British soldiers at the Camp of the Fourth Dragoon Guards pose for a photograph designed to reassure those on the home front that the Crimean War was proceeding without a hitch (*above*). But despite the placid photos, news reached Britain of rampant disease—especially scurvy and cholera—and undernourishment among the fighting men. It was particularly galling to the British public that their sons were dying of scurvy—preventable, as their navy had known since 1795, by adding citrus fruits to the sailors' rations.
Photograph by Roger Fenton
Crimea, ca. 1855

Before the arrival of Florence Nightingale in 1854, mismanagement of the army's food supply and crude cooking facilities (*above right*) compounded the problem of abysmal medical care, which was provided at the time by surgeons such as Doctor Wood and his staff (*below right*), who felt that attending to the hygiene and comfort of sick soldiers was beneath their status. As William Howard Russell of the London *Times* reported in his fulminating dispatches from the front: "No sufficient preparations have been made for the care of the wounded. Not only are there not sufficient surgeons . . . not only are there no dressers and nurses . . . there is not even linen to make bandages for the wounded. . . .

after the troops have been six months in the country there is no preparation for the commonest surgical operations!" In another cable, Russell resorted to pleading: "Let us have plenty of doctors," he wrote. "Let us have an overwhelming army of medical men to combat disease. Let us have a staff, full and strong, of young and active and experienced men. Do not suffer our soldiers to be killed by antiquated imbecility. Do not hand them over to the mercies of ignorant etiquette and effete seniority, but give the sick every chance which skill, energy and abundance of the best specifics can afford them."
Photographs by Roger Fenton
Crimea, ca. 1855

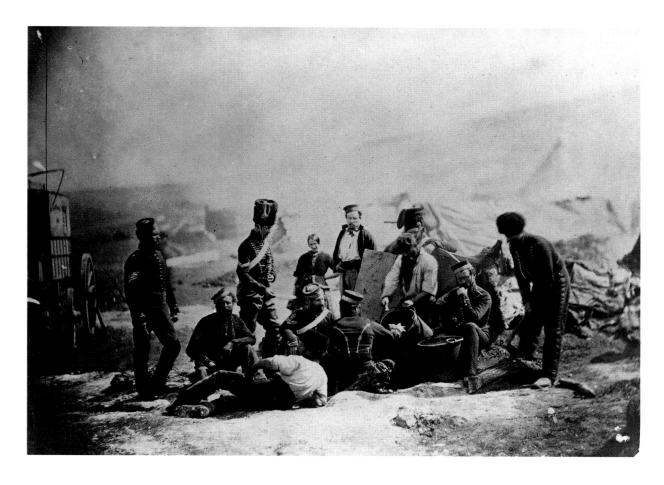

The steamboat *Planter* awaits a shipment of wounded soldiers during the Civil War (1861–65). The Union army used steamboats to transport the wounded by river to hospitals far from the battle lines, and employed smaller oceangoing ships to move soldiers in the rougher waters along the Atlantic Coast. The steamboats held up to eight hundred troops and featured operating rooms, rehabilitation centers, and gauze-covered windows designed to keep out flies and mosquitoes. Boats were also used to isolate and treat patients with smallpox, one type of epidemic that was finally beginning to be understood and prevented.

A nurse on another hospital ship, the *Ocean Queen*, wrote in her diary of the crowded conditions on board: "Last night Dr. Ware came to me to know how much floor-room we had. The immense saloon of the aft cabin was filled with mattresses so thickly placed that there was hardly stepping-room between them, and as I swung my lantern along the rows of pale faces, it showed me another strong man dead. . . . We are changed by all this contact with terror, else how could I deliberately turn my lantern on his face, and say to the doctor behind me, 'Is that man dead?' and then stand coolly while he examined him, listened, and pronounced him 'dead.' I could not have quietly said a year ago, 'That will make one more bed, then, Doctor.'"

Photographer unknown
Appomattox River, Virginia, ca. 1863

Back on his pillow the soldier bends with curv'd neck and side falling head,
His eyes are closed, his face is pale, he dares not look on the bloody stump,
And has not yet look'd on it.

I dress a wound in the side, deep, deep,
But a day or two more, for see the frame all wasted and sinking,
And the yellow-blue countenance see.
I dress the perforated shoulder, the foot with the bullet-wound,
Cleanse the one with a gnawing and putrid gangrene, so sickening,
* so offensive,*
While the attendant stands behind aside me holding the tray and pail.

I am faithful, I do not give out,
The fractur'd thigh, the knee, the wound in the abdomen,
These and more I dress with impassive hand, (yet deep in my breast a fire,
* a burning flame.)*

Thus in silence in dreams' projections,
Returning, resuming, I thread my way through the hospitals,
The hurt and wounded I pacify with soothing hand,
I sit by the restless all the dark night, some are so young,
Some suffer so much, I recall the experience sweet and sad,
(Many a soldier's loving arms about this neck have cross'd and rested,
Many a soldier's kiss dwells on these bearded lips.)

The Civil War was a rifleman's war. In spite of all the heart-stirring paintings and illustrations to the contrary, and a few famous cavalry charges, soldiers actually saw little hand-to-hand combat. The great battles and small skirmishes usually took place at distances of a few hundred yards. Only rarely were round bullets still used. The invention of the percussion cap in 1807 and the cylindrico-conoidal bullet in 1823 had signaled the end of the smooth-bore musket and the birth of rifling, weaponry which became accurate up to five hundred yards.

And as weapons changed, wounds changed with them. The hollow-based Minié ball and other low-velocity bullets of the Civil War tended to flatten out or turn and change direction when hitting a man, causing greater injury than the older, round bullets. After the Civil War, weapons designers would go on to create faster, "jacketed" bullets that pleased the merchants of death by having a higher muzzle velocity than the Minié ball, although frustration arose when it was discovered that they destroyed less tissue because they pierced the body so cleanly. In the 1890s, British soldiers in Dum Dum, near Calcutta, experimented by cutting away a tiny piece of the jacket near the bullet's tip, thereby exposing the soft lead inside and restoring the expansive blasting effect of the projectile.

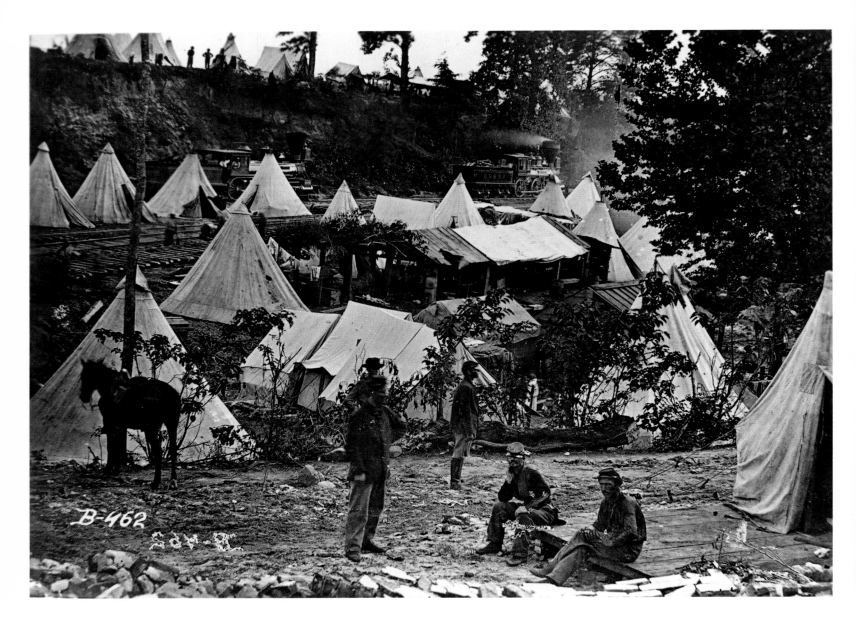

Wounded soldiers pass the time recovering at a convalescent camp in Virginia, just across the Potomac from the nation's capital. Men might stay in these camps for months, waiting to be picked up by relatives or to save enough money to go home themselves. The Union was slow in constructing medical facilities. At the First Battle of Bull Run in July of 1861, hospital sites had been designated, but no further arrangements had been made; and there was no plan for evacuating the wounded from the field to the rear. Jonathan Letterman, M.D., became medical director of the Army of the Potomac a year later, and quickly devised an efficient ambulance system, which was adopted by the Union army. Thomas McParlin, M.D., succeeded Letterman in 1864, and refined a field relief system with dressing stations near the battle lines and field hospitals just out of artillery range. This was a welcome change from the early days of the war, when the wounded sometimes lay on the field for days before help arrived. A Union colonel described the scene after the Battle of Malvern Hill on July 1, 1862: "Our ears had been filled with agonizing cries from thousands before the fog was lifted, but now our eyes saw an appalling spectacle upon the slopes down to the woodlands half a mile away. Over five thousand dead and wounded men were on the ground, in every attitude of distress. A third of them were dead or dying, but enough were alive and moving to give the field a singular crawling effect."
Photograph by Mathew Brady
City Point, Virginia, 1861–65

Wagons of the U.S. Sanitary Commission, bearing supplies, leave the Union hospital-camp at Belle Plain and head for the front lines (*right*). The commission—which aided only Union troops—was founded in 1861 by private citizens to coordinate relief efforts, insist on camp hygiene, and guarantee that Union soldiers had adequate blankets, shoes, and medicine. Members of seven thousand local chapters raised nearly five million dollars in cash and about fifteen million dollars in supplies for the commission, the largest of the private relief organizations to emerge during the war.
Photographer unknown
Virginia, 1864

A mobile operating table and pharmacy, which carried medications and other supplies, is set up at a Union camp (*below*). The drugs often did more harm than good: Civil War doctors frequently used large doses of mercury-based medicines such as calomel to treat intestinal disease, killing their patients in the process. Arsenic and strychnine were prescribed for a wide variety of ills, and liberal doses of addictive substances such as opium and morphine were given to wounded soldiers to assuage their pain.
Photograph by Mathew Brady
United States, 1861–65

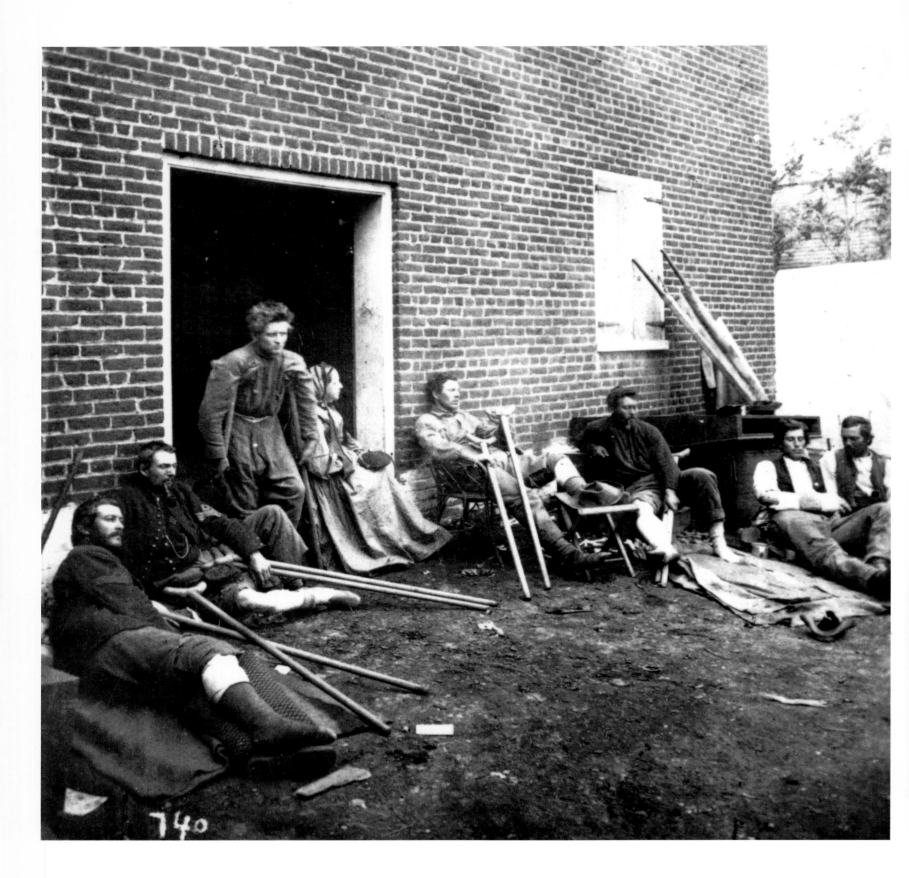

These "dumdum" bullets later inspired the design of hollow-point missiles that combined the speed of the jacketed bullet with the tissue damage of the Minié. Eventually, the outcry against the hideous new wounding capability of rifles was so great that the fifteen signatory nations at the Hague Convention of 1899 finally agreed to ban the dumdums and manufacture only bullets with full metal jackets.

But at the time of the Civil War, these bits of "progress" lay still in the future. So critical was the rifle to the Civil War that it caused the great majority of the 94 percent of all wounds attributed to bullets; only 0.4 percent were from sabres and bayonets. Artillery, using grape and canister, shell and solid shot, inflicted 5.5 percent of wounds. In contrast, artillery would account for some 75 percent of wounds in World War II.

The great improvements in bullets and firepower far outstripped any of the minimal progress that had been made since the beginning of the century in the care of the wounded. Despite its contributions to other fields, science had not yet made much of an impact on medicine, and it would be another two or three decades before the results of laboratory research and scientific thought would be felt in clinical care. The combat officer was so much better skilled than his medical colleague that the Civil War is singular in American experience for that very gap between killing and curing.

The wounds made by lead rifle bullets nearly always became infected. Although scalding oil had not been used since the time of Paré, the tendency to insert something into all bullet wounds to extract the missile was almost as dangerous. In that preantiseptic era, nonsterile probes and instruments of all sorts were pushed and twisted into wounds already gaping with crushed and dying flesh. Fingers were thought to make the best probes, so well-meaning but dirty-nailed surgeons unwittingly injected germs deep into injured tissues. Assistants washed wounds with unclean sea sponges or rags passed from one patient to the next. Nobody knew that infections were caused by bacteria. When a tent-hospital surgeon sharpened his scalpel by stropping it on the leather heel of his boot, or when he licked the frayed end of his stitch to thread the eye of a needle, he had no idea that he was hastening his patient's demise. He hardly had time, in fact, to think of anything but the hurried work before him as, scalpel held tightly between his teeth, he dealt with a bleeding amputation stump as quickly as he could, and then called for the next injured boy to be lifted onto his makeshift operating table.

Amputations were frequent, either to prevent infection in a badly shattered extremity or to treat its rapidly lethal spread through the body. A surgeon could expect that over one-third of his amputees would die, either of infection or postoperative hemorrhage.

In field hospitals, surgeons worked outside to make the best use of daylight. Although most battles were fought in well-manured fields, tetanus was surprisingly infrequent. It occurred most often when barns were used as hospitals; its mortality was almost 90 percent. Although physicians had used general anesthetics in the Mexican War (and later in the Crimea) shortly after their introduction in 1846 and 1847, it was in the War Between the States that they came into their own. Eighty thousand anesthetics were administered: chloroform was the agent used three-quarters of the time, and ether was employed on most other occasions. (Doctors preferred chloroform because surgery performed inside hospitals or tents was illuminated by various lanterns, making the

Men wounded in the Battle of the Wilderness in May of 1864 pick up crutches at a relief station in a hospital run by the U.S. Sanitary Commission, which—in addition to providing supplies—administered several civilian hospitals to supplement the care available at official Army institutions. Perhaps nowhere were doctors and nurses needed more than in and around the savage Wilderness Campaign that spring—which left nearly thirty thousand men wounded, missing, or dead. Writing to his wife, one surgeon reported that he had been operating for four straight days on men wounded in a single two-hour battle. In addition to overseeing its hospitals, the Sanitary Commission also established forty lodges, where invalid soldiers could find shelter and recuperate for the trip home.
Photographer unknown
Fredericksburg, Virginia, 1864

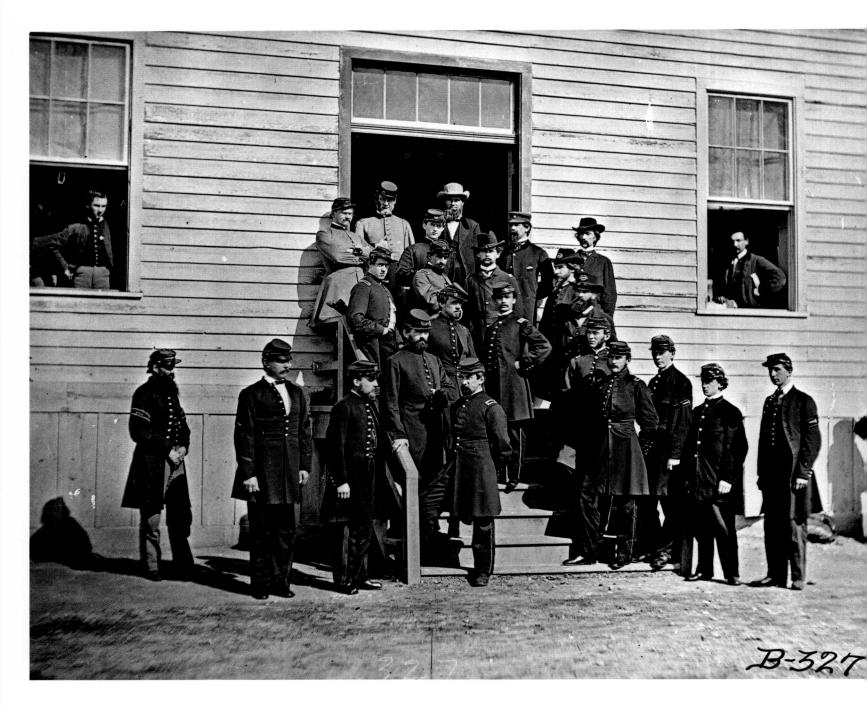

B-327

The staff of the Union's largest hospital—Harewood U.S. Army Medical Hospital in Washington, D.C.—numbered only in the hundreds to cover its three thousand beds. At the beginning of the war there were ninety-eight doctors in the entire medical department of the U.S. Army, but by the end of fiscal year 1865, about twelve thousand doctors had seen service on the Union side. Much of the credit for revitalizing the Army Medical Corps goes to William Hammond, M.D., who began his sixteen-month stint as surgeon general in April of 1862. Hammond's first goal was to eliminate the need for Union soldiers to furnish their own surgeons, as they had done in the revolutionary war. He immediately told Congress that his department needed three times as much money as had originally been budgeted, and recommended that the secretary of war increase the pay of Army doctors as well as establish an Army medical school, a permanent general hospital in Washington, D.C., and a central research laboratory. Although many of his ideas were not realized until years after the war, Hammond "initiated or requested," in the words of one historian, "every major improvement that was carried out during, or for thirty years after, the Civil War."
Photograph by Mathew Brady
Washington, D.C., ca. 1862

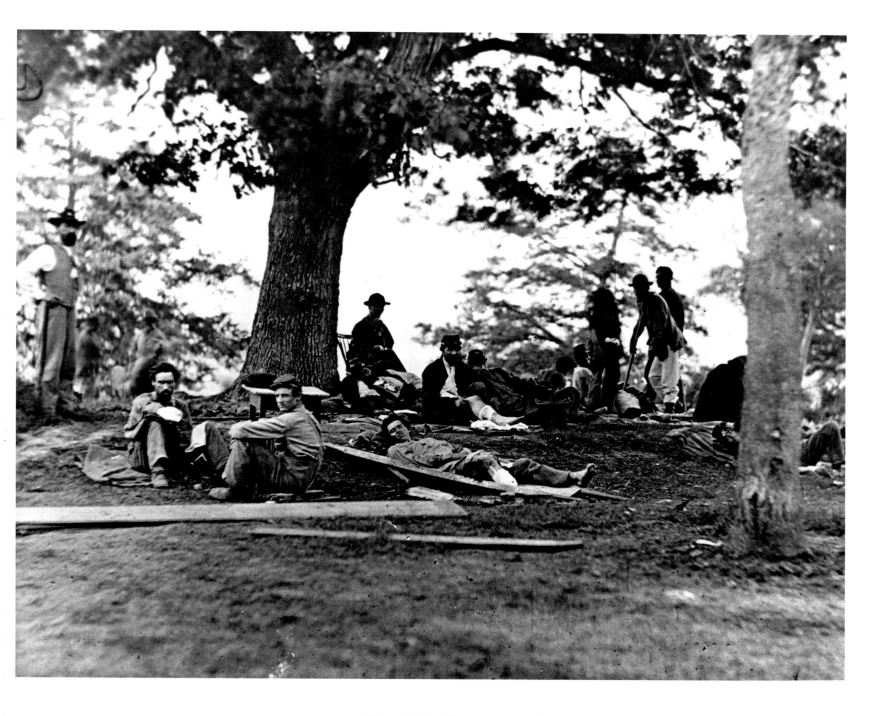

Wounded soldiers, some of them postoperative, rest under a tree during the Battle of the Wilderness in 1864. Union officer D. Watson Rowe wrote of the battle: "The stretcher-bearers walked silently toward whatever spot a cry or a groan of pain indicated an object of their search. . . . [The cries] expressed every degree and shade of suffering, of pain, of agony: a sigh, a groan, a piteous appeal, a shriek, a succession of shrieks, a call of despair, a prayer to God, a demand for water, for the ambulance, a death rattle."
Photograph by Mathew Brady
Near Fredericksburg, Virginia, 1864

explosive quality of ether extremely dangerous.) Almost all wounds of the abdomen were fatal, but occasionally nature, surgical daring, and pure luck would result in survival, although the survivor was likely to live with ugly hernias or permanent sites of intestinal drainage onto the skin of his belly.

At the Battle of Missionary Ridge, which was decisive in lifting the Confederate siege of a federal army at Chattanooga, a young rebel soldier named Albert Jernigan was badly injured when shrapnel tore into his right arm. Years later, he wrote to his parents of the events that took place on that day, November 25, 1863, vividly describing in this previously unpublished letter the conditions under which he and other wounded men were treated during a typical Civil War campaign.

Dear Parents,

. . . I have concluded to write the incidents connected with the loss of my arm, and send them to you, believing that they will be interesting to you.

. . . While loading, a ball grazes the tree striking my gun and splintering the stock. I am putting on a cap, a shrapnel explodes near me, my right arm falls paralyzed to my side. Am shocked by the concussion, feel a dreadful pain in my elbow, my gun falls to the ground, a momentary dizziness comes over me. I recover, take up my fallen right arm in my left hand to hold it steady and walk back up the ridge in indescribable anguish, both of body and spirit, for my arm is dreadfully mangled from the wrist to the elbow, wading through gore, clambering over the bodies of the dead and dying, many of the latter begging in the most piteous tones for help and for water, and expecting every moment to receive further wounds from the shot that are plowing up the ground about me or lodging in the gory bodies which lie thick upon the ground. I find myself at length in rear of our battle line seated by a tree, sick and faint from loss of blood, for my wound is bleeding profusely.

I shall now speak, or write rather, in the past tense—It was about 4 o'clock in the afternoon. I felt that burning sense of thirst, which, I suppose, is only realized from loss of blood. I saw one of the litter corps belonging to my company passing not far from me, called to him and asked for water. He had several canteens full, and handed me one, which I soon emptied—it is a part of the duty of the litter bearers to keep themselves sup-plied with water for the first thing a wounded man wants, if he has suffered much loss of blood, is water. They go in pairs, that is two together, and bear the wounded off the field on litters. This ones [sic] assistant came up, and they ripped open the sleeve of my gray jacket when the ball, which had wounded me, fell to the ground, which I picked up and brought home. They bandaged my arm and pored [sic] water on it, which checked the bleeding. They then assisted me to the brigade hospital, about half a mile in the rear and left me. Here I met one of my messmates—he had also been my "bunkmate" W.J. Sneed, with a ghastly wound in his right breast, through which, as he breathed, the air passed in bloody blubbers. I did not say, but thought, "poor fellow, you cannot live long!" The ball had passed through the upper lobe of the right lung and lodged under the right shoulder blade. —Each brigade had its hospital, say half a mile in rear of the army, to which the wounded were conveyed by the litter-corps; from here they were con-veyed in ambulances, after having received such attention as the surgeon in charge saw

Not all casualties were fighting men. Drummer boy Johnny Clem (*right*) poses for photography pioneer Mathew Brady in his Washington, D.C., studio; and thirteen-year-old Manuel Walker—the personal servant of a cavalry officer—recovers at Harewood U.S. Army Medical Hospital from leg wounds (*below*). Injured youths sparked variety in both doctors' and fund-raisers' lives: copies of the drummer boy's photograph were sold throughout the Union to raise money for hospitals and medical supplies. *Photographs by Mathew Brady Washington, D.C., ca. 1864*

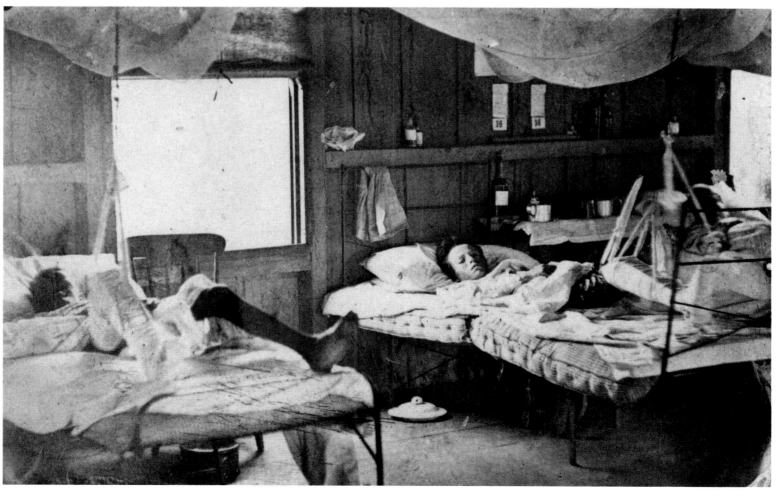

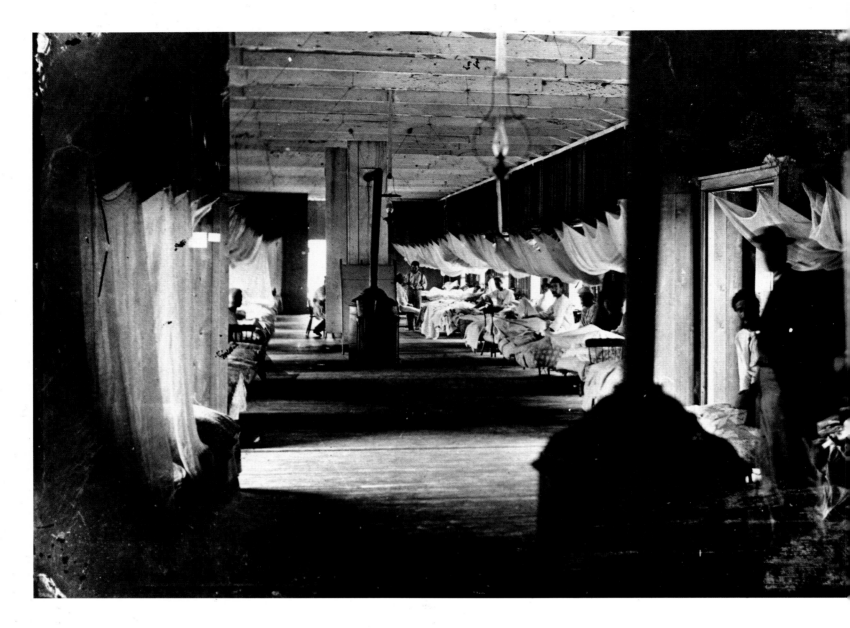

Mosquito netting protects patients at Harewood Hospital from the discomfort of bites—and also, inadvertently, from malaria, yellow fever, and other insect-borne maladies. It would take another fifteen years for medical researchers to discover that mosquitoes spread tropical fevers. With medicine as yet ignorant of the bacteria principle, infectious disease remained a major enemy for fighting men: measles, for example, killed more than five thousand soldiers during the Civil War. Long months in close quarters, contaminated water, filthy camp conditions, inadequate shelter and nutrition, and lax personal hygiene all led to disease—conditions made worse by the fact that many inductees were already in poor health when they took up arms. One Union doctor wrote in disgust that the Army had become an "institution for defectives whose townships would thus be relieved of the burden of supporting them." General Robert E. Lee, in fact, maintained that the strength of his armies actually decreased with the arrival of fresh troops since they brought so many contagious diseases with them. Lee created "camps of instruction," where new recruits from the countryside could recover from their various illnesses. These bivouacs were the first "boot camps" in the U.S. armed forces.

Photograph by Mathew Brady
Washington, D.C., 1864

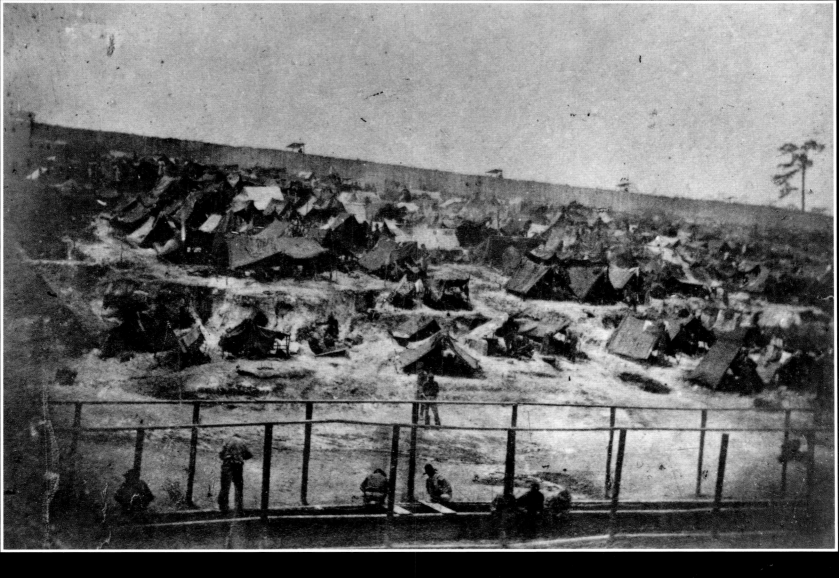

An open-ditch latrine was dug around the perimeter of the Confederate prison camp at Andersonville (*above*), in a futile, belated attempt at providing sanitary conditions to its prisoners. Andersonville, the most notorious of the Confederate camps, saw nearly 13,000 Union men succumb between early 1864 and the war's end. Built for 10,000 inmates, it housed 33,000 by the summer of 1864. Conditions were hellish. There was a shortage of medical personnel; scurvy, diarrhea, dysentery, and gangrene were the primary killers. Malnutrition was the norm, and prisoners subsisted on cornbread and water contaminated by the latrines.

The swarms of sand fleas and mosquitoes left some men, in the words of Confederate partisan Joseph Jones, M.D., "so stung . . . that they appeared as if they were suffering from a slight attack of the measles." He added, "the haggard, distressed countenance of these miserable, complaining, dejected living skeletons crying for medicine and food . . . formed a picture of helpless, hopeless misery which it would be impossible to portray by words or by the brush." One in every eight Union soldiers who died perished in a Confederate prison camp. *Photograph by Mathew Brady Andersonville, Georgia, ca. 1864*

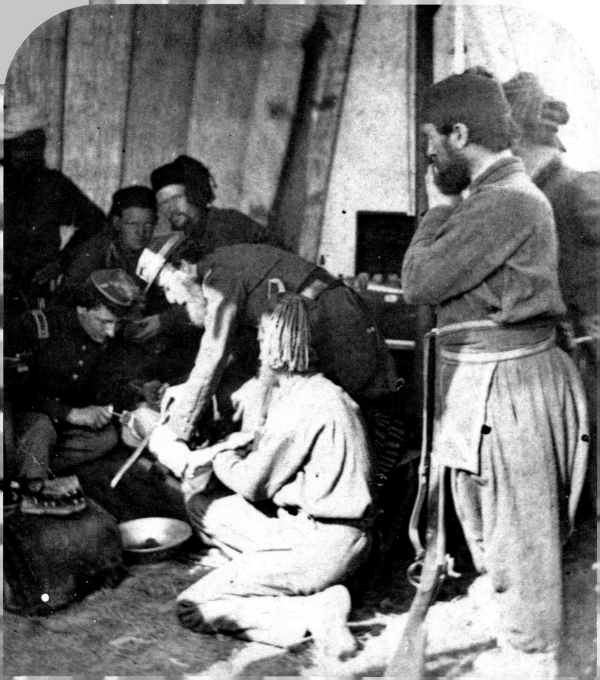

A surgeon wearing hat and sword amputates the leg of a wounded soldier at Fortress Monroe, Virginia (*left*). Sporting the Zouave uniforms from North Africa popular among some regiments of both North and South, curious soldiers watch the operation, while an anesthetist—facing the camera—holds a sponge dipped in chloroform over the patient's nose. One surgical assistant ties a tourniquet to stem the flow of blood, while another holds the leg steady. An estimated 30 percent of Civil War amputees died from postoperative complications—typically infection.
Photographer unknown
Fortress Monroe, Virginia, 1864

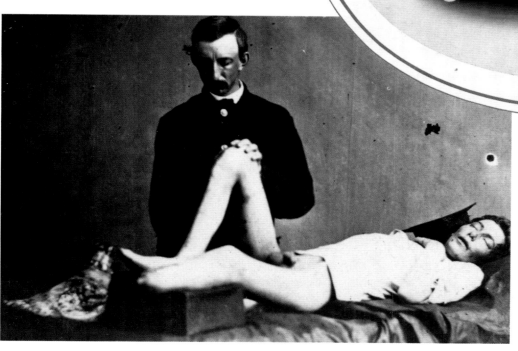

proper to bestow, to the division hospital, which was about a mile further in the rear. At the latter I arrived about dark.

The scene of this hospital will never fade from my memory. Description can only convey a faint idea of it. I shall therefore only give the outlines in brief, and leave to your imagination the filling up. A cloudy night—a pine forest, with but little undergrowth—a long row of blazing fires, on each side of which lie a host of torn, mangled, and bleeding forms in gray jackets, the features of most of whom are distorted and writhing in agony: Some cold and stiff, with eyes glazed in death, are locked in the embrace of that last long sleep that knows no waking; others there are in the last expiring agonies. A few tents in which lie the wounded bodies of official rank. Tables on scaffolds, on which lie the victims of the scalpel. Surgeons cutting and sawing men's flesh and bones, as a butcher would beef. Attendants flitting about, casting ghostly shadows on the dark forest background.—Moans, groans, cries, prayers, curses, screams, and wailings of anguish all commingled . . . My own suffering was great. I felt that my "good right arm" must be severed from my body, that I should never use it again; this mental

Among those who survived Civil War surgery was Private John Parmenter of the Pennsylvania volunteer infantry, whose battlefield wound turned gangrenous from bacteria picked up in the hospital. Before deciding to amputate, Reed Bontecou, M.D., the surgeon in charge of Harewood U.S. Army Medical Hospital, had attempted to treat Parmenter with a technique known as debridement—the localized removal of dead or infected tissue so that healthy tissue can grow—but discovered that the gangrene was too widespread and the foot doomed. Here, Parmenter poses before the operation on June 21, 1865 (*above right*); he then lies on the operating table under sedation after his foot was removed (*above left*) in what was probably a five-minute procedure.
Photograph by Reed Bontecou, M.D. Washington, D.C., 1865

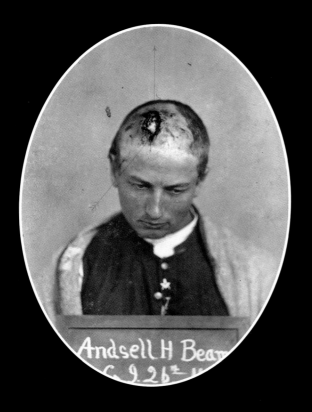

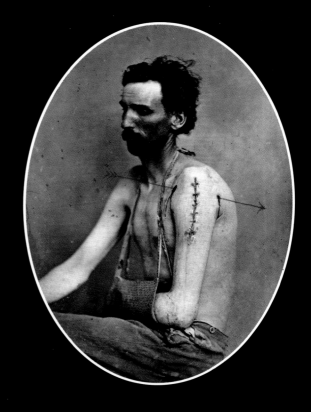

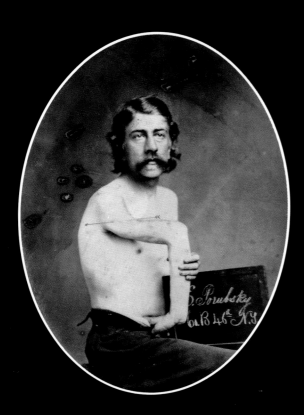

The relatively new invention of photography quickly became a medical teaching tool during the Civil War, as surgeons—prime among them Reed Bontecou, M.D.—arranged to have their cases captured on film to share with other doctors. Dr. Bontecou treated the head wound of Andsell H. Beam (*above left*) conservatively—he merely changed the dressing frequently—and later distributed this photograph, complete with his sketch line of the bullet's suspected path. On the photo of a soldier wounded in the shoulder (*above right*), Bontecou again traced the bullet's path, giving medical students an opportunity to match the wound with the location of the surgery. The technique of bone excision (*below left*), in which shattered bone was removed but a limb left otherwise intact, was developed in the wild hope that surviving bone could eventually be lengthened and the limb restored to function—a medical dream unfulfilled even today.
Photographs by Reed Bontecou, M.D. Washington, D.C., 1865

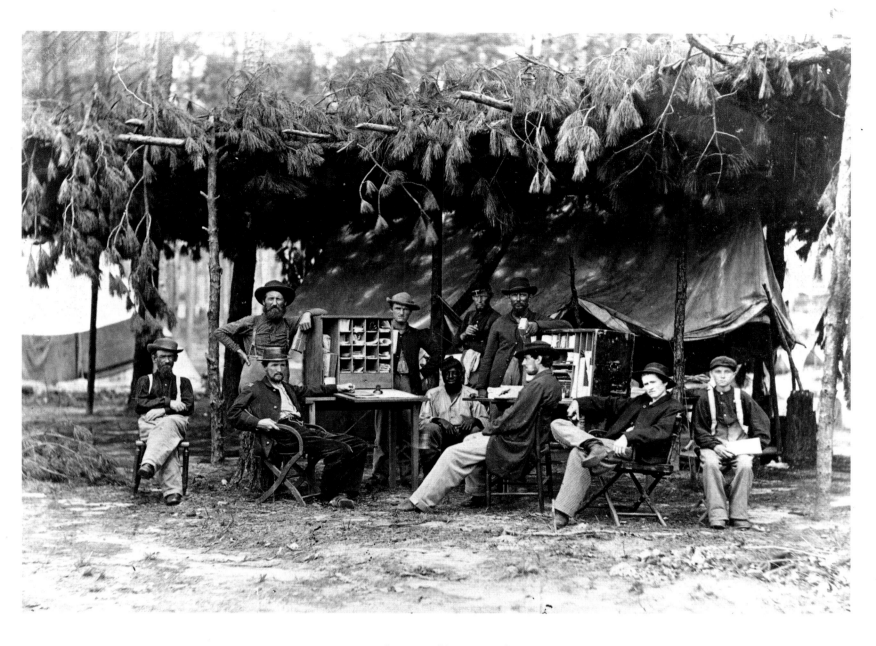

The record keepers of war set up shop during the siege of Petersburg, June 18–21, 1864, tracking fatalities and injuries to determine death benefits and pensions. Surviving U.S. soldiers received eight dollars a month if they were completely disabled, and less for other injuries or as a simple service pension. Union soldiers who lost a limb were also entitled either to an Army-issue prosthesis or financial compensation. Photography was used for the first time in the Civil War to document wounds, and the records of Union soldiers are still accessible today, either through the National Archives or the Army Archives. Confederate records were burned during the fall of Richmond in April, 1865.
Photographer unknown
Petersburg, Virginia, 1864

agony added to my body pain was dreadful in the extreme, and I was constrained to utter in the language of Cain, "My punishment is greater than I can bear." But when I looked around me, and saw the others in a much worse condition, such as, a poor fellow with both eyes shot out, another with both legs torn from his body, another with both an arm and a leg gone, I felt that there was cause for thankfulness to God and self gratulation that my condition was not worse.

Notwithstanding my great exhaustion from the fatigue of the past day and nigh, [sic] and loss of blood, I could find no relief in sleep. I asked a surgeon if he could do nothing to relieve my pain. He replied that "he would attend to my case as soon as possible," that "there were others in a worse condition" than I, and that the worst cases must be attended to first. I readily perceived the justness of his reasoning, and acquiesced. I tried lying, sitting, standing, walking, seeking rest but finding none.

About midnight, the surgeon in charge received notice that the army was in retreat, and orders to pack up and move his hospital to Chicamauga Depot with all possible dispatch. This was the first intimation I had of a defeat at Missionary Ridge. Until now, I was under the impression that we had gained a glorious victory. I knew we had beaten them badly on the right. I learned afterward that our left and center, being very weak, had given way under the overwhelming numbers brought against them: and this, of course, forced our right to fall back in order to avoid being captured.

All was now in confusion in our hospital. Wagons and ambulances were brought into requisition for transferring the wounded and hospital stores to Chicamauga. "All who were able to walk must look out for themselves." I managed to get into a baggage wagon, the jolting of which over a miserably rough road, increased my suffering so much that I was tempted to get out and take my chances a foot. But knowing my inability to walk any distance, and the thought of perishing there or being captured by the enemy prevented my doing so. At length the jolting and jostling came to an end, as all things earthly must. The wagon had stopped. The driver told me he could go no further the way being blocked up by wagons. He assisted me out of the wagon and to a fence on one side of the way, and told me to follow the fence and keep close to it to avoid being run over by the horsemen who seemed to be going at full speed in all directions. I did as he told me and soon found myself at the [railroad] cars.

I made application for admittance into the first box I reached which was a freight car, the floor of which was up nearly to my shoulders, and [was] told there was no room for me. I went to the next and called for some one to help me in, [and] holding up my left arm, was drawn in by it. Here I found Ltnt. Sneed of my company, who had been detailed to take charge of the wounded, and his brother William, of whom I have before spoken as having a wound in his right breast. They were both intimate friends of mine, and I was glad to have thus fortuitously met them.

The boxcar we were in was crowded with wounded: indeed I think the principle freight of the train consisted of wounded soldiers. Near daylight on the morning of

Inspired by Florence Nightingale, members of the U.S. Sanitary Commission (*above*)—most of them women—fought to keep disease losses among Union troops from reaching the devastating levels that British forces suffered in the Crimea. In fact, it was Nightingale who had first suggested that military hospitals be built as pavilions, to separate patients by type of injury or illness, hampering the spread of disease and infection. Mt. Pleasant in Washington, D.C., (*above right*) had rows of both tent and more permanent pavilions; at Hicks General Hospital in Baltimore (*below right*) each pavilion radiated out from a central hospital building.
Above: Photographer unknown
United States, ca. 1864
Right: Lithographer unknown
Above right: Washington, D.C., 1861–65
Below right: Baltimore, Maryland, 1861–65

the 26th the train started, but owing to the bad condition of the road, and the heavy train, we did not reach Kingston, Georgia, a distance perhaps of 60 miles, until the morning of the 28th. During all this time there had been nothing done for my arm except a few applications of cold water. What I suffered during this trip I leave to your imagination.

At Kingston, the two Sneeds and I concluded to stop regardless of an order that we should go on further. I went to a hospital, had my wound examined and dressed by a surgeon. Having some breakfast, the surgeon gave me an opiate and assigned me a bed. I was soon asleep, for I had slept little if any for the past three days and nights. I slept most of the time until next morning, which was the 29th, when the Board of Surgeons consisting of six members met in consultation over my arm. Their decision was soon rendered, which was that my arm must come off. I had begun to entertain a hope that it might possibly be saved by the performance of what is termed a "resection," that is to split the arm open, take out the fractured bone, which in my case was all from the wrist to the elbow, and try to heal the arm without a bone. This I stated to the Board. But they objected, said it would not do. I insisted that they should try it, and if after a sufficient time they found it would not heal that way, they could but then amputate. But they thought that the only chance to save my life was to take it off then, that after trying the experiment of which I spoke, which was sure to fail, my arm must finally come off, and by that time, I would be so reduced that I would not be able to undergo an amputation. I asked my friend Ltnt. Sneed who was present, what he thought about it. He replied that he thought the doctors were right. I then told them that if they were ready, they might proceed with the amputation.

They took what is called a bonnet, but shaped more like a funnel, lined inside with raw cotton which was saturated with chloroform, placed it over my nose and mouth, as I lay upon my back, while one of the surgeons stood by holding my hand and feeling my pulse. I soon lost all consciousness of pain. I was perfectly happy. A feeling of indescribable bliss, ecstasy, felicity, or I know not how to describe it, came over me, then all consciousness of being or existence passed from me. I was totally oblivious. I awoke without knowing where or what I was. I opened my eyes. One of the surgeons spoke to me. A thrill as of an electrical shock ran through my frame. I was myself again. My arm was gone.

By the time of the Civil War, a sustained effort of combat was no longer possible without mobilizing the civilian populace, and therefore its assent was needed before a government could go into battle. The principles of the use of technology and the division of labor, born with the Industrial Revolution earlier, now demanded that huge strides in organization be made in all aspects of mass endeavors, from arms production to medical care. It was during the Civil War that the great names in U.S. military medical organization began to make their appearance. The greatest of them, Jonathan Letterman, M.D., was only thirty-eight years old when he became medical director of the Army of the Potomac in July of 1862. Within a few months, he had developed a plan for the first American ambulance corps, and before he completed his additional reforms, he had created a system that remained the model for medical care during all American conflicts until

The unique wounds seen by military physicians in every war offer invaluable insights to the next generation of military surgeons. This photograph of a Minié ball lodged in the humerus (the bone that connects the elbow and the shoulder) is preserved at the Army Medical Museum in Washington, D.C., for study by future physicians. The Minié ball, developed by French captain Claude Minié, was a heavy bullet used in the Civil War that often stuck in the soft, spongy ends of bones without shattering them, as it did when it hit harder bone shafts.
Photograph by Reed Bontecou, M.D. Washington, D.C., ca. 1864

"What a scramble there'll be for arms and legs," Louisa May Alcott quotes a Union sergeant as saying in her *Hospital Sketches*, "when we old boys come out of our graves, on the Judgement Day: wonder if we shall get our own again? If we do, my leg will have to tramp from Fredericksburg, my arm from here, I suppose." In the first two years of the Civil War, surgeons amputated any limb with lacerations or shattered bone to ward off gangrene and blood poisoning. By late 1862, however, Army regulations stipulated a more conservative approach, but amputation remained so common that this photo, taken outside Harewood Hospital, was dubbed "A Morning's Work." Some 180,000 amputations were performed during the Civil War, many by doctors who had gone to war specifically to refine their technique.
Photograph by Reed Bontecou, M.D. Washington, D.C., ca. 1864

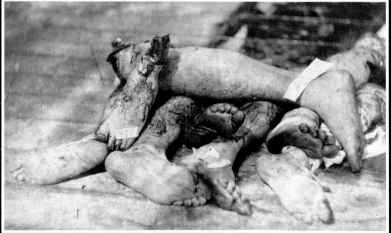

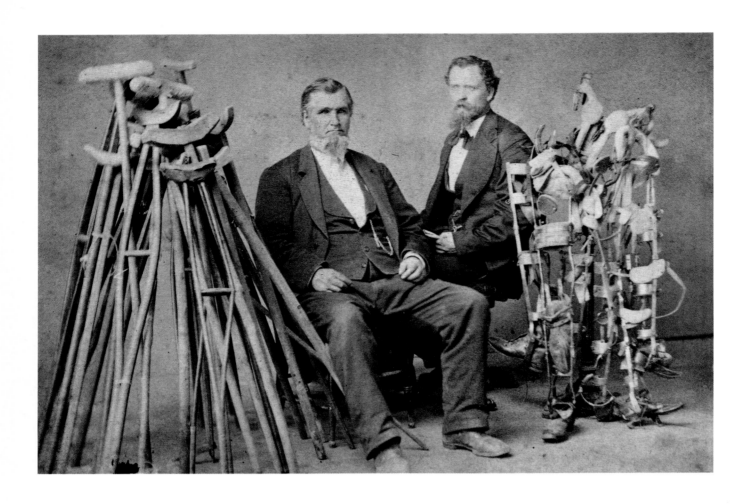

The prevalence of amputation during the Civil War created a need for prosthetic devices, which this pair of salesmen (*above*) was happy to fill. In 1866, more than half of the entire budget for the state of Mississippi was expended on artificial arms and legs. Because demand often outstripped supply, some veterans designed their own mechanical limbs of metal and leather; one of the most famous was Union veteran Sam Decker (*right*), who could eat and write relatively easily with the prosthetic arms he and his wife created. Decker was made Doorkeeper of the U.S. House of Representatives after recovering from his injury.
Photographers unknown
United States, ca. 1866

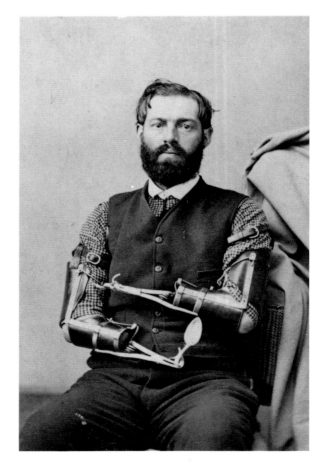

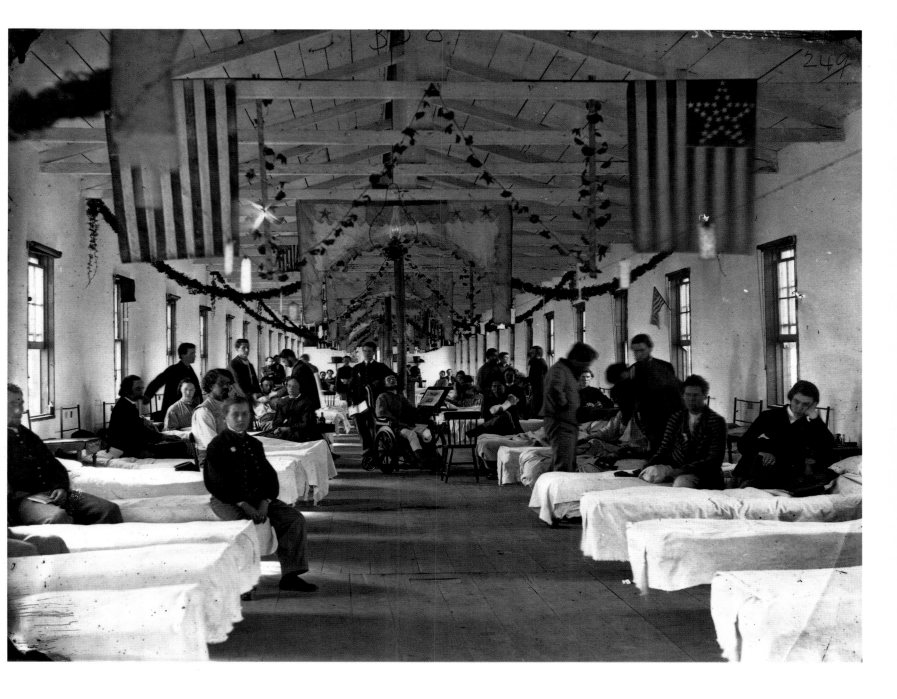

Civil War doctors believed that well-ventilated hospital wards, such as this one at Carver Hospital in Washington, D.C., helped to prevent the spread of infectious diseases, which they blamed on unclean air. Louisa May Alcott wrote that her experience as a Civil War nurse began with "a somewhat abrupt plunge into the superintendence of a ward containing forty beds, where I spent my shining hours washing faces, serving rations, giving medicine, and sitting in a very hard chair, with pneumonia on one side, diphtheria on the other, five typhoids on the opposite, and a dozen dilapidated patriots, hopping, lying and lounging about."
Photograph by Mathew Brady
Washington, D.C., 1864

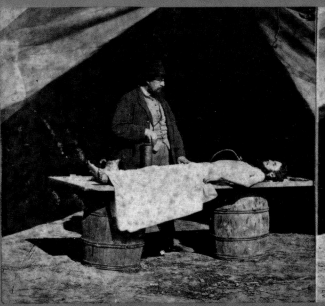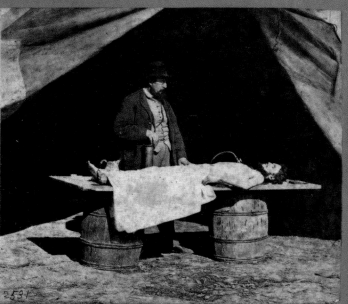

ARMY OF THE JAMES.—1864.

Dr. Burr embalming the body of a soldier to be sent home for burial.

Vietnam. His second great contribution was to create, out of the existing chaos and unpreparedness, a system for the efficient and economical distribution of medical supplies.

Until Letterman took control, wounded men would often lie in the field for as long as two days before being moved, just as they had in the campaigns of Napoleon before Baron Larrey invented the *ambulance volantes*. At the first Battle of Bull Run, injured men were forced to find their way to safety on their own, or with only their comrades to help them. At the second Battle of Bull Run, three thousand of the wounded were not picked up for at least three days, and six hundred remained on the field for a week.

But Letterman's newly organized ambulance corps rapidly changed this grim picture. The efficient functioning of the ambulances, together with Letterman's innovation of placing well-equipped, skillfully staffed, mobile field hospitals within a mile or two of the expected battleground, considerably shortened the time from wound to evacuation to definitive treatment.

Both the Union and the Confederacy built large, pavilion-style base hospitals, with an individual, well-ventilated building for each injury or disease. Some of these facilities became huge, such as the Chimborazo Hospital in Richmond, Virginia, which housed 8,400 patients in 150 buildings and 100 tents. By 1865, the two sides had built 204 general hospitals with a total bed capacity of 137,000 patients.

As always, both sides fought disease as hard, though less effectively, as they fought each other. The Union forces lost 110,000 men to battlefield injuries and 224,000 to disease. Because medical records were burned in the destruction of Richmond, the Confederacy data are much harder to ascertain; the generally accepted figure for disease losses is 164,000, with 94,000 killed in battle. The much smaller Confederate army suffered disproportionately, in part because its troops came primarily from rural areas, without previous exposure and immunity to contagious disease or a commitment to the most basic elements of sanitation. A national public health movement took shape during the last third of the nineteenth century, which owed much of its impetus to the recognition by Civil War doctors of the vital need for sanitary reforms. Ironically, the postwar sanitarians would preserve more lives than the generals had destroyed.

While the bodies of many Civil War casualties were interred in anonymous graves or even left on the battlefield by retreating troops, some were embalmed and sent home for burial. The war's most lucrative medical specialty, in fact, was that of the traveling embalmer—often a trained chemist or pharmacist who set up a tent after every battle, offering his services to soldiers anxious to take proper care of a fallen comrade. Men like Richard Burr, M.D. (*left*), used arsenic or sulphite compounds, usually in alcohol, to preserve the corpses, charging one hundred dollars to embalm an officer and twenty-five dollars for an enlisted man.
Photograph by Mathew Brady
Virginia, 1864

With slavery abolished at the end of the Civil War, black Americans found themselves more welcome in the U.S. Army during the Indian wars, which reached their peak of intensity between 1870 and 1890. Corp. Edward Scott of the Tenth U.S. Cavalry (*left*) had his leg amputated after being shot in the thigh by Geronimo's forces. U.S. military doctors marveled at the Native Americans' successful use of plants and herbs as healing agents, and at their ability to keep wounds clean and free of infection.
Photographer unknown
Western United States, 1886

A dazed soldier, likely to sustain permanent brain damage if he survives the infection and shock from a tomahawk wound to the head (*right*), recuperates during the fight to drive Indian tribes from their ancestral lands. The wounded could be thankful for one thing, at least: the development of the so-called mule litter (*far right*), which allowed a patient to be transported in a prone position, putting an end to long, jolting rides on horseback between battlefields and camp hospitals. The mule litter was invented by Edgar Mearns, M.D., in 1885.
Right: Photograph by Ben Wittick
Fort Wingate, New Mexico, ca. 1890
Far right: Photographer unknown
Western United States, ca. 1885

Doctors in a military hospital in Massawa could do little for these mutilated natives of Abyssinia—now Ethiopia—(*right*), who had had their hands, feet, or legs amputated as punishment for fighting alongside the Italians in Abyssinia's war against Italian aggression in the 1890s. Nine hundred of the twenty-five hundred prisoners taken by the Abyssinian leader Menelek were natives. Stories of Menelek's cruelty to his captives became legendary.
Photograph by L. Maretti
Eritrea, Abyssinia, 1894

Infected prostitutes are isolated in a quarantined camp in Eritrea, Abyssinia during the Italian occupation in 1892. With foot soldiers and sailors the primary carriers of venereal disease, and with the discovery of penicillin still some forty years away, the only effective approach to syphilis was this simplistic, preventive one. Mercury was used to treat syphilis, but with limited success, beginning in the late fifteenth century, giving rise to the adage, "An hour with Venus; a decade with Mercury." Though the bacteria that causes syphilis was discovered by a pair of German doctors in 1905, the first viable treatment—penicillin—would not be discovered until World War II.
Photograph by L. Maretti
Eritrea, Abyssinia, 1892

Plain Women of Character

Martha Saxton

Throughout the nearly twenty-four hundred battles of the Civil War, both North and South were helpless to alleviate the epic suffering of the wounded. At the outbreak of fighting, the North had only sixteen army hospitals and ninety-eight medical officers; it had no nursing corps or provisions for ambulances. The South had even fewer resources. Nursing, such as it was, had been done by men, but both the Union and the Confederacy needed those same men as soldiers. The only women trained to nurse were the Sisters of Charity, some six hundred nuns who had helped establish a number of Catholic hospitals across the United States before the war.

In spite of the dire need on both sides for medical help and the singular availability of women to fill that need, male surgeons and military officials opposed the entry of women into nursing. The idea offended their notions of sexual propriety; and, as they rightly pointed out, women had no training for the job. In 1861, most women's ideas about nursing arose from their domestic experience and were longer on morality than medical knowledge.

But despite their lack of training and the prejudice against them, many women desperately wanted to help: their desire and the deadly momentum of the war breached the male monopoly on care of the sick and wounded. And help they did. Dorothea Dix, a well-known reformer, became director of the Union Army's fledgling nursing program. She issued a circular calling for "plain" women between thirty-five and fifty, with two letters attesting to their good character. They were to wear black or brown and eschew hoop skirts and ornamentation. Dix's matronly specifications testify to the profound fear Americans experienced in imagining women taking care of strange men. The Sisters of Charity, who had taken vows of chastity, presented a reassuringly asexual appearance, adding to their popularity with surgeons. Dix's thirty-two hundred nurses, on the other hand, would often receive ambivalent welcomes.

Some Union nurses had the chance to stop at Bellevue Hospital in New York City for a month's preparation, but most went directly to the front lines. Cornelia Hancock, a Quaker volunteer who managed to circumvent Dix's age and plainness requirements—she was both pretty and under thirty-five—described her first assignment to a field hospital after the Battle of Gettysburg in July of 1863. "Hospital" exaggerates considerably what she found. "Earth was the only available bed," she wrote, "during those first few hours after the battle. A long table stood in the woods and around it gathered a number of surgeons and attendants. This was the operating table, and for several days it literally ran blood. A wagon stood near, rapidly filling with amputated legs and arms: when wholly filled, this gruesome spectacle withdrew from sight and returned as soon as possible for another load."

Clara Barton, who later founded the American Red Cross, recalled arriving at an abandoned farm after the Battle of Antietam, where twenty thousand men were wounded. She wrote that wounded men were squeezed into every corncrib and manger of the barns, where they were bleeding to death from shell wounds, "with only green corn leaves to cover, but not stop the flow. Four tables with patients ready for surgery stood on the porch of the bullet ridden house."

Barton, like Hancock and the others, got used to the sights and sounds of war. Barton even managed to assist at amputations, although some nurses could not go so far. For the most part, they made heroic efforts to change hundreds of soldiers' bandages and keep their patients clean, fed, and as comfortable as wine and whiskey could make them. Jane Swisshelm wrote that she worked from six in the morning until midnight among fifteen hundred men, dressing wounds and providing stimulants and drinks. She felt she was supposed to comfort the dying but "never had time to sit by a death bed."

Disease—by far the greatest killer of the war—attacked the overwhelmed nurses as well as their patients. Twenty or more Union nurses died on duty, and one in ten was struck down by disease while serving in the war. As Kate Cumming, a Southern nurse, wrote when she

was the only woman at her hospital still well: "It is more unhealthy now than ever, and unless some change takes place I fear that we will all die. . . . Three of the ladies are very sick. Miss Marks is not expected to live." Louisa May Alcott nursed only a month before contracting typhoid fever. She was dosed with large quantities of calomel—containing mercury—a "cure" the army would prohibit later in the war. Alcott managed to recover from the typhoid—despite the treatment—but the mercury made her an invalid and hastened her death.

Lack of medical knowledge rendered nurses and doctors helpless in the face of infection as well as disease. Cumming wrote of a young man about to have his arm amputated: "Poor fellow! . . . He says that he knows that he will die, as all who have had limbs amputated in this hospital have died. It is but too true. . . . It is said that the reason is that none but the very worst cases are left here, and they are too far gone to survive the shock which the operation gives the frame. The doctors seem to think that the enemy poisoned their balls, as the wounds inflame terribly; but I scarcely think that they are capable of so great an outrage." Indeed, the North had not poisoned its ammunition. The real killers were bacteria, unwittingly transmitted by doctors who, as yet unaware of the "germ theory," routinely performed surgery with unclean hands and unsterilized instruments on unwashed operating tables.

Despite the heroism women demonstrated in tending the sick under frightful conditions, most men, even after the war, persisted in feeling that women had no place in nursing. Hardly a day passed, wrote Cumming, that she did not "hear some derogatory remarks about the ladies who are in the hospitals, until I think, if there is any credit due them at all, it is for the moral courage they have in braving public opinion." Civil War nurses were not destined to receive praise or gratitude for their gallant service during the war; in fact, women who had sacrificed their health by nursing soldiers would have to lobby nearly thirty years before extracting from Congress a small, monthly pension. Not

until the turn of the century could women begin to enter the nursing profession freely and be fairly compensated for their efforts.

Only the Sisters of Charity elicited thanks from everyone. Mary Livermore, who ran the U.S. Sanitary Commission in the Midwest, wrote after the war that "never did I meet those Catholic Sisters in hospitals, on transports, or hospital steamers, without observing their devotion, faithfulness, and unobtrusiveness. They gave themselves no airs of superiority or holiness, shirked no duty, sought no easy place, bred no mischief."

The reminiscences of many Civil War nurses share a palpable longing for fellow Americans to recognize their contribution to the war, in contrast to the nuns, content with anonymity, who nursed out of a sense of spiritual duty. Barton, writing years later, expressed one of the unarticulated desires motivating non-Catholic women to risk their lives in the Civil War: "Only an opportunity was wanting for woman to prove to man that she *could* be in earnest—that she had character, and firmness of purpose—that she *was* good for something in an emergency. . . . The war afforded that opportunity." Civil War nurses have left a poignant record of their twofold mission: as nurses attempting to heal and as second-class Americans trying to legitimize themselves through their courageous contributions to the nation's welfare. Although they failed at the second endeavor during their own lifetimes, time has ultimately awarded them the victory.

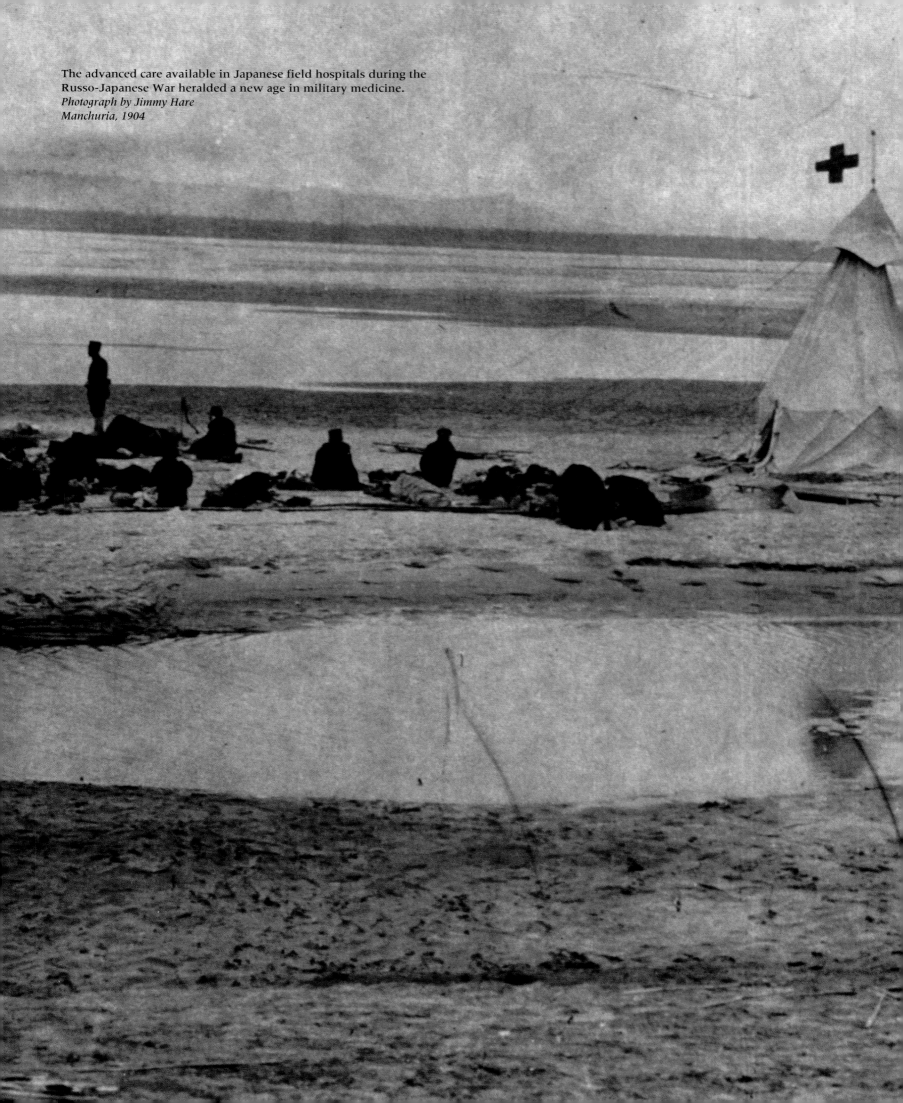

The advanced care available in Japanese field hospitals during the
Russo-Japanese War heralded a new age in military medicine.
Photograph by Jimmy Hare
Manchuria, 1904

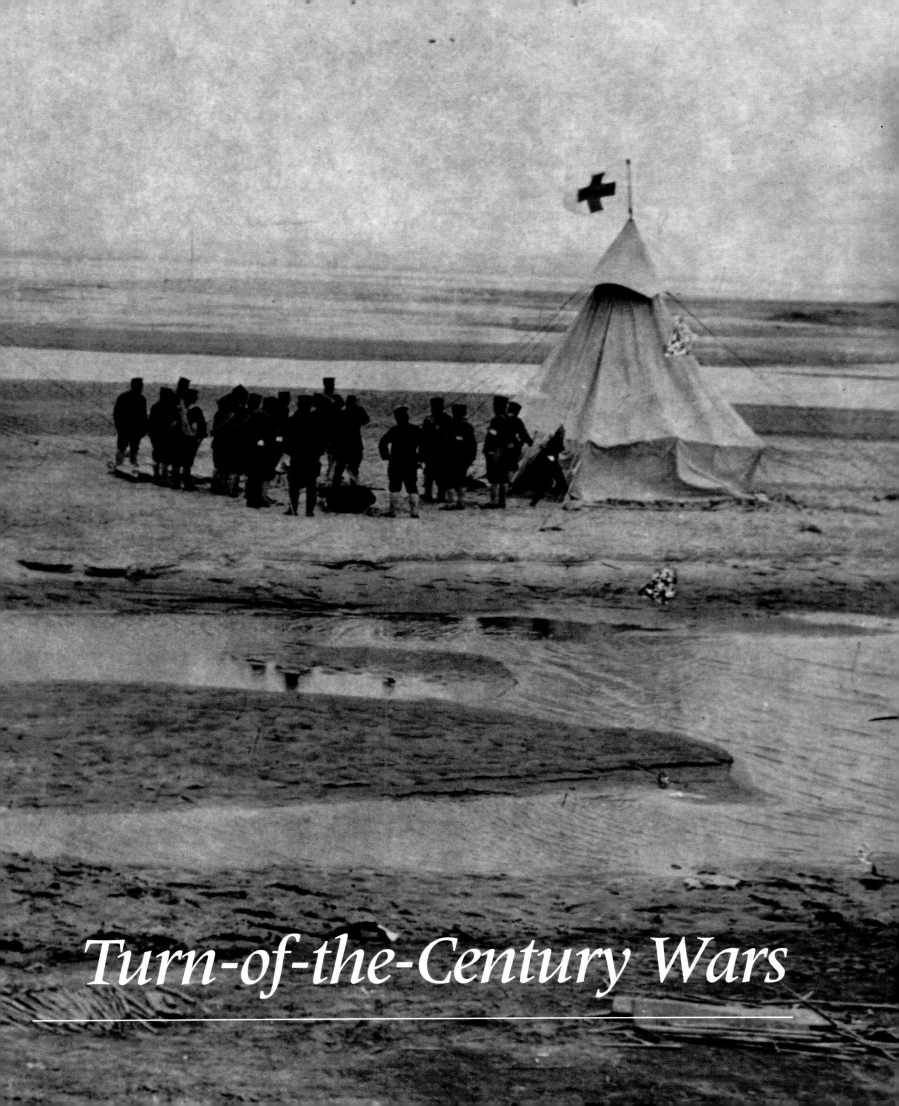

Turn-of-the-Century Wars

The Invisible Enemy

The shelling grew steadily more intense, as well as more accurate. I didn't see how we could live through this night. My lieutenant suddenly screamed, "Lord, have mercy!" and fell on top of me. The wounded man was wimpering, "Mother! Mother!" None of us knew how to tie a bandage that would stop his bleeding. I tried to give him some water, but his mouth was tightly clenched from the pain. I knew if we didn't get him to an aid-station at once, he'd die from lack of blood.

Above us the bombardment was thicker than before. But four of us decided to risk it. Crawling on our bellies, we dragged our lieutenant toward the rear. After going like this for about an hour, we dropped into an empty trench. I struck a match to see how the lieutenant was doing. The match burned down to my fingers. Our platoon commander was without a head, and probably had been for some time. Two of the soldiers began to cry. The sweat had congealed on our bodies, and we now started to shiver from cold.

—Jacob Marateck, from The Samurai of Vishogrod, *Russo-Japanese War*

With the help of the water-boiling machines used in the Russo-Japanese War (*left*), the Japanese reversed one of the oldest, harshest facts of war—that armies lost several men to disease for every one who died in battle. To defeat the much larger Russian army, the Japanese drew on the latest theories on sanitation and disease control coming out of Germany in the wake of the Franco-Prussian War—and perhaps also on the wisdom of the Scottish military surgeon, Francis Home, M.D., who had first recommended that troops boil their drinking water in the 1740s. *Photographer unknown Manchuria, 1905*

Two years before the beginning of the Civil War, a young German surgeon named Theodor Billroth published a remarkable little book entitled *Historical Studies on the Nature and Treatment of Gunshot Wounds from the 15th Century to the Present Time.* What made it remarkable was both its value as a scholarly treatise and the fact that, when he wrote the book, the thirty-year-old Billroth had never seen a battle or treated a wounded soldier. He longed for wartime clinical experience and sought a productive outlet for the German patriotism that burned so intensely within him.

When the Franco-Prussian War broke out in July of 1870, Billroth, by then a highly regarded professor at the University of Vienna Medical School, joined the Austrian Patriotic Relief Society and went off to the front, arriving at Alsace filled with an intoxicating zeal that he called the *furor teutonicus.* But like so many other doctors who have gone off to war in a spate of nationalistic fervor, the sight and sound of the wounded of both sides jolted him back to the reality of his calling. He wrote that as he "mingled amongst wounded of rank and file torn from their illusions, hate and scorn were replaced by sympathy and a desire to be helpful in the relief of suffering."

Immediately faced with three hundred of the wounded from a German victory on the day he reached the area of conflict, Billroth surveyed the disorganized medical system and set about putting it in order. He was quickly successful, in spite of the necessity

that he also devote long hours to operating on the injured. His days began at 5:00 A.M. and continued until he was too fatigued to stand. Late at night on the eleventh day after he had begun his work, the exhausted Billroth wrote home to his wife, echoing every weary battlefield surgeon since doctors first began going to war: "So far I have done nothing else all day long but operate, bandage, and transport patients."

But Billroth was being modest; he was actually doing something quite extraordinary at the same time. It was in his nature to be a medical polymath who operated, researched, taught, and speculated philosophically about the patients who put their lives in his trust. He used every one of his cases to study the nature of battlefield injuries, hoping to learn how he might better treat them and how he could apply his new findings to the patients in his vast practice at the Vienna General Hospital. He quickly familiarized himself with wartime surgery. In another letter to his wife after five weeks of unremitting work, he wrote of his experiences with battle wounds: "There is probably not a square inch on the human body where I have not seen a gunshot wound."

Billroth meticulously recorded his observations and continued to study them long after he returned home. He incorporated everything he had observed into his understanding of the processes of injury and healing, the primary factors in any surgical operation. Not only would he later become a pioneer in the surgery of the larynx and digestive tract but he would also complete a careful study of the logistics of military medical care and transportation. Having studied the U.S. surgeon general's reports with his usual scrupulous care, he was well acquainted with the Civil War experience, and made good use of his knowledge.

Theodor Billroth was far more than a surgeon. He was a fine musician and close friend of Johannes Brahms; his literary and philosophical interests ranged over all of nineteenth-century culture, and came to rest on the Kantian philosophy of obligation to one's fellows as a primary duty of everyone. For Billroth, this obligation applied to doctors in particular. Like several of his fellow physicians in Vienna and elsewhere, he became associated with a movement called *Romantische Medizin*, a moral vision of humanistic medicine embodied in the maxim of one of its prime proponents, Hermann Nothnagel: "Only a man who is good can be a great physician."

Reviewing his own war experience and his studies of the American Civil War, Billroth saw the extraordinary increase in casualty rates that had been brought about by modern weaponry. It had become impossible, even with Letterman's efficient ambulance methods, to remove the wounded from a battlefield fast enough to give them the medical care they needed. Billroth pointed out the need to develop a system of hospital trains to expedite the evacuation and transport of the wounded. He seized on the occasion of the Vienna World's Fair in 1873 to organize an international conference to improve military medicine. By then, his stature as a teacher, researcher, and clinician had made Billroth recognized as the leading surgeon in the world.

The Franco-Prussian War, in which Billroth had served, was brief but ferocious. The French lost 137,000 men; the Germans lost 117,000 men. The diseases of this war were typhus, typhoid, smallpox, and that foul old enemy of soldiers, dysentery. With smallpox, the Germans had a clear advantage. They had done a much better job of vaccinating their men than had their enemies, and had only 4,835 cases of the disease and 278 deaths out

German Army personnel treat the wounded in a military hospital in Höhenheim near Strasbourg, France. Tents were commonly used as field hospitals during the Franco-Prussian War (1870–71), a six-month conflict that ended with Chancellor Otto von Bismarck's rout of the French, and established Germany as the dominant force on the Continent. Heat was piped into larger hospital tents through a trench connected to a stove, but tents were by no means the only medical facilities used during the war. A British observer in Paris—under siege for the war's final three months—reported that every possible building was made into a temporary hospital, including "palaces, churches, theatres, the Great Exhibition building, public buildings, official residences, railway stations, nunneries, schools, colleges, museums, clubs, hotels, public ball-rooms, establishments of trade, banks, insurance offices." Many soldiers were cared for by private citizens in Parisian homes, leading the observer—deputy inspector general of British hospitals, Charles Alexander Gordon—to remark: "Never was help rendered so generously and extensively to the disabled in battle."
Photographer unknown
Near Strasbourg, France, 1870–71

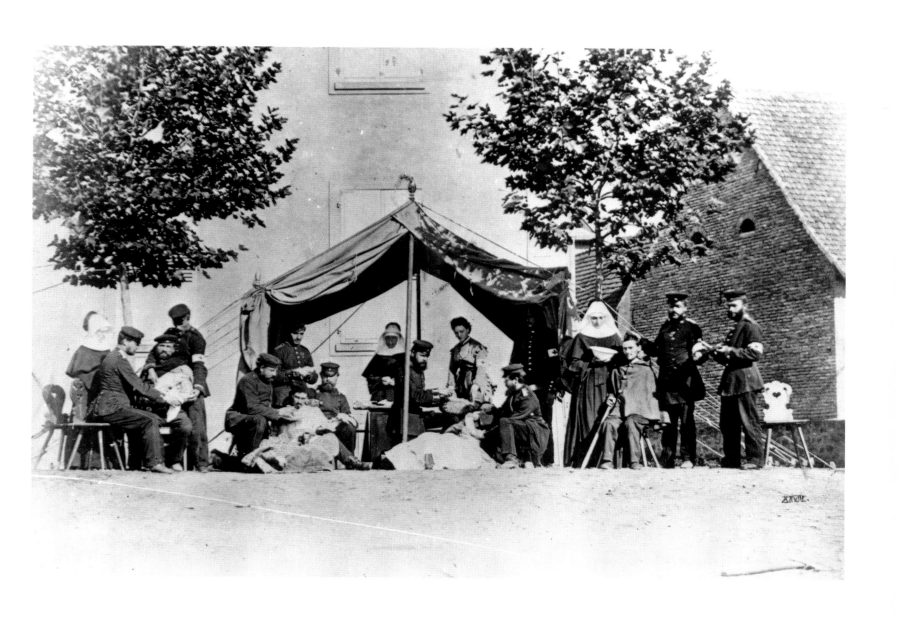

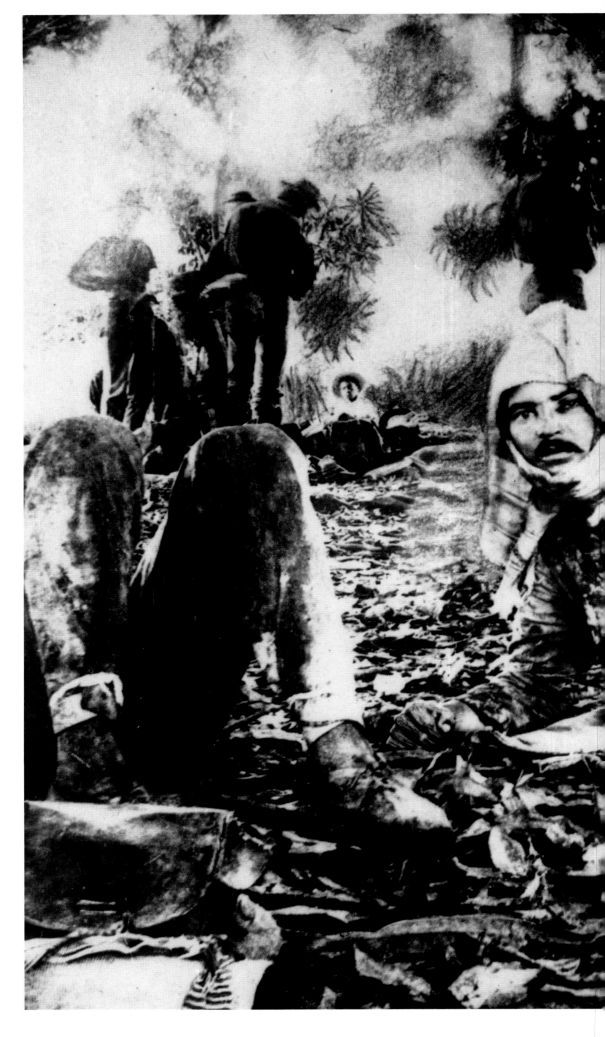

Wounded Spanish prisoners await medical care after the battle of El Caney, Cuba, during the Spanish-American War of 1898. Stephen Crane, author of *The Red Badge of Courage,* was on the scene, and after visiting a church where American doctors were treating Spanish prisoners, he wrote: "The interior of the church was too cave-like in its gloom for the eyes of the operating surgeons, so they had had the altar-table carried to the doorway, where there was a bright light. Framed then in the black archway was the altar-table with the figure of a man upon it. . . . An American surgeon and his assistants were intent over the prone figure. They wore white aprons. Something small and silvery flashed in the surgeon's hand. An assistant held the merciful sponge close to the man's nostril, but he was writhing and moaning in some horrible dream of his artificial sleep. . . . 'Good morning,' said the surgeon. He changed his knife to his left hand and gave me a wet palm. The tips of his fingers were wrinkled, shrunken, like those of a boy who has been in swimming too long."
Photographer unknown
San Juan, Cuba, 1898

of nearly 800,000 men who served. Since they were also better at record-keeping than their enemy, the Germans' statistics on their French captives are the best source for comparison: of 14,178 cases of smallpox among the French prisoners alone, 1,963 died.

But in an ironic way, public health had won a small battle. For the first time in a major war, one side suffered a lower mortality rate from disease than from battle casualties: the Germans lost 17,000 men outright and 11,000 more from wounds, but only 15,000 succumbed to disease. The first seeds of modern biomedical science had grown more rapidly in the German-speaking universities than anywhere else, and Berliners had used modern principles of sanitation to clean up the polluted streets and sewers of their city. Now the German soldier profited from all that had been learned.

Nevertheless, as the German military surgeons perused their statistics, they confirmed what simple observation had told army doctors in every war fought thus far: the mortality from amputations among soldiers was enormous. Georg Friedrich Louis Stromeyer, the father of modern military surgery in Germany, was dispirited when he saw he had lost every one of the thirty-six young men whose legs he had amputated through the knee joint. Equally gloomy were the French reports: of 13,173 amputations of all sorts done in military hospitals, including removal of only fingers and toes, 10,006 men died of infection. Physicians were distressed by these figures. But there was a solution in sight: in British studies whose value had been earlier underestimated, carbolic acid had been shown to prevent postoperative wound infections.

Stimulated by Louis Pasteur's discovery that bacteria cause putrefaction in wine and beer, the British surgeon Joseph Lister, working at the Glasgow Royal Infirmary, had proven that wound infections arise from bacteria as well. Both his and Pasteur's discoveries were possible because advances in the science of optics had enabled the construction of new kinds of microscopes, with which researchers could finally spy on the previously unknown territory that Pasteur had called "the world of the infinitely small."

Though Lister's first report that carbolic acid killed bacteria was published in 1867, it went largely neglected outside of Scotland: it presented a method of prevention that was thought too cumbersome to be practical, and its conceptual basis was too scientific for many late-nineteenth-century surgeons to appreciate. But the Germans, more sophisticated in matters of science than the British and horrified by their recent loss of so many wounded soldiers, now quickly adopted Lister's method of carbolic antisepsis. The French were not far behind. Wound infection rates in French and German hospitals began to plummet, as Lister's principles were rapidly integrated into daily use in operating rooms and on the wards. The distraught Stromeyer was so grateful for the discovery of carbolic acid that he wrote a tribute to Joseph Lister, in somewhat awkward English, in the form of a laudatory poem entitled "Lister." It began: "Mankind looks grateful now on Thee," here referring not to God but to the deified British surgeon.

And well might mankind be grateful: Lister had made, second perhaps only to the invention of anesthesia, the greatest clinical advance in the history of surgery. It took the Franco-Prussian War, and medicine's unequivocal response to its murderously infected ravages, to spur physicians to reevaluate and then finally accept the principle that soon became known as the germ theory.

In the field, efforts to fend off dysentery included the so-called Soldiers' Throne (*right*), a combination toilet and furnace that allowed for the burning of waste. Disease was far more dangerous to American troops than were the Spaniards during the Spanish-American War: fewer than six hundred of the more than four thousand U.S. deaths were classified as combat related. Malaria, typhoid, and dysentery claimed the most victims, with underfed troops living for weeks at a time out in the open, subject to tropical rains, mosquitoes, the hot sun, and abysmal sanitation. In the camps where American soldiers lived, according to medical historian P. M. Ashburn, "conditions [were] disgusting . . . flies abounded and went from [latrines] to kitchens," and latrines were "undug for days while the soils . . . were being polluted."
Photographer unknown
Location unknown, 1898

347.

Walter Reed's discovery in 1900 of the mosquito's role in transmitting yellow fever came too late for many soldiers and civilians during the Spanish-American War, but was a lifesaver for the postwar occupation forces in Cuba, the Philippines, and Puerto Rico. Patients with yellow fever filled hospital after hospital in Havana (*left*) until 1901, when the epidemic was brought under control in ninety days, aided by horse-drawn wagons that spread oil on standing water, thus destroying the breeding grounds of mosquito larvae (*below*). Major William Gorgas, M.D., designed Havana's mosquito eradication program and later took his ideas to Panama; his victory over mosquitoes and yellow fever made the building of the Panama Canal possible.
Left: Photographer unknown
Havana, Cuba, ca. 1900
Below: Photographer unknown
Panama Canal Zone, ca. 1901

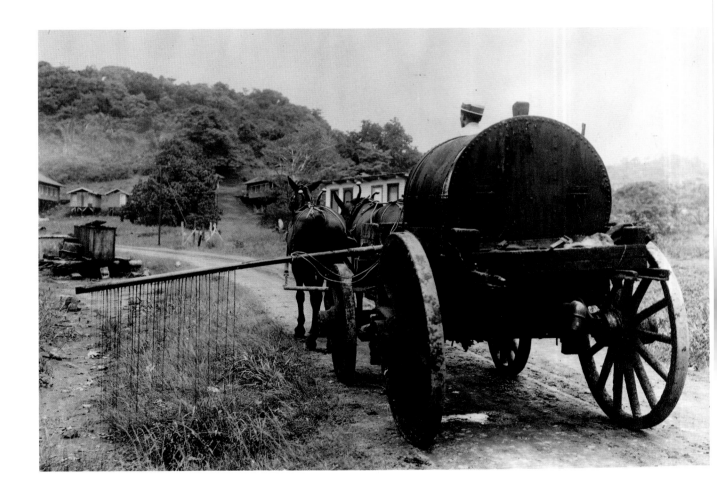

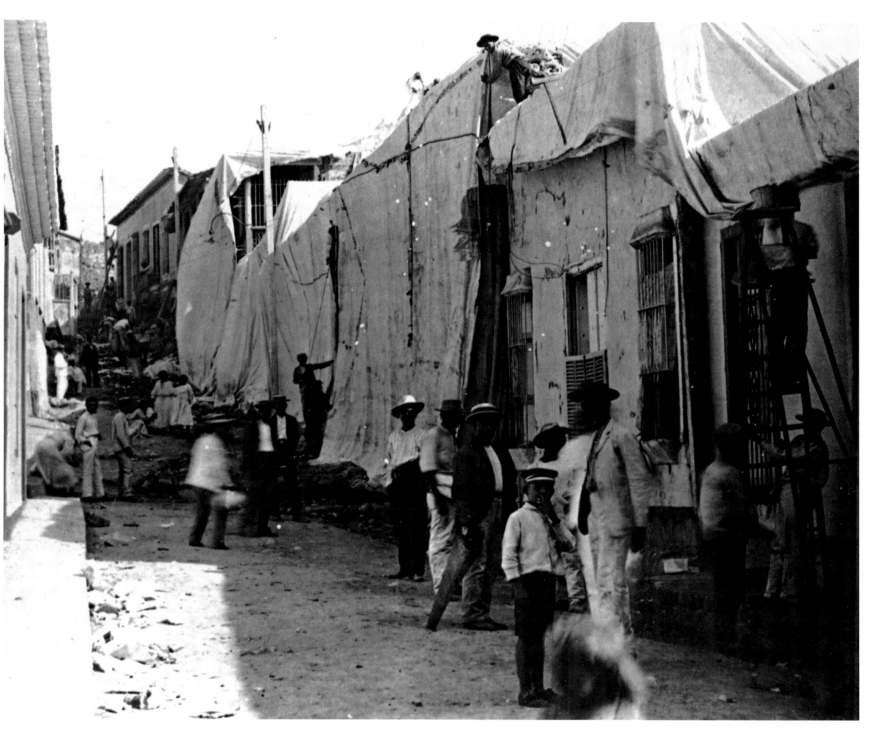

Fumigation was part of the arsenal in the fight against yellow fever: block-by-block, buildings were wrapped in canvas and filled with smoke and gasses to kill the mosquitoes (*above*). Military Governor Leonard Wood, M.D., a friend of Teddy Roosevelt's, had earlier tried rigorous sanitation to rid Cuba of yellow fever; he failed, though one sergeant had remarked, "When Wood gets through, the flies will starve to death in Santiago!" Desperate for a way to stop the disease, Wood donated ten thousand dollars to fund Walter Reed's mosquito studies. Reed's work, and the development of successful techniques in the fight against mosquito-borne illnesses, closed a long chapter in military and medical history: no longer was disease a fighting man's most lethal enemy.
Photographer unknown
Santiago de Cuba, Cuba, 1908

This discovery of the role of bacteria created a new model on which to base the foundation of the burgeoning medical science, which was everywhere changing the way doctors studied disease. Suddenly, there was realistic hope that the causes of epidemics could eventually be understood and rooted out.

When the United States next went into battle, another germ came under the scrutiny of Army doctors. Because the actual fighting of the Spanish-American War in 1898 took place for the most part at sea, neither side lost many men to battle wounds. The entire war, in fact, saw fewer than six hundred battle casualties. But in the aftermath of the conflict, another great triumph of American military medicine took place, in response to the concentration of soldiers assembled in camps in Cuba who began experiencing outbreaks of typhoid, typhus, malaria, and yellow fever.

As professor of bacteriology at the newly established Army Medical School, Major Walter Reed had already made critical contributions to the understanding of how typhoid fever spread. Then in 1899, the year after the Spanish-American War, he was appointed chairman of a commission to study a huge outbreak of yellow fever among the U.S. troops garrisoned in Havana. As Reed reflected on the course of the disease among both soldiers and civilians, several clues became apparent to him: earlier accounts of yellow fever epidemics had dwelt on the prevalence of mosquitoes during the outbreak; the first patients in epidemics often lived or worked near bodies of stagnant water; the disease rarely spread to high, dry parts of a city; some reports noted that the path of the disease seemed to follow the direction of prevailing winds, which is the only way that swarms of mosquitoes can travel; yellow fever was common during hot weather, but disappeared with the first frosts; and the timing of transmission from one person to another fit what was then known about the life cycle of the mosquito and the way that yellow fever germs might be expected to dwell and multiply in the mosquito's stomach.

As Reed thought about these observations, he concluded that yellow fever was spread by the bite of the mosquito *Aedes aegypti*. All that was lacking were the experiments to prove it; for this, volunteers were needed. In August of 1900, several physicians on Major Reed's team allowed these mosquitoes to bite them, but only one, Dr. James Carroll, actually contracted yellow fever. He barely escaped with his life. Following this, a soldier named William E. Dean volunteered, became infected, and he, too, had a close call before finally surviving. And then tragedy struck. A thirty-four-year-old bacteriologist on Reed's team, Dr. Jesse Lazear, unexpectedly contracted the disease during his studies. Interested in mosquito-borne infections, Lazear was a malaria researcher on the faculty of Johns Hopkins Medical School who had only recently joined the volunteer Army Medical Corps. He died, leaving behind the pregnant wife to whom he had been sending home reassuring letters.

Reed and his associates now chose a clean, well-drained area about six miles from Havana to build a site for their planned experiments—and they named it Camp Lazear. When they began seeking volunteers, thirteen soldiers assigned to the army hospital immediately came forward, even though none of them had been asked specifically to join in the experiments. These brave men knew of the work being done by the commission, and

Just as they had done during the Civil War, surgeons in the Spanish-American War recorded their handiwork with cameras. At Fortress Monroe, Virginia, a physician holds a bullet he had removed from Corp. James M. Shepard, who had been wounded in Cuba (*near right*). But physicians were also beginning to create images with a much more radical impact on medicine—the newly invented x-ray. The machine helped surgeons to find bullets without having to perform life-threatening exploratory surgery, and in some cases permitted them to avoid surgery altogether. The case of Pvt. John Gretzer, Jr., is a prime example: his x-ray (*far right*) shows a bullet lodged deep inside his brain, the result of a battle wound in the Philippines. After locating the bullet, and determining that infection had not set in, physicians opted for a conservative treatment consisting of changes in dressing only, and Gretzer survived with only mild brain disturbances.
Near right: Photograph by Edward J. Meyer, M.D.
Fortress Monroe, Virginia, 1898
Far right: The Burns Archive
San Francisco, California, 1898

Name, Jno N Shepard Age, 25 yrs

Nationality, U.S. Service, Corp 6th U.S Inf. "G"

Previous History: Good

Wounded, July 1st 1898 San Juan Hill

Missile, Mauser 700 yds

Description Wound: Entered on left side about 3 in below scapula. exit in axillary space right side entering right arm

Treatment, 1-5000 Bichloride - Dusted Boracic acid

First Dressing, 2 hrs after

Subsequent Dressings, 12 dressings

Result, Perfect

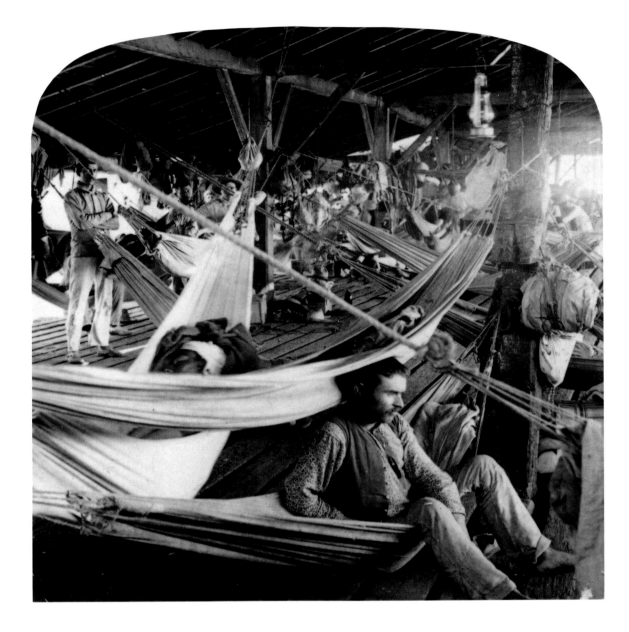

**After the "Splendid Little War,"
Spanish soldiers in the last
remaining camp in Cuba** lived in
squalid, cramped conditions that
promoted disease (*above*). Well-
intentioned attempts at ventilation only
put the men of both sides at the mercy
of mosquitoes carrying yellow fever and
malaria. In an effort to learn from the
mistakes of the war—for which the U.S.
Army Medical Department was severely
criticized—President William McKinley
appointed Grenville Dodge to invest-
igate. In 1899, the Dodge Commission
advised creating a large force of medical
officers, a reserve corps of trained
nurses, a year's stockpile of medication,
and simpler supply logistics.
*Photographer unknown
Cienfuegos, Cuba, 1899*

**American fighting men care for
dying Filipino soldiers** at the Battle
of Malabon (*right*), during the revolt
(1899–1902) against the U.S. forces left
to occupy the islands after the Spanish-
American War. Because the conflict
included unconventional, guerilla-style
tactics, much as the Vietnam War
would years later, the treatment of war
injuries proved difficult. Suppression of
the revolt eventually cost 4,243
American lives—seven times as many
as were lost to battle wounds in the
Spanish-American War. Sixteen
thousand Filipinos were killed, and
approximately 100,000 more died of
the famine resulting from the fighting.
*Photograph by James Ricalton
Philippines, 1899*

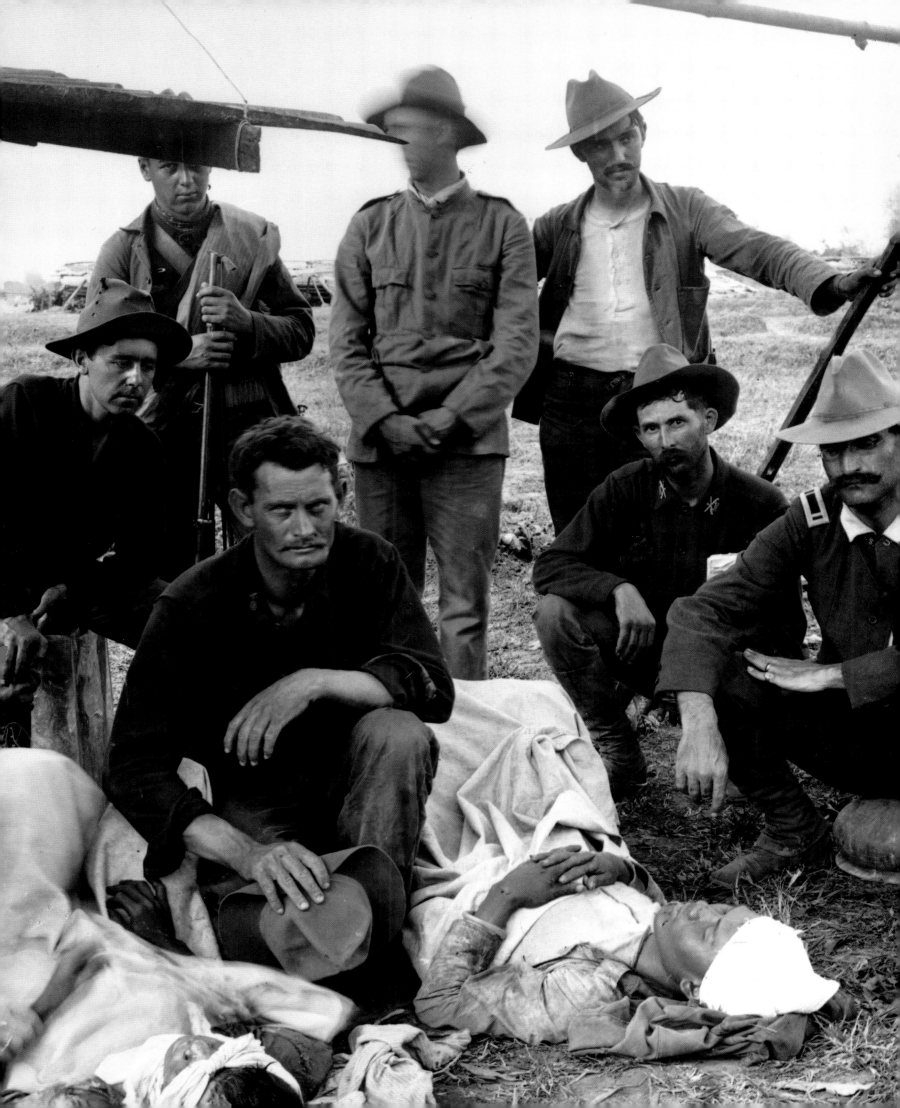

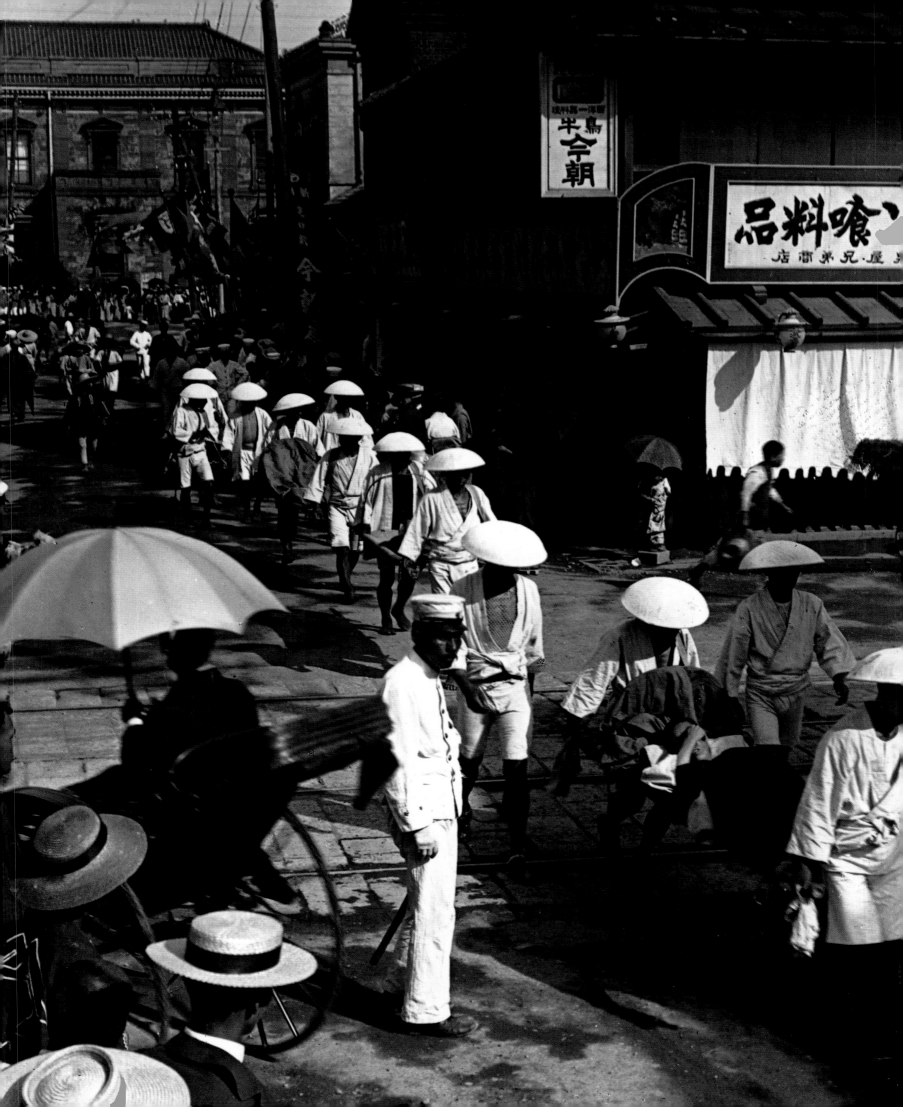

volunteered as a matter of personal obligation. When Reed told the first two, John Kissinger and John Moran, that they would receive a reward for their services, both young men refused it. In fact, they went further: they insisted that they would only participate if there were no remuneration. On hearing them say this, Reed raised his fingers to his cap and replied: "Gentlemen, I salute you." Of the first experiment, on Private Kissinger, he said: "In my opinion, this exhibition of moral courage has never been surpassed in the annals of the Army of the United States." In his own memoirs, Kissinger would later write that he had acted "solely in the interest of humanity and the cause of science."

Several of the twelve volunteers who were bitten by *Aedes aegypti* under the tightly controlled conditions of the experiment developed the disease. Miraculously, none of them died. Reed had finally proved the hypothesis that yellow fever is a mosquito-borne disease.

Like the correspondence of Theodor Billroth and so many other military physicians, Walter Reed's letters to his wife, often written late at night after a grueling day, tell the story of his personal sense of mission. Ten minutes before the New Year of 1901, sitting at his desk in the Columbia Barracks in Quemados, Cuba, he wrote: "It has been permitted to me and my assistants to lift the impenetrable veil that has surrounded the causation of this most wonderful, dreadful pest of humanity and to put it on a rational and scientific basis. I thank God that this has been accomplished during the latter days of the old century. May its cure be wrought out in the early days of the new! The prayer that has been mine for twenty years, that I might be permitted in some way or at some time to do something to alleviate human suffering has been granted!"

Within six weeks, military engineers commanded by Major William Gorgas began a strict program of mosquito eradication and bite prevention. Ninety days later, Havana was freed from the epidemic, and the chronic problem of malaria was curtailed as well.

Vaccination, sanitation, and nutrition were by this time recognized as critical to the health of armies. Even so, no government had yet methodically used them all in an organized campaign to keep its soldiers free of disease. It took the Japanese to prove that careful preventive medicine could win a war.

Shocked by their 1894–95 campaign against China in which they had lost four men to disease for every one who died of wounds, the Japanese began to prepare for what they knew would be an inevitable war with Russia. They sent their medical officers all over the world, focusing on scientifically precocious Germany, to learn about military sanitation and diet. When the Russo-Japanese War ended in 1905 with the first victory of an Asian over a European army, the Japanese military could also claim another feat—while 8.8 percent of their soldiers died of combat injuries, only 2.0 percent died of disease, one-fourth as many. Although the Franco-Prussian War had been the first major conflict in which a nation's deaths by arms exceeded its deaths by disease, the Japanese figures were truly remarkable. The Empire of the Rising Sun had adopted Western discoveries in preventive medicine and brought them to a new level of effectiveness.

Japanese wounded are carried through the streets of Tokyo from Shimbashi Station to the hospital. When Japan declared war on Russia in February of 1904, there were twenty-five thousand available beds in Japanese hospitals—a number that would double within eighteen months. Each hospital had a bacteriology lab, as did every Japanese field hospital, allowing physicians to diagnose diseases quickly and accurately.
Photographer unknown
Tokyo, Japan, 1905

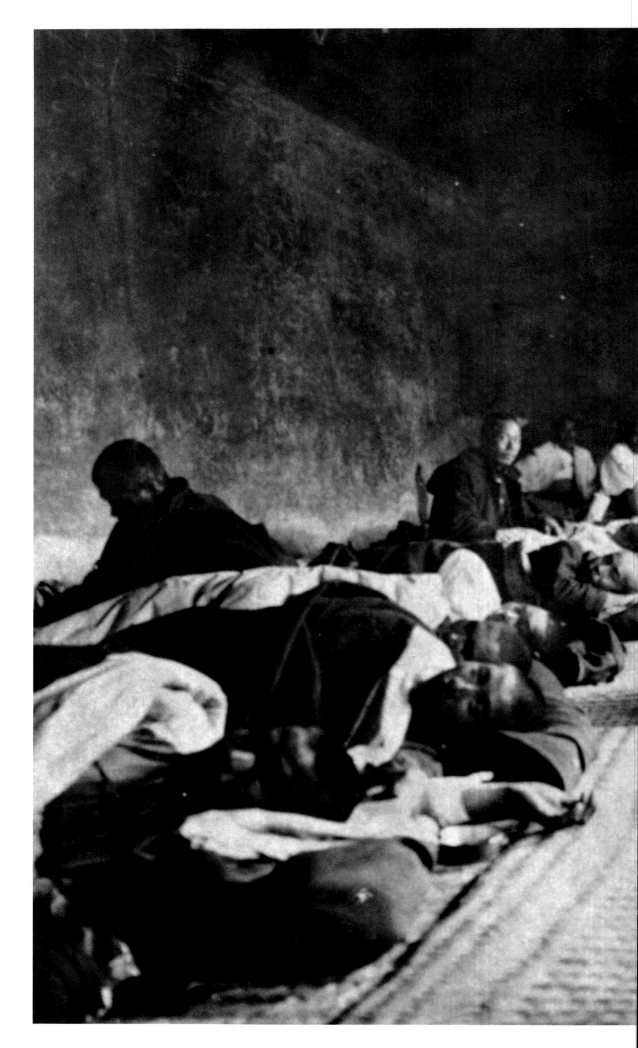

"We no longer talk vaguely of cosmic perturbations, aerial influences, noxious miasmas, and epidemic constitutions of the atmosphere," said an upbeat Benjamin Lee, president of the American Public Health Association, in 1901, "but have exact and definite knowledge of the characteristics, habits and life-story of nearly all the organisms which are the cause of contagion." Although he was American, Lee echoed the optimism and preparedness of Japanese physicians, who had travelled worldwide collecting the scientific knowledge that would make them leaders in preventive medicine. Here, in the Russo-Japanese War (1904–05), wounded Japanese soldiers await treatment following the Battle of the Yalu.
Photograph by Jimmy Hare
Antung, Manchuria, 1904

94

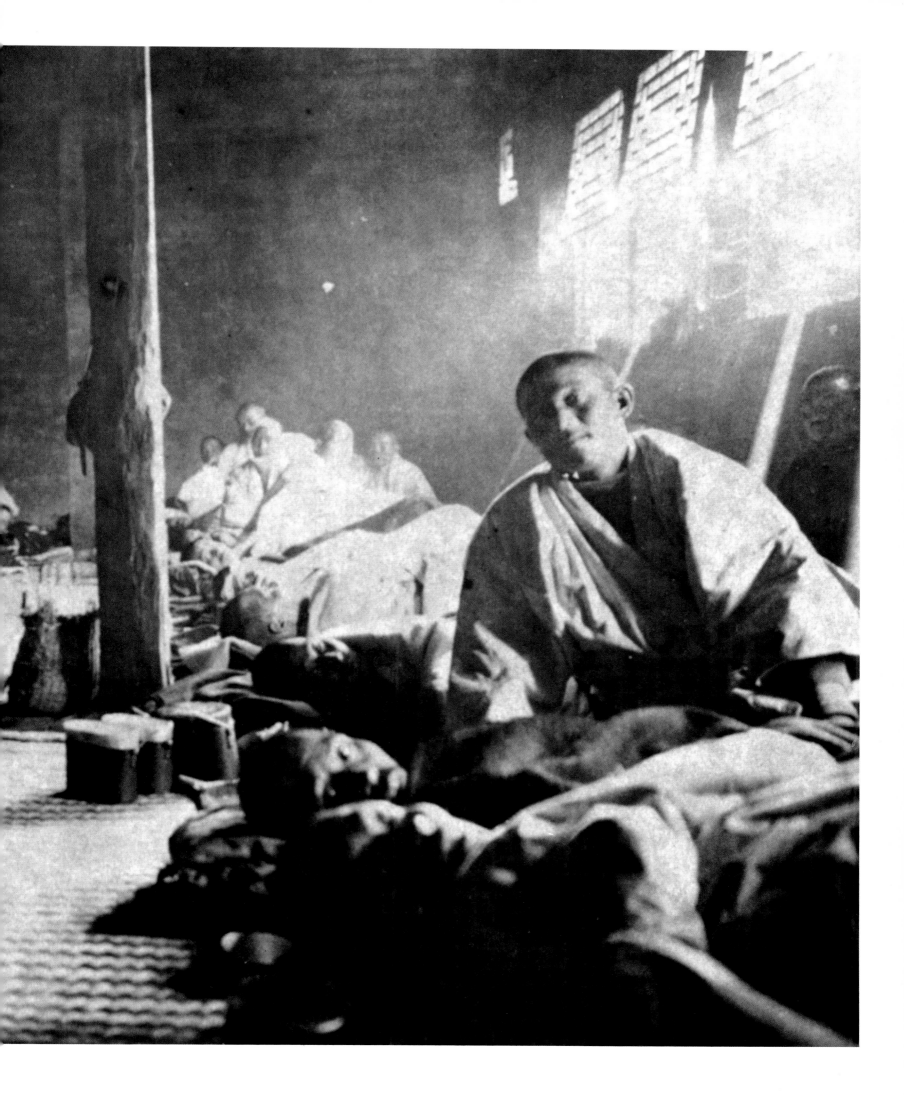

A team of American nurses, headed by Anita McGee, M.D., tends the wounded in Ward 10 of Hiroshima's military hospital during the Russo-Japanese War (*below*). Dr. McGee, vice president of the Daughters of the American Revolution, became acting assistant surgeon general in charge of the Army nurse division during the Spanish-American War, and created the Army Nurse Corps in 1901. McGee had originally wanted to take six hundred nurses to Japan, but the Japanese Red Cross, as a matter of policy, refused aid from abroad. It made an exception for McGee, provided she bring only a few nurses with her. The team of nine stayed in Japan from April to October, 1904.
Photograph attr. T. W. Ingersoll
Hiroshima, Japan, 1904

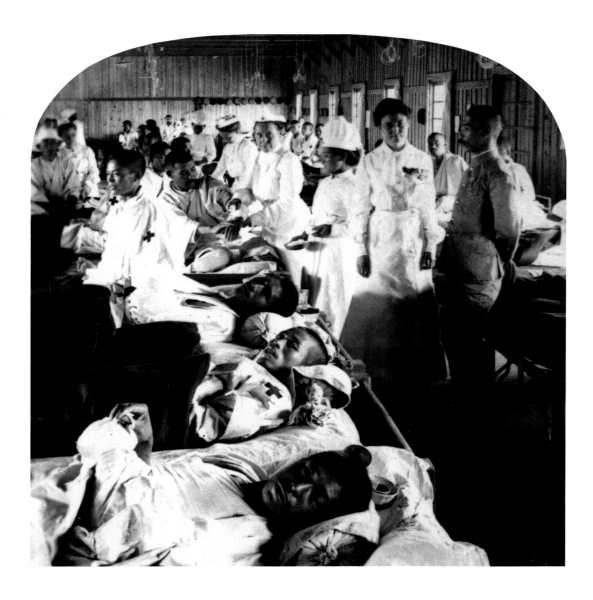

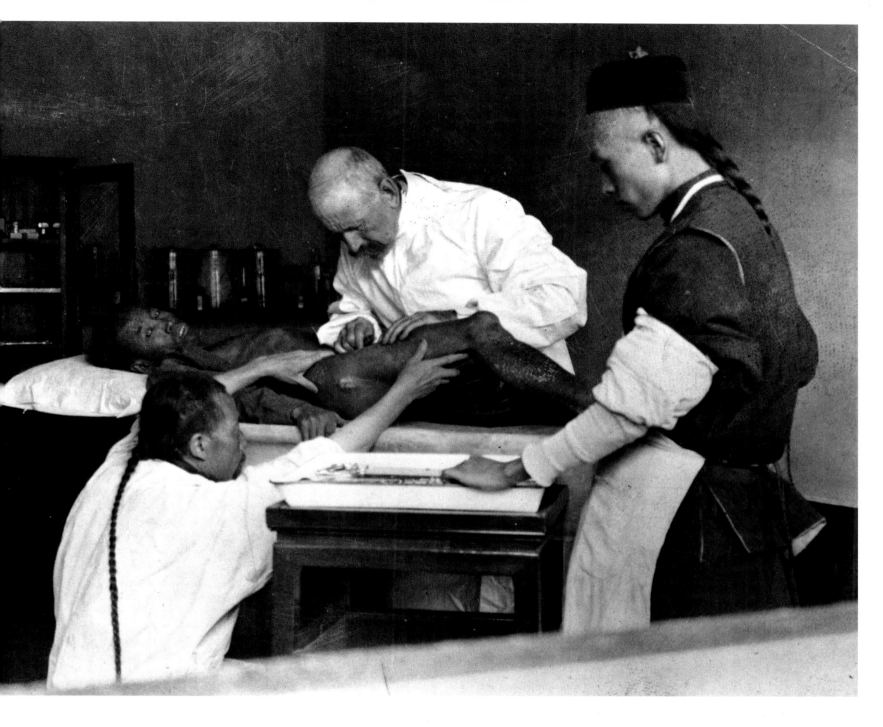

**A medical missionary in Asia,
Alexander Westwater, M.D.,
operates** on a Manchurian civilian
who suffered multiple bayonet wounds
at the hands of Russian soldiers (*above*).
Because Japanese commanders usually
thwarted his efforts to photograph
actual combat, Jimmy Hare of *Collier's*
magazine instead focused on the care
of the wounded. This photo appeared
in his 1905 book, *A Photographic Record
of the Russo-Japanese War*. Hare's work
helped to shape American opinion, and
earned him a medal from the grateful
Japanese emperor.
*Photograph by Jimmy Hare
Near Yantai, Manchuria, 1904*

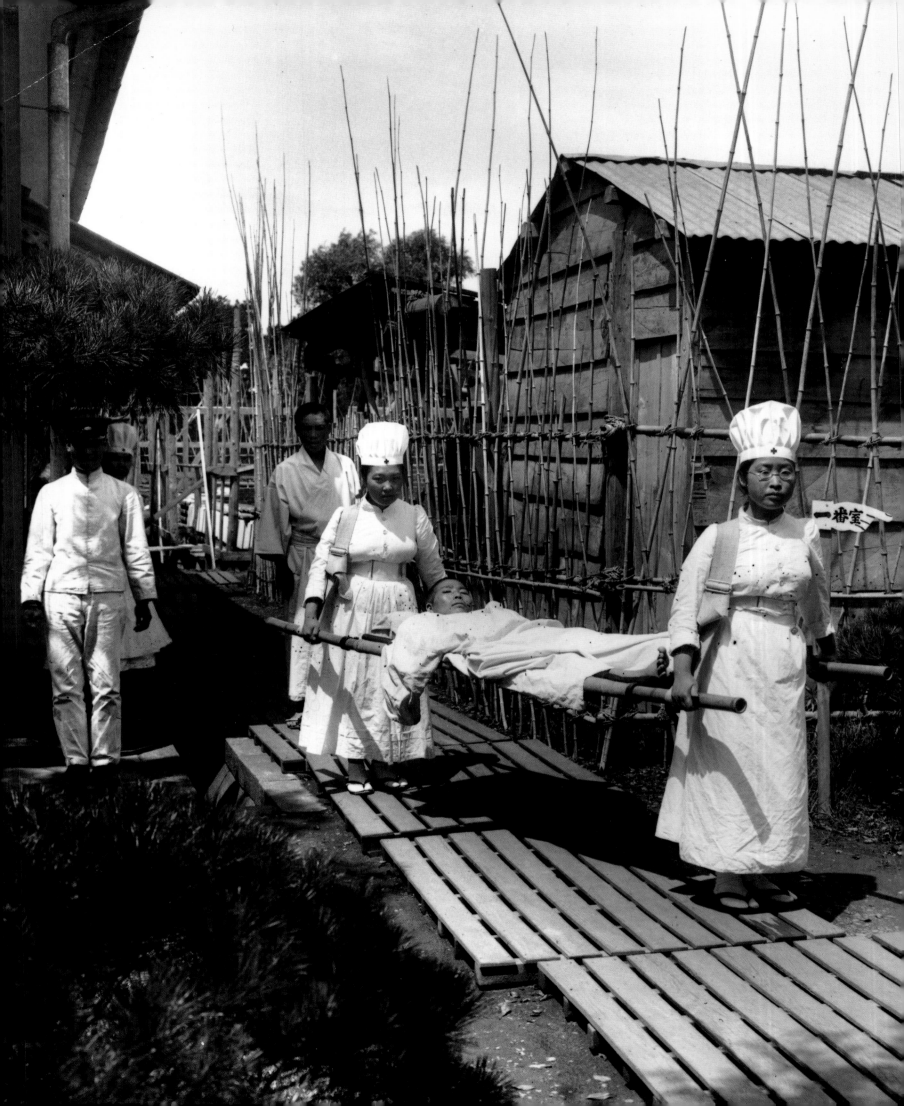

Japanese nurses did more than care for patients in hospitals: they also served as stretcher-bearers (*left*)—a task almost always restricted to men in the West. The highly skilled nurses—often scheduled for twenty-four-hour shifts—were vital to the efficiency of the medical system. Teresa Eden Richardson, a British nurse who volunteered with the Japanese Red Cross during the conflict, wrote: "Surgeons called for what they required, and the nurses had to be very quick in waiting upon them. [They] saw to the comfort of the patients in every way, and wheeled or helped to carry them in and out of the operating theater. At a busy time, when the stretchers were in constant request, the little nurses would often carry a helpless patient on their backs, like a big baby."
Photograph by James Ricalton
Tokyo, Japan, 1905

A team from the Russian Red Cross operates on soldiers wounded in the Russo-Japanese War (*below*). The Russian Red Cross sent doctors, nurses, and supplies to the front, thousands of miles from its base in Moscow. Clothing and surgical supplies were collected in the czar's palace in the Kremlin before being sent to the battlefields in Manchuria and Korea—by train where possible and on ponies over rougher terrain. The wounded and dead were brought home on the Red Cross trains and in ambulance-sledges pulled by the ponies. Even the Russian czarina, Marie Feodorovna, served as a nurse to

evacuated soldiers, and eventually donated fifty thousand dollars to the International Red Cross Committee to fund a competition for inventions that alleviated suffering in the wounded. Red Cross historian Mabel Boardman, describing the contest in 1915, wrote: "Were it not so tragic there would be something comical in the way man invents machines to kill and injure, then uses his ingenuity to provide methods of repairing damages caused by his own destructive genius."
Photographer unknown
Liaoyang, Manchuria, 1904–05

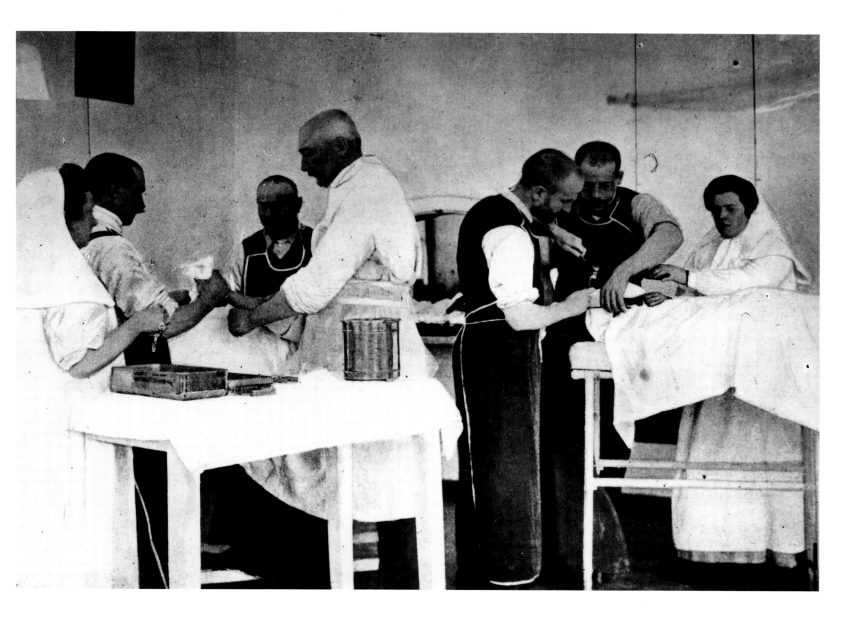

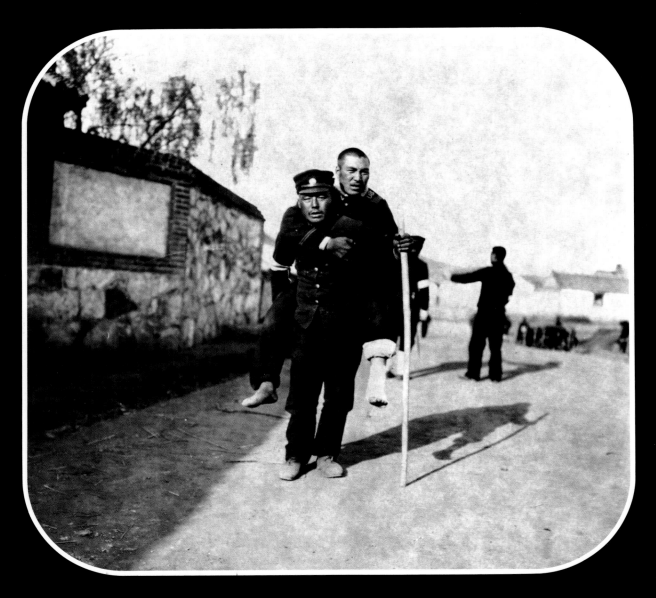

A Japanese soldier carries a wounded comrade to a field hospital (*above*), where a tag will be pinned to his clothing before treatment begins: red for a severe wound, white for a less serious condition. The sound medical policies of the Japanese helped minimize their losses and speed post-operative recoveries. Wounds were quickly dressed with antiseptic compresses and with clean bandages, carried by every soldier in his kit. In addition, all Japanese soldiers bathed and put on a clean uniform before going into battle—a practice that was good for morale as well as for medicine.
Photograph by Jimmy Hare
Manchuria, 1904

The mother and sister of a Japanese officer visit him in the hospital during the Russo-Japanese War (*right*). With most of the fighting taking place in nearby Manchuria, hospital ships could transport the wounded back to Japan, where they had the luxury of convalescing in hospitals close to home. The average Japanese hospital ship carried about 250 patients, who could be brought aboard in less than an hour by a team of litter-bearers working bucket-brigade style.
Photographer unknown
Japan, 1905

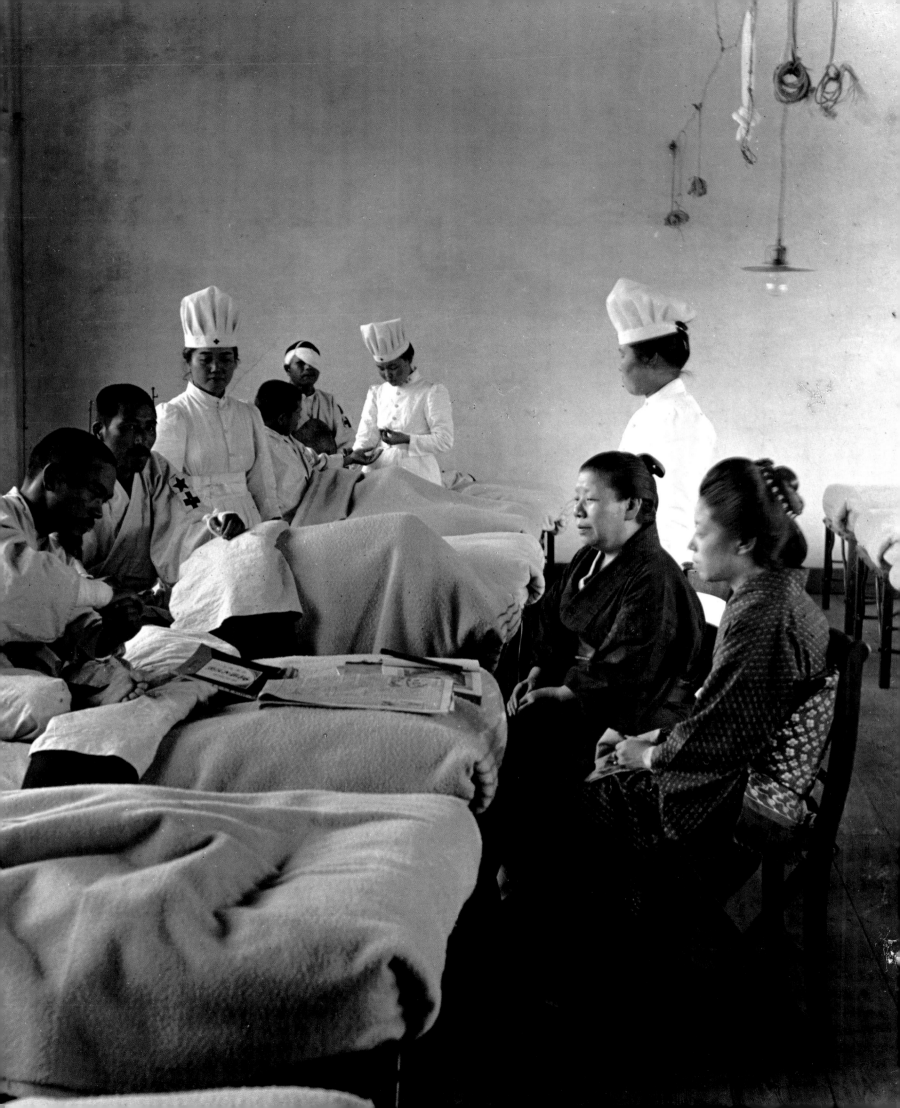

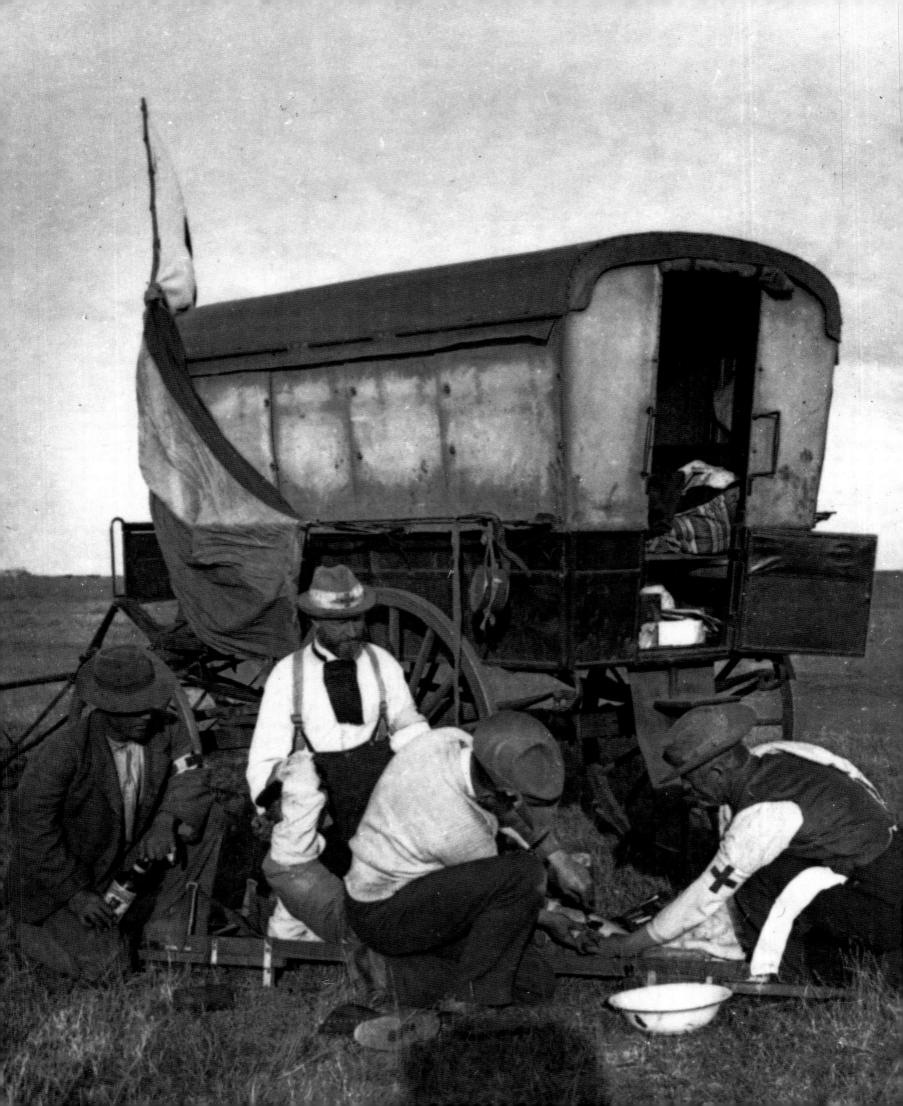

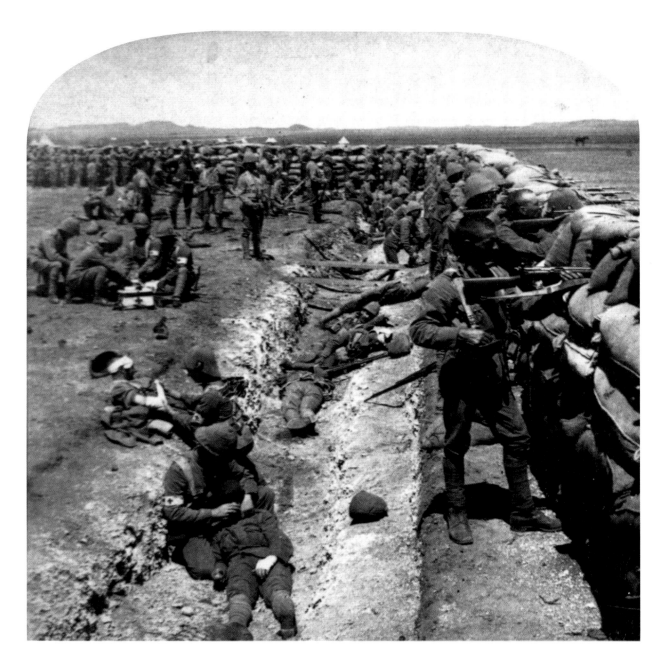

A doctor from the Irish Ambulance Corps treats a British soldier (*left*) in the Boer War (1899–1902), Britain's successful effort to win control of South Africa. Doctors now understood the importance of sanitation, and although the scarcity of water in the dusty South African desert often hampered their efforts, fledgling antiseptic techniques meant that wounds could be dressed on or near the battlefield before infection set in. A half-century earlier, doctors in the Crimean War couldn't save a single man wounded in the knee joint; in the Boer War, they didn't lose anyone to a knee joint injury who had received immediate care.
Photographer unknown
Kalimberg, South Africa, 1900

British medics administer first aid right behind the front lines in South Africa during the Boer War (*above*). Some medical and military historians have described the war as "humane," since bullets from the small-caliber weapons introduced in 1888—especially the 7-mm Mauser favored by the Boers—made relatively small wounds, and did not usually lodge in the victim's body. An American military observer to the Boer War called the bullets "too merciful."
Photographer unknown
Honey-Nest Kloof, South Africa, 1899

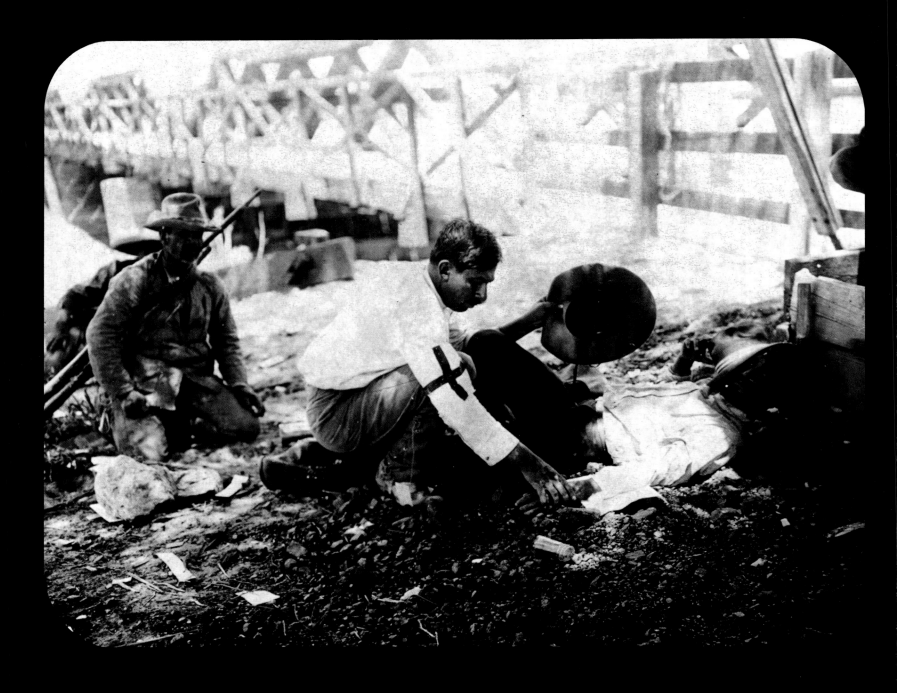

American Army medical personnel in the Spanish-American War, such as this doctor, were ably assisted by nurses sent to Cuba by Clara Barton, president of the American Red Cross. A poem of the time, written by J. Edmund Vance Cooke, sang the praises of Barton's nurses: "She is in the foremost battle, she is in the rearmost tents. / She wears no weapon of attack, no armor of defence; / She is braver than the bravest, she is truer than the true, / She asks not if the soldier struck for red and white and blue, / She asks not if he fell beneath the yellow and the red; / She is mother to the wounded, she is sister to the dead." Cooke's poem concludes with a plea to end all wars, and adds: "But in the stormy waiting till the armaments disperse, / Our blessings on the flower of war— the Red Cross army nurse!"
Photograph by Jimmy Hare
Cuba, 1898

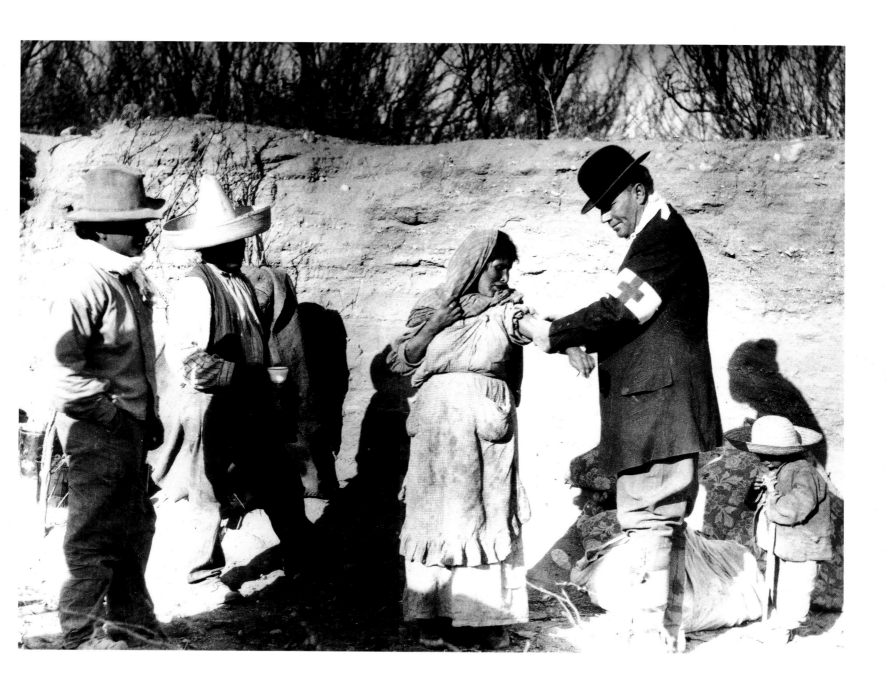

Ira Bush, M.D., heeds the twin calls of humanitarianism and adventure to practice medicine in Mexico during the country's revolutionary conflicts (1911–17), much as other American doctors would later do during the Spanish Civil War and the Nicaraguan Revolution. Bush was the chief medical officer for troops loyal to Francisco Madero, who overthrew dictator Porfirio Diaz in 1911, only to be overthrown himself in 1913. Here, Bush vaccinates some of the family members who routinely traveled with the troops. Doctors from the U.S. Army medical department had begun vaccinating civilians for smallpox during the Spanish-American War; by the time Bush was treating Mexicans fifteen years later, vaccines were also available for diptheria, tetanus, and some intestinal disorders.
Photograph by Otis Aultman
Mexico, ca. 1912

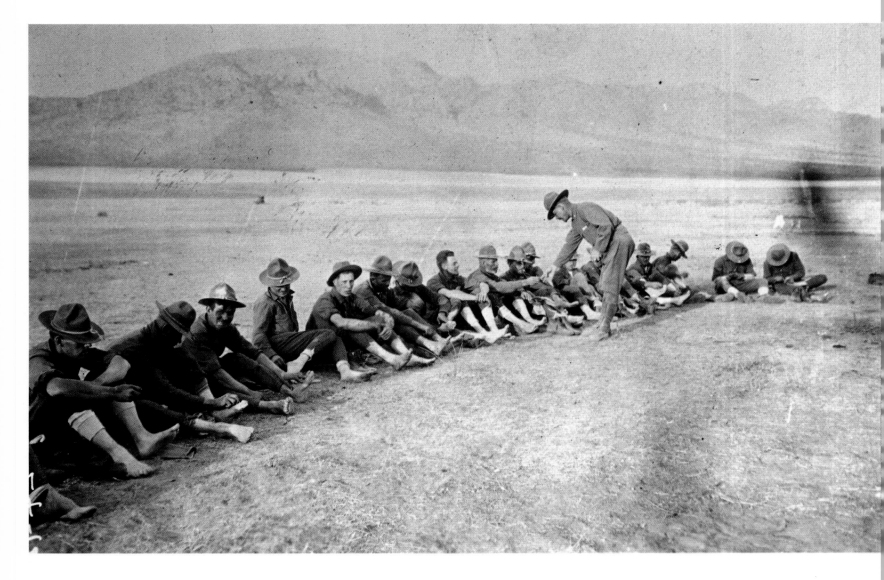

If, as the duke of Wellington once
said, the three most important parts of
a soldier's equipment are a pair of good
shoes, a second pair of good shoes, and
a pair of soles, then the Munson Board
may have been among the most crucial
bodies in American military history.
The board, headed by Maj. Edward
Lyman Munson, M.D., began in 1908
a four-year study of "the feet of some
two thousand soldiers, the fitting of
many thousands of pairs of shoes, and
. . . the shoeing of the United States
soldier." The board came up with the
"Munson last" from which shoemakers
created footwear that was comfortable
for anyone, soldier or civilian, who had
to walk long distances. Here, American
troops stationed in San Antonio during
Pancho Villa's raids across the U.S.
border have their feet inspected by
Captain Napier after a day's hike—
welcome attention paid to soldiers by
the Army after the footsore, sometimes
shoeless Civil War.
Photographer unknown
San Antonio, Texas, 1916

A U.S. horse-drawn ambulance train assembles in Mexico toward the end of the Mexican revolutionary era. Although motorized ambulances were later tried during the U.S. incursion into Mexico in 1916, the rough, dusty roads made their use difficult. As a result, the medical corps fell back on horse-drawn ambulance trains—which, because American troops never caught up with Pancho Villa, didn't see much action.
Photographer unknown
Mexico, ca. 1914

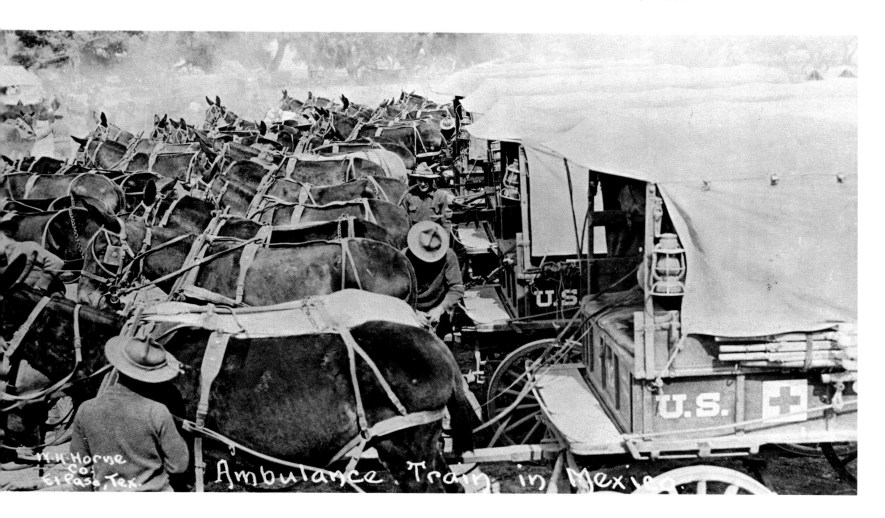

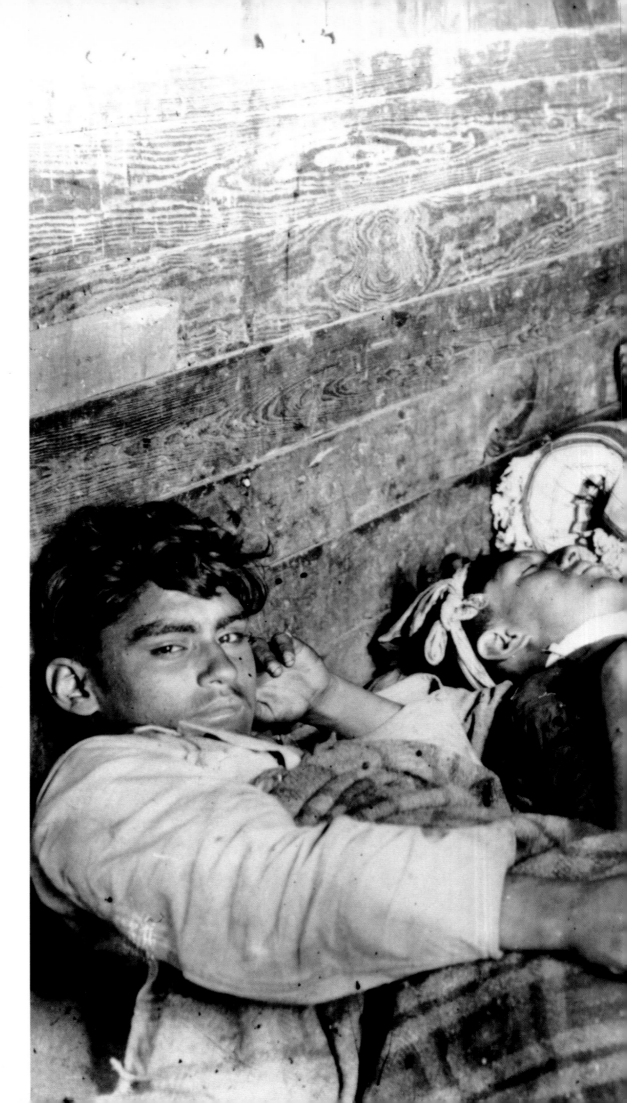

A Mexican medic offers care to his comrades, government troops injured in battles with supporters of Pancho Villa and Emiliano Zapata. Sporadic U.S. involvement in Mexico's several revolutionary conflicts between 1911 and 1917 served as a medical dress rehearsal for World War I, with a successful antityphoid campaign, a well-organized sanitary train of four field hospitals and ambulance companies, and even one motorized field hospital.
Photograph by Agustin Victor Casasola
Mexico, 1911–17

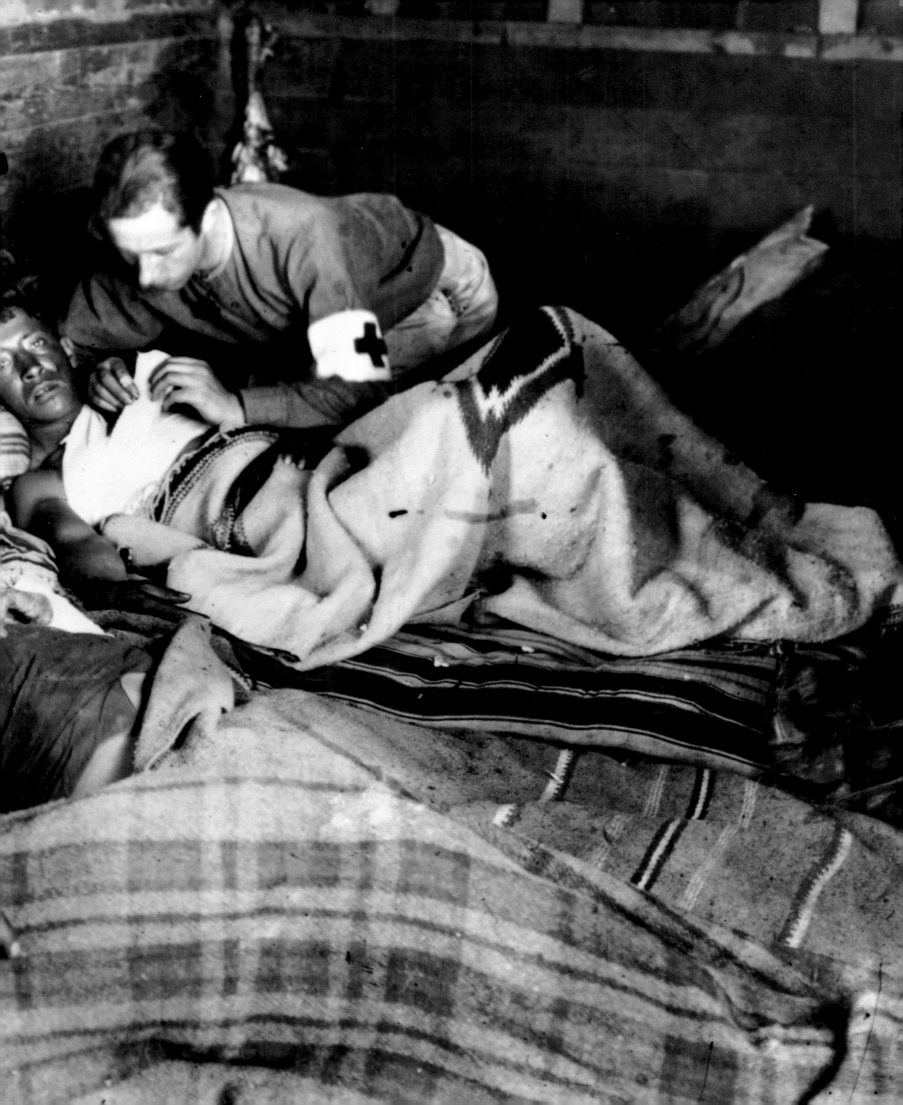

In Manila Envelopes

George F. Telfer

From his letters written while stationed as an officer of the U.S. Army in Manila, Philippines, during the Spanish-American War; to his wife, Lottie, his daughter, Grace, and his mother

Sep. 11, 1898

Dear Lottie,

. . . The lack of nurses and hospital supplys is the greatest scandal of the war. Think of a man sick with typhoid fever—with no nurse. Think of *50 fever* patients in one room with *one* man to look after them—that man a soldier, knowing nothing about the care of the sick. Take this room at night—without lights—except what is afforded by a single candle—carried by the attendant. Think of the misery of it all. Then add to this a lack of mosquito nets—to keep off flys by day and mosquitos by night—nothing but the commonest food—none of the prepared foods ordinarily given the sick—even a lack of medicines.

Crowne had an attack of measles and went to the hospital. Of course he had his own nurse and a room to himself—but he told me that he would lay in the open air and die before he would face the horrors of a night in such a place—that is the suffering of the men. He said to hear some poor fellow calling for something and you know how many things are wanted by the sick—calling and calling until exhausted. He said no man could listen without being sick himself. Some one wrote a poem (during the Crimean War I think) and some of it runs in my head day and night—"there was a lack of woman's nursing, there was a derth of woman's tears."

. . . We have food, clothing, and are comfortable—until we are sick—then God help us. What we want is trained nurses. The doctors do all they can—but a fever patient requires nursing more than medicine.

Oct. 2, 1898

Dear Lottie,

. . . The Red Cross nurses arrived on last expedition. But the old monkey who attends to the killing off of our sick men told them that he had no use for them and that they should not have come. So our men are dying at the rate of two a day as heretofore. I took a typhoid case to the hospital this morning and was glad to see that the ladies were there as visitors—if not as nurses. You have no idea how much more cheerful things looked. They

could not be—called beautiful—but appeared as Angels in those dens. Their coming will bring about some reforms I think. By the way what in the name of wonder did you ladies intend those woolen night caps for? The thought of them makes one shudder. We *do* wear a fever band [an Army-issue flannel band sprinkled with camphor and worn around the stomach to ward off fever] because we don't dare leave it off—but we don't wear much else at night.

Oct. 16, 1898

Dear Lottie,

. . . Capt. Wells gives personal attention to men in hospital (I am sorry to say that most of the captains do *not*) and in his absence, of course, I do. I also look after men sick in quarters.

. . . At my suggestion Capt. Moon made a protest in writing—or rather complaint—regarding a case of bad treatment in hospital. One of his men was sent to hospital—suffering with dysentery. He went to see him and found him in a tent outside the ward. It was a white tent—without a fly, and the heat nearly overpowered the Captain while there. The surgeon in charge assured him that the condition of the patient was in no way alarming. Seven hours after—the man was dead. Now white tents for hospital use are forbidden. Tents without flys are not tenable in hot weather. Dysentery patients must not be subjected to heat. So you see Moon had cause for complaint. His complaint was forwarded and reached Gen'l Otis—who sent for him and asked him to withdraw his complaint as it would make trouble. So it was withdrawn—but I think the Surgeon Gen'l had an unpleasant half hour with the Military Governor.

Oct. 25, 1898

Dear Grace,

I am laid up—sick in quarters. Malarial fever—that democratic disease which hits rich and poor—high and low, with equal impartiality, couldn't let me alone any longer. Everybody was surprised when I gave up—as everybody thought I was fever proof.

Oct. 29, 1898

Dear Mother,

. . . I have recovered from my attack of fever. It was very light. Was not sick over two days. But as there is nothing to do I assumed that I was in danger of relapse, so I stayed on sick report a week.

Our men are keeping in better health. We buy ice for the boiled water and so induce them to drink it instead of the hydrant water. We send armed patrols through the streets and drive them out of native houses and drinking places. We inspect their food, and investigate each case of sickness and generally find that the man eats too much. Five mornings in succession we line them up and give each man 5 grains of quinine. Then we stop five mornings and so on. In consequence the number of new patients is on the decrease.

Nov. 8, 1898

Dear Lottie,

I am still "convalesing." The fever does not trouble me much—but I cannot expose myself in the sun. So I lay around my room and read. Sometimes I will have fever for two or three hours—generally in the middle of the day. Then there will be several days with no fever. I sleep and eat well. Am taking 15 grains of quinine every 3rd day and 3 grains of strychnine daily.

. . . We are in great need of a hospital where we can look after our own sick. We have no money to fit up a building. . . . It will cost about $1,000.00 to fit up a hospital and we need $1,000.00 in addition for contingent. We think of telegraphing the citizens of Portland [Oregon] for the money. The other regiments are arranging for hospitals. The general hospitals are crowded and men do not receive the attention required. If we could have our own hospital—each company would be able to wait on and attend to its own men.

Nov. 22, 1898

Dear Family,

. . . It is interesting to see the mode of treatment in fever cases. . . . A rubber blanket is put on the bed. The patient lays on this. A sheet is rung out of ice cold water and laid over him. It is adjusted so as to come in contact with the body as much as possible. The attendant then takes a piece of ice and passes it over the wet sheet. The whole body is gone over—until the teeth fairly chatter. The wet cloths are then removed and the patient carefully dried—*without friction*—and prepared for sleep. . . . My lank body is a blessing. My fever never goes to the "ice pack point." I am so thin that I cool off quick. I take 25 grains of quinine every 3rd day now. . . . I drink a great deal of whiskey and soda. This puts me on my feet and keeps my spirits up—two things hard to accomplish in treating Malarial fever.

Dec. 2, 1898

Dear Family,

I have just heard that a mail goes out today and as you might worry if you did not get a letter, I will scribble a few lines. I am taking 30 grains of quinine daily and light diet. Of course I cannot do much moving about with so much quinine in my head.

. . . Wells says he is getting fits for saying that the men are responsible for a great deal of their sickness. If people at home don't quit censuring officers for condition of men, we will publish a list of ailments and perhaps some of the fond parents would wish they hadn't spoke. The hospitals are greatly improved since I wrote that first letter. Mosquito bars were received soon after, also pillows and sheets. The medical department allows regimental surgeons to purchase foods for men sick in quarters. So there is nothing to worry about on that score.

Sorry this letter is not better. I never could write in my lap.

CONFIDENTIAL Dec. 7, 1898

Dear Lottie,

. . . Now there is one delicate matter which I must mention—Many of the captains do not like to report the precise nature of some expenditures. Something like 40% of our sick are suffering from venereal disease. The men shrink from letting this be known—and do not go to hospitals for treatment. The cases *must* be treated. The captains frequently furnish the necessary medicines and instruments. This is a phase of Army life which is very hard to talk about—but it is our greatest trial in this country where these diseases are so prevalent. In this connection I am sorry to say that our regiment has about 20 cases of partial insanity from self abuse.

Dec. 8, 1898

Dear Grace,

. . . We were advised of Ordway's death when the ship reached Hong Kong. It was of course sad—but we go through so much of that sort of thing that we become rather hard. . . . We think of the awful hours of that last day in Portland—the tearful mothers who hung about the camp and begged us to look after their boys. And when one dies—we think of having to meet the friends when we go back. How we shall have to relate all particulars and witness the grief which we cannot comfort. So the son of the laborer is as great a care to us as the son of the rich man. And his death is deplored the same.

Love to all.
Affectionately yours,
George F. Telfer

Motorized ambulances, still a relatively new idea in 1918, rumble
through Missy aux Bois near the Western Front.
Photograph by Capt. P. D. Miller
Aisne, France, 1918

World War I

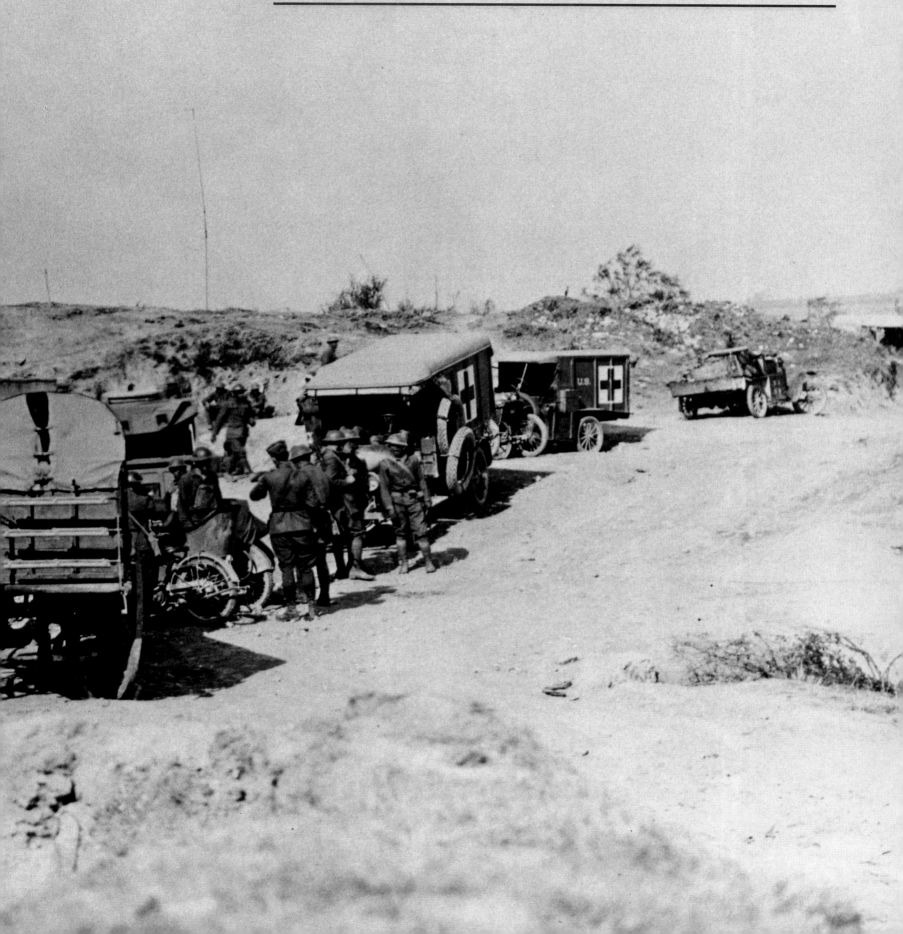

The Gentleman Doctor's War

I have finally seen what I came over for, and a lot more besides—war, real war, stripped of glory. For what chance has a man against a shell? And how does the awful suffering of trench life compare to the thrilling battles of the Revolution? I don't mean that it doesn't take ten times the nerve and the endurance, but there's the rub, for we have become machines, not men. I know that God will protect us over here, but you realize how absurdly weak and helpless you are when a load of dead are brought in, some with arms and legs gone, others with heads and trunks mixed together; and quite often you learn there wasn't anything left to bring.

—Julien H. Bryan, from Ambulance 464, *World War I*

World War I was the first conflict in which x-rays were used extensively. X-ray wards were built next to the operating rooms in military hospitals, and both bedside and mobile units were developed to examine the men who couldn't be moved into the wards. Soldiers with multiple wounds were the most likely candidates for x-ray examinations, as radiologists preferred not to spend time on men suffering from what an official U.S. surgeon general's report called "clean, uncomplicated, perforating bullet wounds." The first use of x-rays in wartime dates back to 1896—when, less than a year after German physicist Wilhelm Conrad Roentgen invented the x-ray machine, Italian doctors used it to locate bullets in the wounded during the Battle of Aduwa in Abyssinia.
Photograph by Sergeant Moscioni Contrexeville, France, 1918

All of the history of warfare that had come before is mere prologue for the events that next overwhelmed Europe. It is as though each individual battle and each innovation in destruction made by Western arms served as a small milestone in the prelude to the carnage on that continent between 1914 and 1918. A single statistic tells the story: of the sixty-five million men mobilized by the sixteen nations involved in World War I, eight million died in battle. Unknown numbers of civilians died, as well.

Although the losses to typhoid, tetanus, and especially typhus were enormous, this was a war in which the power of men to slaughter each other was used with such merciless determination that every prediction of casualties fell far short of the actual numbers killed and maimed. The new artillery presented itself with a startling increase in explosive force, accuracy, range, and mobility, combining to wreak a havoc previously unimagined. Great masses of men, everywhere enmired in muddy trenches and immobilized by the hindrances of miles of barbed wire, fell victim to ferocious volleys of bombardment unleashed by an enemy they would never see.

If in the Civil War the prince of destruction was the rifleman, in World War I the distant artilleryman was the most feared and wanton killer. Since Henry Shrapnel introduced the exploding shell at the siege of Gibraltar in 1782, all manner of "improvements" had been made in that malign concept. By 1914 it was quite ready for its debut on the stage of world conflict.

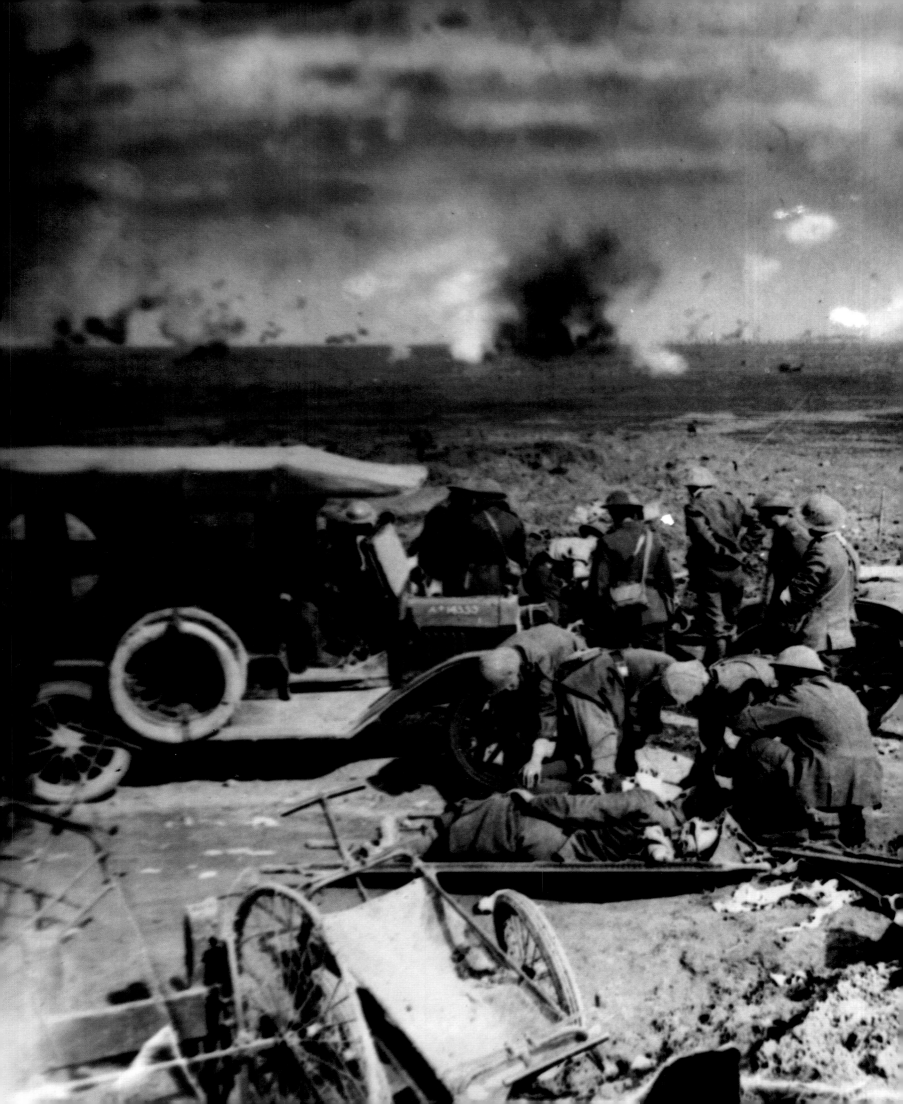

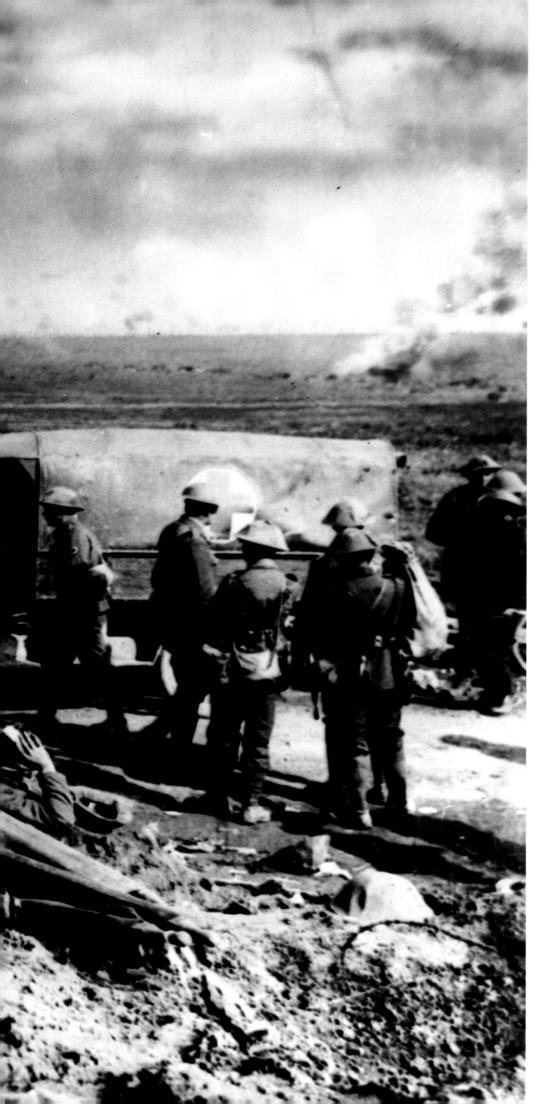

The war famous for life and death in the trenches also featured fighting in the open, where soldiers were the victims of land mines and the targets of long-range artillery fire. Here, on the front lines, British wounded receive first aid before being loaded onto ambulances. Once at a dressing station, soldiers would be grouped by severity of injury and their wounds cleaned and dressed.

One of the more than two million British wounded in World War I was Robert Graves, a poet and author later celebrated for his works *Goodbye to All That* and *I, Claudius*. In his poem "Recalling War," Graves wrote: "What, then, was war? No mere discord of flags / But an infection of the common sky / That sagged ominously upon the earth / Even when the season was the airiest May."
Photographer unknown
The Western Front, 1914–18

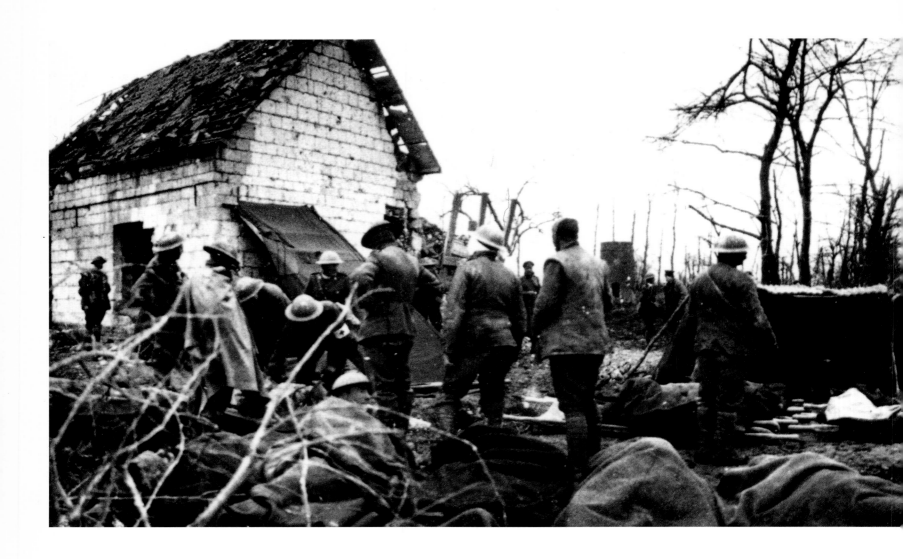

Other new technologies added mayhem in every theater of operations. The machine gun designed by the physician Richard Gatling in 1862 had by this time been developed into a marvelously efficient killing machine. Armored vehicles had evolved into tanks mounted with machine guns, used most effectively by the British near the end of the war. Although poison gas was not a major factor in the conflict's outcome, no one who came into contact with the effects of those choking fumes of death ever forgot their horror.

The rifle bullet itself had undergone another transformation; it was now a high-speed jacketed projectile, mangling tissues into a dead pulp that became an excellent breeding ground for gangrenous infection. Its blunt tip replaced with a point, this new bullet's improved aerodynamics made it more stable and therefore more accurate. The pointed bullets introduced in World War I became the prototype for all subsequent models, and the term *bullet-shaped* entered our vocabulary. In addition to their greater accuracy, these missiles provided another lethal advantage not appreciated until doctors began examining the surprisingly destructive wounds they caused. Because a pointed bullet's center of gravity sat farther back than in its blunt-nosed predecessor, the missile tended to tumble end-over-end when it entered the body, a motion that tore surrounding tissues apart like an explosion, shattering structures far from the projectile's expected

With new weapons capable of firing shells much farther than ever before, field hospitals were established as far as eight miles behind the battle lines, with larger hospitals another ten or twelve miles back. The ambulance corps, to cover this distance, often divided its work into circuits: one set of ambulances (*above*) would make round-trips between the battle lines and the dressing station; a second group carried the more seriously wounded between the dressing station and a field hospital. According to official U.S. government documents, once motorized ambulances became available, Fords were best for the first leg because they could "go through mud and demolished roads more easily than other motor ambulances"; but on the improved roads between the dressing station and field hospitals, "the heavier and more comfortable G.M.C. ambulances were preferable." *Photographer unknown Northern France, 1916*

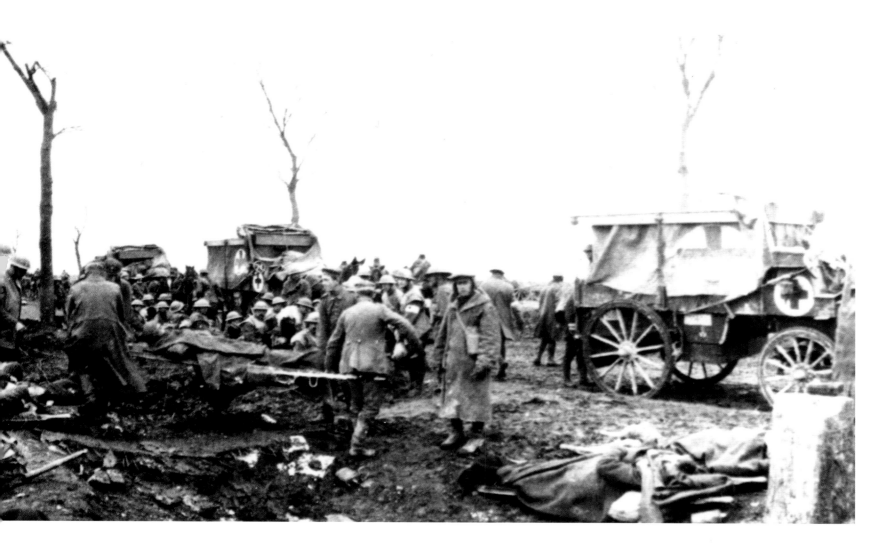

While nurses tend to their physical needs, wounded Russian soldiers in Poland rely on an Orthodox priest to tend to their souls (*right*). The degradation and monotony of life in the trenches, combined with the terrible death toll and the high number of wounded, created a sense of desperation perhaps unprecedented in warfare. The result was a large number of what were called "nervous casualties," suffering from a newly diagnosed war wound called "shell shock." Said a British nun who served as a nurse at a military hospital: "They used to tremble a great deal, and it affected their speech. They stammered very badly, and they had strange ideas which you could only describe as hallucinations."
Photographer unknown
Poland, 1914–18

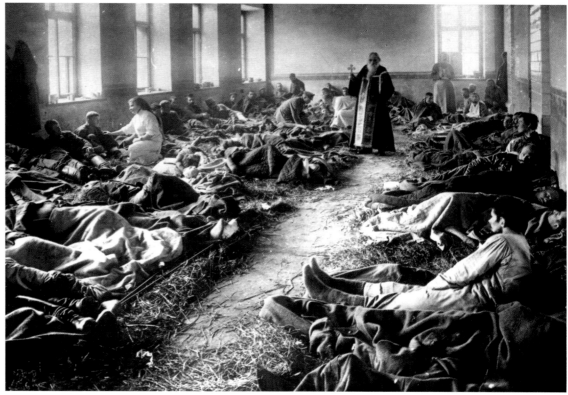

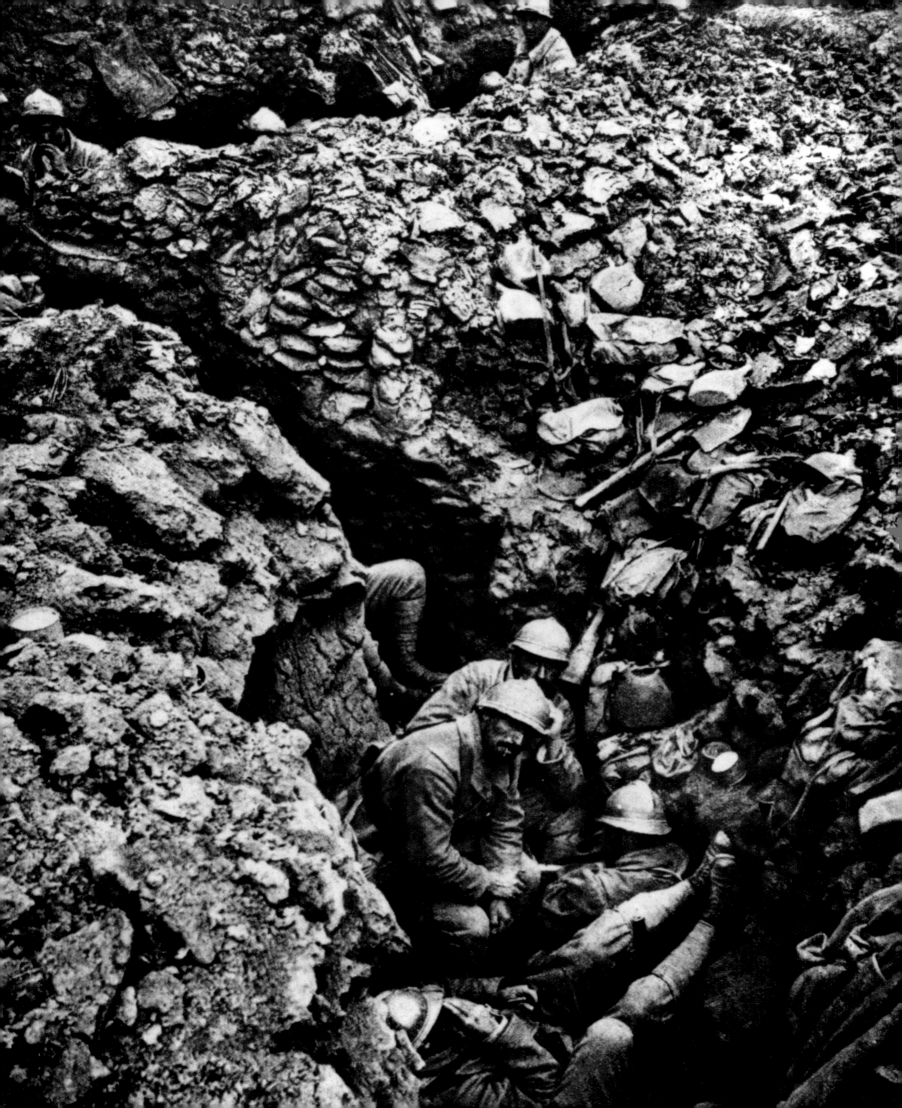

path. Surgeons had to become more aggressive in debriding destroyed tissue from such wounds.

Because of shrapnel, machine guns, and hand grenades, military surgeons were now treating soldiers whose bodies had been torn up in three or four different places. Mangled limbs, protruding intestines, and great gaping holes in faces and chests became common sights in every forward area. The feverish battle between doctors and death reached an intensity unparalleled in history.

Much of the war, especially its earlier phases, was fought on the heavily manured fields of French and Belgian farms. The soil-smeared wounds of those engagements were contaminated by tetanus and other lethal bacteria that live in feces. Gas gangrene was perhaps the worst result; fortunately, that particularly disgusting form of putrefaction lessened progressively during the war as the same lands were fought over again and again. At the first battle of the Somme in 1916, the hospitals were filled with wounded men who had developed the putrid rotting that turned their injured flesh into foul, greenish-black slime. By the time of the second battle of the Somme in 1918, the countryside had been ripped up into a desolate and barren ground pockmarked by shell holes and scarred by deserted trenches, with a chalk subsoil scattered over its ravaged surface. Fortunately for the wounded, the killing fields had become barren, and none of the microbes found in highly cultivated land could live there.

This was a war not of swift campaigns, but of huge, plodding armies, a war in which defense overpowered offense. Platoons, companies, and entire regiments perished as they hurled themselves at the trenches and gun emplacements on the opposite side of the battlefield. The uplifting songs of brave young soldiers going off to battle—"Deutschland über Alles," "It's a Long Way to Tipperary," "Over There"—gave way to the cries of horribly wounded men and boys, and too often faded into "Taps."

Science was by now a full participant in the war. The time of great discoveries of the late nineteenth century had blossomed into a period of rapid growth of scientific achievement and a large increase in the number of scientists. Both sides now turned to them for help. The physicists, chemists, and engineers assigned to devise better ways to kill found themselves lined up against the physiologists, biochemists, and bacteriologists whose duty it was to frustrate their lethal schemes. Sometimes the same man worked alternately for life and death: when he was not busy developing synthetic foods, the great German chemist Emil Fischer turned his attention to inventing new explosives.

Just as the armies were composed overwhelmingly of civilian inductees, so were their medical corps. Eminent academic physicians and researchers of every combatant nation rushed to war zones to observe problems firsthand and to serve as front-line medical officers. Many of those who stayed home devoted the war years to studying the effects of battle or devising methods to prevent and treat diseases resulting from military campaigns.

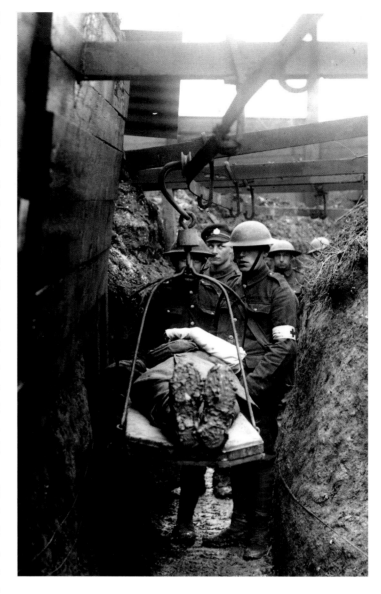

Trench warfare on the Western Front meant that soldiers often lived cramped together for several uninterrupted days and nights—sometimes weeks—in the same narrow ditch (*left*), cramped in with hundreds of frogs and rats, with mud and dirty water at least ankle-deep and sometimes much higher. The typical trench was about seven feet deep and three feet wide, supported by sandbags and wooden frames, and was sometimes equipped with a trolley system to evacuate the wounded. Here, English and American soldiers (*above*) attempt to move an injured comrade to safety.
Photographers unknown
Left: Italy, 1916
Above: The Western Front, 1914–18

The contributions made by these physicians are stunning, especially since so many of the problems had never before been seen, or at least never recognized. The volunteer civilian doctors facing war for the first time may have been in many ways ingenuous, but they also proved to be ingenious. The insights that arose from military medical practice from 1914 to 1918 have served as the basis for many aspects of medicine since that time.

The entire infant specialty of plastic surgery came out of its swaddling clothes in World War I. Trench warfare was hard on the face; and a steel helmet only made things worse, because shrapnel that might kill a man by entering his skull was instead deflected into his cheeks or jaw. Skin flaps, reconstructive techniques, grafts of various sorts, and burn treatment—all emerged in the war.

The grossly contaminated wounds sustained by the soldiers of this conflict demanded expeditious cleansing and debridement, a technique finally accepted after years of debate dating back to Paré. World War I also saw the development of innovative types of antiseptic compounds, such as the sodium hypochlorite mixture called Dakin's solution. The principles of thorough debridement and antiseptic irrigation remain basic to the management of contaminated wounds even today, as has the principle of leaving skin and underlying soft tissue unstitched for a period of time until all infection has been overcome. This approach, called delayed primary closure, has saved the lives of countless military and civilian patients ever since.

Abdominal surgery, too, benefited from new techniques stimulated by World War I. Physicians had always thought that patients with penetrating wounds of the abdomen could not withstand surgery and that the healing of lacerated intestine was too chancy to risk operation. Such wounds had been treated by what was called the expectant or watch-and-wait method, even though the mortality rate of this approach was nearly 90 percent in both the Crimea and in the Civil War. At the beginning of World War I, the conservative theory continued in force, but military surgeons soon realized that not only did their operated patients do better, but also that very early operation was critical. When they began operating as close to the front as casualty clearing stations, the mortality rate dropped to 56 percent, an astonishingly low figure considering the gravity of the wounds and the circumstances under which they were sustained. One outcome of the new aggressiveness was a better understanding of the mechanisms of healing of the intestine and stomach, one of the reasons that gastrointestinal surgery made so much progress in the following two decades.

In the field, the first line of medical defense was the casualty clearing station, typically staffed by seven medical officers, a quartermaster, and eighty orderlies. Although the station could hold up to two hundred patients on stretchers, its doctors were often overwhelmed by the vast numbers of men requiring urgent care. Following treatment, the patients were transferred to a medically equipped train bound for the base hospital. Each division had its own casualty clearing station, whose one operating table was in constant use during battle for wounds of the abdomen and chest and for severe fractures.

Colonel Harvey Cushing, chairman of the Department of Surgery at Harvard's Peter Bent Brigham Hospital, was director of Base Hospital No. 5, one of the units recruited

Numbers chalked on the floor indicating the order in which they'll be attended to, French and German wounded wait together for treatment and transportation from a French field station to a hospital. The French photograph may have originally had some propaganda value in the international arena: "We treat them no differently from our own," reads the photo's original caption, after noting that the German wounded could be identified by the circles around their numbers. A medical team's formidable task of deciding which casualties to treat first is known as triage, from the French *trier*, to sift; the term originated in World War I.
Photograph by Paul Thompson
France, 1914–18

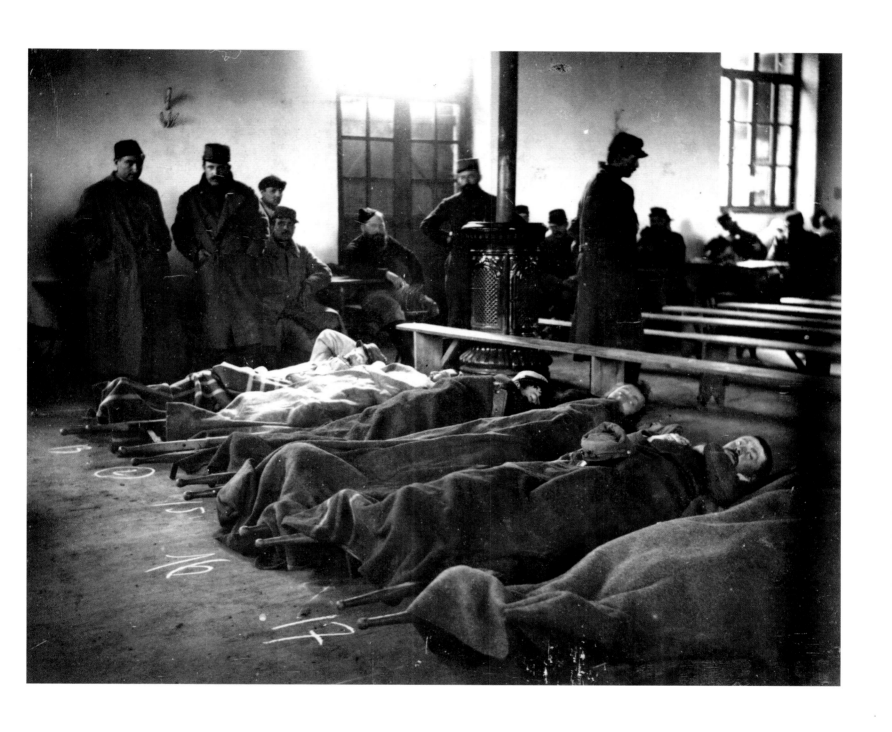

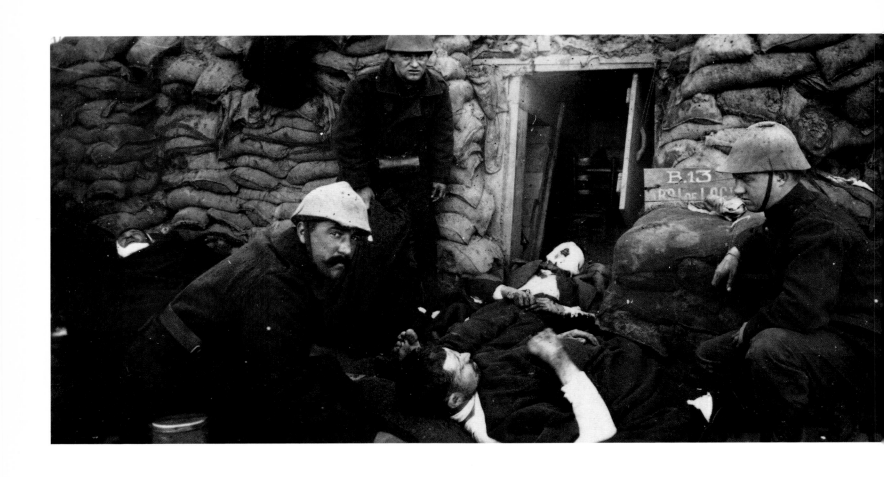

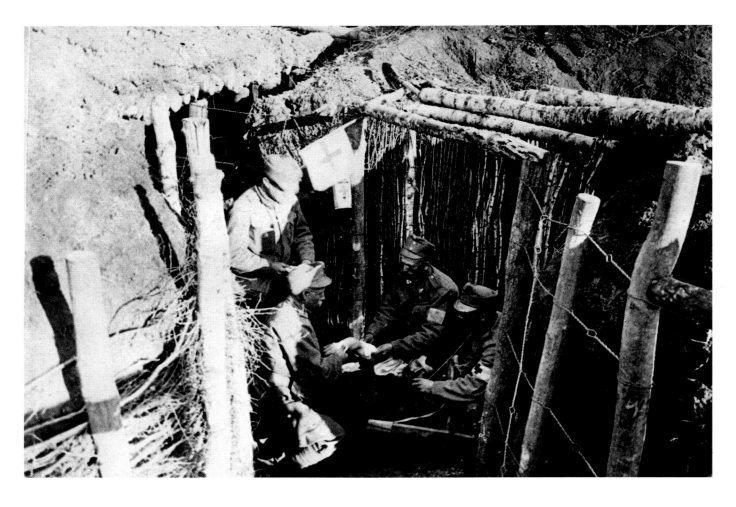

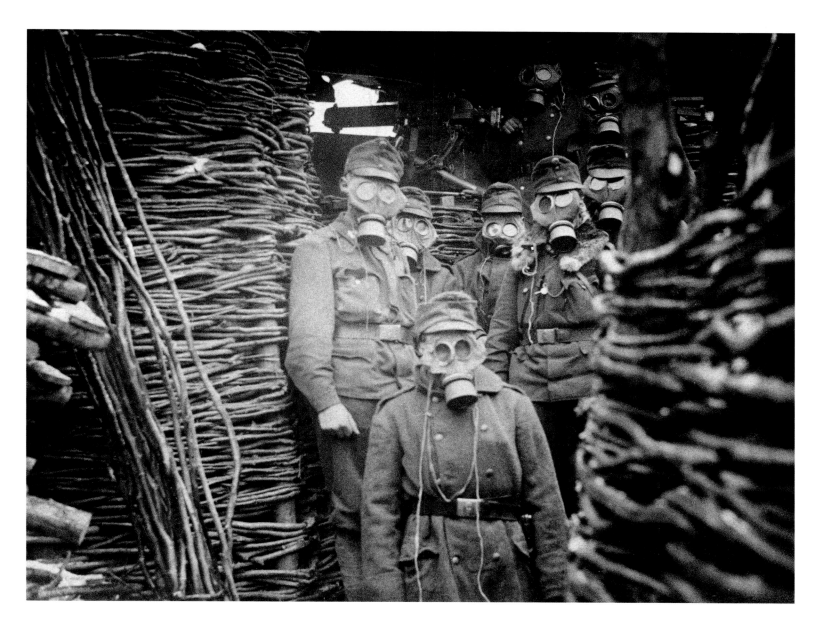

French soldiers evacuate a wounded soldier (*above left*), while an Austrian medical patrol provides the basic care dictated by medicine in the trenches (*below left*). When treatment and evacuation weren't possible, the dead were sometimes buried in trench walls. A British directive on military hygiene recommended that they be "treated with chloride of lime, quick-lime, or sprayed with oresol or solution C and then isolated either by means of boarding filled in with earth and chloride of lime or by sand bags soaked in heavy petroleum oil."
Photographers unknown
Above left: Het Sas, Belgium, 1916
Left: Italy, 1914–18

The Hague Conference in 1907 outlawed the use of asphyxiating gas in warfare, but the Germans broke the agreement less than a year into the war when they unleashed lethal chlorine gas at the Battle of Ypres. Gas masks, such as these worn by Austrian soldiers from the Kaiser's Süddeutschland Army (*above*), soon became standard issue on both sides. World War I historian Lyn Macdonald, writing in *The Roses of No Man's Land,* captured the horror of British medical personnel when victims of the first gas attacks were brought in: "Nothing in their experience had equipped them to deal with wards full of men gasping for breath; with the terrible rasping sound of their struggle; with their blue faces and livid skins; and, worst of all, with their terror as the fluid rose higher and higher in their lungs until eventually they drowned in it. The terror was made worse by the fact that most of the men were blinded and trapped in darkness in their suffocating bodies."
Photographer unknown
Italy, 1914–18

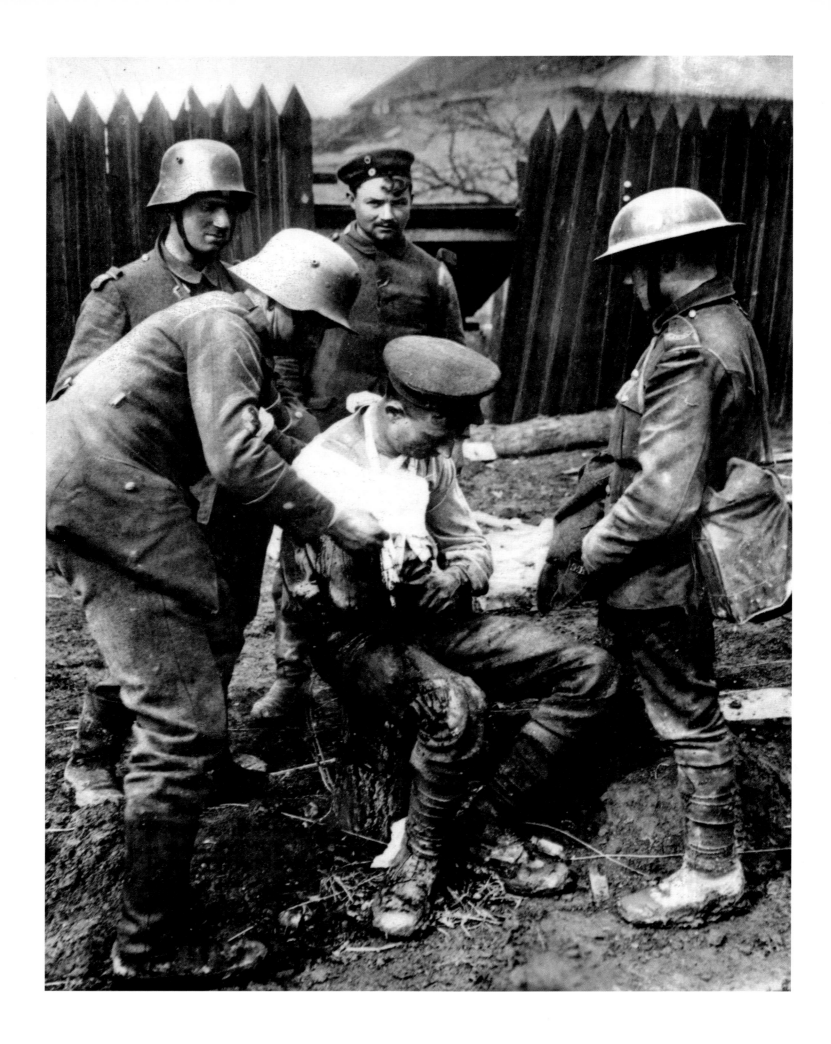

from staffs of university medical centers. In his memoir of war experiences, *From a Surgeon's Journal*, Cushing describes a day in 1917.

> *They are probably all more or less like our No. 46—200 actual beds which may expand into 1200 or 1300, and may "take in" without a struggle, as did No. 46 the day before I got here, 1000 mustard-gas cases.*
>
> *Poor devils! I've seen too many of them since—new ones—their eyes bandaged, led along by a man with a string while they try to keep to the duckboards. Some of the after-effects are as extraordinary as they are horrible—the sloughing of the genitals, for example. They had about twenty fatalities out of the first 1000 cases, chiefly from bronchial troubles. Fortunately vision does not appear to be often lost.*

Not much could be done for the victims of gas attacks. Their survival depended far more on the extent of their exposure to the fumes than it did on medical care. It was in the surgical treatment of the young men whose bodies were torn by artillery and shrapnel that the personnel of the casualty clearing stations made their great contribution. Cushing, a neurosurgeon and a leading exponent of a surgical technique that was as meticulous as it was painstakingly slow, describes the conditions under which he worked at Ypres in Belgium, while serving with the No. 46 Casualty Clearing Station in 1917.

> *Thursday, August 2, 2.30 a.m. Pouring cats and dogs all day—also pouring cold and shivering wounded, covered with mud and blood. Some G.S.W's [gunshot wounds] of the head, when the mud is scraped off, prove to be trifles—others of unsuspected gravity. The preoperation room is still crowded—one can't possibly keep up with them; and the unsystematic way things are run drives one frantic. The news, too, is very bad. The greatest battle of history is floundering up to its middle in a morass, and the guns have sunk even deeper than that. Gott mit uns [God is with us] was certainly true for the enemy this time.*
>
> *Operating from 8.30 a.m. one day till 2.00 a.m. the next; standing in a pair of rubber boots, and periodically full of tea as a stimulant, is not healthy. It's an awful business, probably the worst possible training in surgery for a young man, and ruinous for the carefully acquired technique of an oldster. Something over 2000 wounded have passed, so far, through this one C.C.S. There are fifteen similar stations behind the battle front.*
>
> *10.30 p.m. We're about through now with this particular episode. Around 30,000 casualties, I believe—a small advance here and there, and that's about all. Doubtless there are many prisoners—we've seen a lot of wounded ones, big husky Hun boys. But I do not believe it has been other than a disappointment. Much ground has been lost (e.g., at St. Julien) in counterattacks.*
>
> *Operating again all day, and finished up an hour ago with an extraction of a large piece of shell from a man's badly infected ventricle [of the brain] with the magnet—then dinner, and now to bed. It still rains. A lot of wounded must have drowned in the mud. One of to-day's cases was a fine young Scot having frequent Jacksonian attacks*

Caring for the enemy wounded stirred up a confusing mixture of resentment and compassion in the caregivers of both sides. Here, in compliance with international law, Germans treat a wounded British soldier. English nurse Vera Brittain wrote in her autobiography, *Testament of Youth:* "Another badly wounded boy—a Prussian lieutenant who was being transferred to England—held out an emaciated hand to me as he lay on the stretcher waiting to go, and murmured: 'I tank you, Sister.' After barely a second's hesitation I took the pale fingers in mine, thinking how ridiculous it was that I should be holding this man's hand in friendship when perhaps, only a week or two earlier, Edward up at Ypres had been doing his best to kill him. The world was mad and we were all victims; that was the only way to look at it."
Photographer unknown
The Western Front, 1914–18

[epileptic seizures] from a glancing sniper's ball through his tin hat, a piece of which was driven into the brain. He had lain, he said, in the protection of a shell hole with one or two others—the water up to his waist—for twelve hours before they were found. But there has been scant time to talk to wounded, to prisoners, or to "brass hats," and I know little of what has gone on.

Friday, August 3. In the early afternoon a large batch of wounded were unexpectedly brought in—mostly heads—men who have been lying out for four days in craters in the rain, without food. It is amazing what the human animal can endure. Some of them had maggots in their wounds. Then a long operation on a sergeant with things in his brain and ventricle like the man of last night—the magnet again useful.

Many of the men undergoing surgery on those operating tables had serious wounds of the chest, another area previously thought too dangerous for operation. The army doctors steeled themselves to the challenge of learning about chest wounds as they fought to heal them. The bacteriologists, too, understood more about wound infections with each passing year of the war, so that by 1919 some of the modern concepts still in use today for treating chest infections from wounds, tuberculosis, and pneumonia had been discovered.

The cavalcade of contributions rolls on. It ranges from the strictly logistical provision for large numbers of blood transfusions to technical innovations in x-rays (such as the development of portable bedside equipment) and orthopedics (such as specialized leg splints, bone grafting, and closure techniques). It was during World War I that blood transfusions transformed the care of the seriously wounded, as they would transform the very face of medicine itself after the war. American researchers discovered in 1915 that adding sodium citrate to a flask of blood would prevent it from coagulating, simplifying what had previously been a complicated and cumbersome process. The British surgeon Sir Geoffrey Keynes, then a captain in the Royal Army Medical Corps, described first using transfusions in his casualty clearing station.

It provided an incomparable extension to the possibilities of life-saving surgery. Trained anaesthetists were scarce and often I dispensed with their services. A preliminary transfusion, followed by a spinal analgesic, enabled me to do a major amputation single-handed. A second transfusion then established the patient so firmly on the road to recovery that he could be dismissed to the ward without any further anxiety. When the convoys came in, the wounded whom the responsible officer thought had no chance of recovery were put all together in one tent—because the thing that mattered was to do the best one could as quickly as one could for the men whose lives you could possibly save. So the others were all put into this "moribund" ward and made as comfortable as possible, and were looked after until they died. The possibility of blood transfusion now gave hope to a lot of these people, and I made it my business during any lull in the work to go into the "moribund" ward, choose a patient who was still breathing and had a perceptible pulse, transfuse him and then carry out the necessary operation. Most of them were suffering primarily from shock and loss of blood, and in this way I had the satisfaction of pulling many men back from death.

A seriously wounded Hungarian soldier on the Galician front is pulled off his stretcher by medics. "Out in front at night in that no man's land and long graveyard there is a freedom and a spur," wrote Charles Hamilton Sorley, who was stationed in France in August, 1915. "Rustling of the grasses and grave tap-tapping of distant workers: the tension and silence of encounter, when one struggles in the dark for moral victory over the enemy patrol: the wail of the exploded bomb and the animal cries of wounded men. Then death and the horrible thankfulness when one sees that the next man is dead: 'We won't have to *carry* him in under fire, thank God; dragging will do': hauling in of the great resistless body in the dark, the smashed head rattling: the relief, the relief that the thing has ceased to groan: that the bullet or bomb that made the man an animal has now made the animal a corpse. One is hardened by now: purged of all false pity: perhaps more selfish than before. The spiritual and the animal get so much more sharply divided in hours of encounter, taking possession of the body by swift turns."
Photographer unknown
Galicia, Austria-Hungary, 1916

129

Early in World War I, retreating Allies often abandoned their wounded in churches and schoolhouses, where they lived for days, untended, until someone came back for them. Further into the war, churches, such as this one in Neuilly on the outskirts of Paris, were converted into hospitals, their vast ground floors accommodating the unwieldy numbers of wounded. Medical care in the church-hospitals was usually confined to simple surgeries and the redressing of wounds, although some of the patients were gravely ill. The prominence of these buildings was a mixed blessing: defenders had a clear view of the surrounding countryside, but enemy warplanes had an easy fix on their targets.
Photographer unknown
Neuilly, France, 1918

130

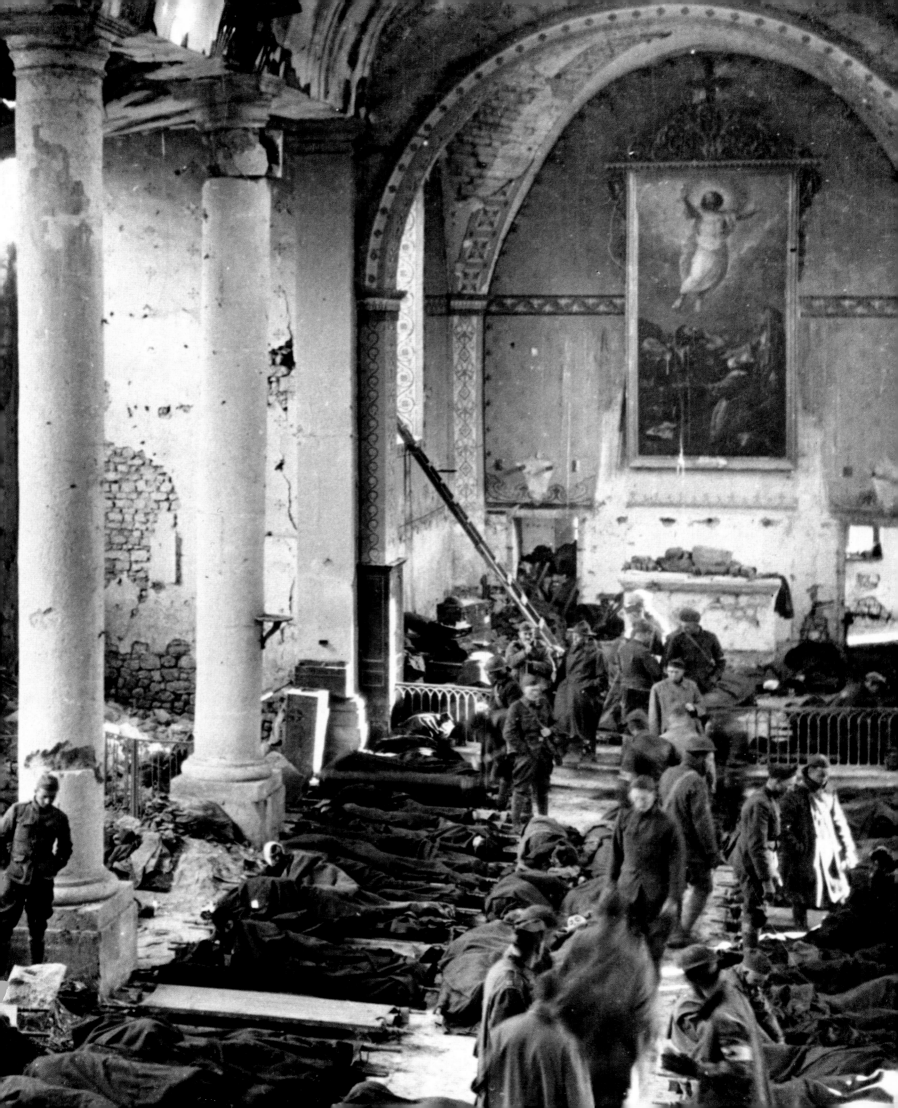

One young man came in practically dead—he'd got twelve holes in his intestine. He'd got his brachial artery severed in one of his arms and several other wounds. I spent a long time on him and gave him a transfusion. Believe it or not, next morning he was alive and perky. He was a Newcastle boy. He would certainly have died without a blood transfusion. It saved countless lives.

The efforts of the doctors succeeded as they had in no previous war—78 percent of the wounded returned to the front, and another 12 percent returned to noncombat duty. Only 6.1 percent of the wounded died, a far cry from the ancient mortality-morbidity ratio of nearly one-to-one, or even the approximate 14 percent of the American Civil and Franco-Prussian wars. Doctors confirmed the value of large-scale vaccination against smallpox, typhoid, tetanus, diphtheria, and the dysenteries. The lessons so painfully learned in the war spurred even greater progress when those new concepts, like most of the doctors with whom they originated, came home to the problems of civilian medical care after the war.

Of course, not all armies were able to give the level of care that the major combatants could provide, and many soldiers and civilians died because of inadequate treatment. J. Breckinridge Bayne, an American surgeon who served as a volunteer in Romania, wrote vividly of his experiences in the German attack on Bucharest.

If there is any romance in war, unfortunately it does not fall to the lot of the nurse or surgeon to experience it. As many of our cases had lain for hours on the field of battle, their wounds became contaminated by dirt and flies, and when we received them they were still wearing the first aid dressings that had been applied days before. When these dressings were removed, the fetid pus would pour out, and maggots could be seen squirming around within the wounds and wriggling in the pus that ran out over the side or attempting to return to the feast of rotted flesh with which their bodies were already bloated.

We got few abdominal cases or bayonet wounds, for usually these succumbed to shock before reaching us. The abdominal cases that did arrive generally had their wounds plugged with gauze, and when this was removed fecal matter would gush from the perforated intestines.

When peace finally came, it brought an upsurge in biomedical science that carried with it a greater and more varied bounty than had ever been dreamed. Researchers began to turn their attention to the actual mechanisms by which disease affects the functions of organs and tissues. During the war itself, for example, a great deal of progress had been made in the study of surgical shock, that often lethal condition brought about by massive injury, blood loss, and diminishing circulation to the tissues. These investigations now reached into respiration, tissue nutrition and repair, cardiac and kidney function, metabolism, endocrinology, and the nervous system. Laboratories and hospitals increasingly devoted their investigative energies to understanding the invisible

A gas-patient ward in Paris is eerily quiet (*right*), although it saw vast numbers of patients: one of every three hospitalized Americans suffered from exposure to gas. Although treatment varied somewhat depending on what kind of gas was used—a U.S. surgeon general's report in 1926 enumerated some three dozen types, which fell into four treatment categories—the therapy usually included administering dry lime to exposed skin, followed by a soapy bath; cleansing the eyes, nose, and throat with bicarbonate of soda; administering oxygen; and keeping the patient warm to fend off the effects of shock. Painful as it was to be gassed, most victims of gas attacks survived if they could fight past the critical first twenty-four hours.
*Photograph by Private Stern
Paris, France, 1918*

Fighting infection was a priority in World War I operating rooms, such as this one at the American Red Cross Evacuation Hospital in Coincy, France. Carts and medical instruments were made of metal so they were easy to clean and sterilize, and doctors and nurses cleaned wounds with antiseptics such as hypochlorous acid 1/4% solution, also known as Carrel-Dakin solution in honor of the doctor and chemist who developed it. Since much of the war's early fighting took place on farmland rich in fertilizer, battlefield wounds became quickly infected—a problem aggravated by modern weapons, which ripped through tissue more brutally and left wider, more complex wounds than ever before.
*Photograph by Lieutenant Puggles
Coincy, France, 1918*

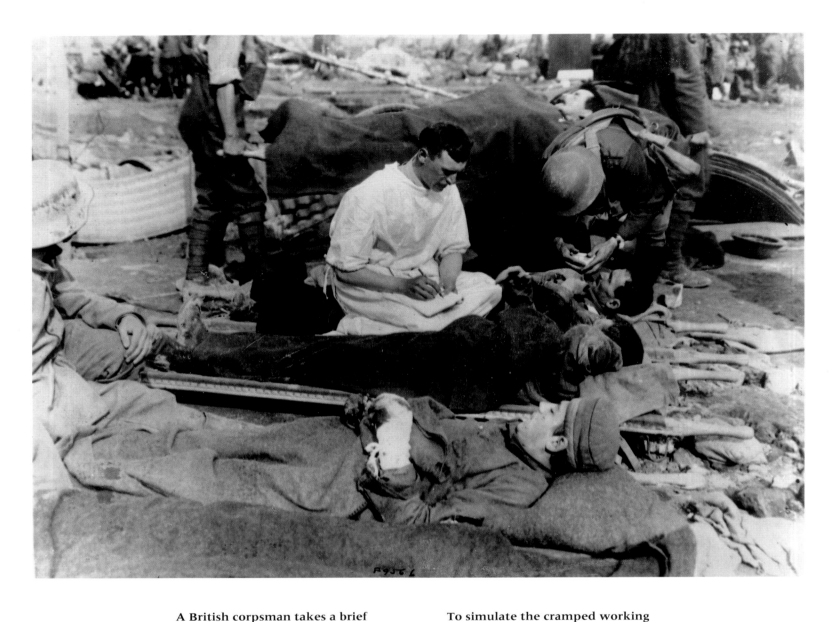

A British corpsman takes a brief medical history from a soldier in triage (*above*). Before the U.S. entered the war in 1917, Americans who wanted to aid the Allied war effort first-hand signed up as corpsmen and nurses with the Red Cross, or as ambulance drivers with the French Army. The largest organization to sponsor the volunteer drivers was the American Field Service, founded in Paris in September of 1914 by expatriate Americans. By 1917, A.F.S. drivers were at the wheel of about 660 ambulances, accounting for nearly a quarter of the front-line ambulances under the French Army's command. "My section is made up of a fine lot of fellows," wrote one American ambulance driver. "Two or three were artists in peacetime, one an architect in New York; some are students just out of college. Some are millionaires, some paupers."
Photographer unknown
The Western Front, 1918

To simulate the cramped working conditions they would soon find overseas, physicians and their assistants operate on a patient aboard a hospital train (*right*) at the Medical Officers Training Camp at Fort Riley, Kansas. The railway cars used by the Allies to transport the wounded ranged from those equipped with the latest in surgical technology to those in which the wounded lay on stretchers in baggage or cattle cars. Doctors were posted to each train and to each railway station along the route from the battlefields to the nearest available hospital.
Photograph by Lt. E. N. Jackson
Fort Riley, Kansas, 1918

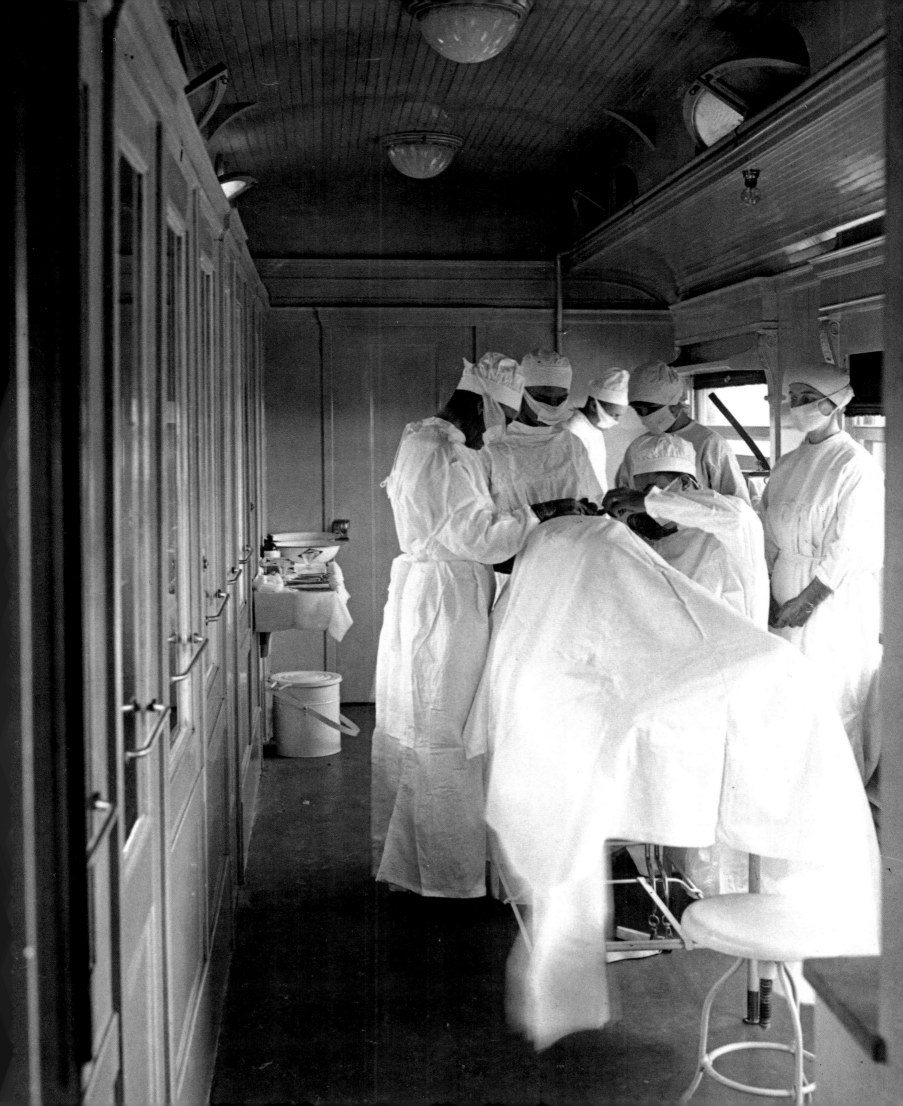

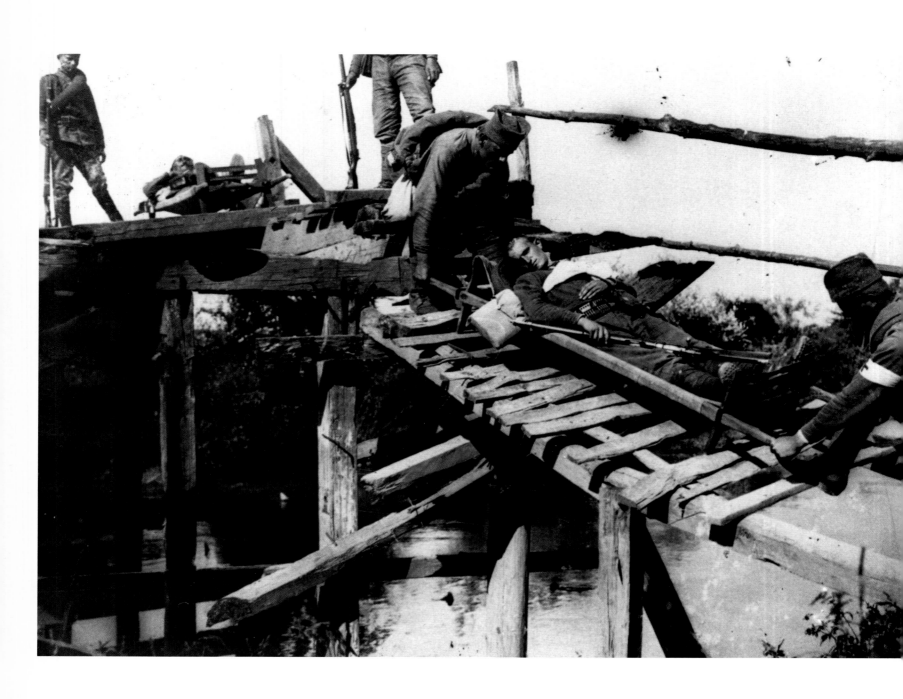

but basic alterations in cells and organs that, once identified, would lead to more effective treatment.

Although medicine underwent great changes during World War I, there was still a long way to go before the forces of healing could compete on equal terms with the forces of war. As this war came to an end, Joseph Lister's nephew, the surgeon Sir Rickman Godlee, wrote a biography of his famous uncle. Wistfully, he expressed his disappointment at the current state of the struggle between medicine and murder and the role that science had come to play in it: "The malign influence of those scientific men whose genius is devoted to devising engines of death has, so far, more than counterbalanced that of their colleagues whose efforts are directed towards the saving of life. The problem has therefore become more difficult and still awaits solution. Will it be solved by means of some new and undreamt of discovery? Or will increasing horrors lead to the abolition of war and make the solution unnecessary?"

Wounded Serbian soldiers are carried across the Morava River, not far from the city of Sarajevo. Stretcher-bearers were usually soldiers who received several weeks of training and drilling before taking to the field with ambulance companies. Their challenge was to move their comrades quickly and yet gently, usually over rough terrain and with little or no light; they often used a relay system to get the wounded to aid stations. A U.S. Army medical department handbook of the time advises that "great care must be taken to get strong men and men of exceptional bravery, as there is no more exhausting work than stretcher bearing and no soldier should possess higher morale than the sanitary soldier."
Photographer unknown
Bosnia, 1915

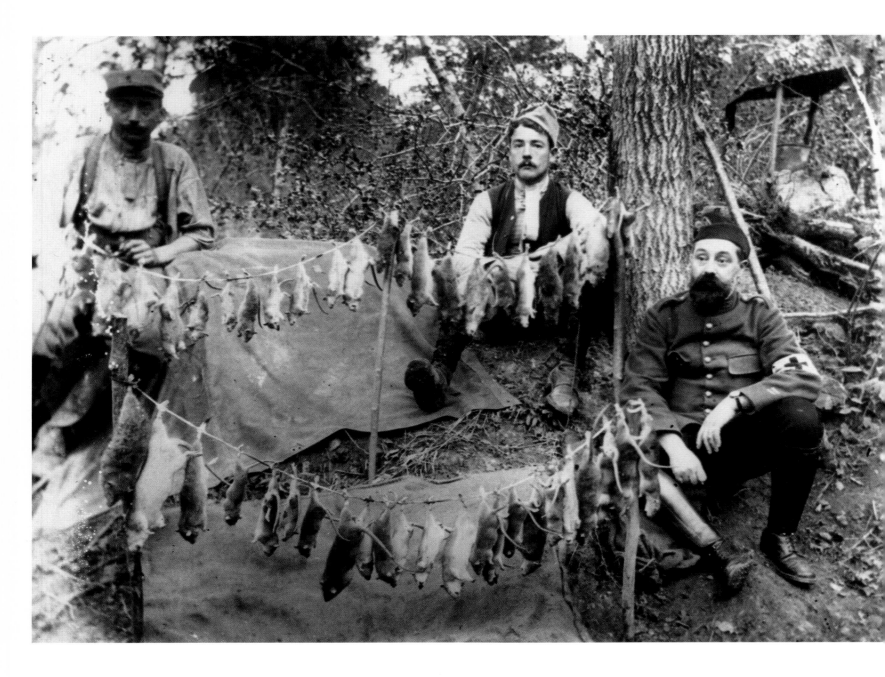

French rat-catchers on the Western Front display a day's work: several dozen dead rats, their extermination part of an Allied campaign to improve sanitation and fight disease in the trenches and in the fields. To suppress the rodent population, the British and French used dogs, poison, and rat-catchers like these men, who were paid according to the number of rats they killed. Early in the war, the Allies feared that the Germans might intentionally unleash plague-carrying rats near the French and British trenches. But while other rat-borne diseases were common in the trenches, plague surfaced only in and around the war's Turkish theater.
Photograph by Jacques Boyer
The Western Front, 1914–18

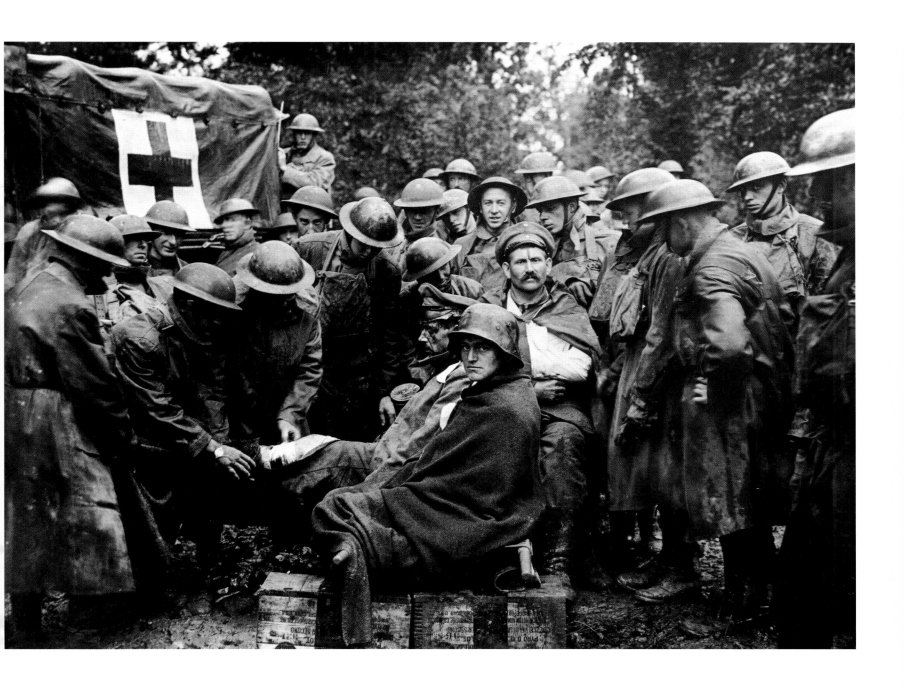

An object of curiosity and requisite kindness, a German prisoner receives medical attention at an American aid station on the Western Front. The red-cross symbol designates the station as a sanctuary for the sick and wounded from any nation, as mandated by the Geneva Convention agreements, which also guarantee protection for those providing medical care during armed conflict. The first of the agreements was signed in 1864 as "The Geneva Convention for the Amelioration of the Condition of the Wounded in Armies in the Field"—launching a moral imperative still esteemed today. Henry Dumant and his colleagues organized the first Geneva Convention conference, under the auspices of a fledgling humanitarian aid organization that eventually became the International Committee of the Red Cross. The Red Cross now has branches in virtually every country in the world and more than 250 million members.
Photograph by Pvt. J. M. Liles
The Western Front, 1918

139

The discovery that lice were responsible for the transmission of typhus came just before the war, when Americans Howard Ricketts, M.D., and Russell Wilder, M.D., studied the sick and dying during a 1910 outbreak of typhus in Mexico City. As a result, the delousing ritual was a familiar one to most World War I soldiers. At military delousing centers (*above left*), soldiers' body hair was carefully examined; and if lice or nits were found, it was cut or shaved. Their clothes were then placed in steam sterilizers (*below left*). After

they bathed in warm, soapy water, the soldiers reclaimed their clothing. Before being shipped overseas, American soldiers were shown an educational film entitled *Fighting the Cootie*, which explained the origin and consequences of lice. "It is no disgrace to have lice," concluded the film, "but it is to keep them."
Photographers unknown
Above left: Poland, 1914–18
Below left: Bomvillers, France, 1918

To combat typhoid fever, which is spread by food or water contaminated by human carriers of the disease, medical personnel inoculate soldiers (*above*) with vaccines that had been developed just before the war. Companies of American soldiers were, in theory at least, also provided with thirty-gallon canvas water bags and vials of calcium hypochlorite to sterilize their water, as a further preventive measure.
Photographer unknown
Europe, 1914–18

Early in World War I the German poet Wilhelm Klemm wrote from a church-hospital like this one (*left*): "Straw rustling everywhere. / The candle-stumps stand there staring solemnly / Across the nocturnal vault of the church / Moans go drifting and choking words." Klemm's poem, "Clearing-Station," concluded: "In the distance the battle thunders grimly on, / Day and night, groaning and grumbling non-stop, / And to the dying men patiently waiting for their graves / It sounds for all the world like the words of God."
Photographer unknown
Europe, 1914–18

The most ruthless killer during the four years of World War I was neither shrapnel nor gas, neither typhus nor grenades: it was the influenza epidemic of 1918, which in a few short months took twenty million lives, more than the combined military fatalities of all the warring nations. Initially, because some feared the disease was spread by dirty laundry, military hospitals took extra pains washing sheets and clothes: here, clothes are hung in a makeshift drying room set up in the sanctuary of a church (*above*). Even when the source of contagion was identified as droplets from the respiratory tract, transmitted by coughing or sneezing, doctors and nurses were unable to stop the epidemic's spread. A British military doctor wrote: "I shall never forget the sight of the mortuary tents. There were rows of corpses, absolutely rows of them, hundreds of them, dying from something quite different. It was a ghastly sight, to see them lying there dead of something I didn't have the treatment for."
Photographer unknown
Germany, ca. 1918

A unit of American nurses arrives in France six months before the war's end (*above*). With the U.S. entry into the war on April 6, 1917, the U.S. Army Nurse Corps began growing almost as fast as their paperwork could be processed—from a prewar nucleus of about four hundred to more than twenty-one thousand by the time the armistice was signed. The nurses, each of whom would bear responsibility for about ten patients at a time, were all graduates of hospital training schools who had passed "a satisfactory professional, moral, mental and physical examination," in accordance with the 1901 act of Congress that established the U.S. Army Nurse Corps. The peacetime requirement that Army nurses be between the ages of twenty-five and thirty-five years was waived, so that nurses as young as twenty-one and as old as forty-five were admitted, provided they were unmarried, U.S. citizens, and white. (A handful of African-American nurses was admitted to the corps in July of 1918, but none was sent abroad.) The pay scale for Army nurses started at sixty dollars per month, from which nurses were required to buy both indoor and outdoor uniforms. Those who served overseas earned an extra ten dollars each month.

Photographer unknown
Brest, France, 1918

Anna Rochester, a 1911 graduate of Smith College, feeds a soldier in France (*below*). Several women's colleges in the United States organized units of alumnae to serve with the Red Cross during the war; with forty-seven members, Smith's was the largest. When the women returned home, Smith president William Allan Neilson lauded them: "They did not make any claim, the government did not insure them, they were paid no pension, they asked for no bonus. They did the thing for its own sake." Rochester again volunteered with the Red Cross during World War II.

In Europe, even the nobility volunteered as nurses' aides. Britain's Dowager Duchess of Sutherland signed up, created her own ambulance unit consisting of a surgeon and several nurses, and insisted on being called "Sister Millicent." In August of 1914, she spent the first of countless days caring for the wounded, and recorded in her diary: "What I thought would be for me an impossible task became absolutely natural; to wash wounds, to drag off rags and clothing soaked in blood, to hold basins equally full of blood, to soothe a soldier's groans, and to raise a wounded man while he was receiving extreme unction."
Photograph by Lt. Adrian Duff
Souilly, Meuse, France, 1918

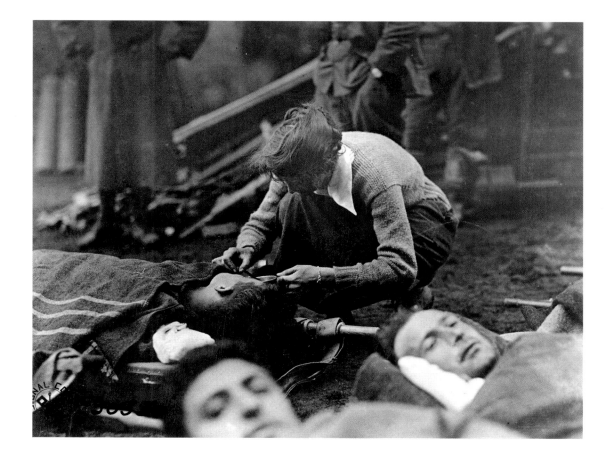

An American prepares to test a portable shower unit before it's sent to the Western Front—a godsend to soldiers in the field. An official U.S. government report noted in 1915, two years before the American entry into the war: "The question of bathing and general cleanliness is . . . a most important one, as aside from the hygienic principle involved it has a general exhilarating effect on the men who have spent days and nights in the trenches."
Photographer unknown
United States, 1918

In an effort to provide basic dental care to as many recruits as possible before shipping them overseas, the U.S. War Department contracted with civilian dentists to serve its several bases. Once in the field, dental care would likely be less sophisticated than that offered to this recruit at Maryland's Camp Meade. An American surgeon wrote in his World War I memoir: "A soldier who had an abscessed tooth . . . came into the hospital to have it attended to. He was a husky big fellow and had just been through heavy fighting and was accustomed to scenes of carnage. I was willing to oblige him, but the only forceps I had was a long pair of lion-jawed bone forceps. . . . He opened his mouth, I applied the forceps, and out came the tooth." The patient then fainted, leading the doctor to note: "It did seem rather incongruous that anyone who could, without a qualm, stick his bayonet through a man should faint because his tooth was pulled."
Photograph by W. L. Mann
Camp Meade, Maryland, 1918

This surgical ambulance, designed by Julien Gehrung, M.D., featured a tent attachment that turned the truck into an on-the-spot treatment center for gas poisoning. One of the last chemical compounds introduced into World War I was also one of the most dangerous: the symptoms of the odorless, initially painless liquid known to scientists as dichlorodiethyl sulfide, to the French as *ypérite,* and to the British and Americans as mustard gas can take several hours to appear, so even the apparently healthy were treated after exposure.

Photograph by Sgt. E. S. Brooks
Paris, France, 1918

The efficiency of medical supply rooms, such as this one run by the American Red Cross at the base hospital in Contrexeville, France, was critical to the wounded, their chances for recovery often depending on the inventory tracking system that sought to ensure that supplies were in stock. With the outbreak of World War I in August, 1914, the U.S. Army War College—anticipating American involvement, which didn't begin until three years later—started refining the "supply tables" that dictated where and how medical equipment and supplies were to be distributed.

Photograph by Sergeant Moscioni
Contrexeville, France, 1918

Flat feet kept many an American recruit out of active service during World War I, but medical examiners at the Episcopal Hospital in Washington, D.C. (*above*), were also looking for evidence of problems with the bones and joints of draftees and volunteers. Measuring a recruit's height was critical to the induction exam, as well: military regulations at the beginning of the war required soldiers to stand between five feet one inch and six feet six inches, although the minimum height was lowered by the war's end to an even five feet. Military doctors worried that shorter men would be unable to carry their weapons and supplies for long distances and that taller men suffered disproportionately from heart disorders and varicose veins.
Photograph by Lieutenant Reid Washington, D.C., 1918

Away from the battlefield, soldiers soak in a bath at a military hospital in Poland. Warm, clean water was an exquisite luxury for fighting men in Europe: the presence of mud and cold, standing water made swollen, numb feet a fact of life in the trenches. Enterprising soldiers and military doctors used salted lard, whale oil, and oil of mustard to guard against trench foot, and turpentine and boric acid to treat it. By war's end, Allied commanders were so concerned about trench foot that they tried to give a fresh pair of socks to each soldier every day, and encouraged their charges to move around within the trenches to maintain circulation.
Photographer unknown
Poland, 1916

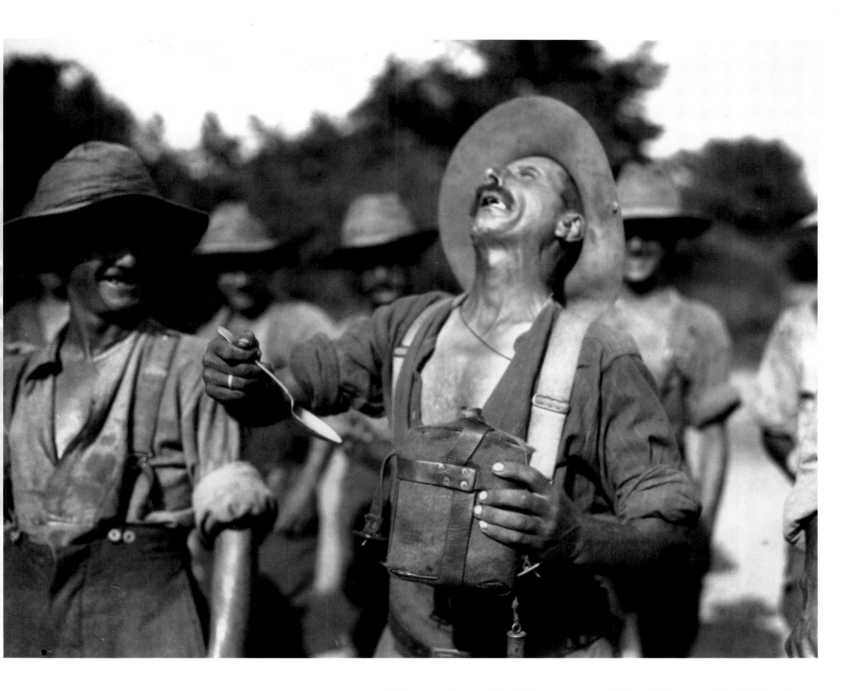

Taking to the open air for a cure, British soldiers form an outdoor hospital ward in Rouen, France (*above left*). Fresh air was prescribed for a number of World War I ills, including tuberculosis and gas poisoning. Victims of gassings had no visible badges of courage: in that respect, they could envy the soldiers with blood-soaked dressings or missing limbs, who were treated as heroes in towns throughout the Allied countries. Some nurses reported that gassed soldiers begged them for bandages, so they might advertise nonexistent wounds and share in the sympathy lavished on their mutilated comrades.
Photographer unknown
Rouen, France, 1917

American soldiers at the South African Military Hospital get the water treatment for septic wounds: day and night immersion in a tub (*below left*). By keeping the water at a constant 98.6°F, doctors hoped to help the body fight off infection. Whenever possible, they also used Dakin's solution to clean wounds, a painful treatment, according to British nurse Gwynedd Lloyd, who served at a hospital in Rouen. "They hated it, it was so cold—it didn't seem to soothe the wound at all." Ultimately, though, wrote Lloyd, "we did manage to save a great many with no other treatment."
Photographer unknown
Richmond, South Africa, 1914–18

A British soldier gets a laugh from his comrades as he reacts to the bitter taste of quinine (*above*), which was used to combat rampant malaria in several theaters of World War I, primarily Greece, Egypt, East Africa, and present-day Iraq. According to a British government report at the time: "The drug should always be given in dilute solution and in a mixture which will render the taste less unpleasant. Syrup of orange will disguise the taste to a certain extent."
Photographer unknown
Location unknown, 1914–18

World War I saw countless injuries to the face and head, primarily because of its trench warfare—which exposed soldiers' heads—but also because of its metal helmets, with edges sharp enough to slice through skin if jammed into flesh. A new generation of prosthetic devices evolved to disguise the deformities. World War I historian Lyn MacDonald wrote: "Spectacles hid a multitude of flaws, besides holding the mask securely to the wearer's face, and a generous moustache could go a long way towards camouflaging a scarred and twisted mouth. . . . Underneath was still the ravaged face. There was nothing anyone could do to alter that. . . . But they helped. They gave back self-respect." So did a relatively new medical specialty, known to its practitioners as reconstructive surgery and to the public as plastic surgery.
Photographer unknown
England, 1918

152

Men so disfigured that reconstructive surgery couldn't help them found a hero in Derwent Wood, a sculptor and English private who made custom masks of thin metal, painted to resemble each victim and to look as much as possible like a real face. Wood created the Masks for Facial Disfigurements Department—known more informally as the Tin Noses Shop—in 1916 at No. 3 London General, where he spent weeks on each mask, often working from a soldier's photograph taken for a girlfriend before the war. The painstaking process involved making a series of casts of the soldier's face (*above left*); sculpting the mask to re-create lost contours of the eyes, nose, and cheeks (*above center*); and adding flesh-colored tints (*above right*), hand-painted glass eyes, eyelashes made of silver foil, and absorbent pads if a salivary gland or tear duct had been damaged. Witnesses claimed the final perfect fit was so delicately done that it was sometimes impossible to detect where the edge of the mask began. Wood's work won him a promotion to captain; more important, it saved lives, for before the creation of the Tin Noses Shop some grossly disfigured soldiers committed suicide or simply lost the will to live.
Photographer unknown
London, England, ca. 1916

In a French workshop, skilled craftsmen create artificial limbs for injured veterans (*below*). An estimated 300,000 amputations were performed as a result of World War I injuries: gas gangrene was common, and limbs were often shattered by high-explosive shells. Many amputees were initially fitted with temporary, one-size-fits-all prosthetic devices, so they could adjust to the experience of an artificial limb while a custom device was constructed. Artificial legs were molded to the patient's stump with plaster of Paris, and made of wood held in place by a light steel frame.
Photograph by Branger
France, 1919

Just as the American Civil War is symbolized by the extraordinary number of amputations—an apt medical metaphor for a political struggle over secession—World War I may be best remembered for its rampant cases of blindness, the result of the lack of political vision that turned an entire generation of young men into cannon fodder in a plodding war of attrition. Many of the sightless veterans, blinded by shrapnel or gas, learned to read (*above*) using the nineteenth-century system invented by Frenchman Louis Braille. Some gassed men lost their sight alone; the eyes and faces of others were burned and swollen beyond recognition.
Photographer unknown
Europe, ca. 1918

Blinded British soldiers depend on each other as they learn to navigate the grounds of St. Dunstan's Villa in London (*above right*), a home founded by American banker Otto Kahn. Douglas Dunn wrote of the wrenching similarity between blinded men and soldiers moving across a darkened battlefield in his poem "War Blinded": "That war's too old for me to understand / How he might think, nursed now in wards of want, / Remembering that day when his right hand / Gripped on the shoulder of the man in front."
Photograph by Jimmy Hare
London, England, ca. 1915

The war over, but the struggle to rebuild their lives just beginning, amputees undergo rehabilitation in a Dutch hospital (*below right*). Men who lost legs concentrated on strength building and balance, but the prescription for men with injuries to the hands and arms was often some practical activity—knitting, weaving, or wood carving. In a turn of cruel irony, the wounded often used spent artillery shells to craft candlesticks, ashtrays, and other everyday objects.
Photographer unknown
The Netherlands, 1918–20

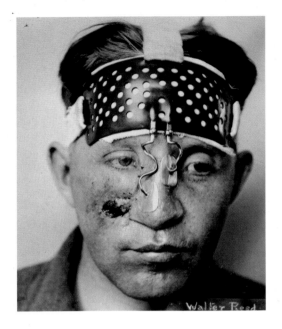
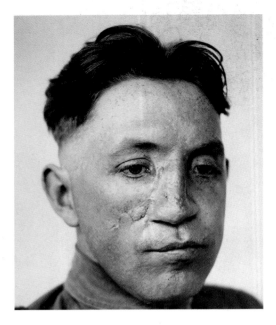

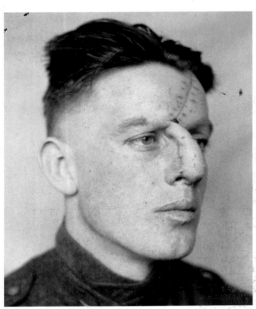
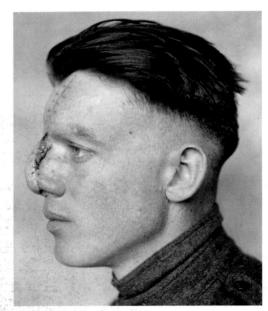

In the Maxillofacial Department of Walter Reed General Hospital, reconstructive and oral surgeons mended the faces of Americans wounded in World War I. With the help of a device to hold grafted tissue in place until it had healed completely, a soldier's cheek and nose are rebuilt (*upper row*). To create a new nose bridge and tip for a second soldier (*lower row*), surgeons grafted tissue from his forehead. These photographs were used to illustrate the 1920, postwar revision of the classic text on reconstructive surgery, *Surgery and Diseases of the Mouth and Jaws,* written by Vilray Blair, M.D. The development of reconstructive surgery was one of the great medical achievements of the war.
Photographs by Alice L. Becht
Washington, D.C., 1919

Specialists in a French hospital guide wounded soldiers through their rehabilitation exercises (*right*). A poem by Siegfried Sassoon—an English writer who served as an officer in the war—captured the feelings of many invalids: "Does it matter—losing your legs? / For people will always be kind, / And you need not show that you mind / When the others come in after hunting / To gobble their muffins and eggs. / Does it matter—losing your sight? / There's such splendid work for the blind; / And people will always be kind, / As you sit on the terrace remembering / And turning your face to the light."
Photograph by Branger
France, 1919

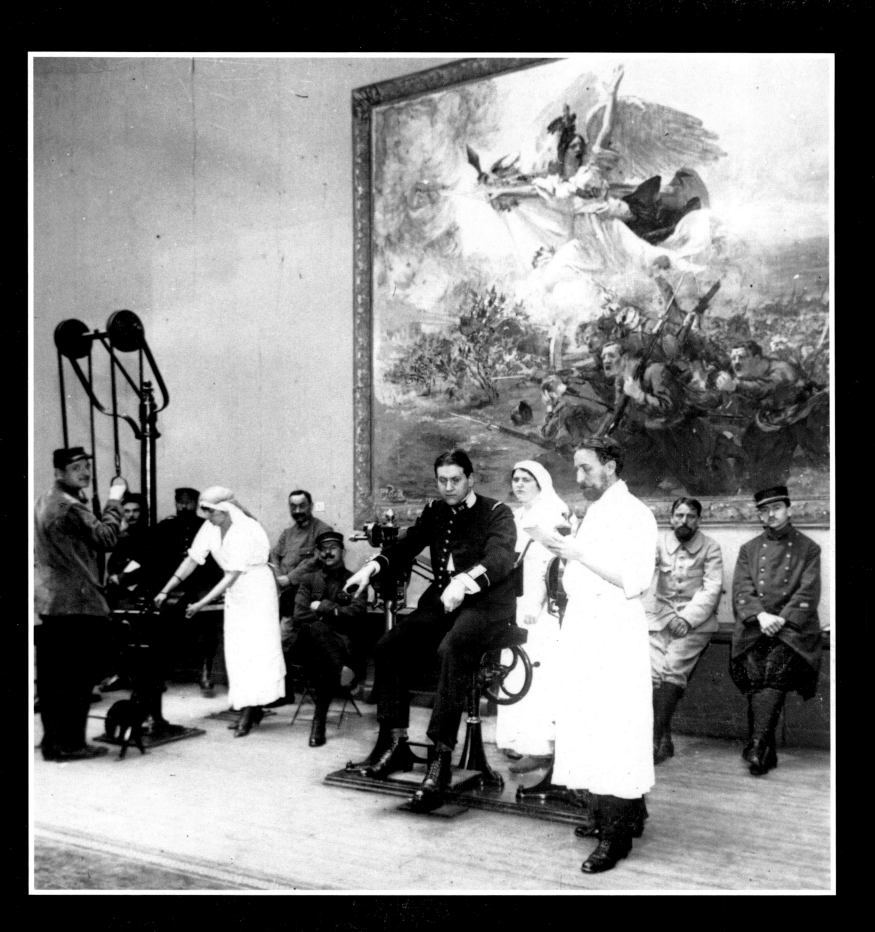

Shell Shock

Gloria Emerson

Sgt. Van Valkenburg uses hypnosis to treat a soldier's "war nerves" at U.S. Army Base Hospital No. 17. In the Civil War, wounded soldiers had often been diagnosed as suffering from "nostalgia," a concept that permeated most writings on depression in the early twentieth century.
Photographer unknown
Dijon, France, 1918

In March of 1916 Robert Graves, a captain in the British trenches in France, knew that the war was breaking him. In his classic war memoir, *Goodbye to All That*, he envisioned his wrecked self: "It would be a general nervous collapse, with tears and twitchings and dirtied trousers; I had seen cases like that." He was not yet twenty-one.

A few of the symptoms in the men suffering from shell shock, the popular term to describe an enormous mass of afflictions during the Great War, were tics, spasms, tremors, stammering, loss of voice, stupor, a state of fugue, loss of muscular power, and delusions. Phobias, disorders of the skin sense, confusion, agitation, hallucination, impaired smell and taste, deafness, amnesia, forms of paralysis, and unbearable nightmares were common. Some of the stricken had been wounded, but not all of them.

At first, the War Office in London insisted that a man was wounded or a man was well. Physicians were hardly prepared to treat the thousands of cases of "war neuroses," and few were familiar with the work of Freud. It was thought that shell shock only became a problem after the beginning of the battle of the Somme, when British troops attacked German lines on a thirteen-mile front. Sixty thousand of their men were killed or wounded on the first day alone, July 1, 1916.

One of the first to treat shell shock with psychotherapy was the English psychiatrist and physiologist, W. H. R. Rivers, M.D., who was highly respected for his anthropological research in India. When peace finally came, it was Rivers who wrote: "One of the most striking features of the war from which we have recently emerged—perhaps its most important feature from the medical point of view—has been the enormous scale on which it produced those disturbances of nervous and mental function. . . ."

He deplored, as did so many others, the misleading nature of the expression *shell shock*, which suggested that its sufferers had been solely damaged by proximity to bursting shells or by having been buried alive by these explosions. Rivers believed that the true origins of shell shock were a complex, defensive, emotional response to

the trauma of war; and he used the writings of Freud—especially the theory of forgetting—to treat officers under his care. Many others thought that the men who cracked were not stable, brave fellows to begin with, but Rivers wrote that "war calls into activity processes and tendencies which in its absence would have lain wholly dormant." In a country that valued stoicism, he sought to teach that the endless struggle to smother the memories of war was injurious and debilitating.

"We should lead the patient resolutely to face the situation provided by his painful experience," Rivers urged. "We should point out to him that such experience . . . can never be thrust wholly out of his life, though it may be possible to put it out of sight and cover it up so that it may seem to have been abolished. His experience should be talked over in all its bearings."

Not many British physicians spoke in that voice.

In Craiglockhart War Hospital near Edinburgh, where Dr. Rivers was in charge of one hundred officers who could no longer sleep at night, let alone command, one of his patients was the poet Siegfried Sassoon. "One became conscious that the place was full of men whose slumbers were morbid and terrifying—men muttering uneasily or suddenly crying out in their sleep. By daylight each mind was a sort of aquarium for the psychopath to study. . . . Significant dreams could be noted down and Rivers could try to remove repressions. But by night each man was back in his doomed sector of a horror-stricken front line where the panic and stampede of some ghastly experience was re-enacted among the livid faces of the dead. No doctor could save him then. . . ."

Because of his treatment with Dr. Rivers, Sassoon decided that "going back to the War was my only chance of peace." It shamed him that he was not with his men at the front and so he went.

Others were far too frail and shattered to act on such a desperate decision. In *Instinct and the Unconscious,* Rivers wrote of one officer in the trenches searching for a missing friend. What the officer found were sections of a mangled corpse, the head and limbs no longer attached to the body. In dreams that persecuted the officer, his friend reappeared in this mutilated state, or as a figure whose face had been eaten away by leprosy, always moving closer to him. Before coming to Rivers at Craiglockhart, the officer had always been advised to keep all thoughts of the war from his mind as if it were merely a matter of willpower.

"The problem before me," Rivers wrote, "was to find some aspect of the painful experience which would allow the patient to dwell upon it in such a way as to relieve its horrible and terrifying character." He eventually did this by making the patient see that his friend had died instantly and had thus been spared the prolonged and grim suffering of the severely wounded.

But Rivers sometimes failed when the experience the patient was struggling to forget was "so utterly horrible or disgusting, so wholly free from any redeeming feature . . . that it is difficult or impossible to find an aspect which will make its contemplation endurable." This described the case of a young officer whose earlier hospitalizations had been useless because, as Rivers put it, treatment was "isolation and repression." The patient was told not to read the papers or talk with anyone about the war. He wept when asked a question about the trenches during an interview with a medical board.

His story was short: an exploding shell had flung the officer face down upon the distended abdomen of a German corpse. The impact of the fall ruptured the belly of the dead man. Before the officer lost consciousness, he realized that the foul-smelling substance filling his mouth was human entrails. In his dreams it happened again and again.

Each month the war kept swallowing more men, and new conscripts were urgently needed. The order came that all officers must be on duty or in the hospital, not recuperating at home.

But the British trenches, greatly inferior to those of the Germans, were sickening, always wet and flooded. In *The Great War and Modern Memory,* Paul Fussell wrote: "The stench of rotten flesh was over everything. . . . Dead horses and dead men—and parts of both—were sometimes not buried for months and often simply became an element of parapets and trench walls. You could smell the front line miles before you could see it."

The poet Wilfred Owen, before his confinement at Craiglockhart, wrote in a letter: "We came to where the trenches had been blown flat out and had to go over the top. It was of course dark, too dark, and the ground was not mud, not sloppy mud, but an octopus of sucking clay, 3, 4 and 5 feet deep, relieved only by craters of water. Men have been known to drown in them. . . . Three quarters dead, I mean each of us 3/4 dead, we reached the dug-out, and relieved the wretches therein." The platoon had to move on to another dug-out which held twenty-five men. "Water filled it to a depth of 1 or 2 feet, leaving say 4 feet of air. . . . I nearly broke down and let myself drown in the water that was now slowly rising over my knees."

Men diagnosed as mental cases often feared they would lose their minds completely. Ignorance about their true malady was widespread, and many Britons thought men with shell shock had an irreversible condition or were malingerers, nothing more. "The sufferer is often haunted day and night by memories which torture him not merely by their horror but also by another aspect which is even worse: the ever-increasing moral remorse which they induce," wrote C. Elliot Smith, M.D., dean of the faculty of medicine at the University of Manchester. "A patient may be troubled not only by the terrible nature of the memory but by the recurring thought, 'If I had not done' this or that, 'it might never have happened.'"

It was assumed that remorse was a greater affliction for officers, and in proportion to their responsibilities. T. A. Ross, M.D., a psychiatrist, pointed out that the training of a common soldier in 1914 tended to make him regress to a childish attitude of compliance: "The soldier is above all things to learn to do what he is told at once without argument as a child is." Officers, however young, became the parent figure, and it was incumbent on them not to give way to panic or confusion. Dr. Ross tried to make his patients see that they were not cowards, which many of them feared, although not always consciously, and to restore their self-respect. The patients would seem to improve but often fell back and forgot what had been discussed. "The illness as a whole was their sole respectable reason for being out of the war," Ross wrote in his book, *War Neuroses*. "The illness itself was horrible, but it was the lesser of two evils."

The war lasted four years and three months. After the armistice in November, 1918, interest in the multitude of mental disorders did not wane. In September, 1920, a committee of the War Office convened for an inquiry into shell shock, to record its origins, manifestations, and treatment, and to discover ways to prevent it. The committee, largely composed of high-ranking officers and medical men, held forty-one sittings and heard fifty-nine witnesses. There were not yet any statistics on how many shell shock casualties existed, for the category was too vague.

There were the predictable opinions from men who clearly felt that too much shell shock was detrimental to the honor of a regiment. A major asserted that if morale were kept up, there would be no shell shock—as if ceaseless shelling, rats, vermin, trench foot and trench mouth, and an abundance of corpses were incidental. It was his opinion, and shared by others, that good officers and medical officers could prevent shell shock if they did their jobs well.

Other witnesses suggested that soldiers suffered from a "hysterical" form of mental illness. (Until the war hysteria was a diagnosis most often used for well-to-do women who were believed to be in need of rest and isolation.) But officers were vulnerable to "anxiety neurosis." These terms, now so old and meaningless, were still quite new to many in the medical and military professions.

Rivers urged his colleagues to believe that the experiences their men were trying to put out of their minds were "far too powerful" for the instrument of repression to be adequate. He was largely unheard.

Another decorated major believed it was a question of character. "You can never tell how a man is going to do in action until you have seen him there," he said. "Some gay and sporting types which one imagines should do well are useless; other foppish, idiotic types do splendidly. Breeding and family tradition count much among officers. The typical Irishman does well, probably brilliantly up to a point, but will not stick it like the typical Scot."

The barely concealed measure of contempt for the shell shock victim felt by so many professional officers was stated bluntly by a colonel who was the consulting physician for gas cases in France. He volunteered his opinion that the man who broke down after prolonged exposure at the Front was in a state of physical exhaustion—no witness disputed this—but classified the soldier as most likely to be "the tremulous, neurasthenic type." Only on the importance of poison gas as a factor in causing genuine symptoms was he more sympathetic: mustard gas could induce hysteria.

"In all serious forms of gas the respiratory organs are attacked, and there is nothing probably more liable to cause panic than the idea of being choked. It is rather akin to being buried alive—the dread of being slowly strangled," the colonel said.

Treatment for men suffering from shell shock varied widely. There were baths, electric shock, massage, hypnosis and hypnotic drugs, isolation, rest, and different methods of psychotherapy. Recovery was often quick, but not for the more traumatized soldiers. Sometimes the physician used harsh methods to make men recover and

was not interested in winning their trust, only in making them submit.

A twenty-four-year-old private, who was mute, was a survivor of the retreat at Mons, the Battle of the Marne, and two battles at Ypres, the names for the slaughters on the Western Front. He had also fought at Neuve Chapelle, Loos, and Armentières. But his collapse came three months later when he was stationed in Greece. Lewis Yealland, M.D., who worked in a hospital for the paralyzed and epileptic in London, wrote in his book, *Hysterical Disorders of Warfare*, that here was an intractable case.

"Many attempts had been made to cure him," Yealland wrote. "He had been strapped down in a chair for twenty minutes at a time, when strong electricity was applied to his neck and throat; lighted cigarette ends had been applied to the tip of his tongue and 'hot plates' had been placed at the back of his mouth."

The patient tried to escape the locked room but Yealland told him: "Such an idea as leaving me now is most ridiculous. . . ." After four hours of continuous treatment of electric shock, Yealland claimed to have restored speech and corrected the tremors that affected the patient's arms and legs.

Another private, buried by a collapsing trench with only his head sticking out, was hospitalized with his trunk rigidly bent forward and his head drawn back. The patient was so crooked his chest touched his thighs when he was seated. The unhappy man did not wish to answer the questions put forth by Yealland. The doctor explained what the treatment would be and wrote: "He then began to ask me if the electricity was painful, but I instantly interrupted him, saying, 'I realize that you did not intend to ask me such a question and I shall overlook it. When I began to treat you I was aware of the fact that you understood the principles which are: *Attention* first and foremost: *tongue*, last and least: *questions*, never.'"

What happened to the "cured" men, the untreated or the untreatable, and how they managed the rest of their lives is not known. The most unforgettable record of their suffering is not in the medical records but in the work of the poets of the Great War. It is these men who haunt us still and have been loved by generations of ordinary soldiers used up and hurt in the wars that were to follow. And no poem has reverberated more strongly for seventy-five years than "Dulce Et Decorum Est" by Wilfred Owen, who was killed on duty just before the end of the war came on the eleventh day of the eleventh month, 1918. It concluded:

> My friend, you would not tell with such high zest
> To children ardent for some desperate glory
> The old Lie: Dulce et decorum est
> Pro patria mori.

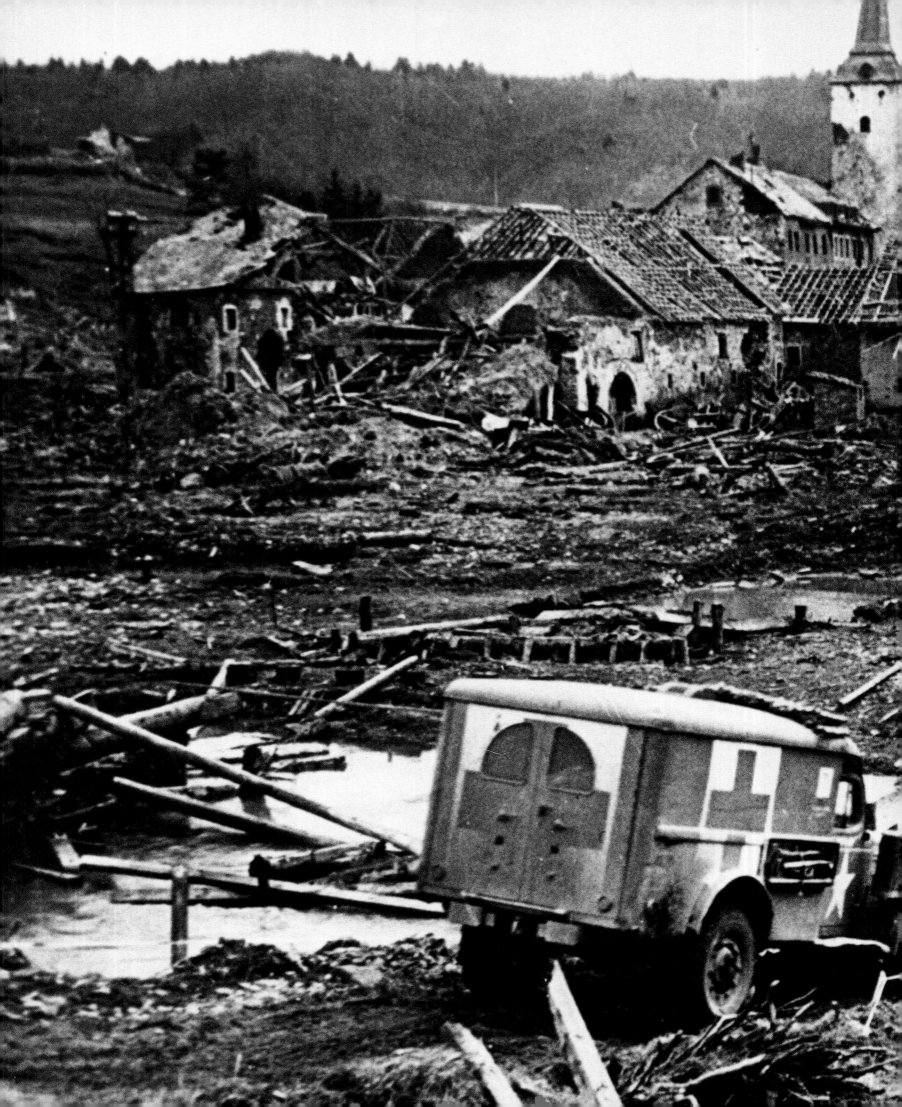

World War II

An ambulance rumbles toward a German village in the waning days of the war.
Photographer unknown
Lünebach, Germany, 1945

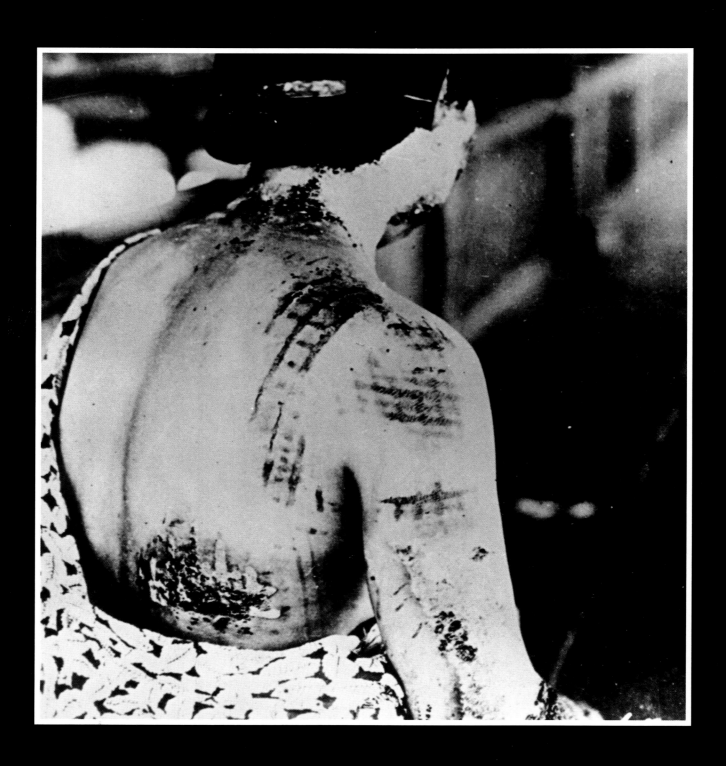

A Naked War of Sounds

A doctor in every action is always relatively protected from the naked atmosphere of aggression that envelops visible antagonists. His is essentially a war of sounds. The doctor's vision is focused downwards on immobile, sanguinous objects lying beneath his hands while only his ears range over the battlefield. He may be more comfortable in body but hardly more so in spirit. He can do little or nothing to influence events, cannot resort to violent action to relieve his feelings and must submit utterly to the discipline of his profession, allowing himself to serve as a one-way channel through which succour and healing may be brought to the wounded, without counting the cost to himself or considering his own position. If his own side abandons the field to fight another day, he must submit to the needs of the wounded and be abandoned with them. Let it not be wondered at, if the fabric sometimes cracks, rather that in the main it holds tolerably together.

—Stuart R. Mawson, M.D., *from* Arnhem Doctor, World War II

A Japanese woman awaits treatment, her back scarred by the pattern of the dress she was wearing when the world's first atomic bomb used in warfare fell on Hiroshima on August 6, 1945. Since white colors repelled the bomb's heat and dark colors absorbed it, fabric designs were burned into the skin. Estimates vary as to how many people perished in the blast itself, but most hover around eighty thousand. Many died because there was no one to care for them: nearly a third of Hiroshima's doctors were killed outright by the blast and many of the others were wounded; 90 percent of the city's nurses were either killed or incapacitated by the bomb; and the hospital buildings not completely leveled were seriously damaged. Over the next year, as doctors streamed into Hiroshima from around the world to help treat the wounded, another sixty thousand people died from the aftereffects of the bomb.
Photograph by Kimura Kenichi Hiroshima, Japan, 1945

If the medicine of previous wars concerned itself primarily with surgery, infection, and public health measures, it might be said that World War II was the physiologist's war.

Once again, the destructive capacities of armies had multiplied. At the beginning of this most extensive of all wars, air power and mobilized armor were the most striking advances in offensive military technology. The combination was used with deadly effectiveness in the strategy that the Germans called *Blitzkrieg*, or lightning war. And by the end of hostilities a new and infinitely more terrifying type of lightning had struck: atomic energy. The world is still horrified by the memory of Hiroshima and Nagasaki and the long-term effects of the radiation injuries produced there in August of 1945.

For the United States, the war began suddenly with a Japanese-style *Blitzkrieg*. Perhaps even more than the military, the medical services were caught totally unprepared for the calamitous events of December 7, 1941. The wounded of Pearl Harbor were brought to Tripler General Hospital at Fort Shafter. Tripler at that time was an old, poorly equipped, frame structure with six operating rooms on the second floor and a single elevator. Local civilian physicians had been attending an early morning lecture about five miles away when the doors of the auditorium flew open and a voice near hysteria shouted out news of the attack. A group of the doctors ran to their cars and set off

167

for Tripler, to help in any way they could. When they arrived, a horrifying spectacle greeted them. It was described years later by one of the volunteer surgeons, Joseph E. Strode.

The operating rooms, the corridors, the lanais, and the surrounding grounds were filled with a mass of severely wounded, dying, and dead. Every conceivable type of wound was apparent. Some individuals had one or more extremities blown away. There were severe head injuries. There were sucking wounds of the chest. Some had their intestines hanging out of gaping wounds of the abdomen. It immediately became apparent that many of the individuals were beyond mortal help.

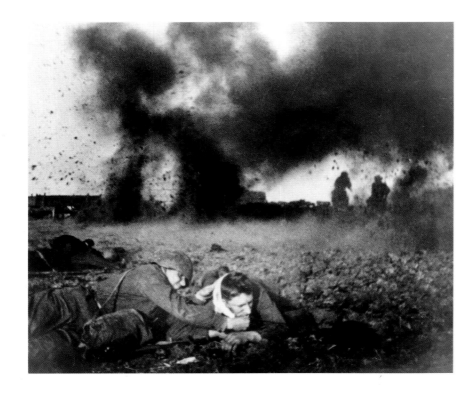

A soldier comforts a wounded buddy (*left*) as artillery fire kicks up dust during fighting between Soviet and German troops in what Russians call "The Great Patriotic War." More than 7.5 million Soviet troops died in the war; another 14 million were wounded. Contributing to this high death toll was the fact that it took an average of twelve hours for an injured Soviet soldier to receive care from his country's overburdened medical system.
Photograph by A. Garanin
Soviet Union, 1941–45

U.S. soldiers and ambulances pass through the German village of Erkelenz (*right*) as they push toward Berlin. Facing severe supply shortages and handicapped by roads destroyed by the war, the medical corps struggled to keep up with the fast-moving Allied army, and to care for large numbers of surrendering prisoners and injured civilians as well as their own troops. Forced to leave a group of men behind without medical care, U.S. Army surgeon Brendan Phibbs, M.D., wrote: "Then I had to do something extraordinarily difficult: I had to tell them that they were to wait there for assistance from the rear . . . and I had to go on to catch the column and keep up with the fighting. . . . The ones who weren't critical, we left with wounds dressed, Red Cross flags flying, guns ready, waiting for ambulances from the rear to catch up. All very logical, but the sense of loneliness was wrenching as I closed the door on the pool of yellow light and the roomful of faces, some bloody, some bandaged, all struggling to plaster reassurance over a sense of fear and desertion."
Photograph by H. W. King
Erkelenz, Germany, 1945

Strode and his colleagues went to work immediately, replacing the military surgeons at the operating tables to make more efficient use of personnel most familiar with the hospital. Only a few trained anesthetists stood by; most of the anesthesia was given by nurses using open-drop ether. Although a blood bank had recently been started at a hospital a few miles away, surgeons quickly used up its small store of plasma. The feverish activity in the operating rooms took place in the midst of frightening rumors that the Japanese had landed and were pillaging their way through Honolulu, moving ever closer to the hospital. The staff soon ran out of sterile supplies, and had no way to replace sutures, needles, or rubber gloves. Unused to the sight of so many mangled bodies, surgeons and nurses alike were grief-stricken and horrified all at once, sometimes

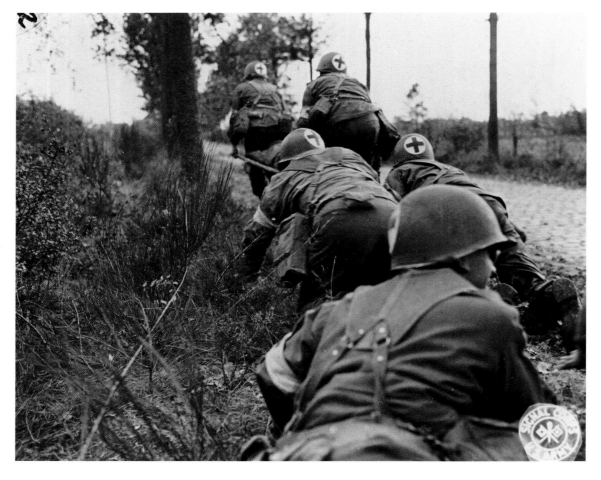

Two American medics in the Netherlands carry a wounded infantryman toward a first-aid station, while several others duck enemy fire. The medics, enlisted men with a few months of medical training, were responsible for first aid and immediate battlefield care before handing the wounded over to professional doctors and nurses. By 1943, about one-third of the practicing doctors in the United States had joined the armed forces, helping the military toward its goal of providing one physician for every 150 men.
Photograph by W. F. Sticalf
The Netherlands, ca. 1944

needing to stop for a moment to recover some sense of emotional control or to wipe away tears, a chaos Strode later described.

> *Everything was confusion. The wails and groans of the injured blended with the roar of planes overhead. The rat-tat-tat-tat of machine gun fire and the explosions of bombs, some of which pierced the roof of the building and landed on the operating floors, made us realize that we were in a somewhat precarious situation.*

Later that day, the Red Cross arrived with a load of supplies, and the staff located the hospital's reserve store of sterile linen and instruments. At about 9:00 P.M., after twelve hours of constant surgery and wound treatment under such trying circumstances, most of the injured had been seen to, and new doctors arrived to take over. "We were so completely exhausted both mentally and physically that we could no longer function efficiently," wrote Strode. "We arrived home too tired to eat, move, or sleep."

This was how American medicine got its first taste of the campaign into which its nation had been thrown. Sometimes as individual citizens and sometimes organized by their hospitals or medical schools, a vast number of American doctors now went to war, predominantly as volunteers. By 1941, the United States had developed, if not yet the most powerful military in history, certainly the most powerful medical research capability, a force it now turned to the healing of the wounded and sick. Although

America's medical readiness for wartime was badly lacking on that December morning, its strong research establishment enabled it to begin the most successful game of clinical catch-up that any major power had ever played.

America's development of a system of military blood banking and transport is a prime example. Just as the Spanish Civil War had been a testing ground for German military hardware, it had also presented a unique opportunity to study the newly developed concept of blood banking. The United States learned from the experience of that war, and went on to develop its own, more efficient military blood banking system. The method proved so effective that by 1943 it had become common practice to draw blood from thousands of donors in an American city, refrigerate it, and fly it to the battlefields of the South Pacific and later to North Africa and Europe. Scientists working under the auspices of the U.S. National Research Council had developed an effective preservative to keep blood usable for prolonged periods of time, making possible such large-scale transportation of blood.

But at times, in the earlier phases of the war, the newly established blood banking system was unable to keep up with the demands made on it by a major campaign. At a base hospital in North Africa, Major Kenneth Lowry wrote of this scarcity in his diary on the evening of February 2, 1943.

Beginning at 4:00 A.M. on the 31st, casualties began pouring in. We started operating at once and kept at it through the night, not stopping till 10:30 next A.M. Just now, 8:00 P.M., two more ambulance loads have come in. Frosty reports that casualties are on litters all over the floor of the dispensary. Surely we are taking an awful lacing

"I saw plenty of riflemen freeze under fire, but not one medic," wrote Donald M. Murray, who fought as a soldier in World War II and went on to become a prize-winning journalist. "Infantry war is lonely. Movies give the wrong impression with everyone huddled together under a camera's eye. Soldiers move apart in modern combat so one shell, one grenade, one raking machine-gun pass cannot wipe out a unit. Front line medics not only heal, they pierce the loneliness of the wounded and the dying. . . . I never doubted that in the loneliness of combat, facing attacking Germans, alone in a foxhole or crouched behind a wall out of sight of other Americans, that if I yelled 'Medic' one would come acrawling out of nowhere, through mud or snow, under rifle or mortar fire, shelling or strafing, to be at my side." Here, Pvt. Elbert Hall gets first aid from a medic during fighting.
Photographer unknown
Belgium, 1944

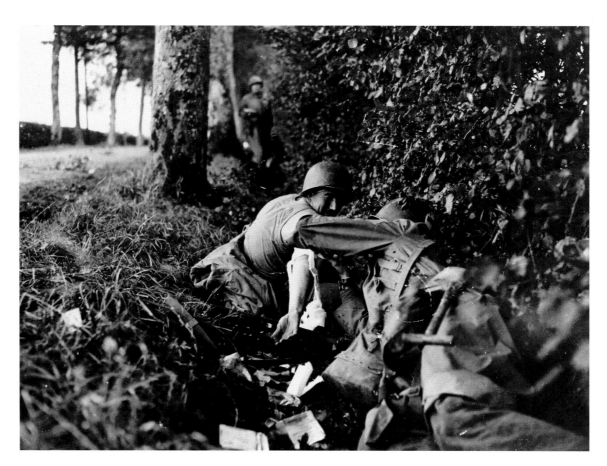

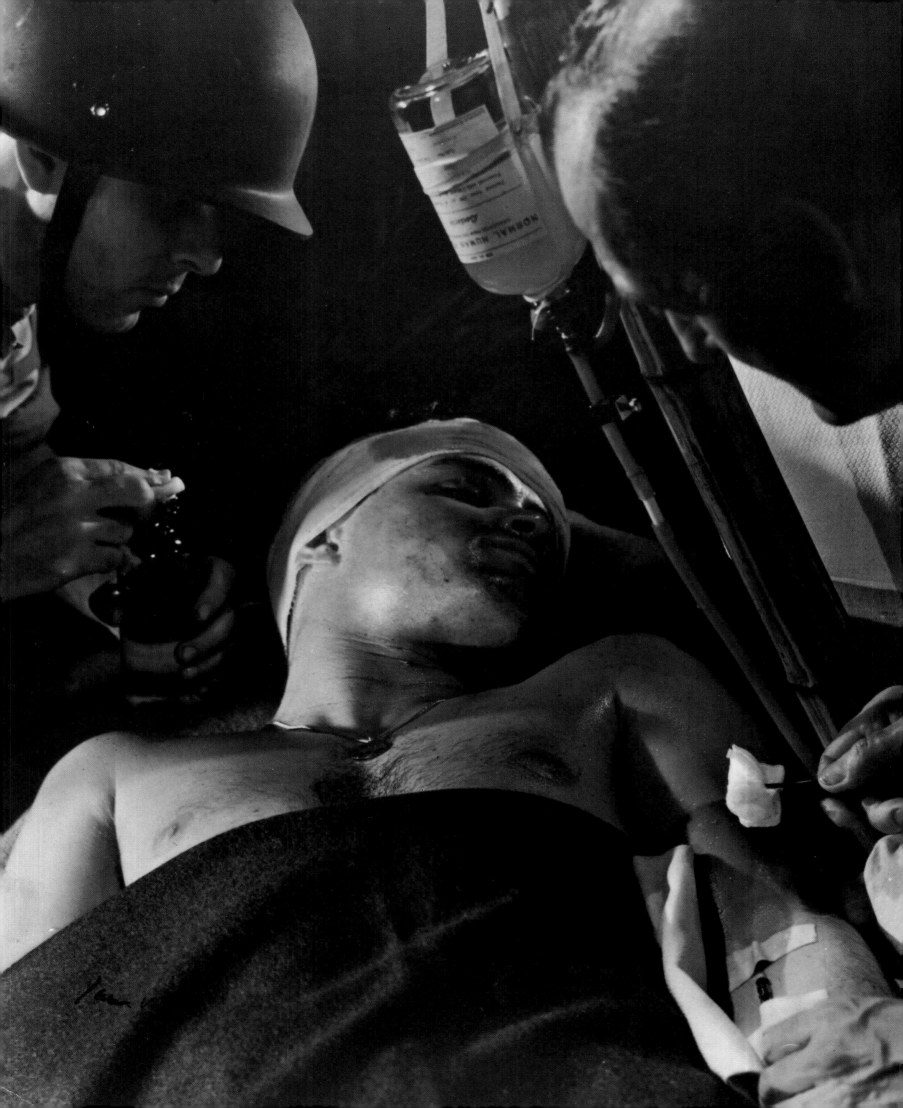

between here and Maknessey. From one company of over two hundred men, thirty-two are now living.

I certainly have a real operating crew. They are all willing to work until they drop and with never a word of complaint. We have had all types of surgery; sucking chest wounds, abdominal wounds, compound fractures, and amputations of arms, legs, feet, and thighs. Some have had an arm or leg either partially or entirely blown off, so we have no choice. To date we have lost only one case here, a lower one-third thigh amputation with multiple wounds of the left leg and thigh. He was in profound shock in spite of 1,500 cc. of plasma, 500 cc. of blood and lots of glucose. The operation did not increase his shock, but neither did he improve. More blood might have helped. Blood is so precious! So urgently needed! *What we do give is being obtained from our own personnel who are most willing, but they really need it themselves after putting in long hours without rest or sleep.*

We could not find a donor for a splendid chap from Maine last night. He was in severe shock and needed something in addition to plasma and glucose, so Frosty gave his blood, took a short rest and went back to operating again. We had to amputate his right lower thigh, do a débridement and open reduction on a compound fracture of his left tibia and fibula and then remove a shell fragment from the left temporal region. He was evacuated back in good condition this evening.

An American battlefield casualty receives a plasma transfusion in a scene repeated countless times during World War II. While the use of penicillin was probably military medicine's greatest nonsurgical innovation during the war, the use of plasma—the liquid part of blood—ranked a close second. "It saves more lives than you could believe," said Gen. George Patton of the seemingly magical fluid, which acted to restore volume to the blood of a wounded soldier. Plasma was dehydrated and packed in cardboard boxes with distilled water, rubber tubing, and needles—everything needed for an instant, life-sustaining injection in the field.
Photographer unknown
Location unknown, 1942–45

Since the researchers of World War I and its aftermath had clarified the mechanisms of shock, medical officers were now beginning to understand how to use blood transfusions most effectively. This in turn allowed physicians to carry out further studies on shock and on the entire range of alterations in human tissues caused by a decrease in the volume of circulating blood with its vital nutrients and oxygen. Plasma, the liquid part of blood that remains after the red and white cells are removed, could be used to restore blood volume and was found to have the added advantage of being easily transportable when dried. Because it required no blood typing and could be reconstituted when needed, plasma became a valuable substitute for whole blood.

Physicians soon learned that even without red and white blood cells, plasma would sometimes induce allergic reactions. Researchers devised ways to take off the separate protein fractions in the plasma so that the globulin portion, the source of the allergic response, could be removed. The wartime work on blood substitutes and fractions resulted in vast amounts of postwar research and the consequent availability of a variety of blood components and derivatives, now invaluable remedies for hepatitis, hemophilia, shock due to injuries or burns, and a number of other medical problems.

Red blood cells carry oxygen to the tissues, but no amount of blood will avail if the lungs cannot deliver proper amounts of oxygen into those cells in the first place. With the advent of military airpower it became necessary to study the physiology of respiration. In World War I, planes seldom flew higher than the critical level of eighteen thousand feet, so pilots and gunners rarely had to reach for the crude oxygen masks of the time. Studies done during World War II showed that exceeding this altitude resulted in dangerously decreased alertness, vision, and mental and physical efficiency; and with airplanes

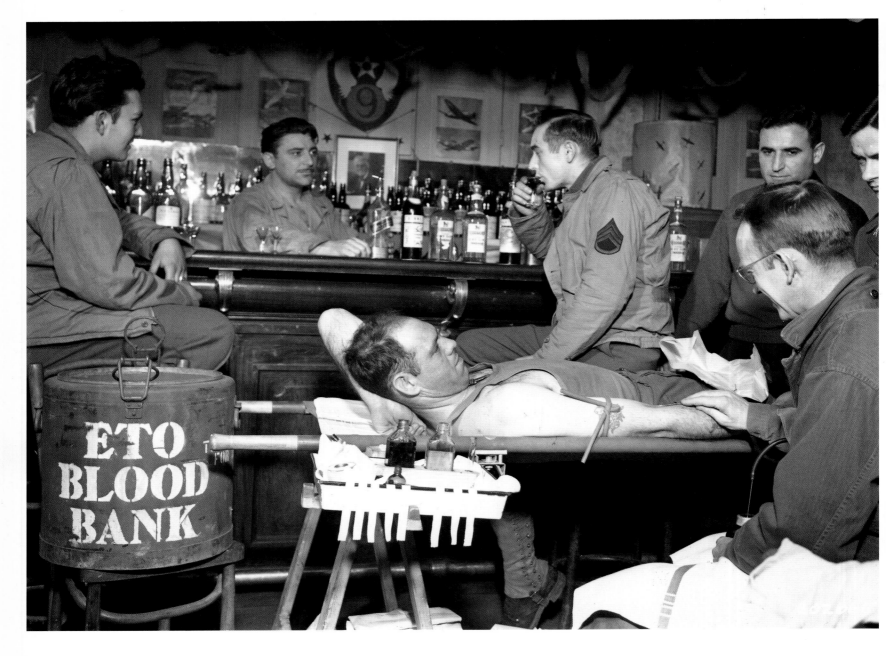

Sergeant William E. Mitchell donates blood (*above*), answering one of several emergency calls for donors during the war. In 1943, the Army and Navy had estimated that they would need four million Americans to donate blood in that year alone, and those already serving the war effort weren't exempt. At home, the American Red Cross set up thirty-odd "bleeding centers"; the first opened in New York on February 4, 1941. Once collected, bottles of fresh blood were shipped to local labs for processing, sent in refrigerating units normally used for fresh fish and fruits.
Photograph by Sergeant Lovell
Location unknown, 1945

Members of the Army Blood Transfusion Service separate plasma from whole blood at Southmeads Hospital, Bristol (*right*). Transfusions saw relatively limited use in World War I: early in the war, coagulation difficulties meant that donor and recipient had to be in the same room, arms linked with plastic tubing during the procedure; after advances made in 1915, the recipient still had to be close by, though blood could be briefly preserved. Storing blood for transfusions first became truly practical during the Spanish Civil War (1936–39), under the guidance of Jose Trueta, M.D., one of the more innovative surgeons of his time. The

European Allies adopted Trueta's lessons early in World War II, and used a combination of plasma and whole blood throughout the war, but Americans were slow to use whole blood—primarily because Army Surgeon General Norman T. Kirk, M.D., was convinced that plasma was easier to ship and store, and just as effective. The British blood program—in place when the war started in 1939—was a model among the Allies: the A.B.T.S. in southwestern England alone had 100,000 volunteers who each gave, on average, a pint of blood every three months.
Photograph by Fox
Bristol, England, 1941

174

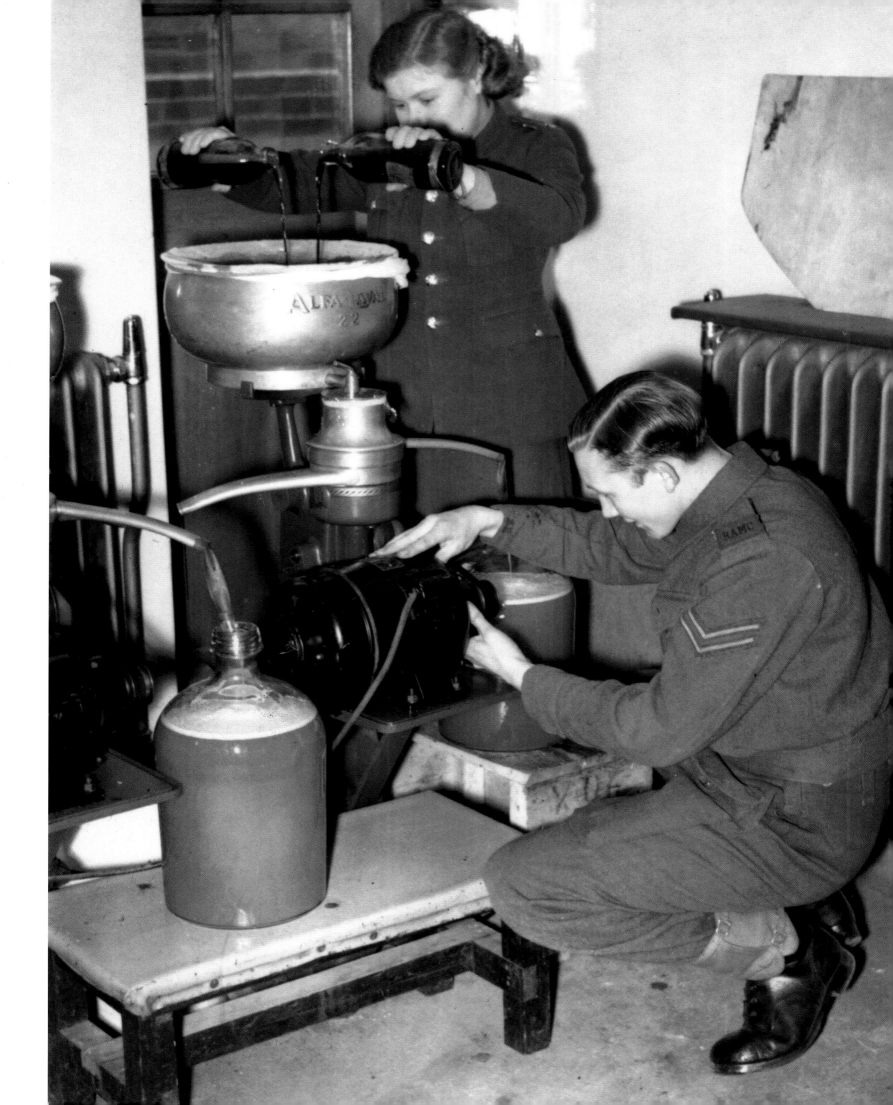

now flying at up to thirty thousand feet, the problem of oxygen deprivation had to be solved. It became one of the first challenges of the new field of aviation medicine.

The pressing need for solutions became an emergency during the early stages of the Battle of Britain. By the summer of 1940, the Germans had developed systems of oxygen supply that enabled their fighters and bombers to attack at an altitude where the air-hungry defenders could not compete on an equal basis. Scientists at England's Flying Personnel Research Committee went urgently to work on the problem and quickly came up with an efficient oxygen mask and delivery system that allowed the British to intercept the *Luftwaffe* at its own altitude. On September 15, 1940, the British pilots shot down 186 German aircraft, effectively ending the worst of the Battle of Britain. Although other critical military and aeronautical factors clearly swayed the outcome of this air war, none of them would have made a difference had not the oxygen problem been solved.

Airplanes had uses other than battle or the transportation of matériel and combatants. Aeromedical evacuation became a standard way of rapidly removing injured soldiers to large, well-equipped hospitals. Patient care begun on the battlefield was taken over by a doctor, nurse, or medic when the wounded were put on the plane, and was continued to the point of destination. Air ambulance squadrons, trained for this specific purpose, cared for the 700,000 troops who underwent military air evacuation during the course of the war. Helicopter medical transport, though now conceived and tested, saw only limited use until the Korean War, and would not reach its full potential until Vietnam.

The two surgical specialties that experienced the greatest changes during World War II were plastic and chest surgery. The treatment of burns, the repair of injured hands, and the reconstruction of limbs underwent a great deal of progress as the innovations of wartime surgeons led to an improved understanding of how, by restoring the structure of a human limb, they could also restore its function. The American subspecialty of hand surgery was born under the influence of advancing technology and in response to the large numbers of injuries caused by hand-to-hand combat by U.S. Marines in the islands of the South Pacific.

In 1945, the U.S. Army Surgical Research Unit was established as the first American hospital for the treatment of burns, the forerunner of the specialized burn centers in various parts of the country today. Plastic surgeons working during wartime returned home to become the teachers of the next generation of their specialty, so that by the early 1960s, training programs had been started in many university centers. It had taken a worldwide conflagration to make all of this happen.

Thoracic surgeons, who until World War II were involved primarily with infections of the chest cavity and wall, now began to operate on the lung itself. With increasing boldness, they learned to stitch the lung, excise its diseased portions, and remove shrapnel and bullets from its depths, as well as from the muscle of the heart. Following the Allied invasion of Italy in 1943, Colonel Lyman A. Brewer III, a volunteer army chest surgeon, identified a condition he and his colleagues called "traumatic wet lung" in severely injured patients, particularly in those who had undergone large transfusions of blood. Leakage of fluid into the delicate tissue of the lung, which prevented the exchange of oxygen and carbon dioxide, caused this pathology. Army doctors responded

A sailor is rushed to sick bay following a fire on the flight deck of the USS *Enterprise* in the South Pacific. Major progress was made in the treatment of burns during World War II, thanks to the use of antibiotics to prevent infection; blood transfusions to forestall shock; morphine to relieve pain; and the introduction of proper splinting and skin grafting to keep the skin from contracting and scarring. *Photographer unknown South Pacific, 1944*

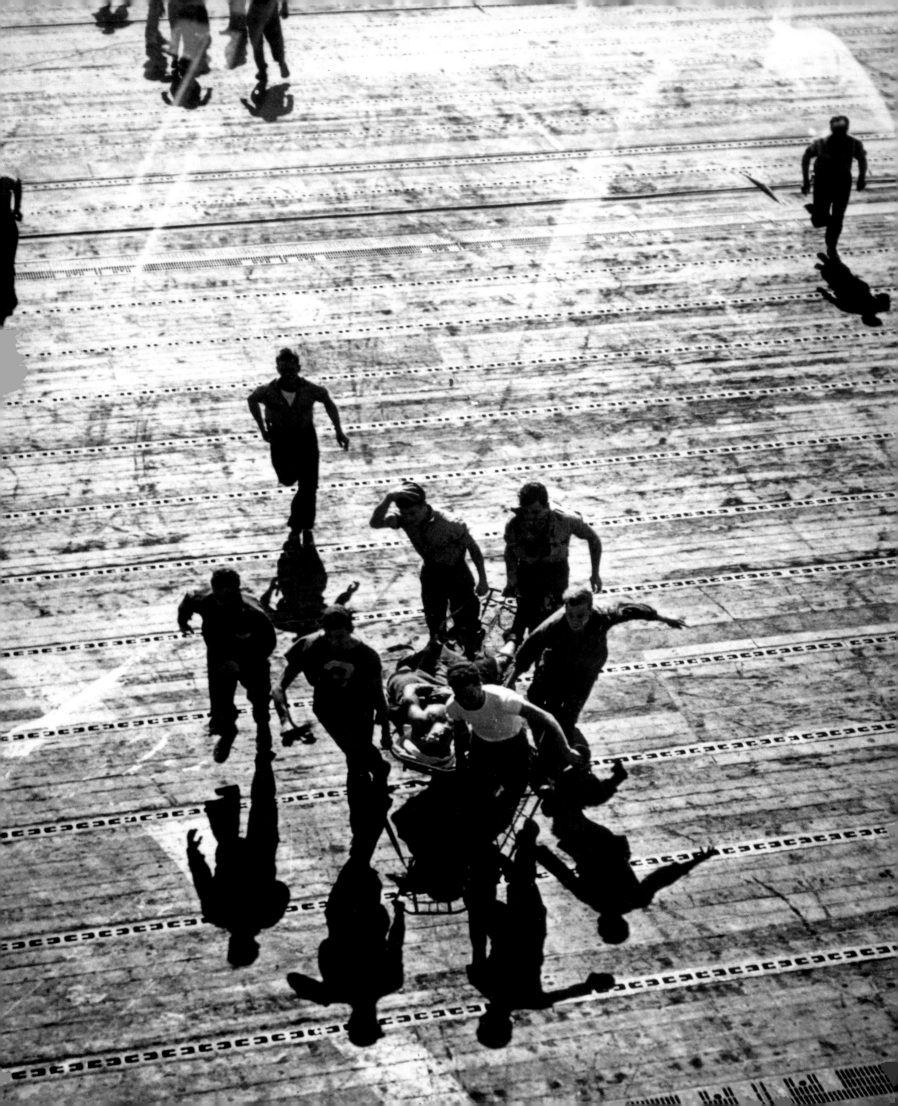

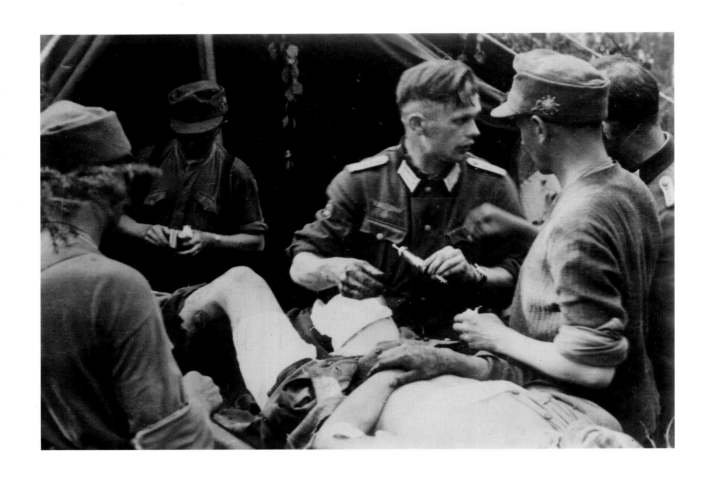

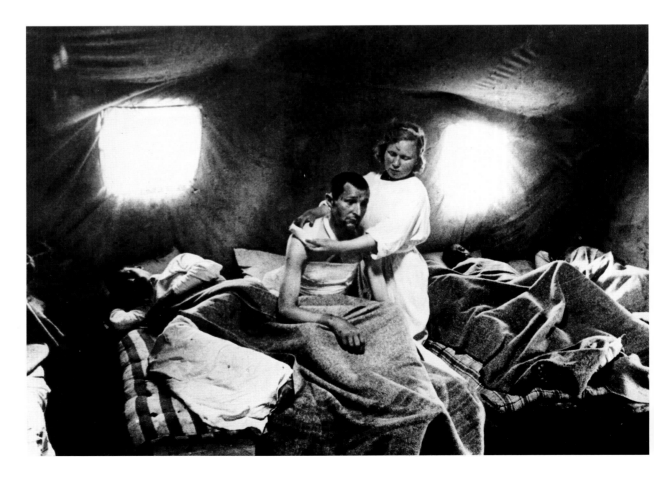

A German medic prepares a tetanus shot (*above left*) in an effort to ward off this often-fatal bacterial infection. Because war—with its poor sanitation, crowded conditions, and prevalence of open wounds—is the ideal environment for the spread of tetanus, it also proved ideal for testing the disease's antitoxin. The wounded were first given tetanus shots in World War I, but it wasn't until World War II that most soldiers were given preventive tetanus shots during basic training. The antitoxin, now routinely prescribed for all American civilians as well as servicemen, has virtually eliminated the danger of this disease in the United States.
Photograph by Bringmann
The Russian Front, ca. 1942

"To lighten our suffering," wrote a soldier wounded in WWII, "there was the unchanging kindness, cheerfulness and devotion of our nurses": here, a Soviet nurse comforts a soldier (*below left*). But nursing was likely to take its toll. "To have to look after cripples, mangled and wounded people who might be happily leading normal lives, makes me very bitter," one English nurse told author Phyllis Pearsall. And 2d Lt. Anne McCaughey, a Pennsylvanian who served in England, wrote in her diary that Army nurses "have a cynical attitude toward life and people, yet withal have managed to preserve a childlike innocence."
Photograph by O. Knorring
Soviet Union, 1942

In the heat of an underground surgery room behind the front lines, an American Army doctor operates on a U.S. soldier wounded by Japanese sniper fire on the South Sea island of Bougainville (*below*). In his book *The Wounded Don't Cry*, British journalist Quentin Reynolds wrote of the formidable conditions he observed the Allied doctors facing throughout Europe. He described one medical team during the evacuations of Paris in June of 1940: "Both surgeons had been doing this for ten hours now and they looked tired. Everything about them was tired except their hands, which were quick and fine and sure."
Photographer unknown
Bougainville, Papua New Guinea, 1943

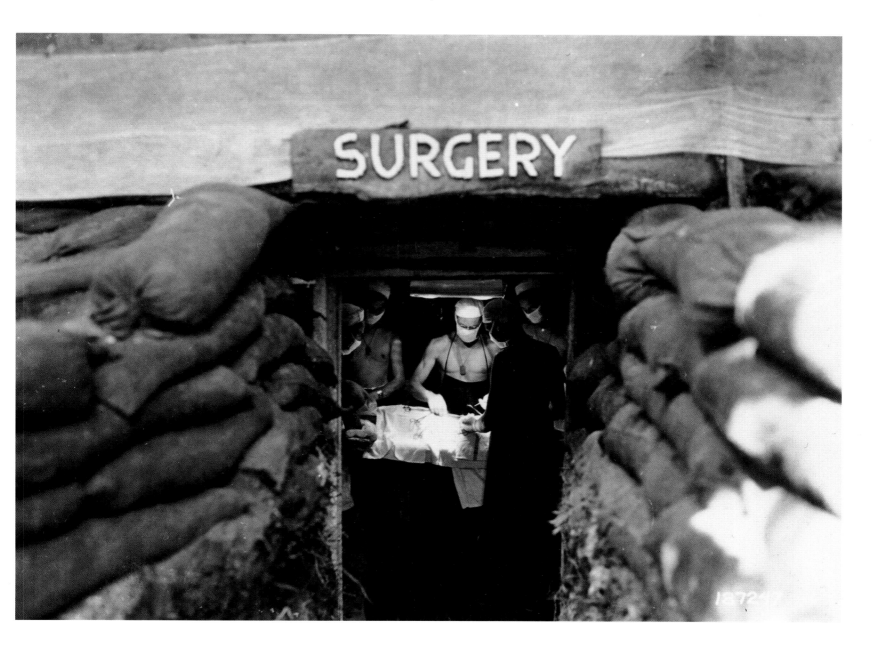

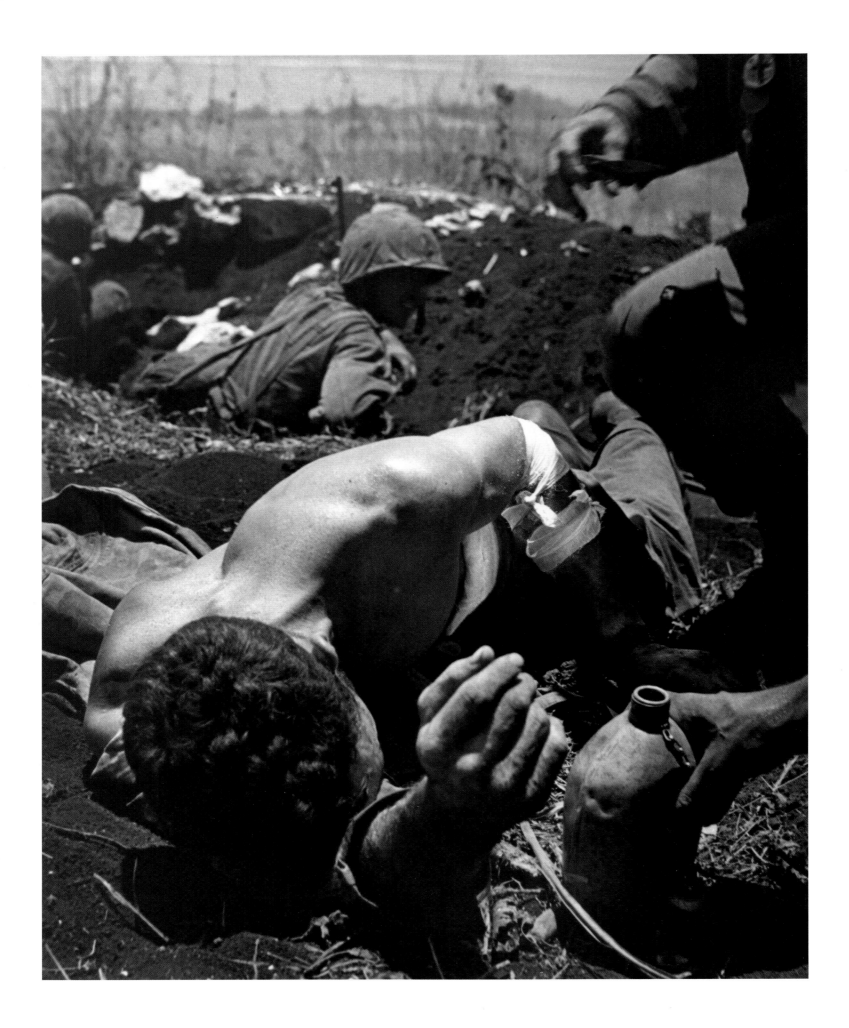

by inventing the first positive-pressure oxygen machine for intermittent inflation of the lungs. "Wet lung" would in later years come to be recognized as a common medical problem in civilian hospitals among patients critically ill from trauma, infection, shock, or disease.

In surgery and in treating infections of all types, the introduction of antibiotics created a heady sense of optimism that proved—at least initially—unjustified. Sulfa drugs were originally used on a large scale to treat the victims of the attack on Pearl Harbor, and it was soon a standing order that sulfa be put into all wounds. Unfortunately, the method not only proved ineffective, but may actually have caused contamination by acting as foreign material. Penicillin, widely introduced during the North African campaign in 1943, created the optimism anew, but this time with good reason. Penicillin had fewer potential side effects than sulfa and had the added advantage of actually killing the offending bacteria, rather than merely stopping their growth. Many operations that might otherwise have been mandatory could now be avoided. It became possible to save a great deal of injured tissue that previously would have been sacrificed in enthusiastic debridement to avoid the spread of infection—and possible for doctors to save a great many more lives. Penicillin was much more effective in most situations than sulfa drugs; it completely changed the complexion of civilian medicine after the war, as it was joined by other products of the new antibiotic era.

One of the most welcome changes occurred in the treatment of venereal disease after 1942, when physicians at Bushnell Army Hospital in Brigham, Utah, proved the effectiveness of penicillin against those two ancient shadowers of armies, syphilis and gonorrhea. For the first time since the sudden appearance of syphilis among European soldiers in 1494, armies were no longer crippled by the loss of vast numbers of venereally infected troops.

In spite of every research-based advance, the focus of military medicine remained the treatment of the individual soldier, sailor, and airman. For the army, definitive care began in the field hospital. Each of a field hospital's platoons worked out of ten ward tents, four of which were laced together in the form of a cross. These tents housed receiving, x-ray and laboratory, surgery, and postoperative care functions. Major Clifford Graves, a surgeon with the Third Auxiliary Surgical Group in France, described how the system worked.

A receiving tent operating at capacity presented a unique spectacle. Casualties were delivered anywhere from one hour to several days after injury. The average was four to six hours. Contrary to what one might expect, these soldiers rarely made a noise. With the grime and dirt of the battlefield still on their faces and in their wounds, they were preoccupied with what they were doing when they were struck. Some mumbled about the grenade or the shell or the booby trap that hit him. Others lay quite still or groaned softly. Most were in shock. All took it for granted that they would recover. Hadn't they been told that only three per cent died? How fortunate that they did not know the facts. The overall mortality did indeed run to about three per cent, but in the field hospital it was closer to twenty-five per cent. Often it went even higher!

A wounded Marine in Iwo Jima is offered a precious, much-needed sip of water. In the early years of World War II, American commanders held fast to the mistaken notion that it was unhealthy to drink water during battle. As a result, there were scores of avoidable casualties from dehydration in the deserts of North Africa and the jungles of the Pacific. By the time the brutal battle of Iwo Jima was under way in February and March of 1945, military doctors had convinced commanders of the need to drink water on the battlefield. It didn't take much persuasion, however, to get the wounded to take their advice, since blood loss dramatically increases thirst. *Photograph by W. Eugene Smith Iwo Jima, Japan, 1945*

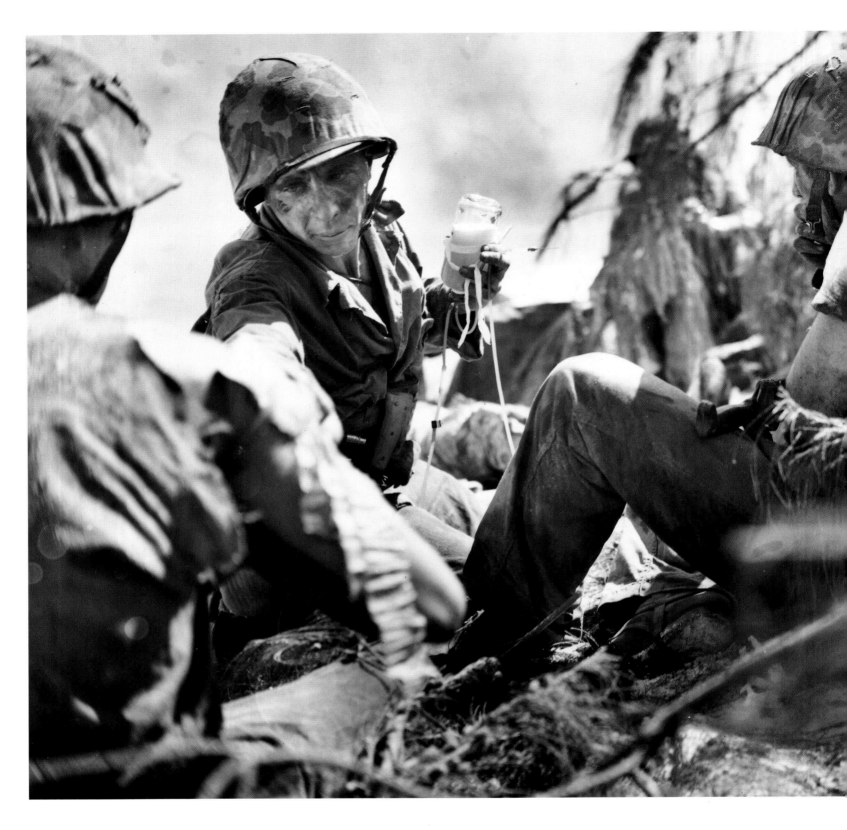

With Allied troops fighting the Japanese for control of the Mariana Islands in the South Pacific, a Marine receives plasma at an aid station on the front lines. U.S. field medics typically carried kits containing splints, tourniquets, bandages, and even needles and small amounts of morphine. Aid stations near the battle scenes were equipped with plasma and drugs such as sulfa tablets, the predecessors of the antibiotic penicillin. From these emergency aid stations, the more seriously wounded were evacuated to medical stations and mobile hospital units a few miles behind the battle lines.
Photographer unknown
Saipan, 1944

Third Auxers quickly learned that field hospital casualties were of three kinds: one-third had abdominal injuries, another third had chest injuries, (often combined with abdominal injuries), and the remaining third had severe extremity injuries. Combinations were common. In fact, about one-third of all casualties had multiple wounds, usually a desperate situation.

In the dim light of a tent, one casualty looked like another. Actually, no two were alike. There was no telling what the wounds would show, once the bloody blankets had been discarded and the clumsy dresssings cut away. There might be just one small puncture wound or there might be a hundred jagged lacerations. One man with a tiny perforation in the flank might be in profound shock while the next one with part of his intestines out on the abdomen would nonchalantly ask for a cigarette.

When a Third Auxer recalls his experiences in the receiving tent, one or two incidents will probably stand out in sharp relief. Perhaps he will see the mortally wounded sergeant who used his last breath to say: "Please get me back to my platoon. There's nobody knows those boys like me." Perhaps he will see the raw recruit who pleaded: "Major, please take my leg off. I know it's no good." Perhaps he will see the fatally burned paratrooper who charged into a flame thrower to bayonet his attacker. Perhaps he will see the arrogant German Feldwebel [sergeant] *who clawed at his splints and spat at the nurse. Perhaps he will see the disciplined grenadier who sat at attention when he was spoken to and keeled over dead two minutes later. A receiving tent showed human nature in the raw.*

Resuscitation was next. It involved everything from blood transfusions to bronchoscopy. Then came the diagnostic procedures, the x-rays, the catheterizations, the intubations, everything that modern surgery demands. The technicians took over a great many of these tasks. They learned quickly and they developed great skill.

From the receiving ward the casualty went to the operating tent. Here, in a narrow, rectangular space with sloping roof and muddy floor, the surgical team held forth. Conditions might be primitive but performance was superb. Two or three operating tables filled all available space. White liners hung from the canvas to improve the light and keep dirt from dropping on the wounds. Improvised reflectors cast their beams on the litters. The team distributed itself. Usually, the leader worked with the second assistant. The first assistant worked at the other table with a technician. The anesthetist went back and forth. At any time he might be called to the receiving tent for an emergency. In a civilian hospital, casualties of this sort would throw the receiving room into uproar for hours. In the field hospital, they came in by the ambulance-load, not once a day but all day and all night.

The postoperative tent too was a fantastic sight. Every cot was flanked by a pole with a bottle of glucose or blood. Some patients had chest tubes draining into water-seal bottles. Others had nasal tubes emptying into the field-version of a suction apparatus. Still others had bladder catheters or oxygen masks or plaster casts. Each patient fought his own battle. The days were long, the nights were cold, the cots were hard, the comforts were meager. As long as there was work to do, Third Auxers did it.

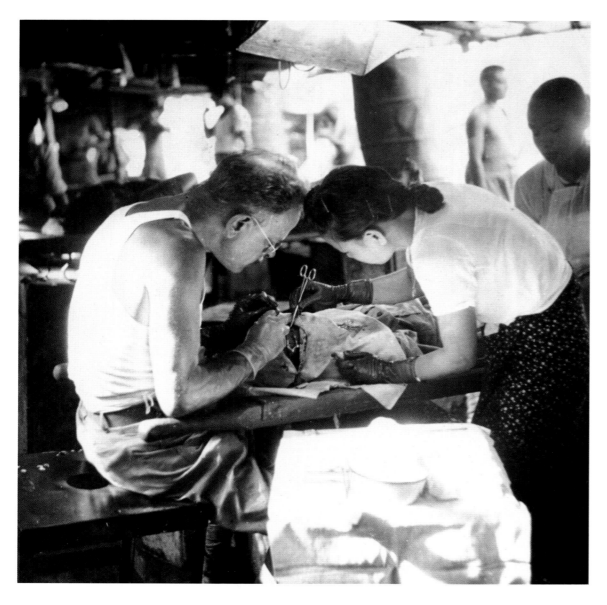

Gordon Seagrave, M.D., head of the portable hospital at Myitkyina in northern Burma, operates on a patient with the help of one of the nurses he trained during the more than forty years he spent practicing medicine in the southeast Asian nation. The son of Christian missionaries who had been in Burma since the 1830s, Seagrave—who came to be known by his patients and nurses alike as the Old Man or simply Daddy—was born in Rangoon and studied medicine at Johns Hopkins University before returning to Burma in 1922 to build hospitals and teach nursing. He worked with the British and Americans during World War II, earning the rank of major in the U.S. Army and amassing material for two best-selling books, *Burma Surgeon* and *Burma Surgeon Returns*. When he died in 1965, Seagrave had become one of the world's leading experts in tropical diseases.
Photographer unknown
Myitkyina, Burma, 1941–45

Ingenuity was a requirement for the medical personnel of a field hospital. But it was not only the front-line doctor, nurse, or medic who was forced by necessity to think up innovative ways to do things. For researchers, too, hardship bred invention. When Japanese forces seized Java, they seized with it the trees that were the world's only natural source of quinine. The United States had to find either a new source of quinine or another treatment for malaria: pharmacologists came up with Atabrine, a synthetic medication. Large-scale testing was done on a willing pool of conscientious objectors and prison volunteers to provide rapid confirmation of the drug's efficacy.

Because of the major epidemics of typhus in World War I, researchers fought to develop more effective insecticides and eventually found DDT successful. Despite the problems arising with DDT in recent years, it was a benison to Army physicians in every combat and occupation zone after its introduction to delouse the populations of Naples and other southern Italian cities. From that time until the liberation of the Nazi death camps, DDT proved to be an invaluable agent in the destruction of typhus-bearing lice.

The most effective mass inoculations of combatants ever attempted occurred in World War II. In the Civil War, the tetanus mortality rate was in the range of 90 percent of the diagnosed cases. Although tetanus antitoxin was used to inoculate troops in World War I, the mortality rate remained high, estimated by some to be nearly 50 percent. But of 10.7 million soldiers in World War II, doctors found only eleven cases of tetanus, of whom six had somehow not been given the tetanus toxoid. Of the four men who died, two were in the nonimmunized group, and the other two had not received a booster shot. Brigadier General Elliott C. Cutler, the chief surgical consultant in the European Theater of Operations during the war and in peacetime a professor of surgery at Harvard University, stated the situation succinctly: "This is, in my mind, one of the great miracles of modern medicine."

A folk hero to many Chinese, Canadian Norman Bethune, M.D., operates on a soldier at a small temple in a village near Beijing, less than a month before he died of blood-poisoning at age forty-nine. Bethune created a mobile operating unit during the Sino-Japanese War, on the eve of World War II. An ardent admirer of the Chinese Communists, he explained to Mao Tse-tung that with a mobile surgical unit he could save three-quarters of his seriously wounded soldiers by operating on them immediately. Mao sent Bethune to northern China, where for two years he waged a one-man campaign to modernize China's wartime medical practices. "The hospital 'staffs' here consist of 'doctors' of 19 to 22," he wrote in his diary in March of 1939, "not one of whom has had a college education or been in a modern hospital or medical school. The nurses are peasant boys of 14 to 18." Despite the hardships he and his staff endured, Bethune described himself as a happy man: "I am doing what I want to do. I have vital work that occupies every moment of my time. I am needed." Bethune's body lies in the Mausoleum of Martyrs in the city of Shijiazhuang, where a hospital and medical school bear his name.
Photographer unknown
Near Beijing, China, 1939

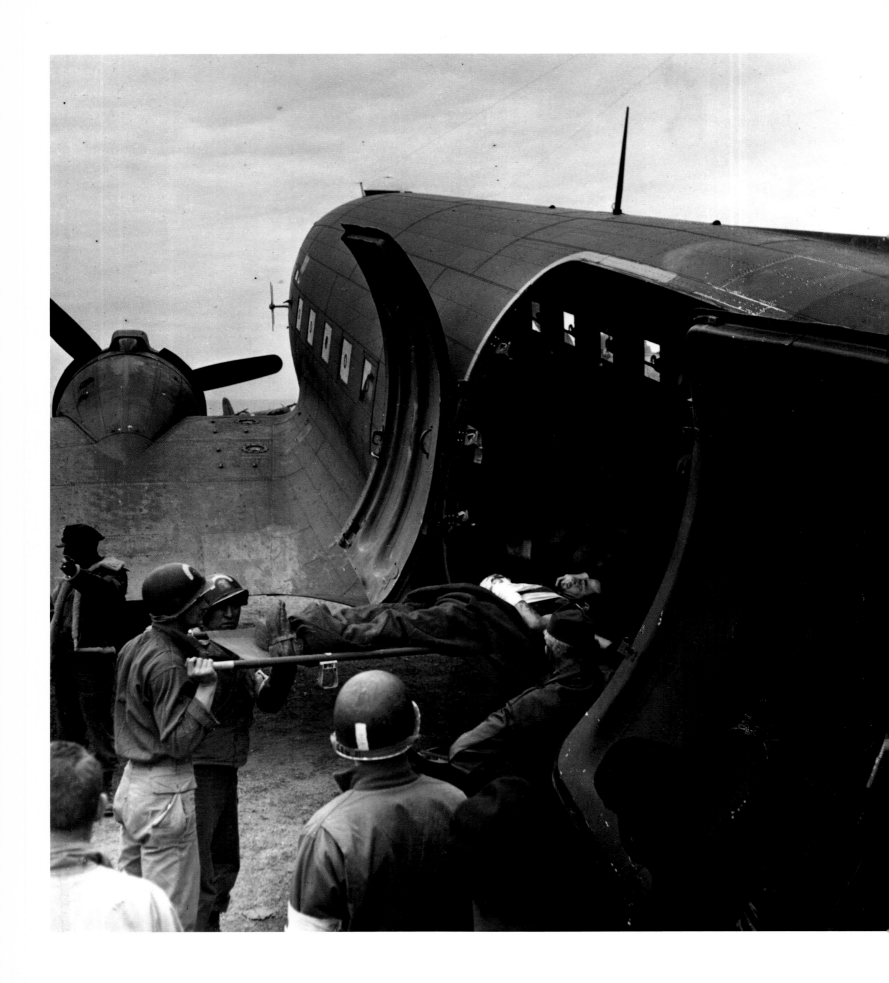

While aircraft saw widespread use as evacuation vehicles for the first time in World War II (*left*), the air war also created a new set of medical problems caused by vibration, acceleration, and glare—and flying at high, oxygen-thin altitudes. Flight surgeons, newly created medical specialists, monitored the training and diet of the young fighter pilots, and examined them for signs of fatigue or mental strain that might impair their judgment, endanger their missions, or lower their chances for survival.
Photograph by Lee Miller
Normandy, France, 1944

Jungle warfare posed a host of strategic medical issues, not the least of which was how to transport the wounded to medical tents through dense, often trackless bush. In Burma, field hospitals were set unusually close to the battle lines, to shorten the distance that soldiers had to travel with their wounded comrades on their backs (*above right*). Medical supplies were either packed in by porters or dropped in boxes from the air—with or without a parachute.
Photograph by Cecil Benton
Burma, ca. 1943

A native of Papua New Guinea leads a blinded Australian soldier to an Allied camp (*below right*). Many Pacific Islanders helped the Allied cause by working as stretcher-bearers over rough terrain. According to Brig. W. P. MacCallum, writing in *Medical Services in War:* "Words cannot describe the loyalty and devotion of these men, nor estimate their heroism and strength. Often it required a team of twelve native bearers to carry a stretcher of their own contriving over the most appalling country."
Photograph by George Silk
Papua New Guinea, 1943

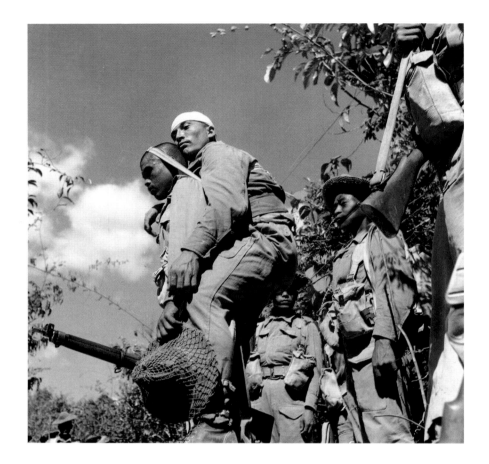

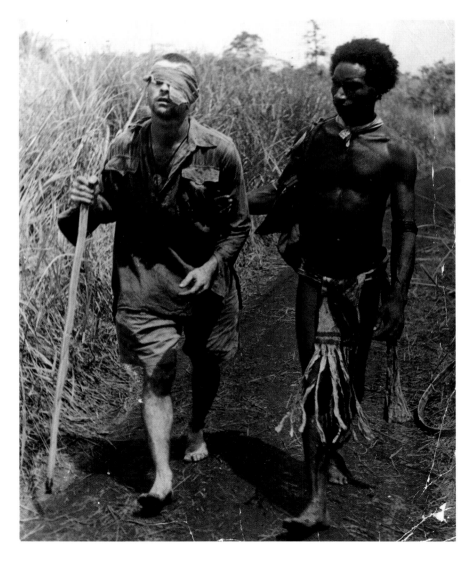

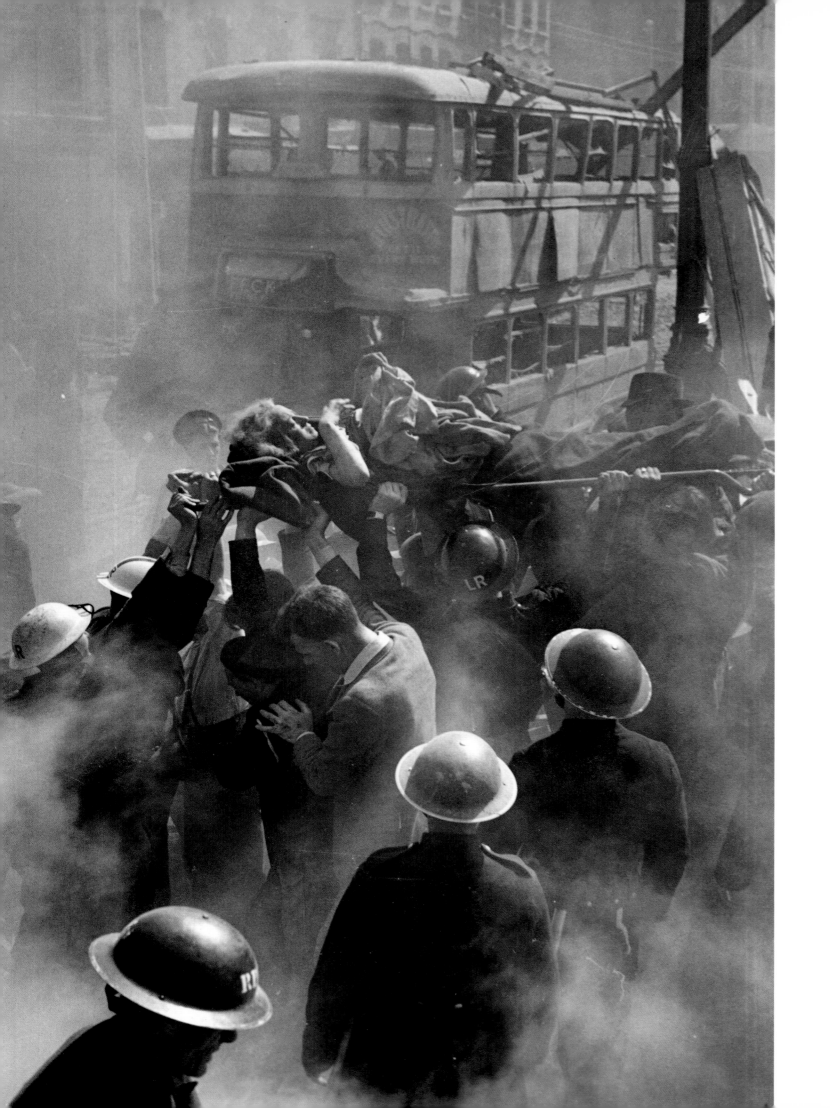

In spite of the tens of millions of soldiers and civilians who had died by the last months of World War II, no thoughtful person surveying the medical scene in mid-summer of 1945 could be blamed for believing that humankind's power to heal might just be achieving some equality with its power to kill. And then, at 8:15 A.M. on August 6, the naiveté of such a belief was made dreadfully obvious. The bomb called Little Boy was dropped from the Enola Gay, exploding with a certain macabre irony directly over Shima Hospital, and ultimately taking more than 140,000 Japanese lives with it. History itself appeared to be mocking the hopefulness of the healers.

The atomic desert left by Little Boy covered an area of more than four square miles. When the second bomb, called Fat Man, hit Nagasaki three days later, the damage was somewhat less, probably because some of the city was shielded by steep hills. Even so, 44 percent of the community was destroyed.

Some of the medical problems in Hiroshima and Nagasaki were as old as war itself, but some had never before been seen in any military campaign. Radiation sickness made its first hideous appearance, followed with dreadful long-term certainty by genetic disturbances and then malignancies. The Japanese haltingly surveyed and tried to deal with the devastation, but many of their doctors and nurses were severely wounded or killed. When the U.S. occupation forces arrived in Japan, they brought with them medical teams to begin the studies that have since continued as a collaborative Japanese-American effort, and remain as the only reliable source of measurements linking radiation dosage with disease.

Rescue squad workers, who often risked death from broken gas lines or falling beams, carry a woman to safety during the London Blitz. Most of the doctors and nurses available to treat civilians were women, since male physicians worked in military hospitals at home and on the front. Said one nurse of the all-female staff at her hospital: "Our surgeons are wonderful. . . . I work in the [operating] theater and what does astonish me is to see our women surgeons looking so delicate and frail compared to the terrible casualties they were operating on; and yet last Wednesday they worked something like twenty hours on end without a rest." Some ninety-four thousand Londoners were killed or seriously wounded in the seven-month-long Blitz.
Photograph by George Rodger
London, England, 1940

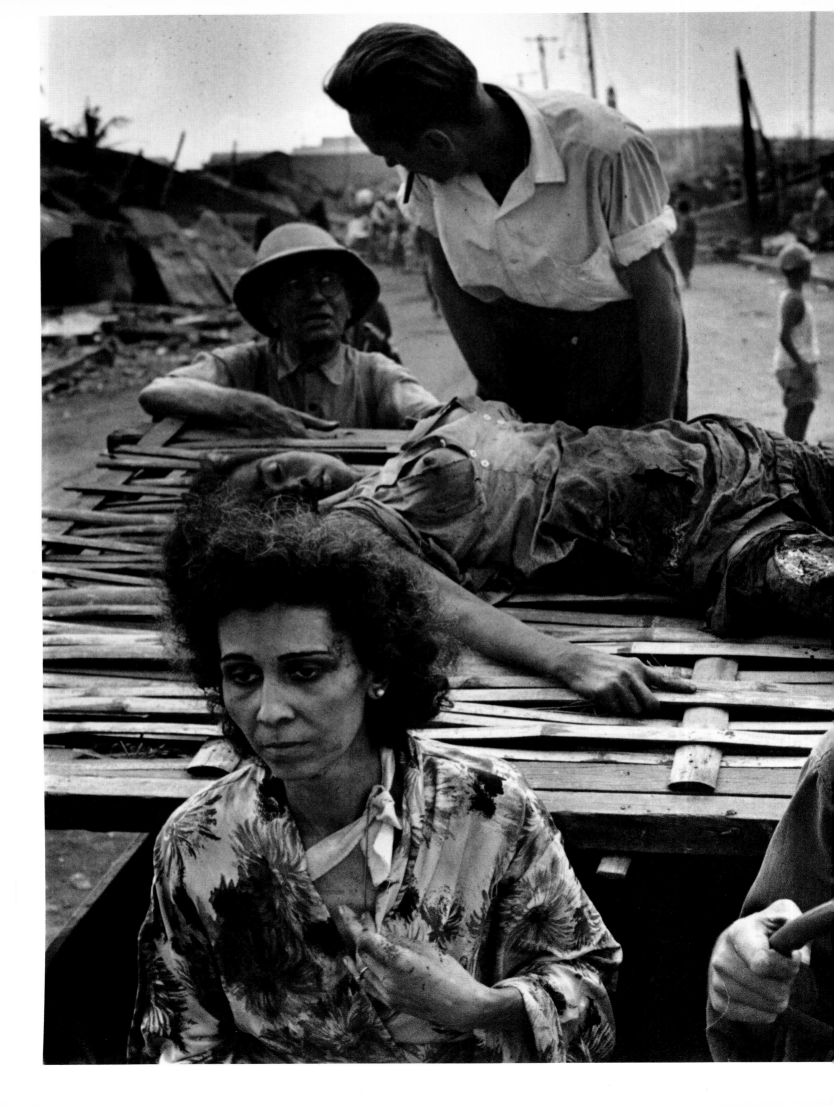

The photojournalist is not always a detached observer, as Carl Mydans can attest. In a 1992 interview, he recalled his encounter with this wounded girl (*left*) on February 15, 1945, while American and Filipino forces were battling the Japanese for control of Manila.

"I found her sitting in debris against a blasted wooden building. Her leg wound was awful. 'How long have you been here?' I asked her.

"'Since yesterday,' she whispered. I had to bend close to hear her.

"'When yesterday?'

"She thought. 'In the morning, I think.'

"'Has anybody helped you?'

"She whispered, 'No.' She was frightened.

"Frank Robertson, an Australian reporter, was with me. We called on Filipinos to help. We broke down a bamboo gate and got her on it and then lifted the gate onto the back of a jeep. I had a morphine syringe in my combat aid kit and I gave her an injection and wrote a note on a picture caption slip saying I had given her the morphine and attached it to her dress.

"An American medic, a lieutenant, came by and looked at her. It was a quick look in the heavy fighting with wounded all around us. He said to the jeep driver, 'Take her to the medic station up the street.' Then he said to me, 'No good. She got gas gangrene. She won't make it.' And he went further into the battle.

"Later I found the medic station where they had taken her and they remembered her. She had died soon after she got there."
Photograph by Carl Mydans
Manila, Philippines, 1945

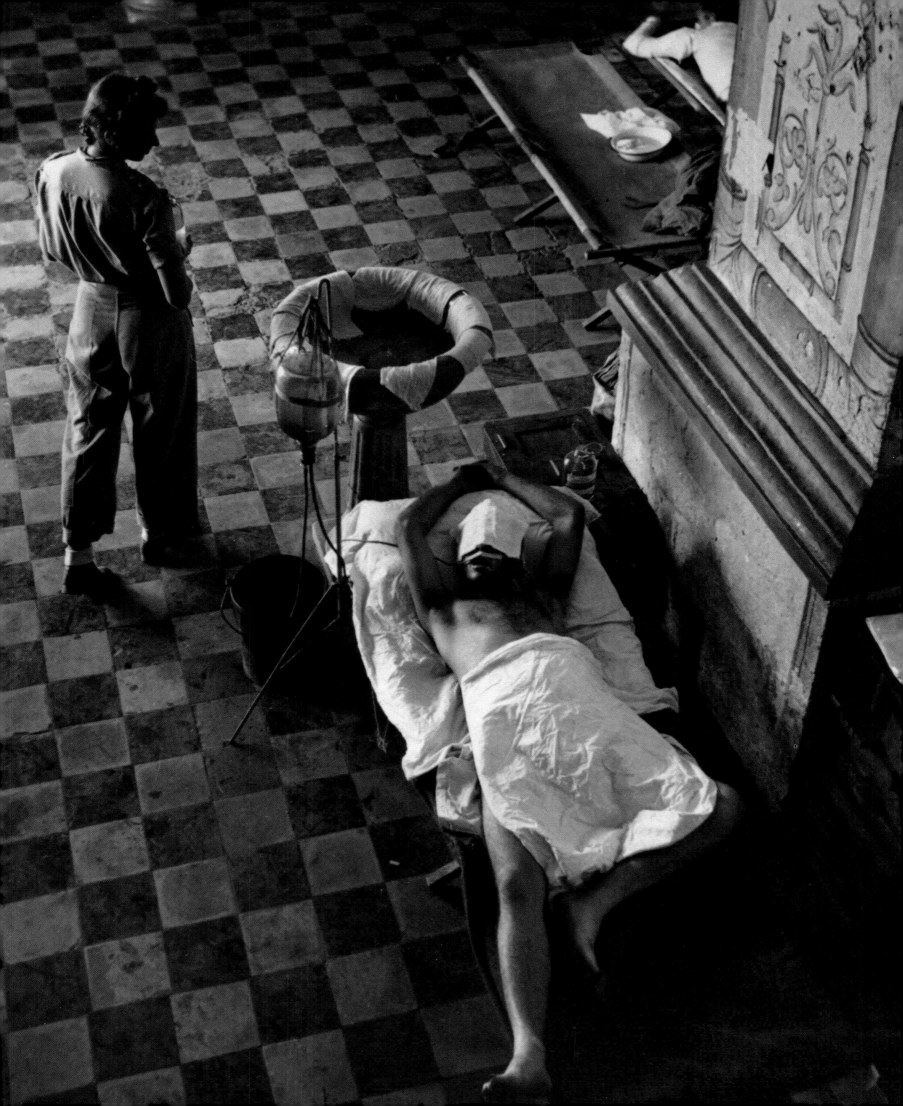

"There are no atheists in foxholes."
Every culture in the world seems to
have its version of this saying, which
reflects the desperate need for hope
and protection that are unavailable to
men under fire except as a kind of
faith. Here, the symbolism is explicit:
this makeshift military hospital (*left*)
was set up in 1944, in an eighteenth-
century cathedral on the Philippine
island of Leyte. Between thick walls,
the wounded lay in cots as far up as
the altar rail, while surgeons operated
in the baptistry with the help of
battery-powered lights. In the text
accompanying this photograph by
W. Eugene Smith, *LIFE* reported that
"the wounded groaned a little, but
mostly they lay quiet and stared at
the church's pale blue ceiling."
Photograph by W. Eugene Smith
Philippines, 1944

**Using a homemade camera and
x-ray film,** a prisoner in a Philippine
POW camp photographed a captured
American medic attempting to help
another prisoner (*below*). Armed with
medical know-how and little else,
captured doctors felt it was their duty
to help fellow prisoners in any way
they could. Aidan MacCarthy, M.D.,
interred in a Japanese camp, described
his eagerness—purely clinical—at
receiving Red Cross packages con-
taining shaving cream: "The cream was
an American product called Barbasol,
one of whose ingredients was a sub-
stance called salycilic acid (a main
constituent of aspirin) and this was
known to be good for certain skin
diseases. We used the cream to dress
the numerous cases of open and
weeping tropical ulcers, which were
then covered with cloth or paper, tied
together with string. To our absurdly
limited medical stores Barbasol was
heaven sent."
Photographer unknown
Philippines, 1943

Japanese soldiers bathe in disinfectant before going home (*left*). Out in the battlefield, the clothes of Allied soldiers were often dusted with dichlorodiphenyltrichloroethane—DDT—every few weeks, with the chemical in some cases applied directly to their undergarments to kill typhus-bearing lice. Prisoners of war, refugees, and civilians were also doused with DDT, banned in the U.S. since 1972 and now outlawed in most other industrialized countries.
Photograph by Sgt. W. A. Morris
Burma, 1946

Seeking a little distraction from the boredom of the long journey home, Pfc. George Witcofsky—wounded by a mine—contemplates a pinup calendar as he recovers on a hospital ship off the coast of France (*above*). While tens of thousands of women at home sustained the U.S. war effort by working in factories and shipyards to produce war matériel and keep industrial output high, GI's were probably more aware of the

contributions made by pinup girls such as Betty Grable, Rita Hayworth, Dorothy Lamour, and the painted "Varga girls."
Photographer unknown
French coast, 1944

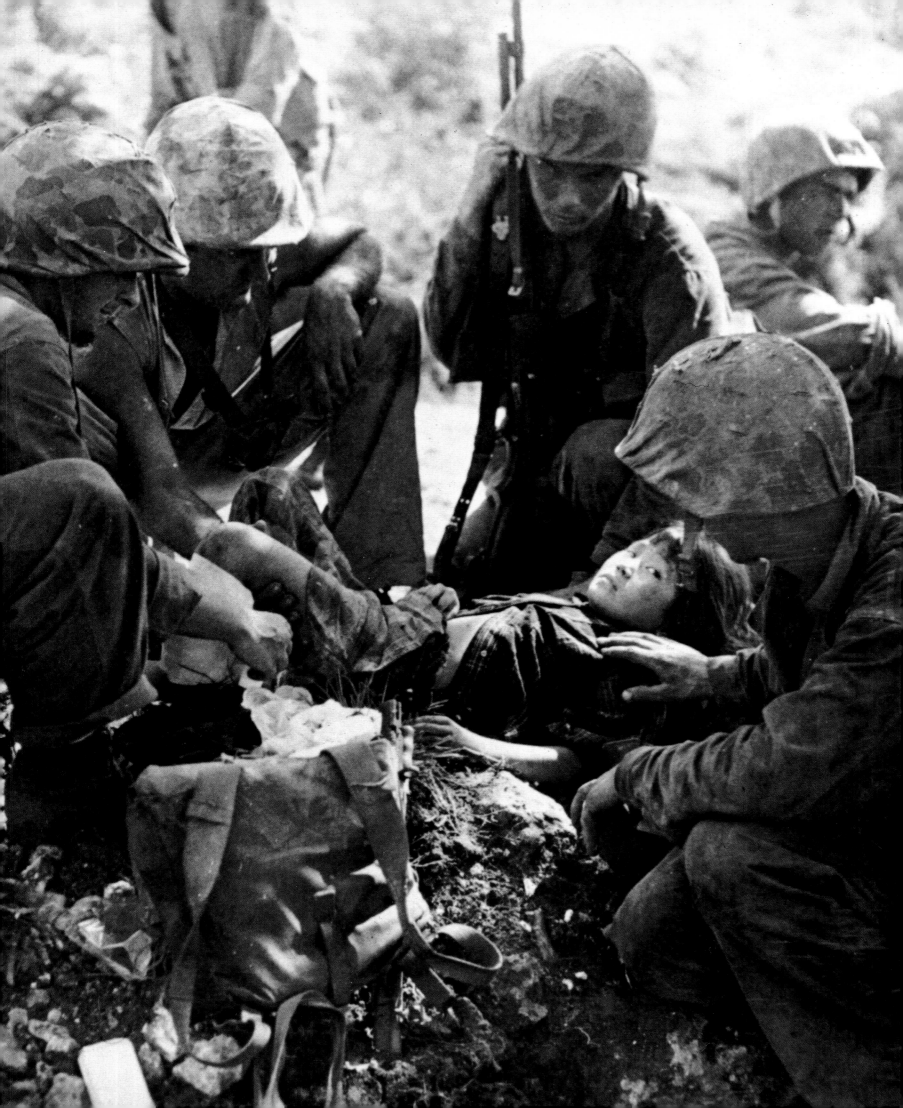

Japanese civilians on the island of Saipan followed the example of the emperor's troops, who preferred to die rather than to surrender. After the United States won the month-long battle for the island in the summer of 1944, *LIFE* correspondent Robert Sherrod witnessed hundreds of suicides. Thousands more joined the Japanese troops in caves and were killed in the fighting. In an effort to convince civilians that they would be well treated by Allied soldiers—and not "butchered," as Japanese propaganda insisted—American media helped the military by reproducing staged but honorably intentioned photographs of U.S. soldiers caring for wounded Japanese (*left*). The caption suggested by the U.S. military

for this photo was: "GOOD CARE—Marine and Navy corpsmen give medical attention to a young Jap girl [*sic*] who was slightly wounded in the leg when found by Marines."

Civilian fear of marauding armies in the Pacific was not without its justification, however, as sixteen-year-old Aurora Valencia (*above*) found out in her home province of Luzon, in the Philippines. She was stabbed by retreating Japanese troops in April of 1945 and treated at an American military hospital.
Left: Photograph by Cpl. A. Robertson
Saipan, 1944
Above: Photograph by Jepsen
Philippines, 1945

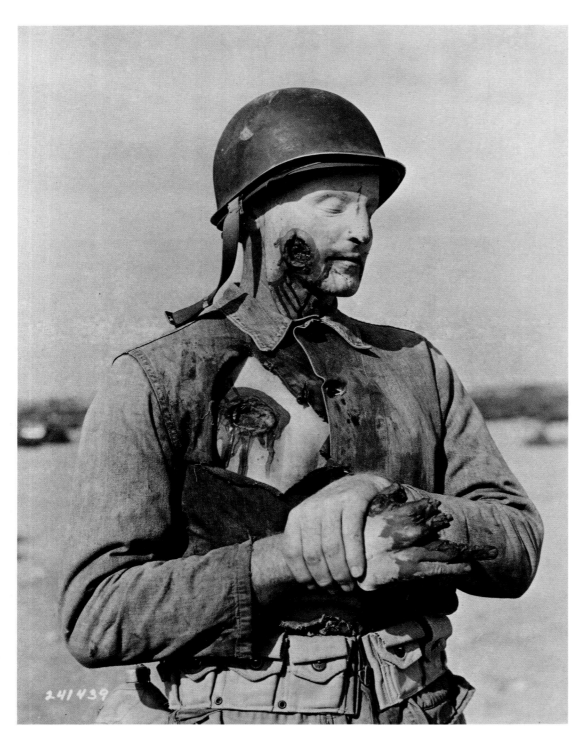

While no boot camp simulations can prepare a soldier for the horror of combat or of its wounds, every member of the U.S. Army in World War II received several hours of basic first aid instruction before shipping out. At Fort Bliss in El Paso, Texas, a soldier wears a wound *moulage* (*left*)—a mask and body cast designed to illustrate common injuries—to teach recruits how to stanch a comrade's bleeding, tie a tourniquet, clear an air passage, and treat shock victims. Predating this *moulage* was the fifteenth-century "Wound Man," a genre of medical engraving that depicted the full range of known war wounds of its time; both served as invaluable—if occasionally overwhelming—medical teaching tools.
Photographer unknown
El Paso, Texas, 1944

Wounded American soldiers convalesce on the rooftop of a hospital in Melbourne, Australia (*right*). The painted red cross identifies the building as a medical sanctuary in hopes that enemy bombers will spare it. The hospital, originally designed to hold 650 beds but quickly expanded to accommodate 2,000, was built in 1942, and housed Allied forces injured in the Pacific theater. Australia's northern port of Darwin was bombed early in 1942, but the more heavily populated southeastern coast was spared.
Photographer unknown
Melbourne, Australia, ca. 1943

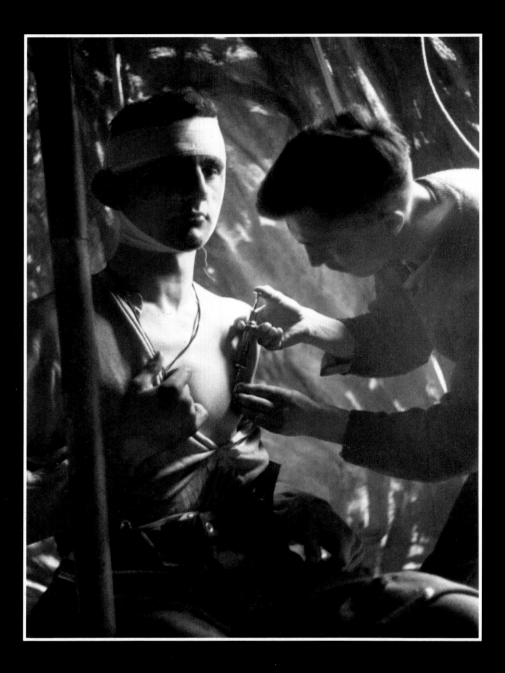

A stoic German infantryman receives first aid at his regiment's camp in Russia (*above*). On the battlefield, the Third Reich's philosophy of triage was chillingly pragmatic: instead of treating the most severely wounded first, doctors at the front line were ordered to give priority to the lightly wounded, who could be patched up quickly and whisked right back into combat. More severely wounded soldiers were sent to hospitals behind the lines, and often didn't survive.
Photograph by Hanns Hubmann
Voronezh, Soviet Union, 1942

"Every film that I exposed was from my heart," said W. Eugene Smith of his World War II photographs, "in the bitter condemnation of war." Several months after taking this photograph of a wounded Marine on the Philippine island of Leyte (*right*), Smith moved on to Okinawa, where he was severely wounded by shell fire.
Photograph by W. Eugene Smith
Philippines, 1944

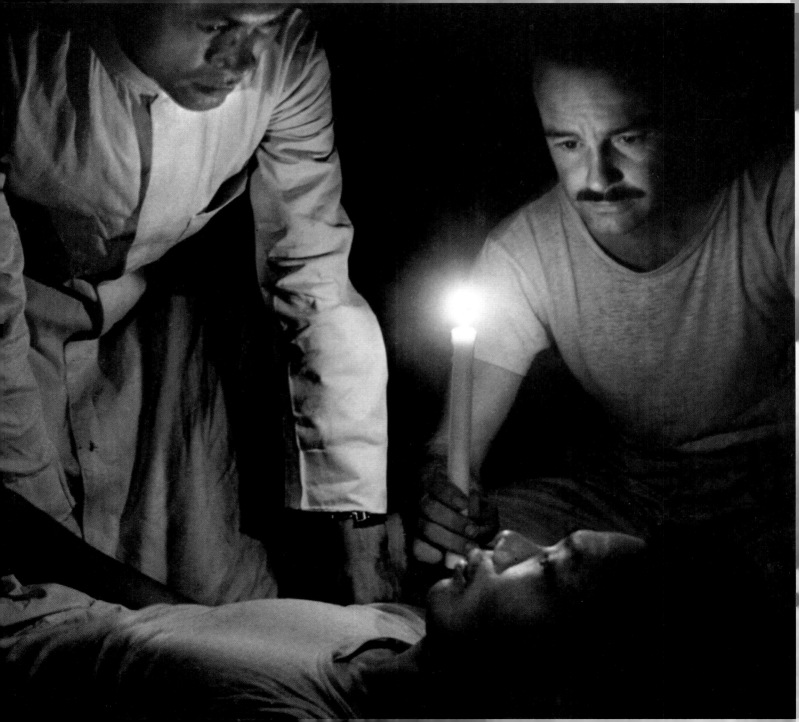

The advent of aerial warfare and long-range guns in World War II meant that no place was safe from bombardment; here, a U.S. Naval Mobile Base Hospital is protected by thousands of sandbags. Servicemen on every front performed the back-breaking labor of filling sandbags to bolster medical buildings, an effort they knew might save the wounded soldiers, healers, and medical supplies within. With Germany's introduction of the *Blitzkrieg*—a swift, hard-driving military offensive combining land and air forces—the Allies could set up even fewer semi-permanent hospitals close to the battle lines. Instead, the more vulnerable, mobile medical units were used, further pressing the demand for sandbag protection.
Photographer unknown
South Pacific, ca. 1942

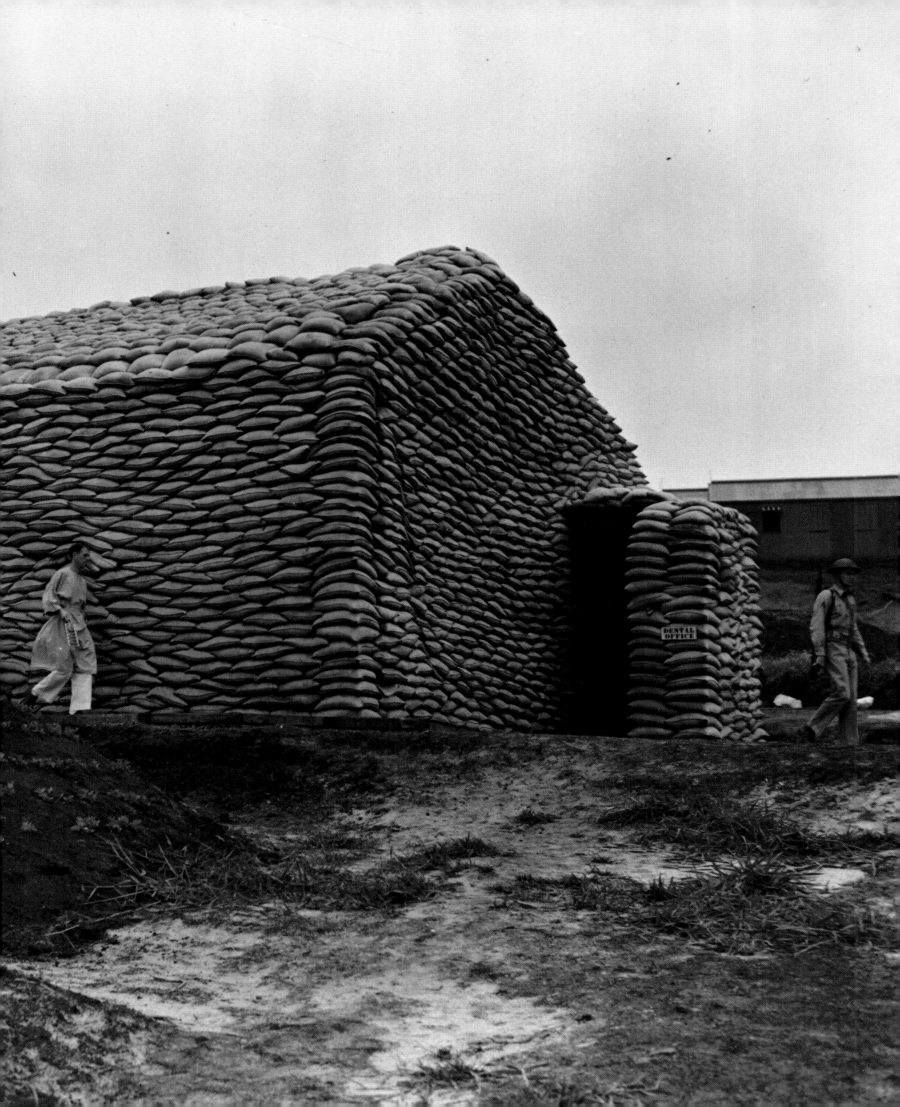

Using a Syrette—a collapsible tube with a hypodermic needle and a single dose of morphine—a Marine medic tries to fend off shock and alleviate the pain of a fallen comrade (*below*). "It's hard to exaggerate how important morphine was to the wounded," wrote Roger Hillsman, injured in World War II in Burma. The drug was a powerful analgesic that produced "a sort of sleepy euphoria," Hillsman said, adding: "I distinctly remember that . . . my whole body would seem to rise a few inches above the bed and float lazily in the air." But morphine had dangerous side effects: it caused an irregular heartbeat and increased shock in some men, and addiction in those who received large doses or prolonged treatment. Early in the war, the typical dose was thirty milligrams, but by 1943 it had been cut to fifteen milligrams. The U.S. armed forces slowed their use of morphine as a battlefield painkiller in the Korean War, in part because evacuation time improved and in part due to its adverse side effects and the potential for morphine poisoning, which was exacerbated by shock and by the extreme cold of the Korean winter.
Photograph by Bailey
Palau Islands, 1944

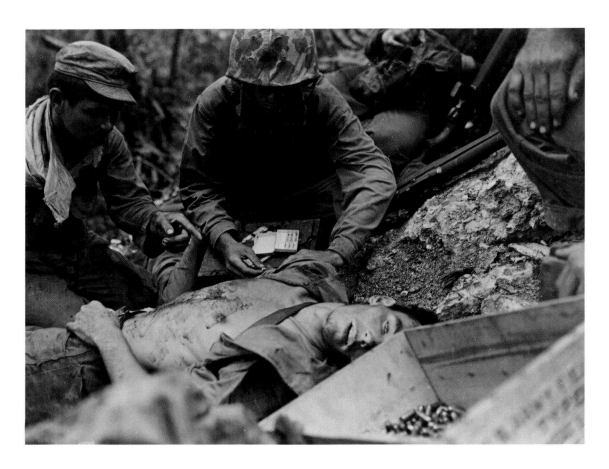

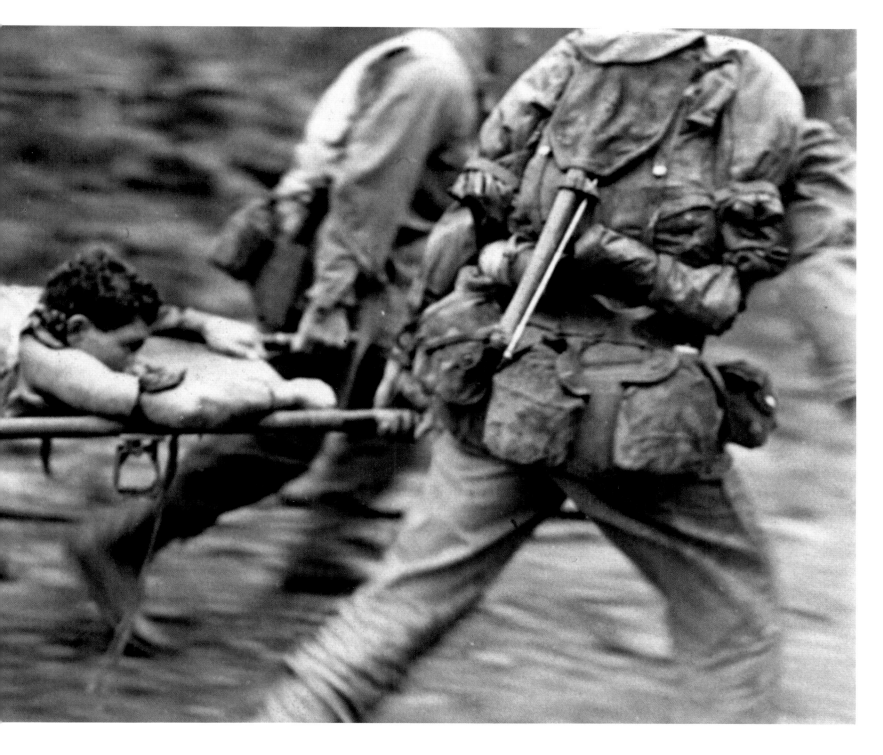

A wounded Marine is rushed from the battlefield in Okinawa (*above*). Stretcher-bearers on every front line often found themselves in as much danger as the fighting men they were engaged to help. An Ally serving half a world away, British volunteer ambulance driver Anita Leslie described the mine fields around her post on the border between France and Germany: "There was an inhuman horror about the explosive cobweb of mines which had been woven into the countryside. In all directions, men advancing through the fields were suddenly blown up in a fountain of scarlet snow and their comrades would drag them back, themselves sinking above the knees at every step. . . . While the stretcher parties carried their loads up the little path of trampled crimson ice that led to every post, we waited ready with hot tea and the merciful needle." She recalled one afternoon when a doctor led two stretcher-bearers into a mine field to rescue an injured German. "'Why did you do it?' I asked, for we all feared losing a doctor. Hands in pockets and swathed with mufflers, Husser looked out from under that steel helmet, even less becoming to him than to others, and answered, 'The reason was pity.'"
Photograph by Griffin
Okinawa, Japan, 1945

"I implore you to believe this is true," photographer Lee Miller cabled to her editor at British *Vogue* after being one of the first correspondents to enter, on April 30, 1945, the newly liberated Nazi concentration camp at Dachau. Miller captured the unimaginable nightmare of Dachau—the stripped and emaciated bodies, the mass graves, the crematoriums—as well as a moment of unexpected tenderness between Ella Lingens, a Viennese doctor imprisoned for helping Jews hide from the Nazis, and a patient gone mad (*above*). As many as ten million people—six million of them Jews—died in Nazi concentration camps. "Sometimes," said inmate and camp doctor Franz Blaha after the war, "prisoners were killed only because they had dysentary [*sic*] or vomited, and gave the nurses too much trouble."

Photograph by Lee Miller
Dachau, Germany, 1945

Ivan Dudnik, a fifteen-year-old Russian boy who has gone mad, is carried from the Nazi concentration camp at Auschwitz after its liberation by Soviet troops in 1945. The horrors of the camps included starvation so extreme that many inmates lost more than half their body weight, and with it, their memories, their sanity, and their will to live. Survivors had their own name for those hopeless cases who simply gave up the struggle—*Musselmen*—a term some believe originated in the victims' similarity to a Muslim's posture when kneeling in prayer. As Gerald Reitlinger wrote in *Final Solution* in 1953: "Most of those who died were just Musselmen, the camp slang word for a walking skeleton wrapped up in a bit of blanket." Many of the dead were also victims of medical torture—"experiments" carried out by doctors in the name of research. Some prisoners were packed in ice until they died to test the body's capacity at low temperatures; others were placed in rooms where air pressure was alternately, and rapidly, increased and decreased. Surgeons-in-training practiced amputations and stomach, spleen, and throat surgeries on healthy prisoners, while other doctors intentionally infected hundreds of inmates with malaria to test various treatments for the disease.

Photograph by M. Redkin
Auschwitz, Poland, 1945

Casualty clearing stations behind the battle lines, such as this one in Normandy (*above*), were usually the first stop for wounded American servicemen. The celebrated war correspondent Ernie Pyle described a clearing station in Sicily, in a dispatch dated August, 1943, as "really a small hospital," with "five doctors, one dentist, one chaplain, and sixty enlisted men. It is contained in six big tents and a few little ones for the fluoroscope room, the office, and so forth. Everybody sleeps outdoors on the ground, including the commanding officer. The mess is outdoors under a tree." The station, added Pyle, is "as proficient as a circus," capable of being moved in "an incredibly short time. Once, during a rapid advance, my station moved three times in one day."
Photograph by Lee Miller
Normandy, France, 1944

In Allied operating rooms within field hospitals (*right*), World War II was characterized by an increased willingness to perform thoracic and abdominal surgery, and—with the widespread availability of penicillin beginning in 1943—by an increased success rate. Doctors had to move quickly, since mortality from abdominal wounds increased dramatically with every hour that surgery was delayed.
Photograph by Lee Miller
Normandy, France, 1944

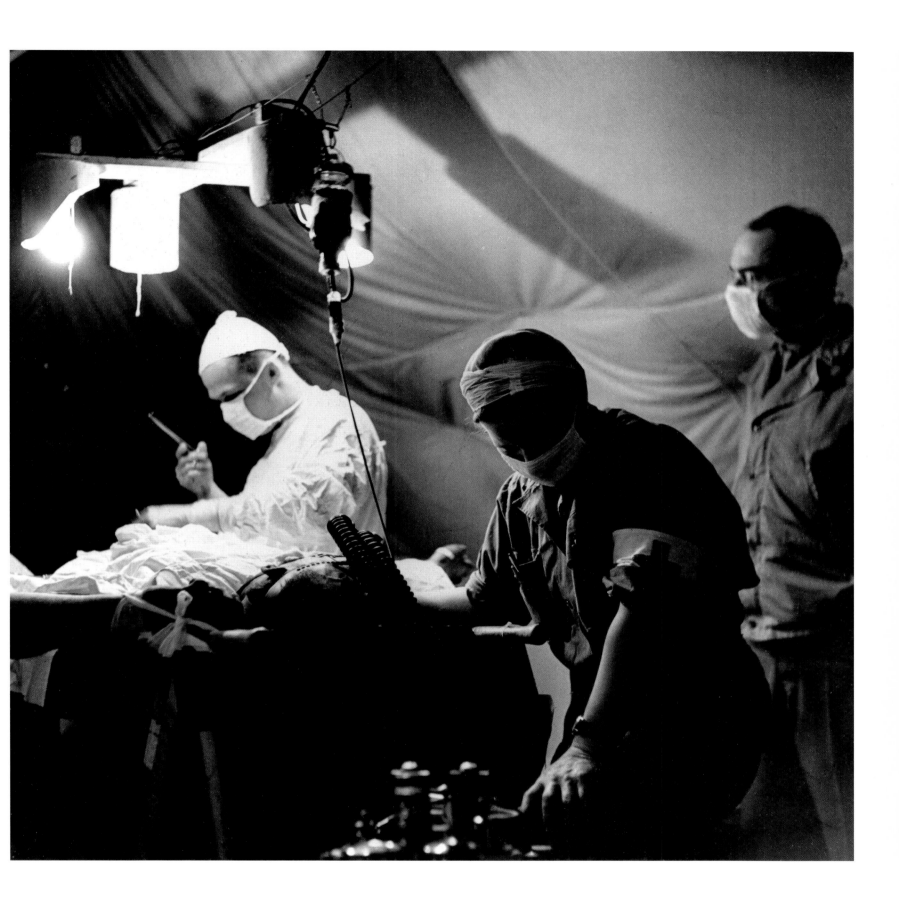

A member of *Lotta Svärd*, **Finland's women's auxiliary,** feeds a German soldier at a field hospital (*below*). More than four hundred members of the auxiliary— who volunteered as cooks, nurses, radio operators, and aircraft spotters—were killed during the war, in which Finland was allied with the Axis powers until 1944. Axis or Allies, military nurses experienced a war similar enough that virtually all of them could see their lives reflected in the words of the American nurse who wrote in her diary: "If I thought yesterday was a day to remember, it was only because I didn't know about today."
Photograph by A. Grimm
Finland, 1943

A soldier leads a stunned German family through the rubble-strewn streets of Mannheim (*right*) following Allied bombing in 1944. The Allied forces bombed German cities with both explosives and incendiary bombs, which caused a searing and fast-spreading ground fire upon impact and sucked oxygen out of the air. But German civilians also lived with acute shortages of food and clothing throughout the war years. Wrote American correspondent Howard K. Smith from Berlin: "People's faces are pale, unhealthily white as flour, except for red rings around their eyes. One might get accustomed to their faces after a while and think them normal and natural but for the fact that one notices the marked contrast between the young men in uniform, who eat food with

vitamins in it and live out of doors part of the time, and the un-uniformed millions who get no vitamins and work in shops and factories 10 to 12 hours a day." Because of vitamin deficiencies, he continued, "teeth are decaying fast—my dentist said they are decaying all at once like cubes of sugar dissolving in water." And the lack of physical health was affecting the emotional state of the average German: "It is morbid," wrote Smith, "the way people with weary deadpan faces can flash in an instant into flaming apoplectic fury over some triviality or imaginary insult. . . . Partly it's the jitters, but mostly it is because people are sick— just plain sick in body and mind."
Photographer unknown
Mannheim, Germany, 1944

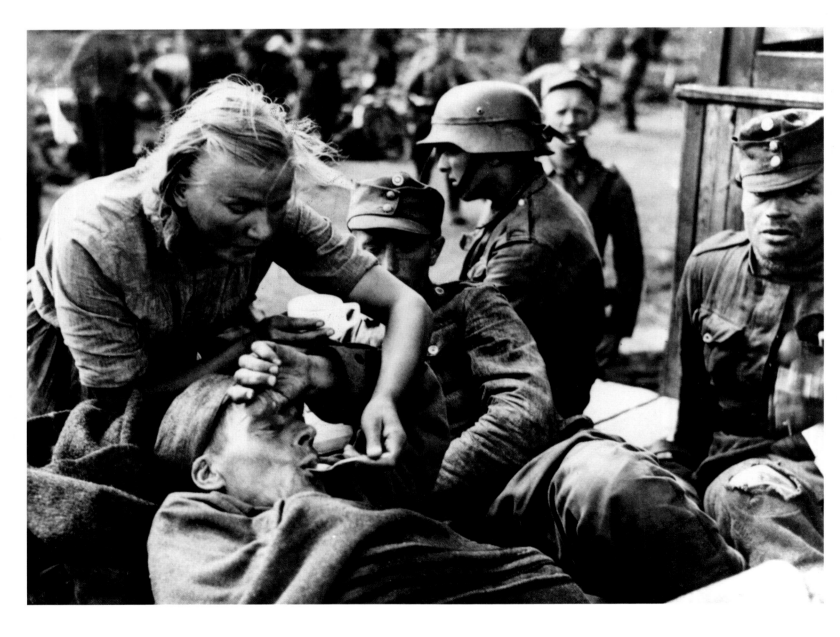

210

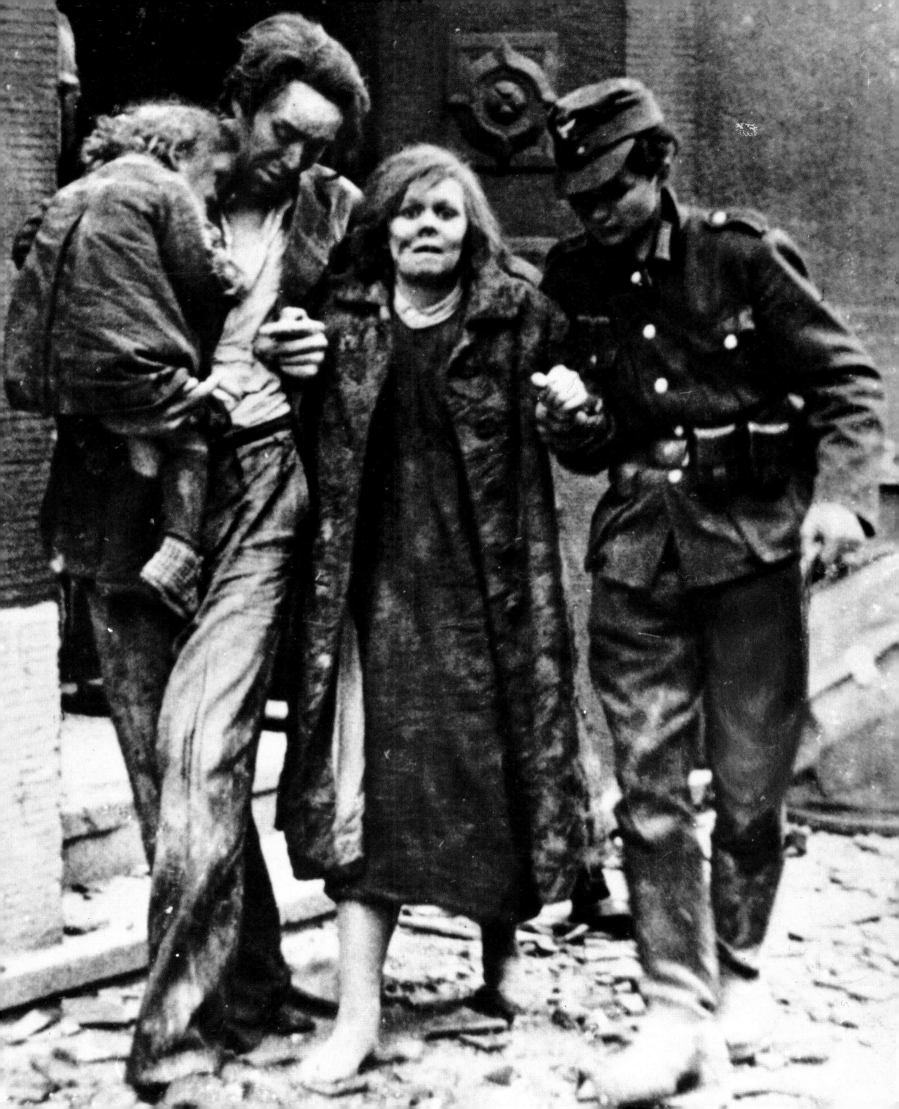

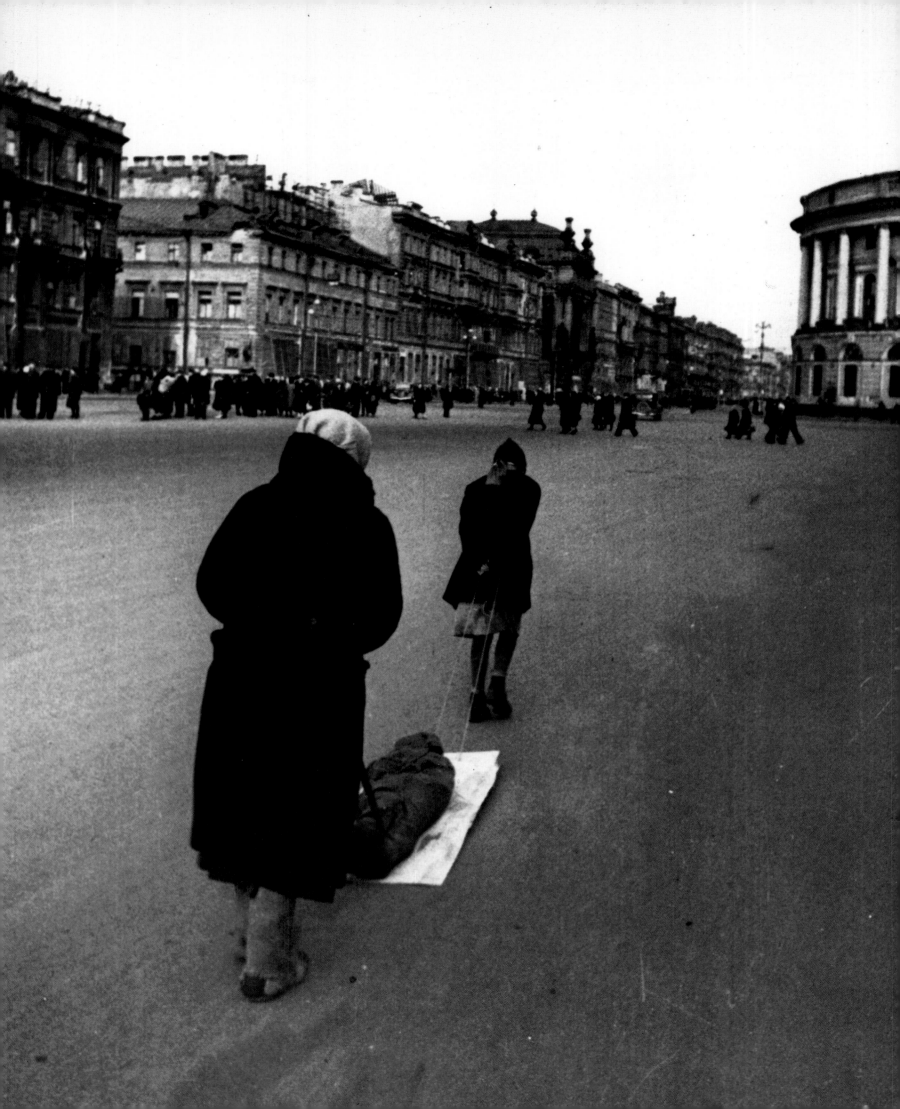

now St. Petersburg—carry their dead on a child's sled (*left*) to a mass grave excavated by army engineers using dynamite. The German siege lasted nine hundred days, but most of the civilian deaths came during its first winter. With food and heating fuel rare commodities beginning in September of 1941, Leningraders literally dropped in their tracks, unable to survive on official daily ration: five to eight slices of bread and whatever else they could scavenge. The desperate ate animal feed; flowers from the city's botanical gardens; petroleum jelly and glue; dogs, cats, crows, and rats; and—according to some reports—one another. Public health was further imperiled by the polluted water and by the many corpses, which, left to be buried by the thick winter snows, began to rot in the spring thaw. Starvation alone probably killed a million of the besieged residents of Leningrad, a figure greater than the combined civilian and military casualties of Great Britain and the United States for the entire war.
Photograph by M. Trakham
Leningrad, Soviet Union, ca. 1942

wound in a tent hospital at a division aid post near the front (*below*). When it entered the war, the Soviet Union had only one-sixth of the doctors the U.S. had, and its hospitals were severely undersupplied. Nurses used moss and linden tree shavings to dress wounds when they ran out of cotton, and recycled bandages and splints whenever they could. "We had run out of morphine six months before the war ended," one Soviet nurse recalled. "I would sit with wounded soldiers, hold their hands, and pray for them to die quickly."
Photographer unknown
Russian Front, 1945

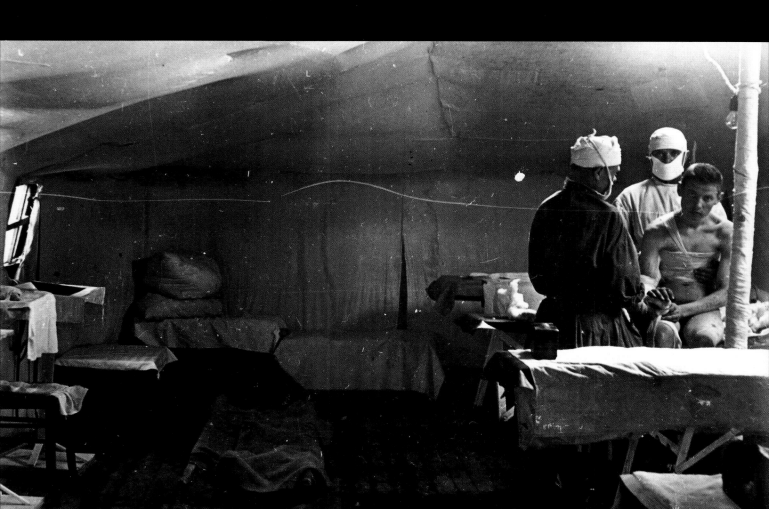

The luckiest victims of Hiroshima, some Japanese believe, are the ones who died instantly. Survivors of the atomic bomb, dropped on August 6, 1945, suffered from excruciating burns, contusions, lacerations, and acute radiation sickness. Because so many medical supplies were destroyed by the bombs and subsequent fires, doctors were reduced to using Mercurochrome, cucumbers, cooking oil, and even seaweed on the skin of burn victims. Here, doctors check a survivor for levels of residual radiation (*below*); too high a level causes radiation sickness.
Photographer unknown
Hiroshima, Japan, 1945

In a makeshift hospital in a Hiroshima bank building a month after the bombing, a Japanese man struggles to survive radiation sickness (*right*). A daunting medical challenge, its immediate symptoms include nausea, vomiting, diarrhea, nervous disorders, hair loss, fever, and bleeding from the nose and mouth. Years after the bombing, Japanese doctors were still reporting abnormally high rates of cataracts, leukemia, and thyroid, breast, and lung cancer among survivors. The evolution of nuclear weapons since 1945 guarantees that today's doctors and nurses would find their work exponentially more grueling should the more deadly hydrogen and neutron weapons ever be deployed: one MX missile has more than two hundred times the power of the Hiroshima bomb, and one Trident submarine carries about one thousand times the power.
Photograph by Lt. Wayne Miller
Hiroshima, Japan, 1945

The war over, orphaned children play in a Roman park in a photo taken by American photographer David Seymour— better known as "Chim"—as part of a series sponsored by the United Nations Educational, Scientific and Cultural Organization (UNESCO). These children represent only a tiny fraction of the estimated five million war orphans; countless others were injured or traumatized. Halfway through the war, an estimated forty million children were seriously malnourished in Europe alone.
Photograph by David Seymour
Rome, Italy, 1948

Allied amputees undergo physical therapy in Thailand following their release from a Japanese POW camp in 1945. The universal need for recovery and humanitarianism after war has been answered, on a larger scale, by the Geneva Conventions, a series of post-war treaties designed to protect prisoners of war, civilians, medical professionals, and the sick and wounded during war. The healing profession has always had a voice in shaping them: in 1864, a clearly recognizable emblem was designated to protect people and places on medical missions; and, after World War I, a neutral nation would be allowed to inspect prisoners' camps. The war crimes of World War II released an outrage that led to the most recent, expanded conventions of 1949. But those who lived through World War II, and those who would enter into future conflicts, know that as yet no international mechanism exists—save morality—to force a warring nation to abide by these humane doctrines.
Photographer unknown
Thailand, 1945

A Brief Reminder of the War in Spain

Martha Gellhorn

A Spanish citizen gives blood during the Spanish Civil War, the first conflict in which blood was stored for transfusion.
Photographer unknown
Zaragoza, Spain, 1938

You should remember that the Spanish Civil War was a military coup that didn't come off as scheduled. From the beginning of the plot, Hitler and Mussolini gave the Spanish generals any help they wanted. The hierarchy of the Spanish Catholic Church (and not only the Spanish) blessed the endeavor. The great Spanish landowners and the upper-class rich provided money and influential contacts. And after the fifty-year term of official secrecy, British government documents now reveal that Chamberlain and his cabinet also assisted Franco covertly and nastily because they wanted him to win. The U.S. government was uninvolved, not a world power but a huge, self-isolated island, intent on its own trauma, the Great Depression.

With such a lineup of allies on their side, the Spanish generals expected a quick, easy victory since their opponent was only the surprised, disorganized, unarmed Spanish people. It took the generals two years and nine months of ferocious pounding to defeat the Spanish people and destroy their Republic, which they had chosen by vote and fought for until there was nothing left to fight with.

You need to know about the Non-Intervention Agreement, cynically imposed by the British government. It pretended to forbid foreign powers from meddling in the Spanish conflict. This embargo did not hamper Franco, Hitler, and Mussolini, but it ruined the Republic, deprived of credits and essential supplies from the European democracies.

The Republic bought where it could, but never enough; and ardent partisans, in the betraying democracies, raised money for humanitarian aid. But you cannot win a war on CARE packages. The Republic had to improvise a medical service for the military and civilian wounded.

The Palace Hotel, which had been and is again the grandest hotel in Madrid, became a military hospital. The operating room was a salon on the ground floor where surgeons worked by the light of an elegant crystal chandelier. The ground floor stank of ether. The stair carpeting was filthy, and the overall smell of dirt mixed with cooking smells, none good. The hotel bedrooms were filled with five or six cots, with gray blankets but

no sheets or pillowcases; and no other furniture. I visited soldiers on the sixth floor, foreigners from the International Brigades, where a mishmash of languages served because neither they nor I spoke Spanish.

A Pole, with blond hair and beard, and paper-white skin except for fever-pink cheeks, lay on a cot clearly dying. His body had the emaciation formalized in images of Christ crucified; he talked seldom and in a whisper; he smiled like sunlight. The Italian with a head wound wore a beret over his bandages. The others knew that his sight had been gravely damaged, so they encouraged him to draw in crayons a portrait of the Pole, praising his talent. None of the wounded ever complained. I did not realize how young they were; pain ages, and shapeless gray pyjamas hid their bodies. They had all been operated on, as rather grimy bandages showed, and now it was up to them to survive. They were only as clean as they could manage, the walking wounded with the use of their hands helping those who could not move. It was the first time that I saw the tact and gentleness wounded men have toward each other; they ennobled this improvised hospital.

To drive a car was like being some sort of specialist, since few people in the Republic had owned cars. So I drove blood in stoppered flasks, in crates, as if they were Coca-Cola crates, to what I suppose was a battalion aid station. It was a peasant farmhouse; everywhere outside Madrid, farmhouses had all-purpose use. The wounded lay on the cold dirt floor, for want of cots. The operating table was the kitchen table. In the entry passage, among the new wounded, a soldier of the Republic, perhaps sixteen years old, could not stop crying from pain. An older man, sitting with his wounded legs stretched out, tried to comfort him, saying that *los medicos* would come soon. The boy wore a pilot's helmet of ersatz leather; his clothes were blood-soaked. Nobody came to give him a morphine injection; morphine was in short supply, as were medics.

I didn't visit a civilian hospital until the last months in Barcelona, when Mussolini's air force bombed the city daily from a safe, high altitude. The children's wing of the city hospital was full of the infant casualties of that casual bombing. The small cots had neatly pressed, stained, greasy looking sheets. Soap had run out by then. The children were either silent inside their pain or strangely lively. The nurses were perfect and loving and explained that the fever of tuberculosis often had this effect on children. When I asked where an enchantingly pretty baby was wounded, the nurse picked the child up, making her laugh with delight, and cuddled her, and showed her wasted legs and distended stomach. She said, "Wounded by hunger." The medicine they all needed most was food, but Barcelona was on the edge of starvation. Twice a day, bitterly, the nurses doled out all they had: a watery yellow soup with some white beans and limp cabbage leaves floating in it.

It was the same for small children as for soldiers: they were operated on to remove bits of steel, to amputate, to set broken bones; afterward it was up to them to survive, or not. The medical service of the Republic had tragically lacked basic necessities from the beginning to the end.

It is all long ago, isn't it? More than half a century ago; and there have been many wars since, from the largest to the small and ugly, as in El Salvador. But there was no other war like the war in Spain. Such bravery in the midst of such poverty, such certain belief in the justice of the Republic's cause, brought us all—Spaniards and a multitude of foreigners—as close to the brotherhood of man as we had ever been, or ever would be again.

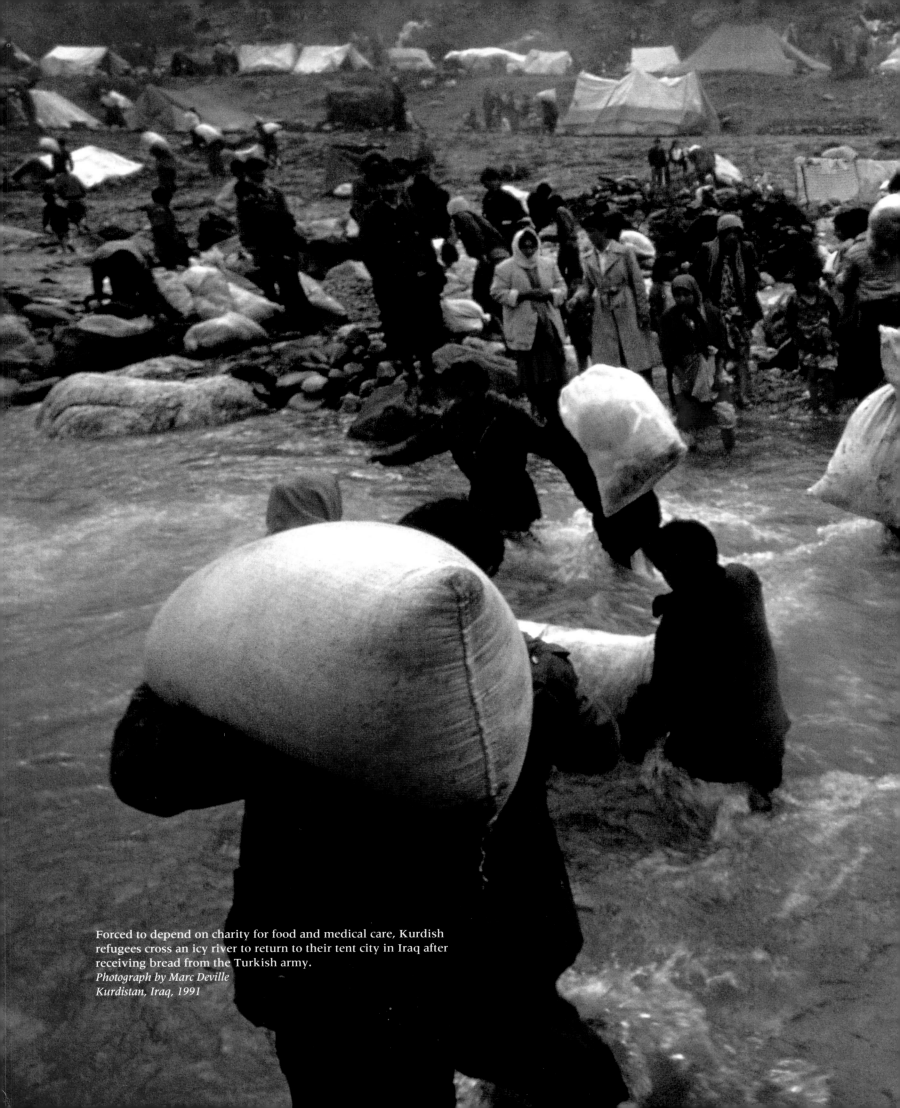

Forced to depend on charity for food and medical care, Kurdish
refugees cross an icy river to return to their tent city in Iraq after
receiving bread from the Turkish army.
Photograph by Marc Deville
Kurdistan, Iraq, 1991

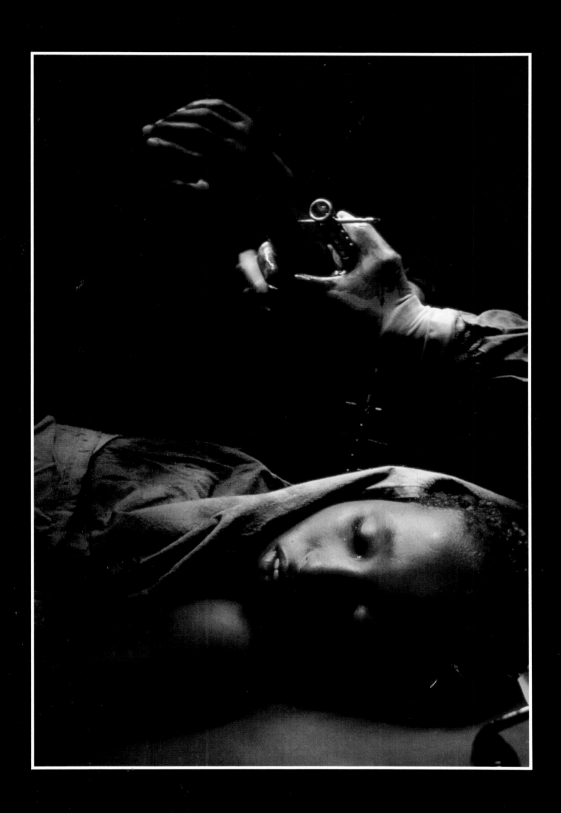

A few months later I myself was in a field hospital. I was not prepared for the fury of medics; though given my experience with the general, I should have been. I had been hit by a grenade explosion, thirty-plus holes in my back and legs, one in my head, two in my arm. Most were superficial but one, astride my left kidney, was very bad and hemorrhaging. I had been last off the battlefield because my wounds were slight compared to many of the troopers I was with. Still, there was the bleeding and, perhaps as important, the industrial-strength hit of morphine given moments after the grenade; I was feeling not the least bit distinguished. Owing to the press of business I was left on a stretcher outside the forward field hospital for too long, and when the medics came to lift me into a bed they found the stretcher filled with blood. They were alarmed, realizing they had two courses of action: to do nothing dramatic and hope there wasn't a chunk of shrapnel inside; or to operate, almost certainly causing an infection that might be worse than the shrapnel. Two of the medics argued about the dangers of operating in unsanitary conditions and the dangers of not operating. The younger medic asked me if my stomach hurt. He asked again and again, and I could not answer because I was trying to recite the Lord's Prayer.

He said, Speak to me, you son of a bitch.

I said, Hallowed be thy name.

He said, You *asshole!* Does it *hurt?* Does it hurt inside?

I said, Dunno.

He said, Oh, *Christ.*

So they did not operate, and probably that decision saved my life. But I remember the look on his face, infinite weariness tempered by profound disgust. I remembered thinking that he looked younger than I— I was thirty—and that was no way to speak to an older man, and a civilian as well.

Three or four days later, bandaged and more or less composed, I was transferred to the great hospital complex at Nha Trang. It was probably a better hospital then than Mass. General is today. I had a thick plaster on my back and smaller bandages elsewhere and looked much worse than I felt, and probably that was why I was in the intensive care ward. It was perhaps also true that because I had been out of touch for a week, my editor was very worried and had made the usual calls; and word had come down from the Pentagon: let's try not to lose the correspondent from *The Washington Post.*

This was the time of the murderous battles in the central highlands, and Nha Trang was full. The first night I was there the man on my right died. The next morning his bed was taken by a man with a large open wound in his stomach. He cried for morphine all day and all night, and the nurse finally refused to give him more; he had had too much already. Then a doctor arrived, looked at the soldier, and conferred with the nurse. The look on the doctor's face was unambiguous, and presently the soldier had all the morphine he wanted. The next morning his bed was empty, too.

Then friends came to visit; and they brought with them a cold bottle of beer, which they poured into a paper cup. I was sipping the beer, feeling exceptionally jaunty, when my favorite nurse happened by. She was very pretty and young, no more than twenty-two or twenty-three years old. I asked her if she wanted a sip, and her eyes went wide and she began yelling at me—screaming, really. She broke down. What did I mean, drinking beer in a hospital ward. People were dying. There were maimed people, crazy people. For God's sake, look around you. Who do you think you are? *Where* do you think you are?

And I mumbled an apology, as she snatched the beer cup from my hand and hurled it into a wastebasket. I made a feeble joke but she was having none of it, and indeed would not speak to me for the rest of the time I was there.

What good people they were. It was so much more serious for them than it was for me. Their fury was a consequence of their devotion. I was alive with no serious damage. I was a newspaper correspondent and my wounds could therefore be said to be self-inflicted. I think from the perspective of the medics I was a dilettante. I did not belong in Nha Trang. I did not belong there the way the troopers did, and indeed in a few more days I would be gone, to a small private hospital in Saigon; and then I would take a vacation in Hawaii and go on to Washington, to receive whatever credit was due.

The last night at Nha Trang I thought I was dying. It was a stomachache, though to call it a stomachache is to understate the matter; the god of pain himself had taken residence in my gut. For many years I thought it was a reaction to the morphine—withdrawal—but doctors have told me that could not be so. Probably gas in the stomach, but I did not think so then. That night I thought a piece of shrapnel was working its way to the center of my tender intestine. No one could explain it, but my demand for morphine was refused. A nurse offered to keep me company through the long night. She was a much older woman, probably the age that I am now. She knitted while we talked; and I cannot now recall a syllable of our conversation. But when time came to be wheeled onto the tarmac and lifted into the hospital plane for the trip to Saigon, she was in the doorway. She gave a deft little wave and, I thought, a wink. I think the wink said, Don't come back. You don't want to be here. We don't. Nobody does.

The Fury of Medics

Ward Just

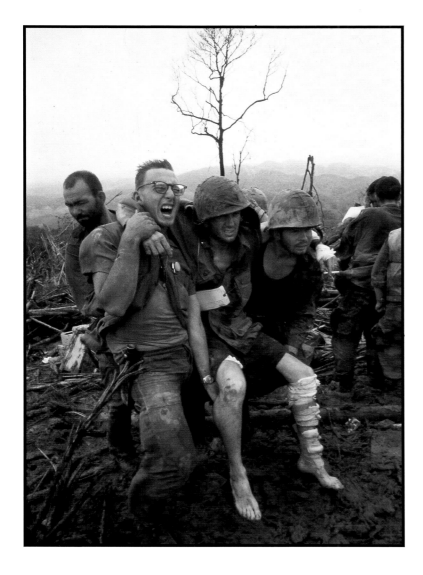

American medics carry an injured
Marine to safety in the DMZ.
Photograph by Larry Burrows
South Vietnam, 1966

This story truly begins with an explosion, but an earlier event casts its own shadow. Sometime in the spring of 1966 I was invited to spend a day with General William Westmoreland as he visited bases here and there in South Vietnam, receiving briefings on the war's progress: excellent, and improving every day. His last stop on the itinerary was a field hospital, where he would visit the wounded.

The commanding general must do this, he said.

It goes with the job.

The general, followed by his aides, went quickly through one of the wards. He murmured words of encouragement, sometimes shaking hands, sometimes patting a man on the shoulder; occasionally he got a salute, more often a blank stare. The men in this ward were badly injured. He paused at a bed containing a soldier in shock. The soldier abruptly grabbed the general's arm and tried to say something, but no words came. He said, Unh unh. He tried desperately to speak and Westmoreland hesitated, listening hard. Impossible to know what the soldier wanted to convey: some memory, certainly. It would be a memory of home or of the battlefield, and conceivably the two were merged in his mind. Whatever it was, he was straining to get it out. Suddenly he began to weep, and still he did not release the general's arm. Westmoreland pulled gently, but the soldier had his arm in a death grip. I felt as I always felt in these circumstances: a voyeur. But you must do this, I thought. It goes with the job.

There seemed to be a fierce concentration of emotion in those few seconds, and it was a consequence of this fact: everyone was mortified. And then I glanced around at the medics, doctors, and nurses. They were standing a little way off and they had not moved, not to aid the soldier and certainly not to aid the general. One of the nurses gave me a hard-faced look that said Westmoreland should be forced to *live* here; as the rest of us do, in order to view the results of his war. And you, newspaperman. You, too. But put away your notebook now. For God's sake, leave us in peace.

The weapons of war have escaped the confines of the battlefield, as inner-city gang wars in South Central Los Angeles provide military surgeons with the specialized training they need. These civilian paramedics helping a gunshot victim (*left*), often called upon to treat wounds from semi-automatic weapons, will rush this man to the emergency room at the Martin Luther King, Jr./Drew Medical Center in L.A.—where U.S. Army surgeons-in-training spend several months learning how to treat combat-type trauma injuries. Throughout history, doctors have volunteered for military duty to hone their craft and bring home to civilian practice the wisdom acquired under fire. It is a tragic irony, and an outrage in the face of the teachings of Hippocrates, that doctors who are willing to go to war to learn medicine can do so at home, in their own "peacetime" neighborhoods.
Photograph by Alon Reininger
Los Angeles, California, 1992

261

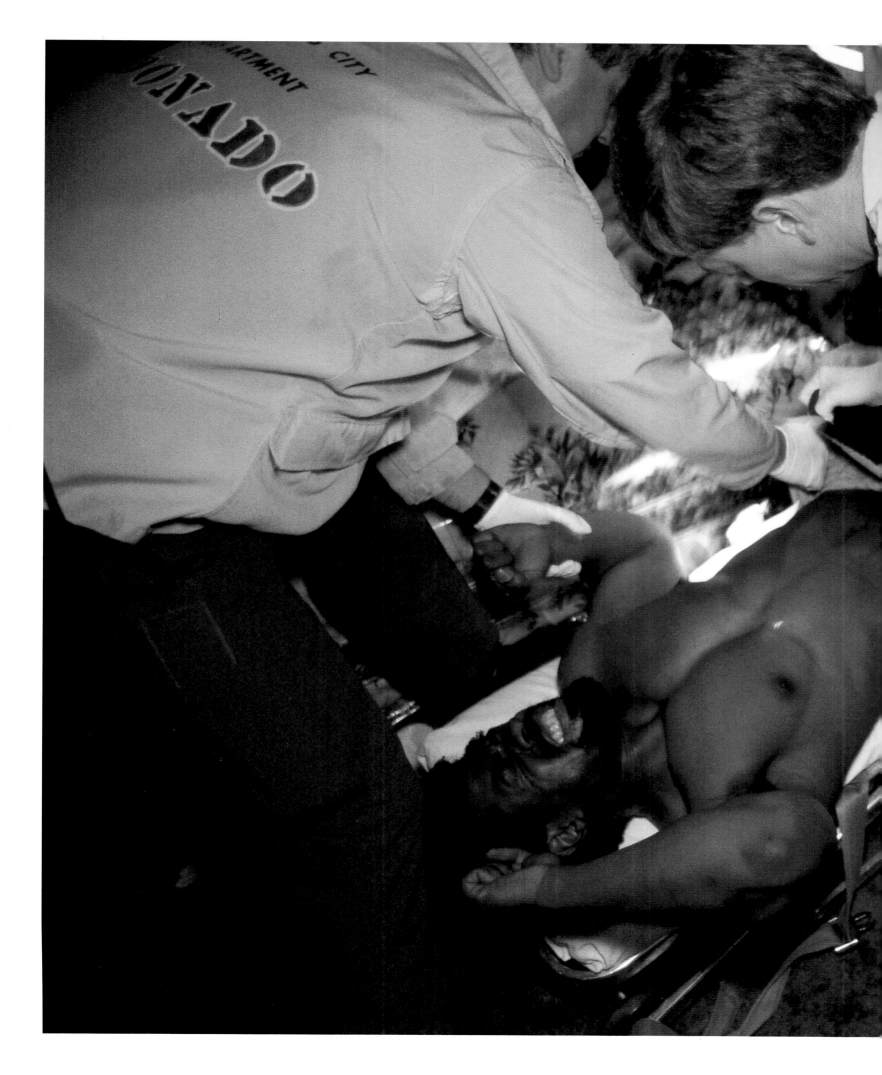

A Croatian medic, in the hurried first moments of trauma care, realizes that one of the wounded men brought to her for attention is her husband. Hospitals in most parts of the former Yugoslavia were generally well supplied before fighting broke out in June of 1991; a year later, when these photos were taken, supplies were dwindling in the face of sieges, blockades, and disruptions in the transport system, and many hospitals had been bombed or shelled in the fighting. Croatian army medics are, for the most part, untrained civilians who spend several days learning triage and basic trauma care, such as how to stabilize bleeding and treat shock. Once they administer initial care, the medics wait for a lull in the fighting before trying to move the wounded to a field station, and, from there, to the nearest functioning hospital. In its first year alone, the civil war in the former Yugoslavia killed twelve thousand people and created 1.5 million refugees—Europe's largest refugee population since World War II.
Photograph by Christopher Morris
Lipik, Croatia, 1992

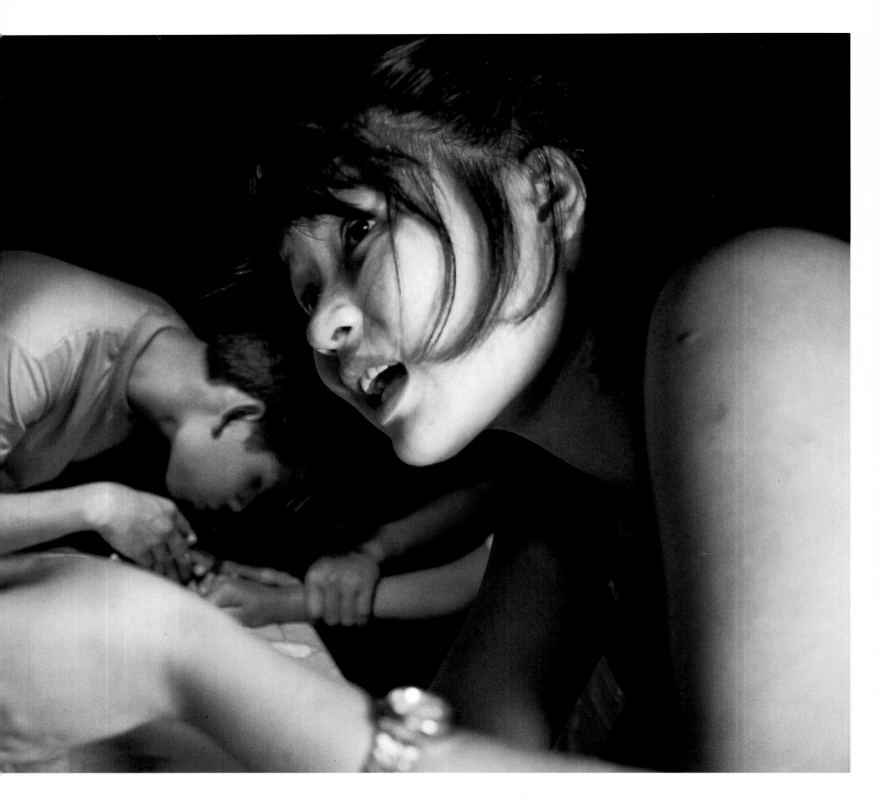

Young medics from the All Burma Student Democratic Front work quickly to pack the gunshot wounds of a young soldier injured in fighting against government troops in April, 1992, in Burma. The medics' formal training, if any, is likely to consist of a few weeks under the tutelage of another medic. The three thousand or so armed members of the Student Democratic Front—which has been fighting the country's military rulers since 1988—count among their numbers only a handful of qualified doctors. Says photographer Suzanne Keating, who spent several weeks covering the fighting: "There's a dramatic shortage of basic medical supplies, such as gauze and antibiotics; painkillers are unheard of, and adhesive tape is so scarce that they cut each piece into eight strips." *Photograph by Suzanne Keating Burma, 1992*

matter how many pictures they show you, and no matter how many words they say, you don't know what it's going to look like until you see the real thing."

Despite uncertainty and even fear, military doctors awaiting that perilous moment for which they have been attempting to prepare seem always enabled, by their own innate sense of moral responsibility, to overcome doubt and anxiety. Baron Larrey explained away his selflessness by asking, "How could we attend to anything else but the performance of our sad but humane task?" A century and a half later, Isaac Goodrich would also understate his own courage: "When a man's hurt and he's one of yours, you just go to him and take care of his wounds—that's all there is to it. You don't think about anything but that."

In the presence of the bravery and suffering of wounded young soldiers, the battlefield doctor and the men and women serving today in hospitals and research laboratories can do nothing else. A two-thousand-year heritage of professional beneficence, a personal sense of humanity, a chosen and nurtured altruism—these are the catalysts of caring and the secret of medical effectiveness. Those of us who would honor these heroes are ourselves honored by their presence among us, to affirm the truth that men and women are capable of such deeds.

At the conclusion of the campaign, up to 100,000 Iraqi soldiers had lost their lives and between 100,000 and 300,000 had been wounded. While the exact number is uncertain, an estimated 60,000 to 70,000 were interned; of these, many were injured, dehydrated, or malnourished. Medical officers returning to the States reported that their facilities in the Gulf had been crowded with Iraqis who appeared seeking treatment for health problems they had lived with for years, to take advantage of the presence of the highly regarded American doctors and nurses.

Even with this level of preparedness, military officers felt a degree of uncertainty about the performance that could be expected from this magnificently organized medical capability. Such uncertainty has existed in every modern American war, and always the commanders' highest expectations for success have been at least fulfilled and usually exceeded. But because Desert Storm proved to be a relatively short-term challenge in an unfamiliar environment, the medical teams were not able to test several issues that concerned them. One of these was the vulnerability to heat and sand of the highly sensitive laboratory and clinical equipment that had been brought to the Gulf. Another serious worry was the combat performance of the cumbersome clothing and masks designed to protect the troops against chemical or biological weapons. The maneuverability and effectiveness of this gear, called the Mission Oriented Protective Posture (MOPP) suit, is still under active research and development.

In February of 1991, in preparation for war, the Center of Excellence at Walter Reed Army Medical Center in Washington, D.C., published its *Combat Casualty Care Guidelines—Operation Desert Storm*. In the foreword to that handbook, Lt. General Frank F. Ledford, Jr., surgeon general of the Army, spoke directly to his corps of doctors. His words sounded an echo of what might have been said by any military medical commander to the men and women going off to treat the casualties of one or another of the wars of the last two centuries: "At this time, your involvement in caring for casualties in Operation Desert Storm is almost certain. Your preparedness must be honed to respond with the dedication and expertise that clearly exist in all of you. We call upon you to exercise good judgment and to take responsible action." He ended with an aphorism so profound in its simplicity that it might well be emblazoned on a coat of arms for that brave company of doctors who must go to war: "Be as ready as you can possibly be."

Ledford chose those final words carefully. Like every other doctor who has ministered to the battle-injured since the invention of gunpowder, he well knew that neither training nor past experience is sufficient to anticipate the horrors that each new war, and indeed each new campaign, brings to those who fight and those who try to heal them. As Captain Vito Imbasciani, M.D., wrote in his war notes from the 207th Evacuation Hospital in Dahran during the Gulf War: "The concussive effects of high-power explosives are something rarely experienced in civilian medicine. Would I be up to the task ahead of me? There was little time to debate the issue, because the first convoy of ambulances was arriving at the bay with full Saudi military escort, their flashing red lights creating a strobelike effect on the tinted glass doors of the hospital." While Imbasciani was focusing his mind for the imminent arrival of the wounded on that grim night in Dahran, his thoughts echoed through the ages and resonated with the voices of centuries of his medical forebears: "No

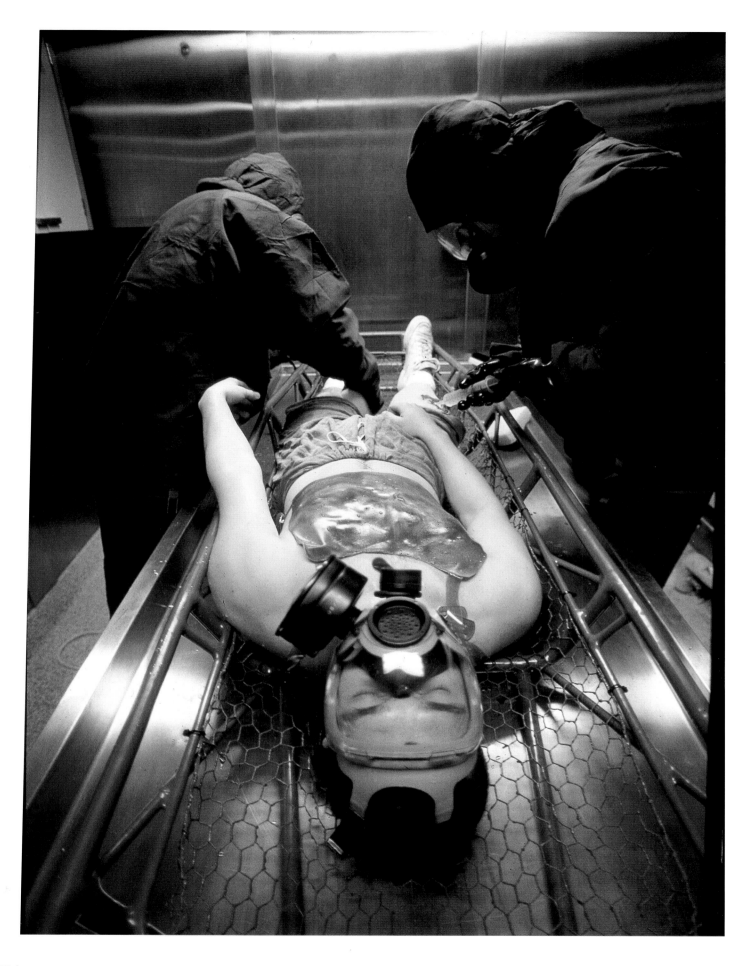

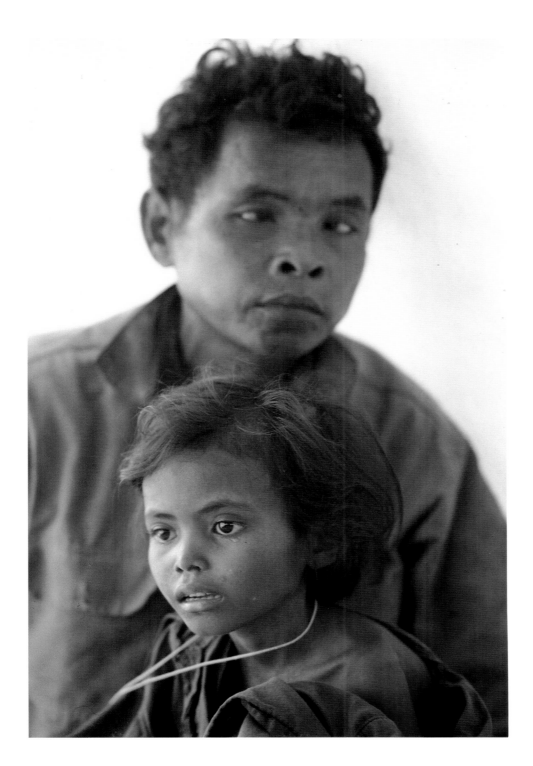

A young Cambodian girl, a triage tag around her neck, sheds a solitary tear after leading her blind father on a two-week trek through a mine-filled jungle to an Israeli medical station at the Sa Keo refugee camp in Thailand. Says physician and photographer Matthew Naythons: "The eeriest part of the camp at Sa Keo was the silence. A thousand sick and dying infants were suffering quietly, as if the Khmer Rouge—which had destroyed Cambodia's medical system—had wiped out human emotion as well."
Photograph by Matthew Naythons, M.D.
Thailand, 1979

While nature has changed the outcome of past wars, it may also prevent them—by devastating a nation's people to such a degree that civil protest is impossible. These Northern Ethiopians, driven south by their country's communist party in November, 1984, lost an estimated 50,000 to 100,000 of their people during their forced relocation alone, primarily from the lack of food, water, and medical care. A few were allowed to make their way back home (*right*), hoping to replant their land and survive the country's massive famine.
Photograph by Alain Keler
Near Addis Ababa, Ethiopia, 1985

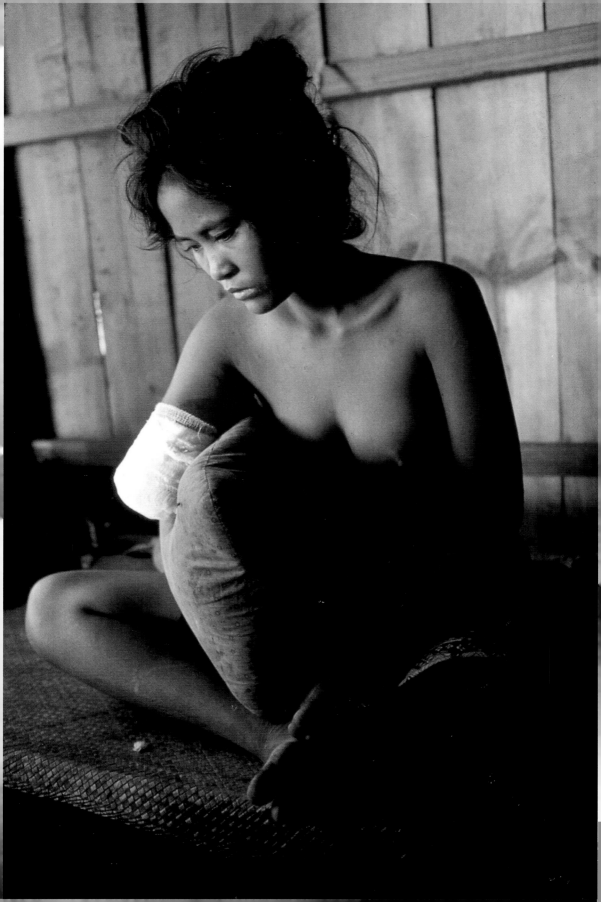

every hour, in the jungles and hamlets of Vietnam. Added to all of this was the danger of the jungle itself, and of what lurked in its fearsome beauty. And the psychological stresses haunted them just as deeply, from the ambivalence that so many soldiers felt about their own roles in the war, the perceived unfairness of the military selection system, the antiwar protests and animosity reported from home, and the government's own confusion about its political goals. The emotional ambience of this most unpopular of all American wars triggered yet another new kind of wound: drug abuse both during and after the war. The use of drugs was rampant among the troops, airmen, and sailors; heroin and opium use in themselves reached what military physicians considered epidemic proportions. This war, perhaps more than any other, created unique psychological and later social problems for veterans, indelible imprints that have haunted dreams and, for some, prevented the return to normal, postwar lives. Long-term follow-up studies indicate that Vietnam veterans have 65 percent more suicides and a 49 percent higher motor-vehicle death rate than the rest of the population. Regardless of medicine's ability to perform magnificently in the acute crisis of military trauma, it has remained in many ways impotent in the face of the chronic, festering aftermath of war.

Since World War II, this aftermath has, to a great extent, involved the treatment of the enemy's troops and the responsibility for their safe return home. Because of the destruction of much of Germany's and Japan's medical resources in that conflict, and the inadequate capability of the enemy's physicians in Korea and Vietnam, American doctors have increasingly had to provide health care on a large scale for foreign troops and civilians. This obligation reached massive proportions after Operation Desert Storm in 1991.

Between the actual theater of operations and the turn-key hospitals in Europe prepared to receive heavy casualties, the U.S. Army, Navy, and Air Force deployed a total of more than 46,000 medical personnel for active overseas duty in the Persian Gulf effort. Military physicians prepared themselves for the worst. The U.S. Army alone expected 15,000 deaths and another possible 20,000 soldiers injured from their contingent of the 540,000-member combined U.S. fighting forces. Fortunately, only 148 were killed and 458 wounded.

But before the campaign, the military mobilized a huge effort to prepare itself for its many possible wounded—a huge moral leap from the days of the Roman Empire, when wounded soldiers had to fend for themselves. Forty-four tent hospitals had been brought into the Gulf region in an extraordinary effort that saw entire hospital facilities delivered by plane, ship, and rail. A full operating room could be shipped in a single packing case. A typical hospital occupied more than twenty acres and was so extensively equipped that it required sixty forty-foot railroad cars to transport it (and eighty thousand sandbags to build the six-foot wall required to protect it from desert sand and the inadvertent incursions of the troops' own tanks). Medical personnel were usually reservists who were highly skilled specialists in both civilian and military medicine. This was perhaps the first war in which the excellence of the fighting forces would be matched in every way by the excellence of their medical care. Even in Vietnam, this high a level had not been attained.

A woman shot by the Khmer Rouge recuperates in a government hospital in Kompong Thom during the civil war in Cambodia—where, according to the International Red Cross, one of every eighty-five Cambodians lost a limb to a land mine or bullet in more than a decade of civil warfare (1975–89). A French group, Handicap International, has set up workshops throughout Cambodia and the refugee camps in neighboring Thailand to teach amputees how to make their own prostheses, crutches, and wheelchairs from local materials such as bamboo and rubber. "Rare is the doctor in Cambodia," according to journalist Peter Goodman, "who does not have a story about using a pair of pliers to do cranial surgery or cleaning a wound with the juice of a green coconut. 'Listen, you can perform basic surgery with a butcher knife,' says one chief surgeon. . . . 'Of course, I prefer not to have to do it that way.'"
*Photograph by Lori Grinker
Cambodia, 1989*

The success of trauma medicine, of course, depends on the speed of evacuation. After doctors in Vietnam gave initial treatment to wounded men following their helicopter delivery to a surgical hospital, casualties went on to airfields in Saigon, Da Nang, Nha Trang, or Qui Nhón, to await small-plane transport to the Philippines, and then jet transport to hospitals in Okinawa (then held by the U.S.), Guam, or Japan. It was a complicated feat of logistics that depended on the extraordinary speed and efficacy of the initial step from battleground to surgical hospital. All of this was a far cry, albeit a steady progression, from Baron Larrey's *ambulances volantes* of a century and a half earlier.

Such rapid evacuations meant that many of the soldiers who arrived at the surgical hospitals were so badly wounded that they would have died in any earlier war, before they could be treated. The speed of the helicopter evacuations therefore presented surgeons with far more clinically devastating injuries than they had seen in any previous surgical experience, whether military or civilian. Such potentially catastrophic injuries make even more remarkable the fact that less than 2 percent of these men did not survive.

True to the honored tradition of murder that is sanctioned by governments and sanctified by patriotism, this war brought ever more refined barbarity—and with it, new types of wounds—as the relentlessly advancing technology of death continued on its morally regressive course. The injuries seen in this war were the reflection not of progress, but of a malignant regression to primitive forms of brutality. Among the most memorable were the repulsive wounds caused by sharpened lengths of fine bamboo called punji sticks. The Vietcong most commonly used punji sticks by partially burying them along jungle paths at angles of twenty to sixty degrees, with their pointed ends protruding into the underbrush to impale unwary soldiers. Punji sticks were also hidden in helicopter landing sites, shallow streams, camouflaged pits, or bear traps, or in locations so obvious that soldiers would tread widely away—and step on a hidden mine or booby trap.

Because the tip of a punji stick was often fire-hardened, it kept its point for a long time. When such a hard, sharp object (often carefully smeared with the enemy's feces) pierced a man's foot or leg, he was in great danger of serious infection. The military cost of widely debriding these loathsome wounds was considerable time lost from combat; in one series of 324 such injuries treated at a single surgical hospital over nine months, healing time averaged three weeks, even though the typical wound was less than an inch deep.

Punji sticks were not the only danger lurking in the dense vegetation of Vietnam's tropical forests—as in all wars, nature too sometimes conspired with the enemy. Captain Goodrich tells of an enlisted man bitten on the calf by a poisonous snake while on night patrol deep in a Vietcong-dominated jungle. The patrol's medic quickly applied a tourniquet above the bite, hoisted the soldier on his back and carried him three thousand meters through the enemy-infested jungle until he reached the perimeter of his own forces, where the battalion surgeon cut into the snake bite, removed the venom with a specially designed suction cup, and ordered his patient evacuated to a field hospital by the helicopter that was already waiting for him. The soldier was back fighting in the jungles within two weeks.

Punji sticks, guerrilla warfare, the inability to identify the enemy, tactics of infiltration, and terrorism—these were but some of the military pressures that U.S. troops faced, at

'It is our duty as humans and doctors," say the founders of Médecins Sans Frontières, "to assist and bear witness for peoples in danger of death, whether their governments approve or not." In countries where basic health care is hard to come by even in peacetime, the care of the wounded is an immense challenge during war. Toward this end a small group of French doctors banded together in 1971 under the name Médecins Sans Frontières—Doctors Without Borders. The organization now sends some eight hundred physicians, nurses, and medics to alleviate the world's crises every year. Here, surgeon Bruno Dehaye, M.D., (left) adjusts a lamp in the operating room at the Kompong Champ refugee camp, where Cambodian patient Heng Chu has come to flee the Khmer Rouge regime of Pol Pot—under which an estimated one million Cambodians died. *Photograph by Sebastiao Salgado Eastern Cambodia, 1975–79*

Eight years of a war of attrition with neighboring Iraq *(previous page)* meant the need for thousands of artificial limbs for the Basij—volunteer soldiers—fighting for Iran and the Ayatollah Khomeini. The limbs were fitted, and the wounded trained to use them, at this house in north Tehran. *Photograph by Michael Coyne Iran, 1986*

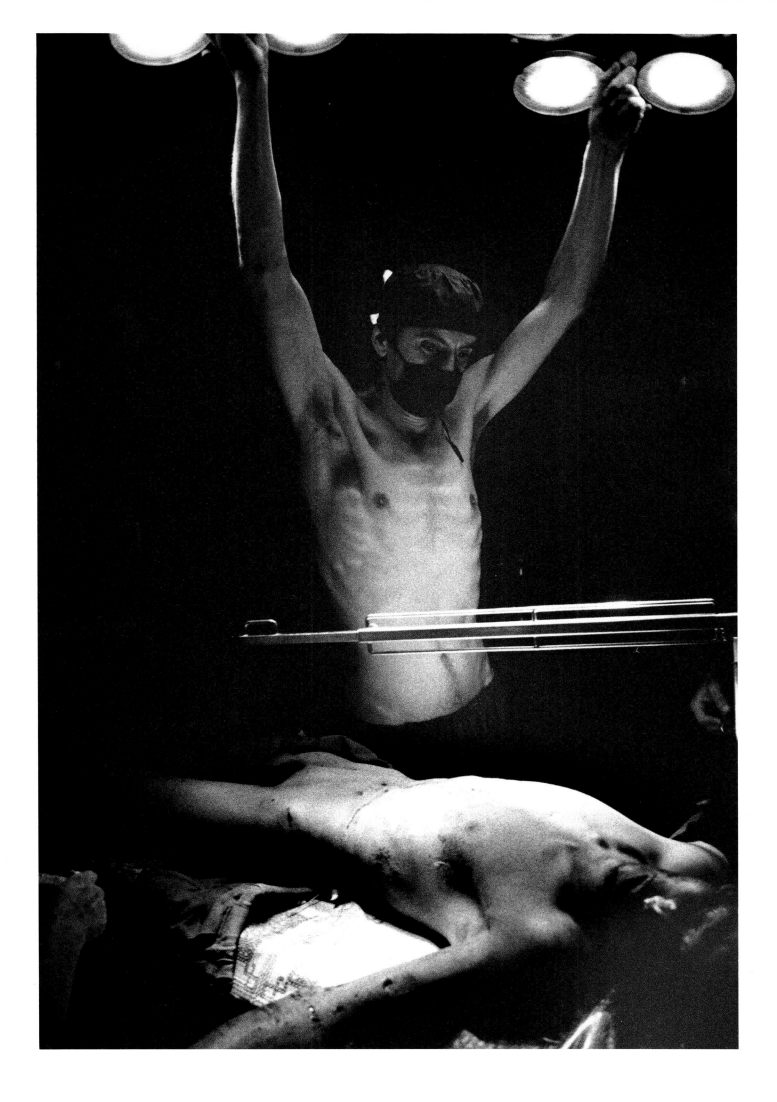

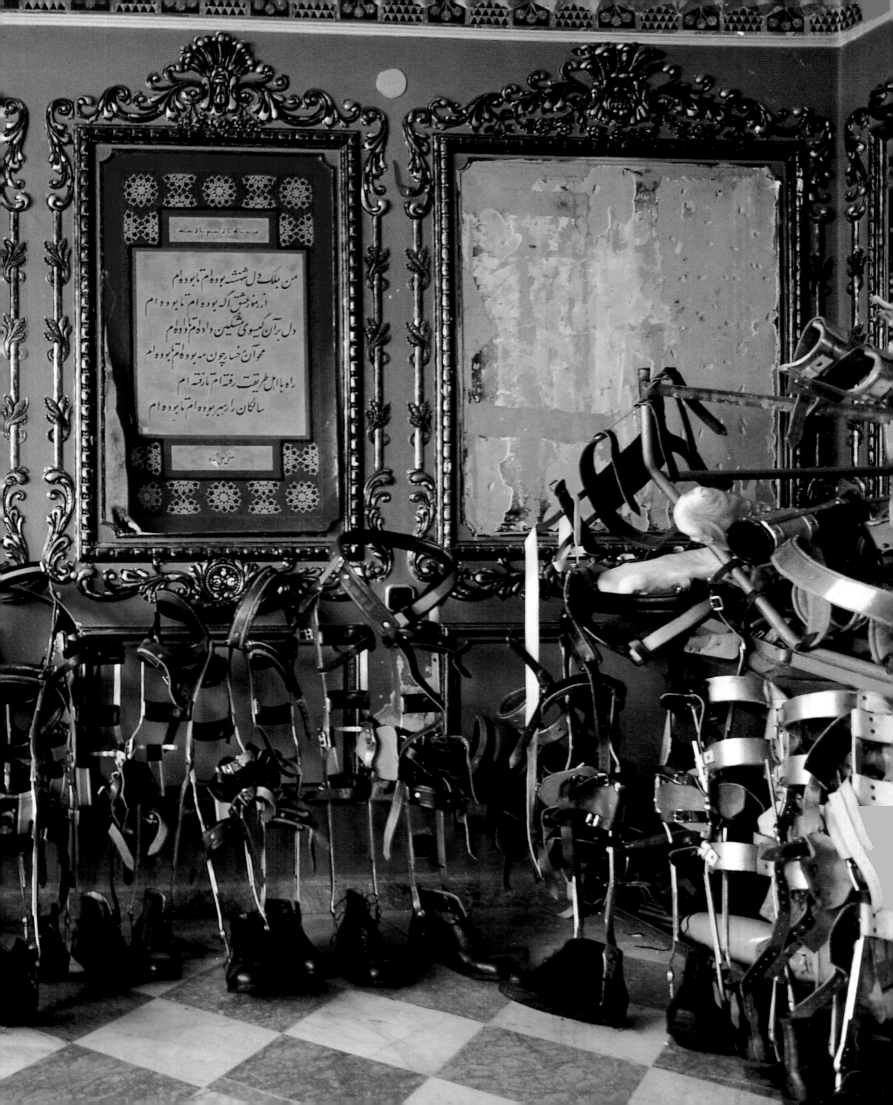

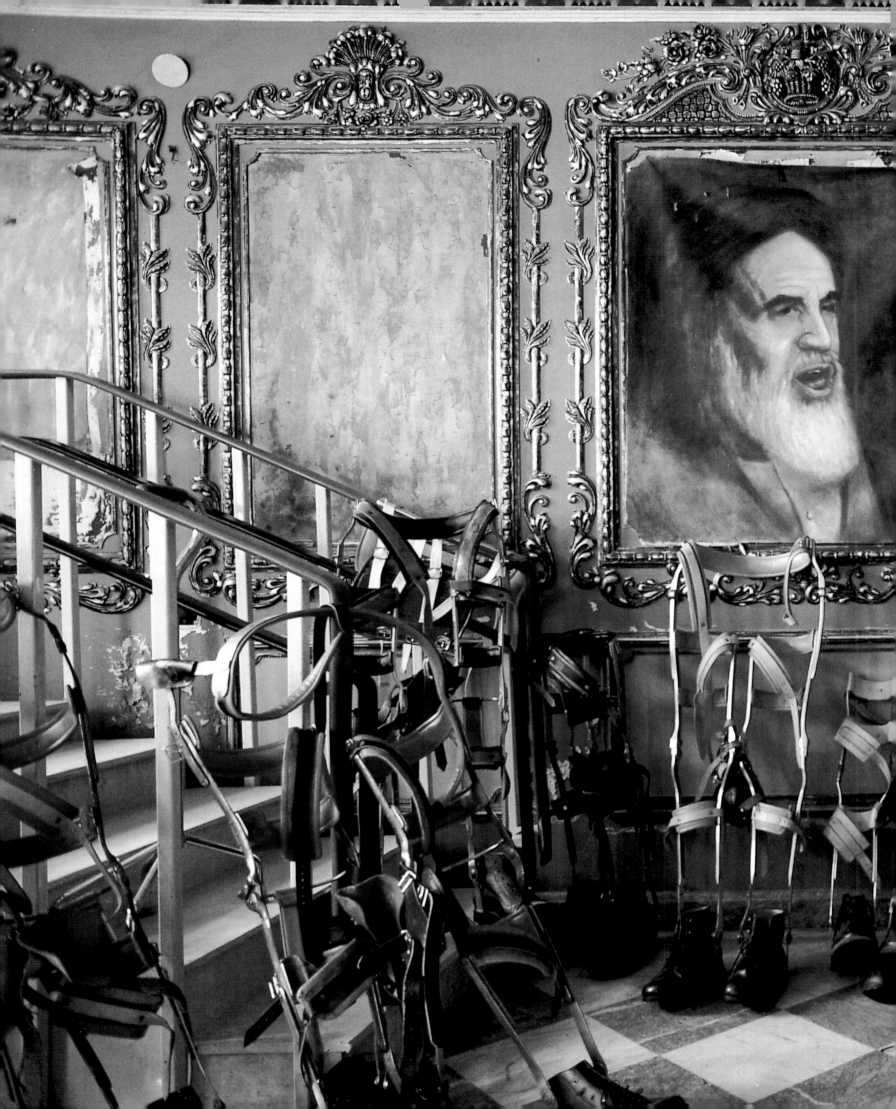

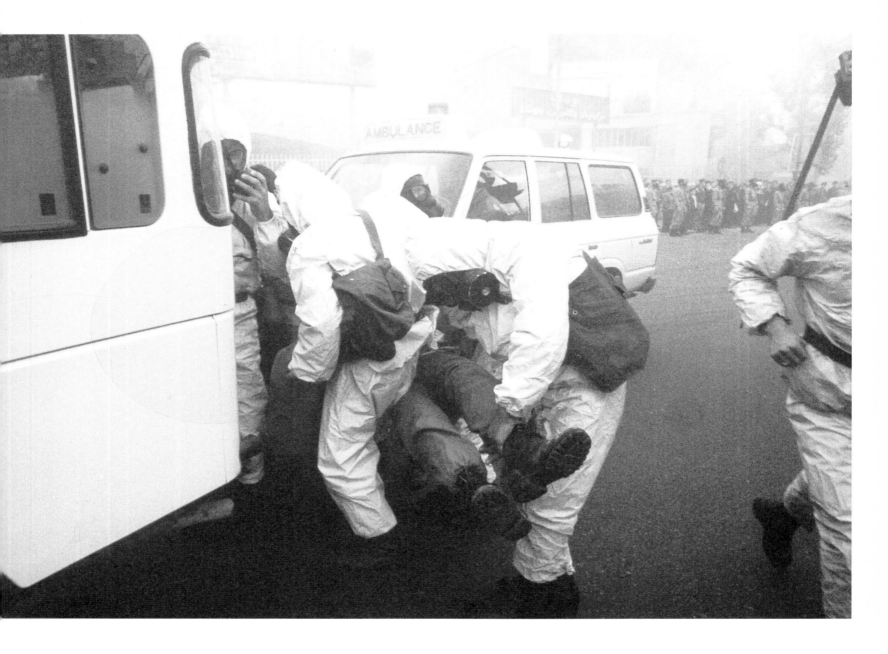

Iranian medical personnel wearing full body suits—in anticipation of a poison gas attack—hurry victims of Iraqi missile attacks into ambulances in Tehran, in an all-too-common scene from the war between the neighboring countries (1980–88). International observers confirmed that Iraq dropped mustard-gas bombs on Iranian positions during the war, in clear violation of the Geneva Protocol of 1925—an agreement that, in response to the brutal use of mustard and other gasses in World War I, had outlawed the use of chemical weapons in warfare.
Photograph by Farnood
Tehran, Iran, 1986

245

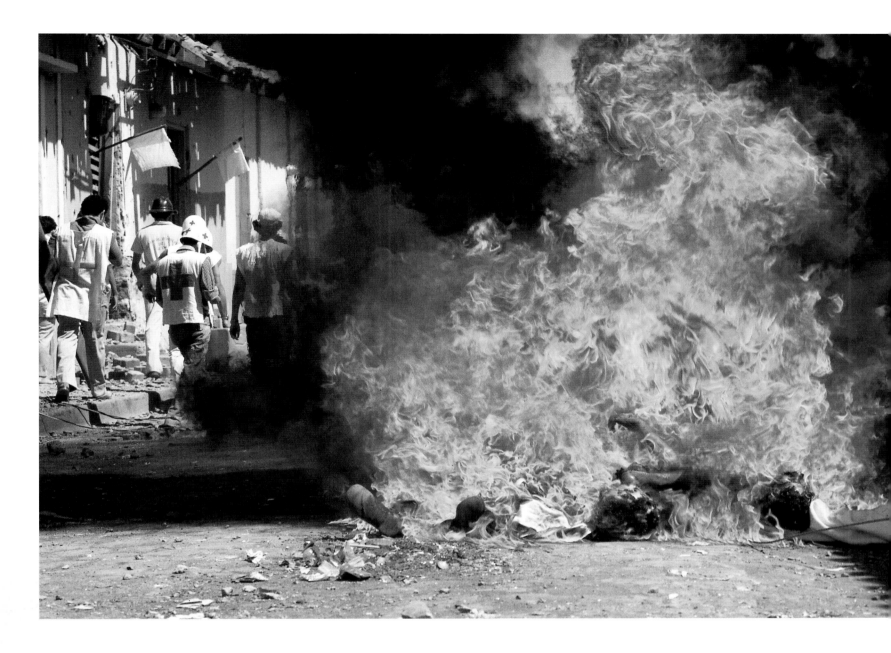

**The Nicaraguan Red Cross burns
the bodies of the war dead in the
streets of León**, in an attempt to
prevent disease and improve wartime
sanitation during the insurrection
(1978–79) that brought the Sandinista
National Liberation Front to power in
Nicaragua. The country's splintered,
underdeveloped health care system—
already dangerously short on
physicians and supplies—was ill-
equipped to meet the needs of the
thirty thousand soldiers and civilians
killed during their nation's civil war.
*Photograph by Matthew Naythons, M.D.
Nicaragua, 1978*

the medics diverted a supply helicopter, but to their chagrin found that the jungle foliage was too dense to permit them to land. "For the next two hours, we and the colonel hovered over the battle, trying to figure out a way to get my medics and me into the fight. The best we could do was to send in a troop from the Fourth U.S. Cavalry, to push into the jungle with its vehicles so that a clearing could be opened up within five hundred meters of the fighting. When the cavalrymen had cleared a small hole in the jungle, not much larger than the size of a helicopter's rotor blades, we landed."

During the next three-and-a-half hours, while the tanks, tank dozers, armored personnel carriers, and the infantrymen drove the enemy snipers from the area, Goodrich and his medics worked swiftly among the wounded. They stanched bleeding, opened airways, started intravenous fluids, and put the injured aboard the aircraft for one lift after another to the evacuation hospital. When the assistant commander of the infantry division set his helicopter down in the small clearing, it too was taken over for the evacuation of the casualties. Twice it was necessary for Goodrich to fly to the hospital with soldiers whose wounds were so serious they demanded the continuous care that only a surgeon could give them. Each time he returned, he began again his ceaseless efforts to attend to the young men whose lives had so suddenly been placed in his hands.

Meanwhile, the fighting raged on. Newly arriving troops launched an airmobile assault, and helicopter gunships joined the battle. It was growing dark as the advancing men overtook the enemy positions. Finally, the firing stopped. The team had given primary medical care to forty-five casualties and lifted them out to the Ninety-Third Evacuation Hospital at Long Binh, twenty-five kilometers away. Many others, whose wounds were relatively minor, had returned to battle.

But Goodrich had mixed feelings. He had arrived over the action within minutes of the first shots and been frustrated by his inability to land. As he put it later: "The wounded had to wait until all the battalion's resources could be thrown into the battle to relieve the pressure and to prepare a clearing in the dense jungle. But it was comforting to the men in battle to know that medical personnel were nearby, and that every effort would be made to reach and to care for them if they were hurt. This knowledge—that the best medical care in the world was only steps away—enabled the men of the battalion to concentrate their thoughts on the job that had to be done, and to do it in a competent and professional manner."

In Vietnam, the procedure of rapid resuscitation from shock used by Goodrich in that small jungle clearing was honed to a fine art and performed with a high degree of skill. Recent lessons learned in physiology research laboratories and city emergency rooms on the nature of shock found generous application in that otherwise confused and uncertain war; this new knowledge was refined in the military hospitals and later brought home. In the United States, the lessons of Vietnam would be influential in spawning innovative approaches to emergency medical care, such as trauma and intensive care units for precarious postoperative patients. The trauma teams at work in an inner-city U.S. medical center derived their roots from Vietnam. The medical subspecialties of the trauma surgeon and the intensive care specialist were created largely out of that wartime experience.

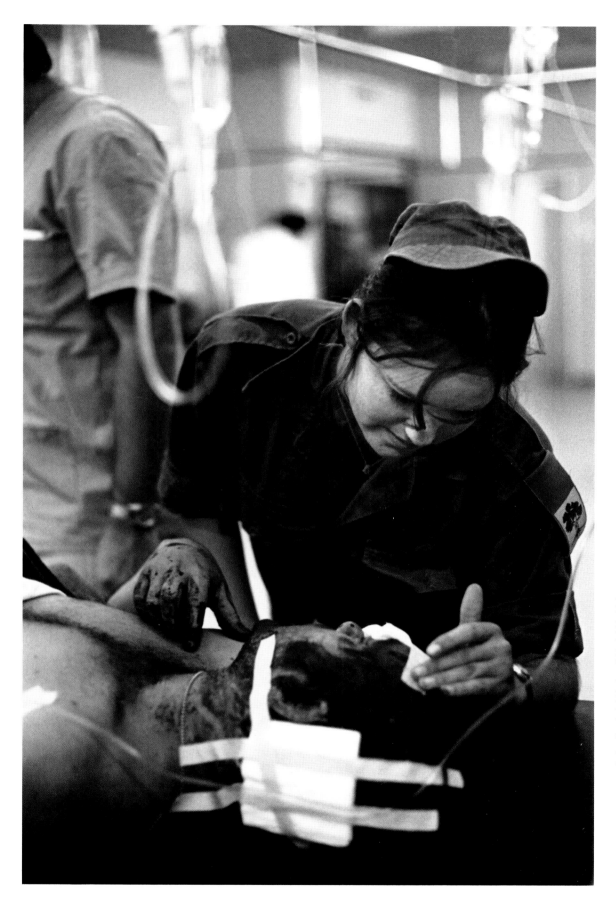

An Israeli soldier from the Solani Brigade reassures a comrade wounded in his tank on the first day of the Yom Kippur War in 1973 while he awaits more definitive treatment after triage. The Israeli military medical system— a branch of the Army given top priority for resources—is built on a comprehensive reserve system that puts even the country's top civilian surgeons on call to serve at a moment's notice. *Photograph by David Rubinger* *Golan Heights, 1973*

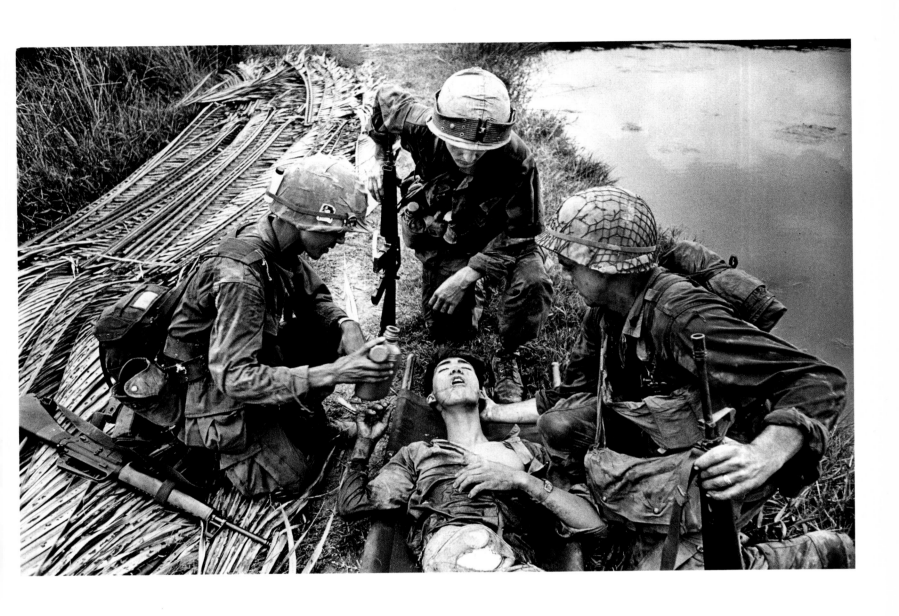

technicians. Within minutes, the casualties were examined and processed." After the insertion of appropriate intravenous lines and bladder catheters, the required x-rays were rapidly done for each man. "Then he was taken to the surgical building, where he entered one of the four operating rooms for definitive surgery and continued shock treatment. Subsequently he was taken to the postoperative ward. If shock continued to be a problem he might be placed in the special shock ward, where much special equipment was available." Hardaway echoes Ben Eiseman when he adds, "Such rapid treatment was unobtainable even in our best-equipped cities."

As it had been since Troy, the injured soldier himself, a medic, or a friend performed the first step in treating wounds on the battlefield. When the status of a given tactical operation permitted it, a field litter ambulance or an armored personnel carrier would be stationed close enough to the action to transport the wounded to the nearest aid station where the battalion surgeon could institute immediate care. Sometimes casualties were brought by litter, ambulance, or personnel carrier to a collecting point from which they were picked up by Medevac helicopters and taken either to an aid station or directly to the field hospital. Especially from areas of dense foliage, where it was impossible to get the battalion surgeon close enough to the wounded, helicopters would bring the men immediately to the hospital. In Vietnam, helicopters were employed in the transport of more than 90 percent of all combat casualties.

There was seemingly no end to the ingenuity and resourcefulness of the front-line doctors and the medics who worked at their sides—and there was certainly no end to their bravery. A battalion surgeon would, without hesitation, clamber aboard a helicopter and order its crew to let him down in the midst of a small clearing where a few wounded men had been carried. Within close range of the enemy's fire, he would begin resuscitation of the bleeding and mangled men, start IVs, insert breathing tubes, and even cut into a boy's windpipe to perform a tracheostomy on an obstructed airway. The doctors and their corpsmen risked their lives, and many of them died, for their young patients. The enemy made a special target of medics and doctors, and many medical personnel were killed by enemy action.

Isaac Goodrich, M.D., today a neurosurgeon in New Haven, Connecticut, was the battalion surgeon of the First Battalion, Twenty-Eighth Infantry, First Infantry Division during an action called ADELAIDE I in the jungles of Vietnam. He remembers one morning in 1966, when "I realized that I was near, and yet so far, from multiple casualties in the jungle beneath my helicopter." Several of the battalion's platoons had unexpectedly come upon an enemy camp, and had sustained severe casualties in the ensuing firefight. As then-Captain Goodrich describes it: "Despite the enemy's fire, the platoons' medics were running from casualty to casualty giving emergency medical treatment—a bandage here, an IV there, a single word of encouragement. One was shot twice through his helmet, sustaining a severe skull fracture and minimal brain damage. A doctor was urgently needed."

The battalion's commanding officer, Lt. Colonel Robert Haldane, ordered his executive officer, Major Robert J. Allee, to commandeer the next incoming helicopter so that Goodrich and two medics might be brought to the battle area. Haldane himself went up in another helicopter to establish a command post over the fighting. Allee, Goodrich, and

American GIs offer a drink to a captured North Vietnamese soldier with a three-day-old stomach wound: he'd put his intestines in an enamel cooking bowl and strapped it to his waist—one of countless examples of inventive first aid in the field. "I learned that you can save a man's life with what he has on his person," U.S. medic Douglas Anderson wrote after the war. "It's nice to have a first-aid kit because you have an airway, morphine, tourniquets and battle dressings. But you can stop bleeding with a belt, you can stop bleeding with a piece of string out of a poncho. You can tear a piece of clothing off a man for a battle dressing. You can stop a sucking chest wound with the cellophane off a cigarette pack. You can use his chin strap to secure things. I learned that first aid is a matter of primitive wits."
Photograph by Philip Jones Griffiths
South Vietnam, 1968

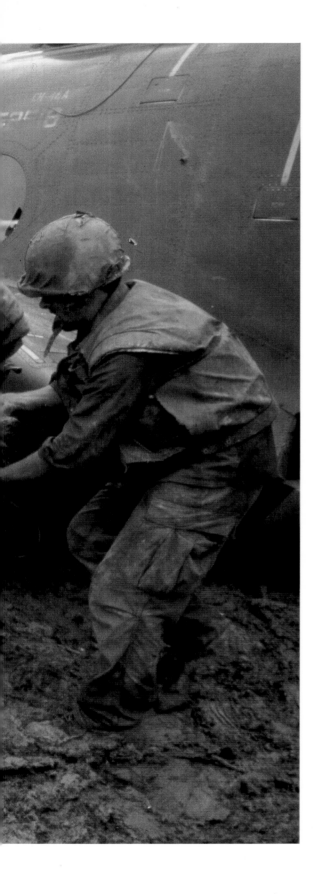

"It was mud, screams, and the terrible smell of death," recalled Al Levin, M.D., of his days as a Marine Corps doctor in Vietnam. Here, medics from Levin's unit load casualties into a chopper in the demilitarized zone (*left*). Amidst the chaos, Levin and his colleagues found themselves hampered by a lack of sophisticated equipment aboard the Medevacs. "We were morally obliged, as doctors, to save lives," he said, "and we weren't always able to do it. We were using fuel pipes for tracheostomies. And the soldiers would look at me like I was God, like I could put this mess back together. But a lot of the time, there was nothing I could do." Levin is still haunted by his first sight of casualties: "I remember the sense of timelessness. Except for the helicopters, I might as well have been in the mud in Gettysburg or Valley Forge—that's how much I could do for those guys." Twenty-five years after his arrival in Southeast Asia, Levin reflected on the famously terse description of war by the Civil War's General Sherman, "War is hell." Said Levin of his thirteen-month-long tour of duty in Vietnam: "It wasn't hell. It was far worse than that."

Like Levin, photographer Larry Burrows said that the toughest part of bearing witness to Vietnam was "to keep feeling, in an endless succession of terrible situations." Before his helicopter was shot down over Laos by the North Vietnamese, Burrows captured the anesthetized gaze of the wounded after Operation Prairie (*below*), a "sweep" south of the DMZ by twenty thousand men.
Photographs by Larry Burrows
South Vietnam, 1966

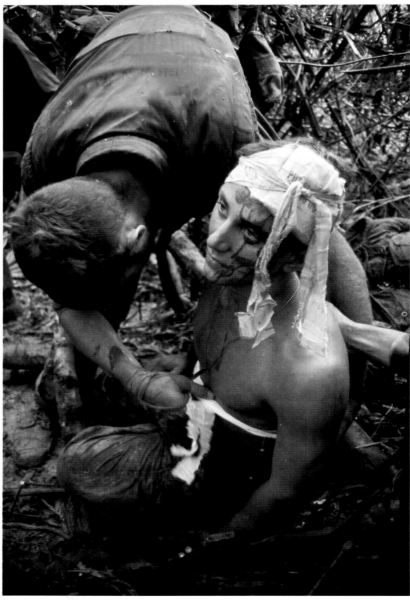

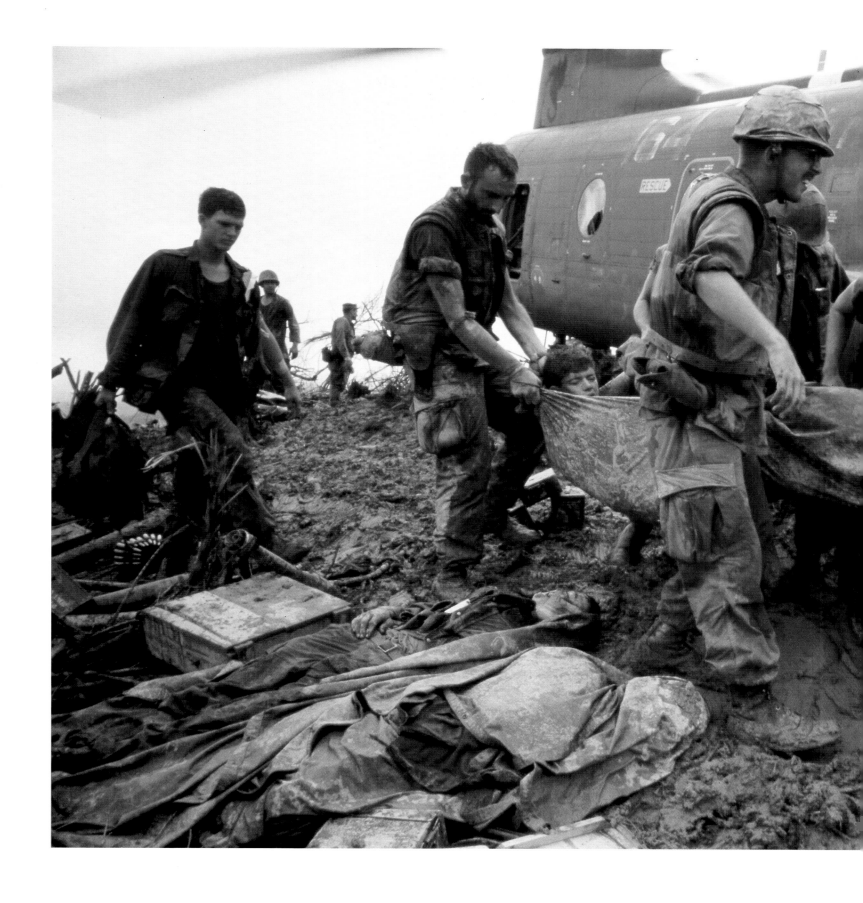

research that, in the short time since Korea, had expanded exponentially and brought to the bedside its new insights into organ function and basic physiology. The high-tech savvy of the foremost American medical centers was brought to the wounded of the Vietnamese jungles, and the doctors who took it there represented more clinical sophistication than the scientific community had ever seen. This was one war in which the lessons learned on the battlefield were not so much taken home to be applied in the civilian hospital as the other way around—the world's foremost clinical and biomedical research establishment sent some of its most promising young doctors off to the war, and provided them with the equipment they needed to accomplish their task.

The result is that some 30,000 additional American fighting men in Vietnam would have died had the medical care been unchanged even from the high level of the Korean War. Had the medical care of Vietnam been available in World War II, 118,000 fewer men in that war would have died.

Ben Eiseman, M.D., chairman of surgery at the University of Kentucky Medical School and a naval surgical consultant during the Vietnam War, summarized the medical corps' experience in 1967: "Wounded in the remote jungle or rice paddy of Vietnam, an American citizen has a better chance for quick definitive surgical care by board-certified specialists than if he were hit on a highway near his hometown in the continental United States. Even if he were struck immediately outside the emergency room of most United States hospitals rarely would he be given such prompt, expert operative care as routinely is furnished from the site of combat wounding in Vietnam."

Eiseman was not condemning stateside trauma care; he was commending the excellence of care in the military. At the very outset of the war, medical generals and physician advisers to the Department of Defense made a strategic decision. In previous wars, the principle first articulated by Baron Larrey in Napoleon's time had been the basis of medical logistics: treat casualties as close to the battle lines as possible. For all its advantages, this philosophy had spawned several generations of small, scattered treatment facilities where doctors performed complex procedures with inadequate equipment. The decision in Vietnam was to try exactly the reverse: a small number of relatively permanent and fully staffed surgical hospitals were outfitted with the finest equipment possible, and serviced by rapid helicopter transport to bring patients to them. What the military developed in Vietnam grew into the concept of major trauma centers back home in America.

In trauma medicine, whether civilian or military, transportation is critical to success. The first step is evacuation of the wounded. In World War I, the average interval between wounding and definitive care was between ten and eighteen hours. In World War II, it was reduced to six to twelve hours. In Korea it was cut again to four to six hours; and in Vietnam, it was reduced to only one to two hours and became shorter as the war went on. In 1967, physicians at the Third Surgical Hospital in Bien Hoa found that their usual patient was delivered to the helipad within forty minutes—and some as early as within fifteen minutes—of being wounded. Brigadier General Robert M. Hardaway, who organized a research team in Vietnam, describes the orderly sequence of events that took place when a helicopter landed at one of the surgical hospitals: the wounded soldier was "immediately surrounded by expert teams of surgeons, nurses, and

A soldier gives landing directions to a helicopter hovering above a small jungle clearing in Vietnam as wounded men on the ground and in the arms of other soldiers await evacuation. The helicopter system first used by the United States in Korea reached new levels of precision and efficiency in Vietnam, often getting the injured to a first aid station or field hospital in well under an hour—a far cry from the several days it took some Civil War wounded to receive medical attention.
Photograph by Arthur Greenspon South Vietnam, 1968

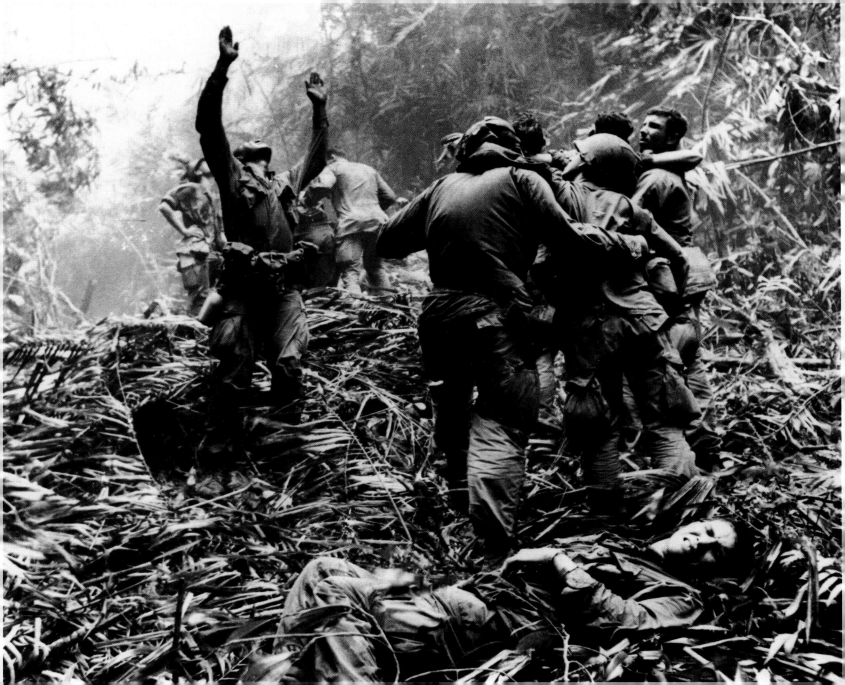

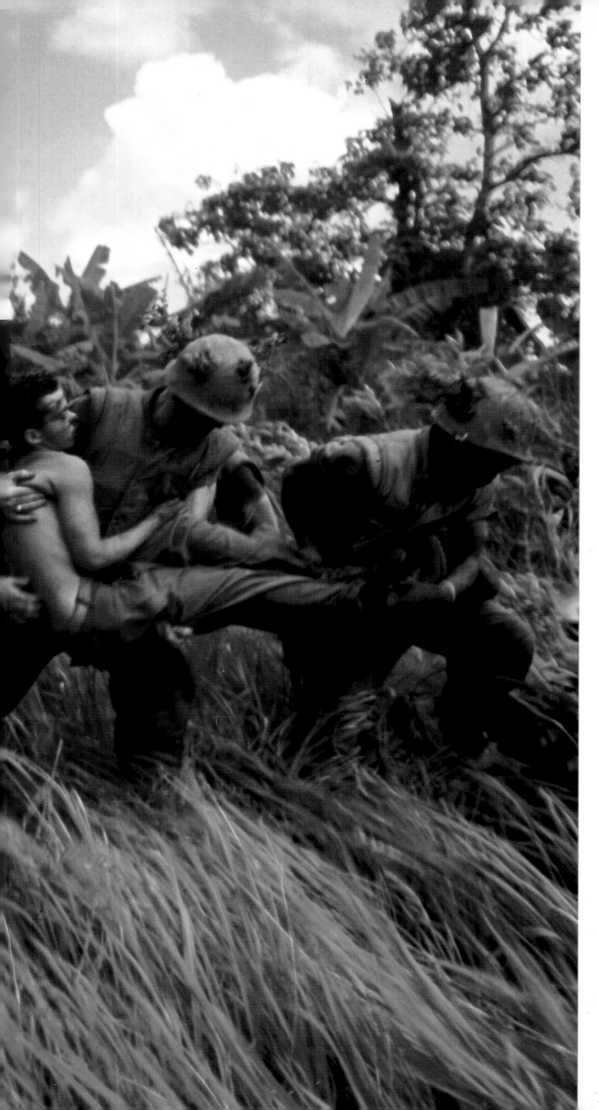

In the first war to acknowledge fully the emotional impact of combat, troops wounded just south of the demilitarized zone are carried to safety. "Oh Christ, where shall I begin," wrote a Marine Corps medic to his psychiatrist seven years after serving in Vietnam from 1963 to 1964. "There once was a man who saw two hundred fifty bloody brothers in a single afternoon. Two were the first I ever saw (he ever saw) one hysterical and bleeding from his nose and ears and the other one with most of his hand blown away. And that was the way the day started and the day went on unending and has never ended. Time ended. Time broke apart. Living broke apart. . . . I didn't go to destroy men. I went to help heal them. This man of whom I speak was never of intention to harm anyone. He did great good, many lived because of him. Many would have died if not for him. Yet that matters little because the ruin so far outweighed the remnant that was preserved that the comparison is not even to be noted. Simple sight of some things stains a man."
Photograph by Larry Burrows
South Vietnam, 1966

235

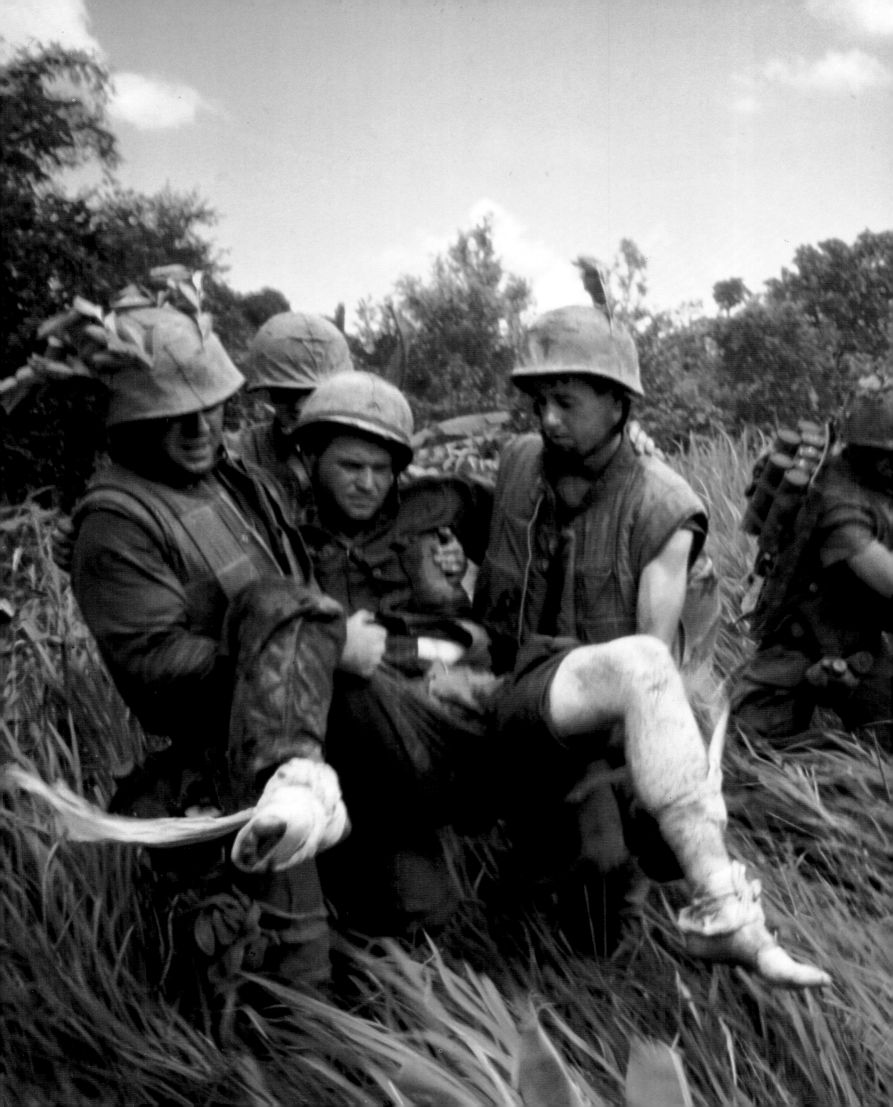

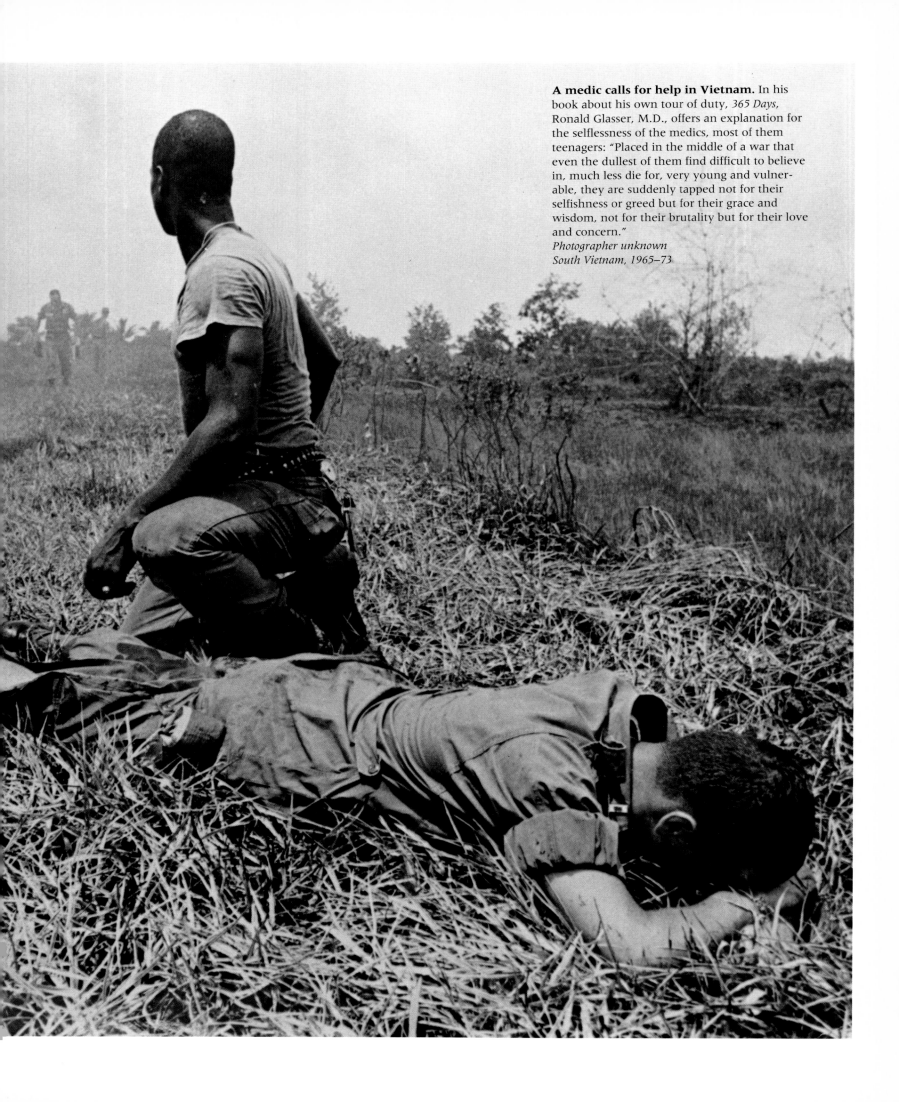

A medic calls for help in Vietnam. In his book about his own tour of duty, *365 Days*, Ronald Glasser, M.D., offers an explanation for the selflessness of the medics, most of them teenagers: "Placed in the middle of a war that even the dullest of them find difficult to believe in, much less die for, very young and vulnerable, they are suddenly tapped not for their selfishness or greed but for their grace and wisdom, not for their brutality but for their love and concern."
Photographer unknown
South Vietnam, 1965–73

Marines developed some degree of frostbite; many of them, according to Holloway, were "literally frozen into their boots." The helicopter evacuations and MASH units were yet to be commonplace.

Holloway's company consisted of five Naval medical officers, a dentist, and eighty corpsmen, typically stationed near the regimental command post or a few miles from the front lines. Like the casualty clearing station and the field hospital of earlier twentieth-century wars, it was the fast-paced site where medical staff provided resuscitation and major surgery to the wounded who required immediate treatment. The wounded stayed on their original litters during treatment and even through their evacuation. The first step in the evaluative process of triage was the removal of weapons and ammunition from the soldier; as Holloway pointed out: "It is extremely disconcerting to the surgeon while he is operating to have a hand grenade drop out of a man's uniform." All patients with skin breaks were given a tetanus booster, and penicillin and streptomycin to prevent infection. The staff then transfused the men in shock, started intravenous fluids, and began surgery; at Chosin the operating tables consisted of two sawhorses and the patient's litter.

As in all wars, shock was a major problem. The Korean conflict was the third consecutive American war in which military researchers studied this phenomenon and its sequellae. Once again, treatment was improved, most particularly for the kidney damage caused by the compromised circulation of shock. Of equal importance was the new light shed on "wet lung," the problem first identified in the lungs of severely wounded men by Dr. Lyman Brewer during World War II, and which was now called adult respiratory distress syndrome. The experience of Vietnam brought this condition under research scrutiny, and after the war it became a topic of widespread clinical investigation.

Physicians evaluated new blood substitutes and synthetic, morphinelike drugs. Army physicians and epidemiologists successfully combatted malaria, dysentery, Japanese B encephalitis, and other infectious diseases.

The medical care of American fighting men in Korea was by far the best the world had ever seen, and it continued to improve. In World War II, only 4.5 percent of the hospitalized wounded died, a figure that made the medical services justly proud. In Korea, only 2.5 percent died. It was hard to believe that such statistics could be improved upon—and yet they were. In the Vietnam War, only 1.8 percent of hospitalized soldiers died, and 87 percent returned to duty. This achievement in treating the wounded in Vietnam appears even more admirable for several reasons: each of America's wars had brought with it more deadly weapons; most of the men were wounded while isolated deep in jungle terrain without roads or traditional means of evacuation; the war had no front lines behind which aid stations and MASH units could closely and safely be positioned.

From the vast writings about doctors at war in Vietnam emerge some obvious reasons for the unprecedented success of this war's medical efforts. Three factors appear paramount: a system of medical evacuation so rapid that even seasoned veterans of earlier conflicts could not believe its efficiency; medical officers more highly trained and specialized than in any previous campaign (and in sufficient numbers); and biomedical

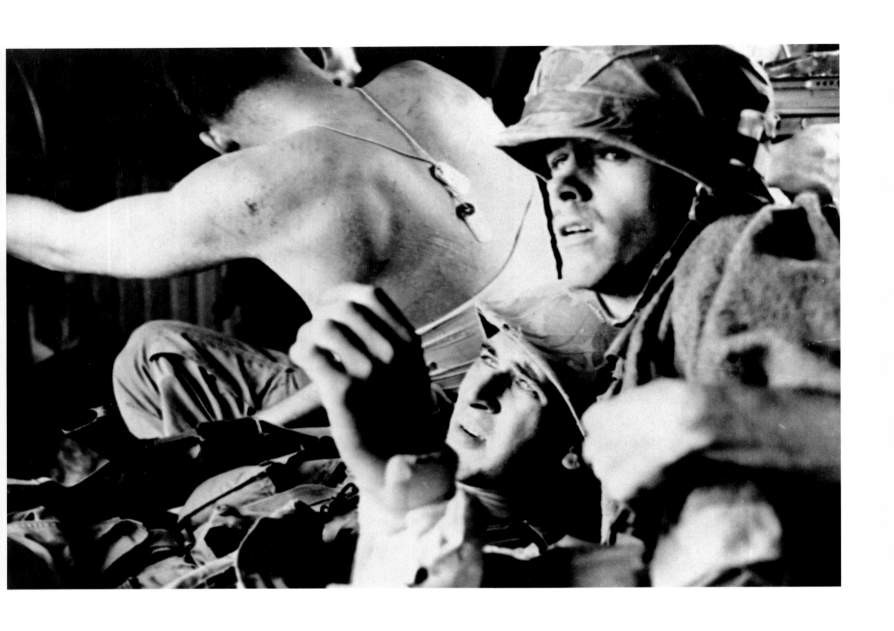

The cold bore down relentlessly. It reduced efficiency. It numbed our thinking and judgment. It inflicted crippling frostbite on many thousands who did not have adequate protection. We were especially distressed when our water and rations froze and could be thawed for only a few hours during the daylight and when many of our precious medications froze and burst their ampules and bottles. Frozen Morphine Syrettes had to be held in the mouth for thawing before they could be used.

The Hagaru-ri area was surrounded by the enemy for ten days. We received supplies and equipment by air drop; and, for medical needs, it was quite effective. Our hospital building, once the city hall for a town of 5000, was equipped to handle 100 litter patients, stacked in triple-deck fashion. Being surrounded, we were unable to move our wounded by ambulance south to Hamhung; and with the air strip still unfinished, the patient load rapidly increased to over 800. Our drafty old building was full to the limit, and there were patients both standing and lying in line in the freezing cold, waiting and hoping to get in. Every outfit gave up its best shelters to care for as many wounded as possible whether they had a medical officer or not.

The Chinese could be seen atop many of the hills overlooking us, and they attacked every night. The hills often exchanged control several times a day. Wounded and dead enemy lay like cord wood around the outskirts of Hagaru-ri. They presented no disposal problem. All were frozen.

Air-evacuation of our casualties began on the first of December from an air strip that was carved out of the frozen hills under enemy fire. But on the third of December when the two Marine Regiments from U-dam-ni broke into the Hagaru-ri perimeter, we received an additional 1500 casualties and thousands of cases of frostbite. It was a difficult task to sort the frostbite casualties for evacuation from those who, though frostbitten also, were required to march and fight their way down the mountain. By the end of the sixth of December approximately 6000 casualties were flown out to safety.

Meanwhile, the Marines regrouped and broke the enemy blockade for the final southward push. As the convoy departed, all usable buildings and equipment were destroyed, and the entire local population of the town left with us. We were ambushed repeatedly during the 27 hours it took to struggle the twelve miles down to Koto-ri, which was also surrounded. Sometimes the Red troops were successful in breaking into our convoy, and they set fire to trucks and inflicted casualties. The side of the road was strewn with frozen Chinese dead and dying. Our wounded were stacked and lashed onto every truck, on fenders, water tanks and generators; but all of them were brought out.

Corporal Larry R. Niklos anxiously waits for the Medevac chopper carrying him and a companion to pull out of range of enemy fire and away from Da Nang, where he was wounded in an ambush. As in every conflict, the loss of friends was a wrenching experience for American soldiers in the Vietnam War (1965–73). Some have yet to recover emotionally: "When you see friends shot up, blown up, and killed day and night it does something to your mind and you can never forget the tears, blood and death," wrote Sfc. Leroy Massie, who spent nine years as a motion picture cameraman for the Department of the Army Special Photo Office in Vietnam. "I have nightmares about the war," he said. "I am always being chased by the Viet Cong." He added: "I take cover sometimes when I hear a loud noise. I cry sometimes when I think of all the brave soldiers I have seen wounded or killed." Untold numbers of Vietnam veterans still suffer from post-traumatic stress syndrome, a potentially debilitating psychological reaction to the constant, acute, uncontrollable horrors of war.
Photograph by Sgt. W. F. Schriden Da Nang, South Vietnam, 1967

But all of them were brought out. That understated final sentence epitomizes the doctor at war. Holloway's few words express the mercy, the pride, the skill, and the ingenuity displayed by the medical officers of every nation that has ever gone to war since the beginning of formally organized military medicine, and even long before. As war is the ultimate medical challenge, Holloway has articulated the ultimate medical response: every wounded soldier would be given the best medical care its sponsoring nation could provide.

The withdrawal from the Chosin Reservoir took place early in the war, before scientists learned how to improve cold weather gear. More than 90 percent of the regiment's

While some military and civilian casualties were treated in urban hospitals (*left*), one of the primary medical innovations of the Korean War was the development of Mobile Army Surgical Hospitals. U.S. military brass drew up plans for the MASH units in 1948, and the first mobile hospital was in place less than two weeks after Korean hostilities began in 1950. Once the war's fronts stabilized, soon after the beginning of the conflict, the units became more sophisticated and less mobile, and in fact rarely moved at all. They were noteworthy, however, for the high level of military care they provided close to the front.
Photographer unknown
South Korea, 1950–53

Before America's protracted involvement in Vietnam, French doctors work alongside Vietnamese nurses in makeshift "reviving rooms" (*below*) in Dien Bien Phu, during France's unsuccessful eight-year attempt to keep control of Indochina (1946–54). Many military doctors and nurses began to question the wisdom of, as one nurse put it, suturing a man "up and down . . . to get that guy, no matter how many times he had been hit, in a good position to go back and do the same thing again."
Photograph by Paul Grauwin
Vietnam, ca. 1954

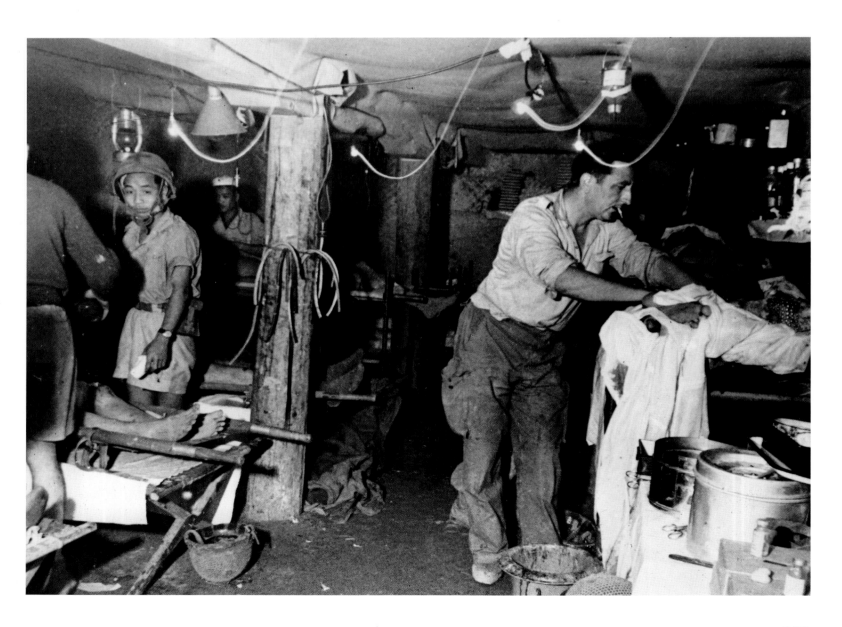

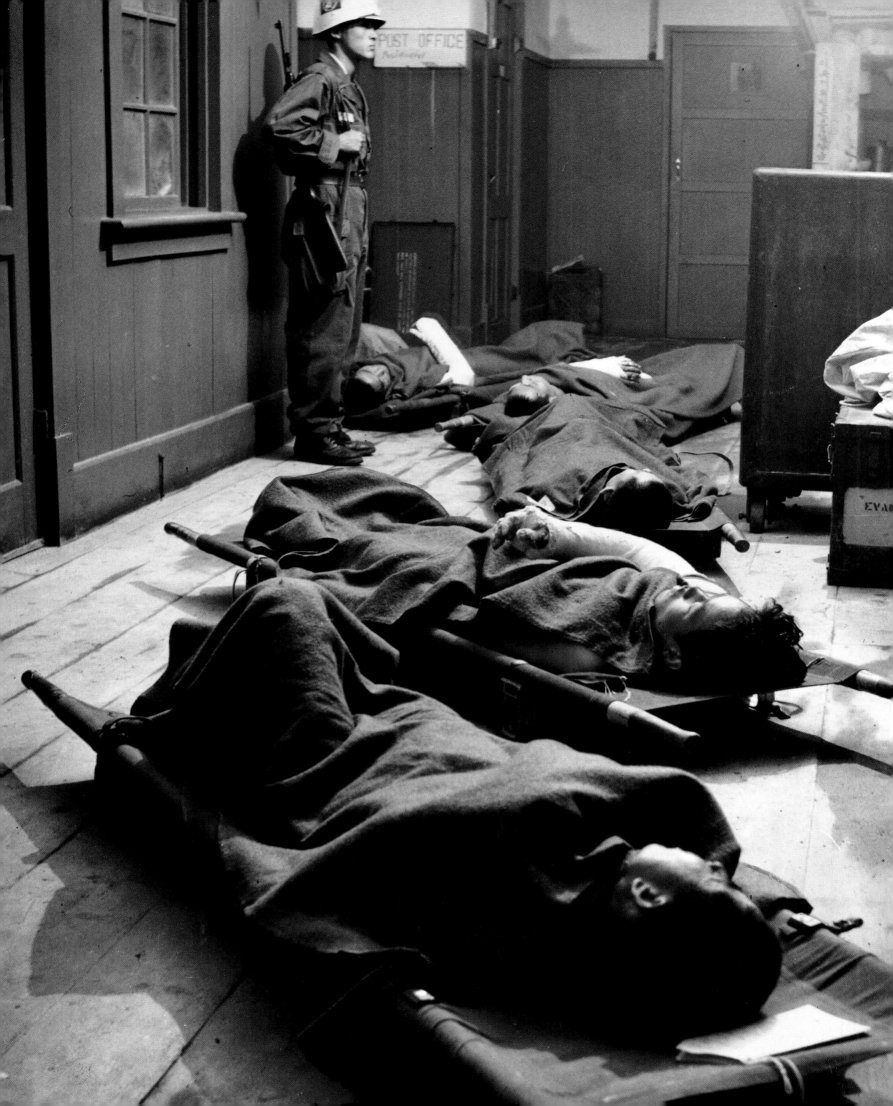

confusion and less-than-ideal triage decisions. Because instrumentation and fuel capacity were often inadequate, night flights were dangerous and available flying time was restricted. The helicopters often lacked the power to carry a heavy load of wounded men or to maneuver easily in mountainous terrain. Further, the aviation units gave priority to repairing their combat and transport planes, so that throughout the war, evacuation helicopter repairs were delayed. Even with all these difficulties, some twenty thousand helicopter transfers were made during the Korean conflict.

Although much better equipped, the typical MASH unit was not otherwise much different than its predecessors. It was a sixty-bed hospital near the front, enlarged to two hundred beds in the later stages of the war. Made of tents so it was easy to dismantle and move, the unit was staffed by one hundred nurses, doctors, and enlisted and administrative personnel. Its operating rooms were capable of any emergency procedure required, although the O.R. equipment was in no way comparable to what was standard for a good hospital in the States. The relatively small staff did have the advantage of producing a unique esprit de corps that boosted the quality of medical care in incalculable ways. Alan Alda, who played television's Dr. Hawkeye Pierce, is worth quoting here, because he seems to have captured something that even a civilian could feel, although Alda had never been near the action he portrayed: "We came in to tell jokes and stayed to touch the edges of art . . . maybe it gets to the heart of existence—the utter caring in the face of utter brutality."

One of the war's few major contributions to civilian medicine was improving the repair of injured blood vessels. Just as plastic and thoracic surgery had come of age in the two world wars, army surgeons in MASH units and hospitals transformed vascular surgery. The result was a dramatic decline in amputations due to gangrene from interrupted circulation. Medical teams also made technical innovations in the repair of peripheral nerve injuries, and refined their use of intravenous fluid therapy.

Much of our current knowledge of the effects of cold and moisture came about during this conflict. The Army's Cold Injury Research Team was able to prove that the simplest of measures—properly designed clothing and cold weather discipline—would prevent most of the damage done by extremely low temperatures. Charles K. Holloway, M.D., was the commanding officer of a medical company attached to the Seventh Regiment of the First Marine Division when it withdrew from the Chosin Reservoir in December of 1950, after breaking through the surrounding Chinese force; he later described the conditions faced by troops trying to fight a war in the frigid climate of North Korea.

The weather conditions presented the most cruel of all the problems we faced. . . . We soon noticed that the oil which burned in our tent stoves was frozen. We substituted 80 Octane gasoline, and this made our stoves glow to a nice cherry red. There were ten such stoves in our shattered building; and with all going full blast, the temperature rose to just above freezing. We had a few misgivings about operating with a red-hot gasoline stove two feet away from the anesthesia machine where gas, oxygen and ether were being used. But there were no accidents.

An American doctor treats a young Korean girl while her mother and neighbors look on. Through the auspices of the Armed Forces Aid to Korea (AFAK) program, U.S. Army Medical Service personnel provided emergency medical care to Korean civilians, as well as training programs for Korean doctors and nurses, supplies for existing hospitals, and funds and technical guidance for the construction of ninety-two new health care facilities. Much of the aid was provided by doctors and nurses volunteering on their own time, and by "virtually every member of the Army generously giving cash donations," according to Col. Floyd L. Wergeland, M.D., who was deputy director of AFAK's medical program. Nearly 3.5 million dollars' worth of aid and 320,000 medical procedures were donated to Korea through the program.
Photograph by J. Launois
South Korea, 1950–53

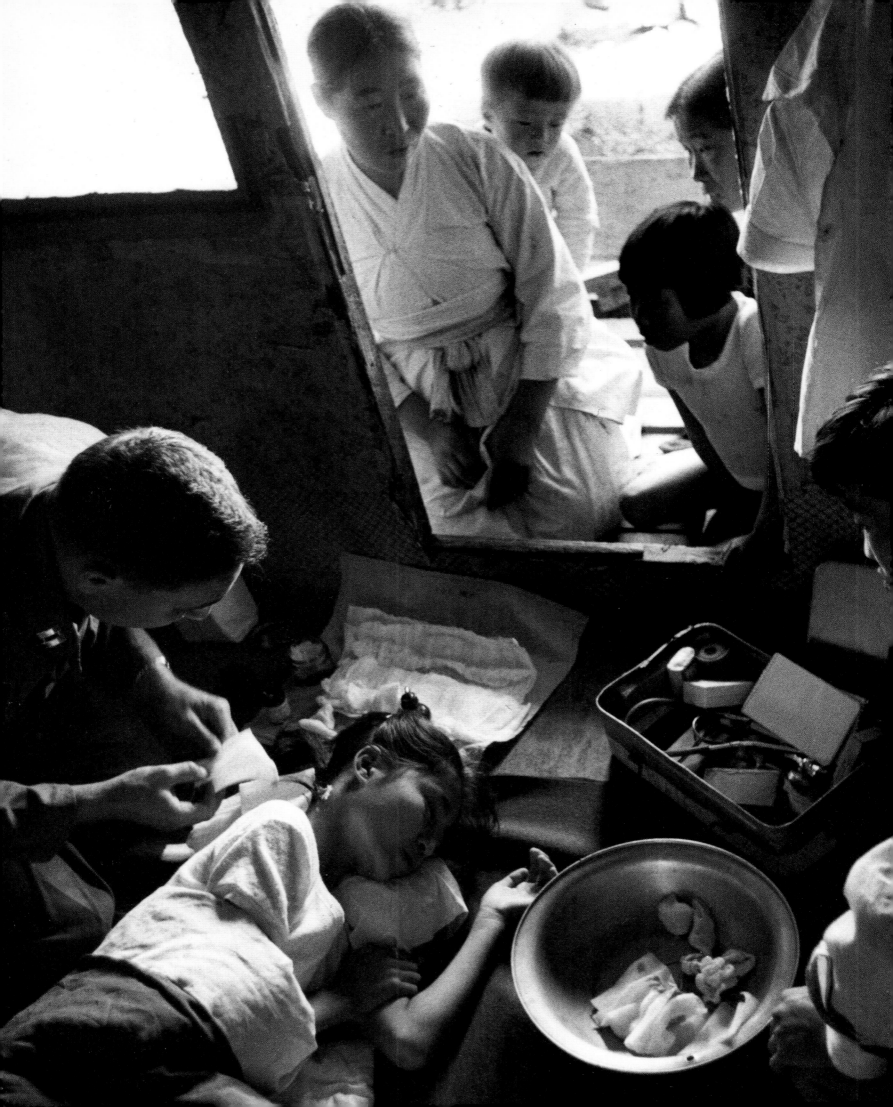

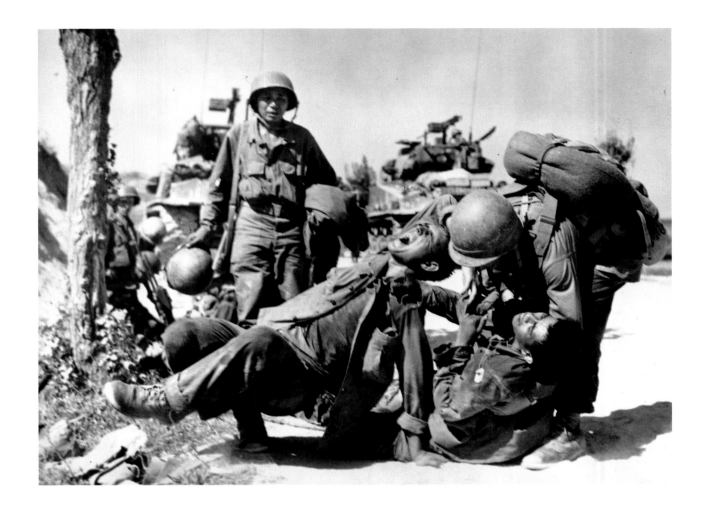

U.S. troops scramble to aid a wounded buddy in the battle for "Heartbreak Ridge" (*left*), which left fifteen hundred Americans dead on its slopes. "The front-line medics were superb," wrote Pfc. Leonard Korgie, who served with the U.S. Army in the Korean War (1950–53). "When someone got hit, even if he was probably finished, the medics would go down to him. God they were brave! . . . Every medic that day should have received a medal for valor. Unfortunately, only in nice, tidy actions does anyone have time to write someone up for a medal. That day the action was chaotic and I'm sure no one remembered who did what. . . . I remember one in particular, a heavyset kid, don't even know what unit he belonged to. A guy got hit on the slope below. . . . The medic jumped out of his hole. We yelled at him to get back, that he'd never make it. We tried to cover him. He died on the way down the hill."
Photograph by Cpl. Karl T. Burkholz
North Korea, 1951

Infantryman Kenneth Anderson, overcome by rage and fatigue, entrusts his buddy into the care of a corpsman—after carrying him two thousand yards to safety (*above*). Despite the care of the best military medical system the world had ever seen, the intense fighting and sub-zero temperatures took their toll on the men fighting in Korea. "I had changed," wrote Pfc. Doug Michaud in 1950. "I no longer wanted any buddies. Afraid I'd lose them. If I liked someone, I believed he'd get killed. Who needed the additional trauma? I sure as hell didn't. If you get killed, I don't know you and I don't care. You're just another number, another rifle—who cares? New people: 'What's your name? How ya doin'?' But nothing more. Don't tell me your hopes and dreams. You're going to get killed and I don't want to know you, think about you, remember you." Fifty thousand Americans died in the Korean conflict—as many as were killed in Vietnam.
Photograph by Ed Hoffman
Near Taejon, South Korea, 1950

225

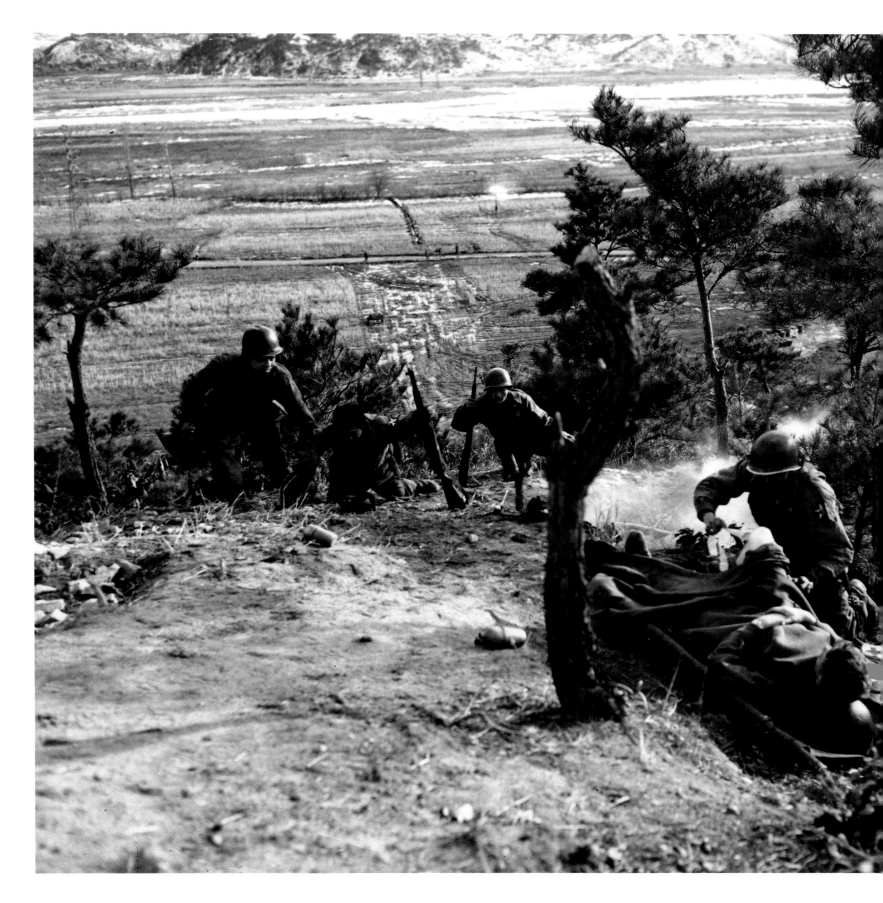

The Blurred Battlefield

The O.R. doors swung open and the surgeon, still in his scrub suit, strode out, peeling off his bloody rubber gloves. He came straight to me. "Are you that man's commanding officer?" he demanded. I said that I was and asked about Howard. "How is he? What the hell do you mean, how is he? He's lost an arm, that's how he is!" I was startled at the man's anger. He was a major, an army surgeon in Vietnam, and surely he had seen cases as bad, or worse. But he was furious—sputtering, screaming, furious—and his anger was directed at me. "Can you justify that, lieutenant?" he yelled. "Can you justify that? Losing an arm to take a goddamned picture? Can you?"

—*Nick Mills, quoted in* The Vietnam Experience: Combat Photographer

The escalation of Asian civil wars into international conflicts—in Korea in the 1950s and Vietnam in the 1960s—meant increasingly high ratios of civilian-to-military casualties: the Vietnam War left more than 300,000 civilians dead, compared to fewer than 50,000 U.S. combat deaths. Here, a South Vietnamese woman fans a young relative in the Quang Ngai Province south of Da Nang, unsure whether the child's family survived the past night's bombings. Most of the civilian victims of American attacks were wounded at night and sought treatment early in the morning, after the curfew was lifted. The hospital, run by a Spanish physician and his small staff, had intermittent electricity, little water, few medications—and a small room where hopeless cases waited to die.
Photograph by Philip Jones Griffiths
Quang Ngai Province, South Vietnam, 1967

The Korean War was fought under the constant threat of an atomic weapons strike, and its medical corps feared that the horrors of Hiroshima would be witnessed again. But instead of facing newer and yet more devastating injuries, the doctors in Korea were confronted by wounds more typical of World War II.

The role of physicians was perhaps less dramatic than it had been in either of the world wars. This was a war attended by young doctors: only a handful of America's leading medical authorities, and few of its great medical centers, were directly involved in the conflict. Perhaps because the physicians of World War II had routinized their treatment of the wounds they had encountered, because no radically new weapons were now introduced, and because a smaller number of men fought between 1950 and 1953, fewer medical contributions were made in Korea than in World War II. The Korean War was a war somewhat tangential to the progress of medicine, and somewhat tangential to the everyday concerns of most Americans at home.

But Korea did see considerable progress in several aspects of medicine: helicopter evacuation of the wounded improved and the principles of the Mobile Army Surgical Hospital, the MASH unit, were refined. In Korea, the more seriously wounded soldiers were evacuated to a MASH unit from a battalion aid station, or even from the front lines. The system, however, proved hampered by several factors. Rescue pilots received their orders from military commanders rather than from doctors, which tended to lead to

Conflicts of Our Time

Epilogue

Judith Thurman

O
n village greens in every small town in America, sometimes next to the firehouse or the church, one finds an obelisk, or the statue of a man in some old-fashioned uniform, and on its base—adorned with crude stone wreaths and crossed sabres—an honor roll of names. Here are the native sons who went to the wheatfields of Gettysburg and died there, to the beaches of Normandy and died there, who died off the shores of Iwo Jima and in the jungles of Khe Sanh.

In Europe, the honor rolls are often organized by profession. One finds them in smalltown post offices and museums, in college dining rooms and in railroad stations. There is such a list, a long one, particularly incongruous with its setting, in the entry hall of the Bibliothèque Nationale in Paris. These memorials are so common and ubiquitous that we cease to notice them—and in that respect, they pay homage as much to the fact that time passes and life goes on as that men and women died for their country.

But *The Face of Mercy* is something harder to walk away from. It's a memorial to their pain.

Pain is the most fundamental form of vigilance: it alerts the body to danger. When the danger is past, the body usually cancels the alert. But extreme experiences of loss and violence abuse the nervous system so profoundly that it mistrusts its own signal that all is well. "War trauma," observes Paul Fussell, "is one of our dirty little secrets, always there, never showing."

This dirty secret unites those who share it as much as it isolates them from the rest of us. More often than not, survivors of war don't consider themselves "the lucky ones." They feel a deeper solidarity among themselves and with the dead

A Somalian child is treated by a French doctor in Mogadishu after being wounded by a bullet in his country's ongoing civil war, which began in 1988. Four years later, the U.S. launched Operation Restore Hope, a military effort that escorted food and medical supplies to the people of Somalia.
Photograph by Frank Fournier
Somalia, 1991

than with the living, and are sorry to have come back. The first time a civilian hears such a statement, "I wish I had died there," it rings false. Either it sounds too self-pitying and depressive, or the evidence of pleasures, vices, ideals—of engagement with life—seems to contradict it. But the statement is insistent. Veterans of battle, like victims of torture and sexual abuse, seem to lose something fundamental of their wholeness.

When you steep yourself in the literature, and particularly in the images, of war, you begin to hear the cry—the same in every language and across the millennia—that goes up from the battlefield: make it stop. That cry is what the military doctor, nurse, and medic hear, if they can bear to listen, every minute of their active duty. In Vietnam, healers were targets of choice for North Vietnamese gunners—precisely because they were such precious figures to the men, even when the medics had no supplies and couldn't administer an IV or a shot of morphine. Courage for the soldier is proportional to his fear. Courage for the healer is probably proportional to his or her sense of inadequacy. That inadequacy is galling, even bitter, and anything but heroic to the healers themselves. But soldiers desperate less for first aid than for trust see beyond it. For them, the healers are, in the midst of the carnage, the only ones with a function that is still rational and human. Whatever their uniforms, those who seek to preserve life represent the same side, they champion the same principle of defiance: they are Davids facing death's Goliath.

The function of a warring nation's propaganda is to anesthetize the pain of its civilians and potential soldiers. (The actual combatants need something stronger.) Reportage, on the other hand, is a form of vigilance, and in the case of the extraordinary photographs in this book, a form of pain that survives the healing process, and the inevitable forgetting that comes with it. Thus the best kind of war book is, to paraphrase Fussell, ultimately an anti-war book, and an anti-anesthetic. It challenges you to imagine what the most murderous kind of persecution feels like. But it also, paradoxically, provides the glimpse of an ideal. For in the realm of shared grief, rage, fear, and sacrifice—but also of solidarity—war is unique. And here we see that the work of the healer and the photographer serve a single purpose with two names: survival and remembrance.

A gathering of the Ruined Faces Club, men disfigured during World War I. *Photographer unknown France, ca. 1920*

Writers

Stanley Burns, M.D., is the creator, curator, and proprietor of The Burns Archive, the nation's largest collection of early medical photography. A practicing ophthalmologist in New York City, Burns began collecting original photographs in 1976, and today has accumulated more than 125,000 images, created several exhibitions, and authored four books based on his photography collection. *Masterpieces of Medical Photography*, co-authored with Joel-Peter Witkin, was chosen by the International Center of Photography as one of the best photography books of 1987.

Gloria Emerson's coverage of the Vietnam War won the 1971 George Polk Award for excellence in foreign reporting, and her 1972 book about the conflict, *Winners and Losers*, won a National Book Award. As a foreign correspondent for *The New York Times* from 1965 to 1972, she also covered the conflict in Northern Ireland and the Nigerian Civil War. She is the author of *Some American Men*, and has held teaching fellowships at Harvard and Princeton Universities.

Martha Gellhorn has authored thirteen books, chronicled seven wars, and established residency in seven countries. She began her writing career describing the hospital conditions of the Spanish Civil War for *Collier's*, and went on to cover conflicts in Europe, Vietnam, and Israel. Her books include *The Face of War, The Honeyed Peace*, and most recently, *Travels with Myself and Another*, a memoir of her journeys through the trouble spots of the world.

Ward Just has been writing eloquently about war and politics for the past thirty years. He covered the Vietnam War for *The Washington Post* until 1967, when he was seriously injured by a grenade while on a reconnaissance patrol. He has received National Magazine Awards for both fiction and non-fiction, and his books include *Jack Gance, To What End: Report from Vietnam*, and *Military Men*.

Sherwin Nuland, M.D., is a medical historian and clinical professor of surgery at Yale, his alma mater. In a review of his recent book, *Doctors: the Biography of Medicine*, *The New York Times Book Review* called him "a gifted and inspiring storyteller." His "Annals of Surgery" has appeared in *The New Yorker*, and he is a contributor to the *Los Angeles Times, Discover*, and numerous historical and medical journals. Nuland is Chairman of the Board of Managers of the *Journal of the History of Medicine and Allied Sciences*, where he is also an associate editor.

Bernard Ohanian has written the captions for several photojournalistic books, including *A Day in the Life of Italy* and *The Power to Heal: Ancient Arts & Modern Medicine*. An award-winning writer and editor for magazines including *Mother Jones, Parenting*, and *The Los Angeles Times Magazine*, he is currently on the editorial staff of *National Geographic*. He has taught writing at the University of California at Berkeley and California State University at Hayward.

Martha Saxton has written two books: a biography of Louisa May Alcott and *Jayne Mansfield and the American Fifties*. She received her doctorate in American history from Columbia University and is presently working on a history of women's moral standards. She has written for *American Heritage, The New York Times Book Review*, and *The New Yorker*, and has taught history at Columbia University and New York University.

William Styron is the author of *Lie Down in Darkness, The Long* Set This House on Fire, The Confessions of Nat Turner, Sophie's Choice, Quiet Dust*, and *Darkness Visible*. He has been awarded the Pulitzer the American Book Award, the Howells Medal, and the Edward MacDowell Medal.

Judith Thurman is the author of *Isak Dinesen: The Life of a Story* which won the 1983 National Book Award for biography and ha translated into eleven languages. She is a frequent contributor to New Yorker*, and is at work on a biography of Colette to be publis by Knopf in 1995.

Medical Advisory Board

Alfred Jay Bollet, M.D., is a professor of medicine at Yale Uni Medical School and was the Vice President for Academic Affairs Danbury Hospital until 1992. He is recognized as an expert in the history of medicine, with numerous publications on the topic, in ing the book *Plagues & Poxes: The Rise and Fall of Epidemic Disease*. many professional honors include the 1981 Hammond Award fr the American Medical Writers Association, and he has served on editorial boards of several medical magazines.

Maj. Gen. William L. Moore, Jr., M.D., is the commandant of U.S. Army Academy of Health Sciences, the world's largest milita medical training center. In his more than twenty years in the Ar Medical Corps, he has served in Frankfurt, Germany; Vietnam; a Okinawa, Japan. Moore is a specialist in infectious disease, and graduate of Special Forces military courses in counter-insurgency SCUBA/UDT, and airborne training. He is currently on the Board Directors of the Army Medical Department Museum Foundation

Personal Narrative Research

Althea St. Amand Dana Sachs
Maryellen Driscoll Bill Shapiro
Kate Kelly Marilyn Wann
F. Jackson Lewis Susan Wels

Photo Archives

AUSTRIA
Heeresgeschichtliches Museum, Vienna
Kriegsarchiv, Vienna
Kunsthistorisches Museum, Vienna

BELGIUM
Belgian Military Archives, Brussels

CZECHOSLOVAKIA
Czechoslovak News Agency, Prague

FRANCE
Agence Vu, Paris
BDIC, Paris
Bibliothèque Nationale, Paris
Bulloz, Paris
Collection Sirot-Angel, Paris
Edimedia, Paris
Explorer, Paris
Gamma Photos, Paris
Giraudon, Paris
Jean-Loup Charmet, Paris
Magnum Photos, Paris
Médecins Sans Frontières Archives, Paris
Musée du Val-de-Grâce, Paris
Paris Match Magazine Archives, Paris
Roger-Viollet, Paris
Sipa Press, Paris
Sygma Photos, Paris

GERMANY
Bildarchiv Preussischer Kulturbesitz, Berlin
Bundesarchiv, Koblenz
Süddeutscher Verlag, Munich
Ulstein Bilderdienst, Berlin

HUNGARY
Hungarian News Agency, Budapest
Kiscelli Museum, Budapest
Museum of Contemporary History,
 Budapest
Semmelweis Medical History Museum,
 Budapest

ISRAEL
Mogen David Archives, Jerusalem
Yad Vaschem Archives, Jerusalem

ITALY
Aliniere, Florence
Contrasto, Rome
Dufoto, Rome
Farabola, Rome
Fornacciari, Rome
Fototeca, Rome

Publifoto, Rome
Scala, Florence
Storia Nationale, Rome
Ufficio Storico, Rome

POLAND
Central Archive of the Army, Rembertow
Central Photo Agency, Warsaw
Commission for Research of Nazi Crimes,
 Warsaw
Military Museum, Warsaw
Old Documents Archive, Warsaw

SPAIN
A.G.E. Photostock, Madrid
EFE, Madrid

SWITZERLAND
International Committee of the Red Cross,
 Geneva
World Health Organization, Geneva

UNITED KINGDOM
Hassler Hospital for the Navy, Portsmouth
Hulton Picture Company, London
Imperial War Museum, London
Lee Miller Archives, East Sussex
London Daily Mirror, London
Popperfoto, London
Wellcome Museum, London

UNITED STATES
American Field Service Archives, New York, NY
American Photographic Archive, Cleveland, OH
American Red Cross Archives, Washington, DC
Art Resource, New York, NY
Barker Texas History Center, Austin, TX
Benson Latin-American Collection, Austin, TX
Bettman/UPI Archive, New York, NY
Black Star Photo Agency, New York, NY
Burns Archive, New York, NY
California Museum of Photography, Riverside, CA
Center for Creative Photography, Tucson, AZ
Center for Southwest Research and Medical
 Library, Albuquerque, NM
Contact Press Images, New York, NY
El Paso Public Library, El Paso, TX
Fort Leavenworth, KS
Fort Sam Houston Medical Museum, TX
FPG International Stock Agency, New York, NY
Gamma Liaison Photo Agency, New York, NY
Granger Collection, New York, NY
Harry Ransom Humanities Research Center,
 Austin, TX

Institute of the History of Medicine, Johns
 Hopkins University, Baltimore, MD
Library of Congress, Washington, DC
Magnum Photos, New York, NY
Matrix Photos, New York, NY
Metropolitan Museum, New York, NY
Museum of the Great Plains and Fort Still
 Museum, OK
National Archives, Washington, DC
National Library of Medicine, History of
 Medicine Division, Washington, DC
New York Academy of Medicine, New York, NY
New York Journal American Morgue,
 Austin, TX
New York Public Library, New York, NY
Sipa Press Agency, New York, NY
Sovphoto / Eastfoto, New York, NY
Sygma Photo News Agency, New York, NY
University of California Riverside Archives,
 Riverside, CA
Uniformed Services University of Health
 Sciences, Bethesda, MD
U.S. Armed Forces Collections,
 Washington, DC
U.S. Department of Defense, Washington, DC
U.S. Marine Corps, Washington, DC
Visions Photo, New York, NY
Walter Reed Army Medical Center,
 Washington, DC
Wide World Photo, New York, NY

U.S.S.R.
St. Petersburg Museum, St. Petersburg
Red Army War Museum, Moscow
Novosti Press Agency, Moscow
TASS Press Agency, Moscow

Commissioned Photographers

Suzanne Keating
Christopher Morris
Robert Nickelsburg
Alon Reininger

Illustration Credits

Illustration credits are listed by page and separated from left to right by semicolons, from top to bottom by dashes.

ii National Archives iv Library of Congress vi Bildarchiv Preussischer Kulturbesitz, Berlin viii Robert Capa, Magnum Photos x Catherine Leroy, Gamma Liaison Agency xii Erich Lessing, Art Resource, New York xvi Suzanne Keating 4 Erich Lessing, Art Resource, New York, Musée du Louvre, Paris 6 Erich Lessing, Art Resource, New York, Kunsthistorisches Museum, Vienna 8 Bildarchiv Preussischer Kulturbesitz, Berlin 10 Art Resource—Scala 11 Erich Lessing, Art Resource, New York, Museo Archeologico Nazionale, Naples 12 Bibliothèque Nationale, Paris 13 *All* Jean-Loup Charmet, Paris 14 National Library of Medicine, Bethesda 15 Jean-Loup Charmet, Paris—Roger-Viollet, Paris 16 Prado, Madrid 19 Granger Collection, New York; Museo Correa, Venice 20 Musée de Laval 21 Jean-Loup Charmet, Paris 22 Musée des Beaux Arts, Rouen 27 Prado, Madrid 28 Giraudon, Musée du Louvre 31 Musée du Val-de-Grâce 32 World Health Organization, Geneva 36 National Archives 38 Dr. Stanley B. Burns Collection 40 Hulton Picture Company, London 43 Jean-Loup Charmet, Paris 44 Hulton Picture Company, London 45 *All* Roger Fenton, Library of Congress 46 National Archives 48 Brady Collection, National Archives 49 Library of Congress—Brady Collection, National Archives 50 Dr. Stanley B. Burns Collection 52 Brady Collection, National Archives 53 Brady Collection, National Archives 55 Brady Collection, National Archives—Dr. Stanley B. Burns Collection 56 Brady Collection, National Archives 57 Dr. Stanley B. Burns Collection 58 Dr. Stanley B. Burns Collection 59 *All* Dr. Stanley B. Burns Collection 60 *All* Dr. Stanley B. Burns Collection 61 Library of Congress 62 Dr. Stanley B. Burns Collection 63 *All* Library of Congress 65 *All* Dr. Stanley B. Burns Collection 66 *All* Dr. Stanley B. Burns Collection 67 Brady Collection, National Archives 68 Dr. Stanley B. Burns Collection 70 Otis Historical Archives, National Museum of Health and Medicine, Armed Forces Institute of Pathology; Ben Wittick, courtesy of the Museum of New Mexico 71 Library of Congress 72 *All* Fototeca Storica Nazionale, Rome 76 Jimmy Hare, Photography Collection, Harry Ransom Humanities Research Center, The University of Texas, Austin 78 Hulton Picture Company, London 81 Bildarchiv Preussischer Kulturbesitz, Berlin 82 National Archives 85 Dr. Stanley B. Burns Collection 86 Library of Congress—Otis Historical Archives, National Museum of Health and Medicine, Armed Forces Institute of Pathology 87 National Archives 89 *All* Dr. Stanley B. Burns Collection 90 Library of Congress 91 James Ricalton, California Museum of Photography 92 California Museum of Photography 94 Jimmy Hare, Photography Collection, Harry Ransom Humanities Research Center, The University of Texas, Austin 96 Dr. Stanley B. Burns Collection 97 Jimmy Hare, Photography Collection, Harry Ransom Humanities Research Center, The University of Texas, Austin 98 James Ricalton, California Museum of Photography 99 Leningrad Military Museum 100 Jimmy Hare, Photography Collection, Harry Ransom Humanities Research Center, The University of Texas, Austin 101 California Museum of Photography 102 California Museum of Photography 103 Dr. Stanley B. Burns Collection 104 Jimmy Hare, Photography Collection, Harry Ransom Humanities Research Center, The University of Texas, Austin 105 El Paso Public Library 106 Library of Congress 107 Library of Congress 108 ©Archivo Casasola, Bolivar, Mexico, Harry Ransom Humanities Research Center, University of Texas, Austin 112 National Archives 114 National Archives 116 AP / Wide World Photos 118 BDIC, Paris 119 Kriegsarchiv, Vienna 120 Edimedia, Paris 121 Imperial War Museum, London 123 Photoworld / F.P.G. International, New York 124 Musée Royal de l'Armée, Brussels—Military History Museum, Vienna 125 Military History Museum, Vienna 126 Dr. Stanley B. Burns Collection 128 Museum of Contemporary History, Budapest 130 National Archives 133 *All* National Archives 134 Dr. Stanley B. Burns Collection 135 National Archives 136 Musée Royal de l'Armée, Brussels 138 Roger-Viollet, Paris 139 National Archives 140 Museum of the Polish Army—Imperial War Museum, London 141 Library of Congress 142 Military History Museum, Vienna 143 Military History Museum, Vienna 144 National Archives 145 National Archives 146 *All* National Archives 147 *All* National Archives 148 National Archives 149 Central Archive Wojskowe, Warsaw 150 Imperial War Museum, London—National Archives 151 Imperial War Museum, London 152 Imperial War Museum, London 154 *All* Imperial War Museum, London 155 Imperial War Museum, London—Roger-Viollet, Paris 156 Roger-Viollet, Paris 157 Jimmy Hare, Photography Collection, Harry Ransom Humanities Research Center, The University of Texas, Austin—Library of Congress 158 *All* Dr. Stanley B. Burns Collection 159 Roger-Viollet, Paris 160 National Library of Medicine 164 National Archives 166 National Archives 168 Novosti Press Agency, Moscow 169 California Museum of Photography 170 National Archives 171 National Archives 172 American Red Cross 174 National Archives 175 Hulton Picture Company, London 177 National Archives 178 Bilderdienst Süddeutscher Verlag, Munich—TASS, Moscow 179 National Archives 180 W. Eugene Smith, Black Star 182 Dr. Stanley B. Burns Collection 184 Library of Congress 185 Eastfoto / New China Pictures 186 Lee Miller Archives 187 Cecil Beaton, Imperial War Museum, London—George Silk, Australian War Memorial, *LIFE* 188 George Rodger, Magnum Photos 190 Carl Mydans for *LIFE* 192 W. Eugene Smith, Black Star 193 U.S. Army, courtesy Col. Eugene C. Jacobs 194 Imperial War Museum, London 195 National Archives 196 National Archives 197 National Archives 198 National Archives 199 Library of Congress 200 Bildarchiv Preussischer Kulturbesitz, Berlin 201 W. Eugene Smith, Black Star 202 American Photographic Archives 204 National Archives 205 National Archives 206 Lee Miller Archives 207 Sovfoto 208 Lee Miller Archives 209 Lee Miller Archives 210 Ullstein Bilderdienst, Berlin 211 Ullstein Bilderdienst, Berlin 212 Novosti Press Agency, Moscow 213 Leningrad Military Museum 214 Bildarchiv Preussischer Kulturbesitz, Berlin 215 Lt. Wayne Miller, National Archives 216 David Seymour, Magnum Photos 217 International Committee of the Red Cross, Geneva 218 EFE, Madrid 220 Marc Deville, Gamma Liaison Agency 222 Philip Jones Griffiths, Magnum Photos 224 Dr. Stanley B. Burns Collection 225 Ed Hoffman, American Photographic Archives 226 J. Launois, Black Star 228 Ifot / Black Star 229 Popperfoto, London 231 National Archives 233 National Archives 234 Larry Burrows Collection 236 AP / Wide World Photos 238 Larry Burrows Collection 239 Larry Burrows / *LIFE* 241 Philip Jones Griffiths, Magnum Photos 242 David Rubinger 244 Matthew Naythons, Gamma Liaison Agency 245 Farnood, Sipa Press 246 Michael Coyne, Black Star 248 Sebastiao Salgado, Magnum Photos 251 Lori Grinker, Contact Press Images 252 Matthew Naythons, Gamma Liaison 253 Alain Keler, Sygma 254 Steve Raymer, National Geographic Society 257 Suzanne Keating 258 *All* Christopher Morris, Black Star 259 Christopher Morris, Black Star 260 Alon Reininger, Contact Press Images 262 Larry Burrows Collection 264 Frank Fournier, Contact Press Images 267 Collection Sirot-Angel

Acknowledgments

Advisors, Consultants, and Friends

J. Breckenridge Bayne: *Bugs and Bullets*, New York, R. R. Smith, 1944.

Paul E. Bechet: "Jean Dominique Larrey: A Great Military Surgeon" from *Annals of Medical History*, 1937.

Edward D. Churchill: *Surgeon to Soldiers*, copyright ©1972 by J. B. Lippincott Company, Philadelphia. Reprinted by permission.

F. Edmund Vance Cooke: "The Red Cross Army Nurse" from *War-Time Echoes* edited by James H. Brownlee, copyright © 1898 by The Werner Company.

Harvey Cushing: *From a Surgeon's Journal*, copyright © 1936 by Harvey Cushing.

Douglas Dunn: "War Blinded" from *Selected Poems 1964-1983*. Reprinted by permission of Faber and Faber, Ltd.

Fielding H. Garrison: *Notes on the History of Military Medicine*, Washington, Association of Military Surgeons, 1922.

Clifford L. Graves: *Front Line Surgeons*, copyright © 1950 by Clifford L. Graves.

Robert Graves: "Recalling War" from *Poems About War*. Reprinted by permission of A. P. Watt Ltd., London, on behalf of The Trustees of the Robert Graves Trust.

C. K. Holloway, Cdr. MC, USN: "The Military Surgical Aspects of the Chosin Reservoir Withdrawal" from *The Western Journal of Surgery, Obstetrics and Gynecology*, May 1955. Reprinted by permission of the author.

Albert Jernigan's Civil War-era letter. Reprinted by permission of The Center for American History, The University of Texas at Austin.

Wilhelm Klemm: "Clearing Station" copyright © Limes Verlag in der F. A. Herbig Verlagsbuchhandlung, München, 1961. Reprinted by permission.

Lyn MacDonald: *Roses of No Man's Land*, London, Michael Joseph, Ltd., 1980. Reprinted by permission of Penguin Books, Ltd.

Ralph Major: *Fatal Partners, War and Disease*, Doubleday, Doran and Co., Inc., 1941.

Wilfred Owen: "Dulce et Decorum Est" from *The Oxford Book of War Poetry*, edited by Jon Stallworthy. Reprinted by permission of Chatto & Windus Ltd. and the Estate of Wilfred Owen.

The Apologie and Treatise of Ambroise Paré, edited by G. Keynes, London, Falcon 1951.

Siegfried Sassoon: "Does it Matter" from *War Poems*. Reprinted by permission of George Sassoon.

"Oh Christ," March 2, 1971. Letter compliments of Chaim Shatan, M.D., New York.

Manila Envelopes: Oregon Volunteer Lt. George F. Telfer's Spanish-American War Letters, edited by Sara Bunnett copyright © 1987. Reprinted by permission of the Oregon Historical Society.

E. E. P. Tisdall: *Mrs. Duberly's Campaigns; an Englishwoman's Experiences in the Crimean War and Indian Mutiny*, London, Jarrolds, 1963.

Walt Whitman: "The Wound Dresser." Reprinted by permission of New York University Press from *Leaves of Grass*, Reader's Comprehensive Edition edited by Harold W. Blodgett and Sculley Bradley copyright © 1965 New York University.

Deborah Abrams
Brig. Gen. Clara L. Adams-
 Ender
Bill Allen
John Altberg
American Red Cross
Harry Arader
Andy Bechtolsheim
David Beers
Col. Ronald Bellamy
Michel Bernard
George & Keedje Berndt
David Biehn
John Blair
Keith Boas
Lucas Bonnier
David & Iris Burnett
Phyllis Cairns
Michael Campbell
A. F. Castro, M.D.
Alex Castro III
Philip Castro
Frank Catchpool, M.D.
Mike & Gina Cerre
Howard Chapnick
Dr. Harris & Louise Clearfield
Sara Cleary-Burns
Jennifer Coley
Michael Patrick Collins
Rob Cook
James Curtiss
Donald Custis, M.D.
Sashka T. Dawg
Thatcher Drew
John Durniak
Maureen Egen
Peter Eisenberg, M.D.
Sandra Eisert
Ralph L. Elder
Steve Fairchild
Tibor Farkas
Douglas Ferguson
Michel Ferla
Fred Francis
Sara Frankel
Eleanor Freedman
Charles Fry
Jamie Gangell
Cyril Gardiner
Rebecca Gardner
Elizabeth Gehman
L. D. Geller
Sheldon Gilgore, M.D.
Glaxo Pharmaceuticals
Lynn Goldberg
Kathy Golden
Ray & Claire Golden
Eleanora Golobic
Arthur & Florence Grace
Mary Ellen Guroy, M.D.

John & Connie Gustafson
Don Guy
Dirck Halstead
Acey Harper
Alan Hawk
Ivan Held
Graham Hellestrand
Angel Luis López Hernando
Brenda Herschbach
Dr. Harry & Sharon Hirsch
Pearl & Arnold Jacobs
Peter Jaret
Donald Jenkins, M.D.
Frank Johnson
Bill Joy
Col. Robert Joy, M.D.
Devyani Kamdar
Terry Keane
Jack & Honey Keating
Tom Kelly
David Hume Kennerly
Pat Klein
Rebecca A. Kondos
Dorothy & Howard Krakowitz
Michael Kramer
Lawrence Krames, M.D.
Stephanie Krames
J. P. & Eliane Laffont
Denise & Jim Larsen
Billie Jean Lebda
Al Levin, M.D.
Dr. Carl & Karen Levitsky
Brian Linklater
Norman & Dongshen Lloyd
Bill Longley
Tom Luginbill
Lyn Macdonald
Dr. Bob & Bernadette Mack
Noam Maitless
Janice Maloney
James Mason, M.D.
Tim McNichols
 Médecins Sans Frontières–
 Paris & Sri Lanka
Susan Meiselas
Charlotte "Arky" Meisner
Dorothy Mendolson
Doug & Tereza Menuez
Neil Midgley
Karen Miura, M.D.
Phillip Moffitt
Mike Moritz
Ann Moscicki
Donald Murray
Museum of the Academy of
 Health Sciences
Benjamin Naythons
William T. Naythons
Stephen Neale
Eduard Aleksandrovich

Nechaev
Adrian Noe
Rod & Sheila Nordland
Peggy Orenstein
Dean Ornish, M.D.
Barbara Pathe
Joanna Pearlman
Liz Perle
Robert Rabkin, M.D.
Sylvie Rebbot
Tom Rielly
Ty Roberts
Jerry Rosenberg
John Rosenberg, M.D.
Roger Rosenblatt
Galen & Barbara Rowell
Michael Saleski
Jay Sanford, M.D.
Bud Saylor
Terry Schaeffer
Aaron Schindler
William Scoville
Robert & Patti Seidman
David Servan-Schreiber,M.D.
Carol Sheggeby
Gordon & Rosalie Sheggeby
Michael Sheggeby
Ron Shelton
Susan Siegel
Goksun Sipahiouglu
David g. Smith
Marvin Smolan
Judy Sollosy
Roger & Holly Spottiswoode
Dieter Steiner
Michele Stephenson
Ruth Sullivan
Rebecca Swanston
Joe Tartt
Priscilla Taylor
Roger C. Taylor
General Lah Too
Gordon W. Tucker
U.S. Army Military History
 Institute
Louise Velázquez
Jacque & Larry Vidal
Marc Vincent
Tom Walker
Geoffrey Ward
Emma Warne
Marion & John
 Warne
Walter Weintz
Kay Whitmore
Dr. George & Chris Wilkinson
Preston Williams
Michael J. Winey
Robin Wolaner

The Face of Mercy

WAS TYPESET IN
MERIDIEN AND TIMES ROMAN
ON MACINTOSH IIci COMPUTERS
USING QUARK XPRESS 3.1 SOFTWARE.
PRINTED AND BOUND BY
AMILCARE PIZZI, MILAN